D1539993

The
Camden
Town
Group

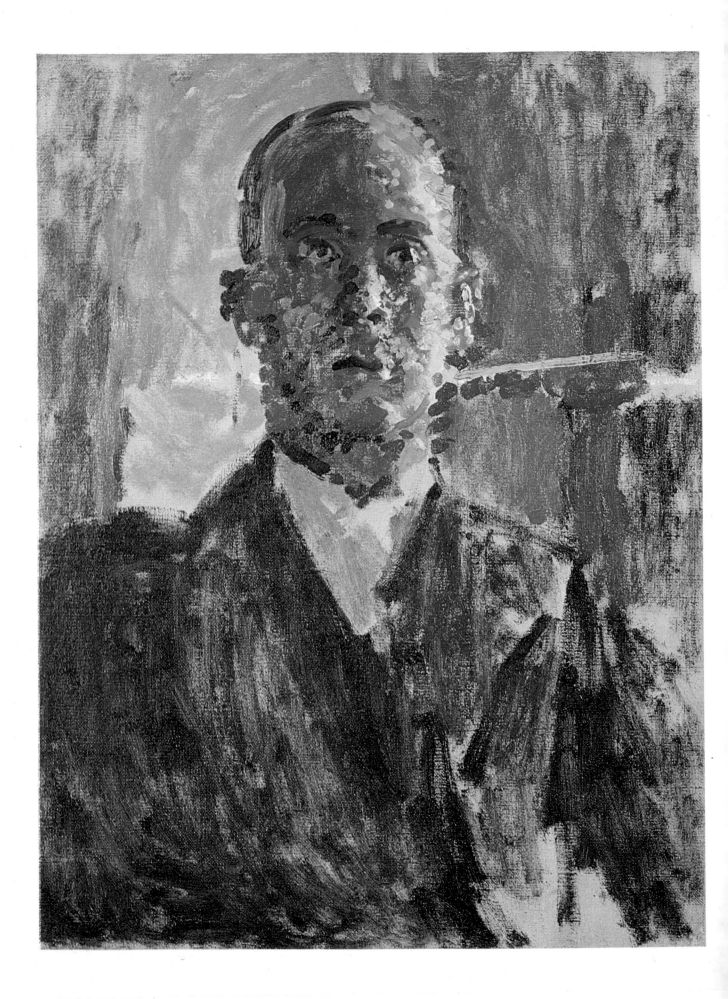

The
Camden
Town
Group

Wendy Baron

Scolar Press, London

Also by Wendy Baron
Sickert, 1973
Miss Ethel Sands and her Circle, 1977

ND
468.5
.C35
B37

E. M. CUDAHY
LOYOLA
UNIVERSITY
MEMORIAL LIBRARY
WITHDRAWN

(Frontispiece) Sickert: *Portrait of Harold Gilman*

First published 1979 by Scolar Press,
90/91 Great Russell Street, London WC1B 3PY

Scolar Press is an imprint of Bemrose UK Limited

Copyright, © Wendy Baron, 1979

British Library Cataloguing in Publication Data
 Baron, Wendy
 The Camden Town Group
 1. Camden Town group
 I. Title
 759.2 ND489

ISBN 0-85967-517-3

Designed by Ray Carpenter
Filmset in 11/14 point Plantin
Printed and bound in Great Britain by W & J Mackay Limited, Chatham

Contents

Acknowledgements

This book is a direct consequence of the Fine Art Society's decision to include an exhibition on Sickert and his circle in the programme of their centenary celebrations in 1976. They asked me to undertake the research for the exhibition and generously allowed me a free hand to select and catalogue the 150 pictures which were displayed in the autumn of 1976 as 'Camden Town Recalled'. They enthusiastically supported my ambition to attempt an historical recreation of the original Camden Town Group exhibitions by re-assembling a representative selection of pictures shown at the Carfax Gallery in 1911 and 1912. We hung these forty or so works together in the downstairs gallery of the Fine Art Society's premises in New Bond Street so that the modern visitor could experience something of the visual impression received by his counterpart sixty-five years earlier. My preparations for the exhibition are the basis of this book, and had I not received at the outset such sympathetic encouragement and help from Mr Andrew McIntosh Patrick, Mr Peyton Skipwith, Mr Tony Carroll, Mr Edward Casassa, Mr Simon Edsor and Mr Pablo Copello, I should not have pursued my research when the exhibition ended.

Dr Malcolm Easton, in his years at the University of Hull, amassed a unique archive on Camden Town and with extraordinary generosity put all this research at my disposal. He also answered my many queries, particularly about John, Manson and Ginner, with rapidity and authority.

Professor Quentin Bell has likewise been an unfailing source of help. He lent me all the material he had gathered in the 1950s as preparation for his own published and unpublished writings on Camden Town and its artists.

I have naturally relied heavily on the unstinting assistance of specialists on particular members of the Camden Town Group. Anne Thorold has taken great trouble to check my data on Pissarro and guided me through the Pissarro archives at the Ashmolean Museum, Oxford, where Christopher Lloyd was also most helpful. Mrs Thorold put me in touch with John Bensusan-Butt who has kindly and carefully scrutinized the Pissarro family documents for me. John Hoole has examined and contributed to my notes on Innes and, fortunately, while writing about the artist I was able to see his excellently researched and catalogued Innes exhibition. Richard Shone has been helpful in many ways, especially in connection with Duncan Grant, and I have also been thankful for his published writings on Grant, Roger Fry and his circle. Michael Holroyd's biography of John and John Woodeson's work on Gore and Gilman have greatly assisted me.

I am much indebted to Frederick Gore (son of Spencer Gore), to the late Mrs Ruby Dyer (sister of Charles Ginner), to John H. Gilman (son of Harold Gilman), and to Miss Mary Manson and Mrs Jean Goullet (daughters of J. B. Manson) for their help and encouragement. I am also grateful to Mrs Kitty Bayes, Mrs Natalie Bevan, Mrs Margaret Drummond, the executors of Duncan Grant, Romilly John, Lady Pansy Lamb, Henry Lessore, and Omar S. Pound on behalf of Mrs G. A. Wyndham Lewis.

I should also like to record my thanks to Benjamin Fairfax Hall, who lent me a proof copy of his admirable text on the works of Gilman and Ginner from Edward le Bas's collection, and to Max Rutherston who led me to his grandfather's letters. Others who have been of especial help to me include Dr David Brown, David and Duncan Drown, Evelyn Joll, John Lumley, Valerie Mendes of the Victoria and Albert Museum costume department, Mrs Nora Meninsky and K. T. Powell.

Particular thanks are due to Messrs Thomas Agnew and Sons, Messrs Christie, Manson and Woods, Sotheby Parke Bernet and Company, the Fine Art Society Ltd, the Anthony d'Offay Gallery and the Browse and Darby Gallery for supplying me with information and photographs. I would like to record my gratitude to the public art galleries from whose collections I reproduce paintings. They have all taken great trouble to provide me with photographs.

The owners, both private and public, of pictures by Camden Town artists have all responded to my enquiries with courtesy and enthusiasm. The public collections answered a daunting questionnaire; private owners have welcomed me to their houses and provided information about their pictures. I cannot name the public collections individually because they include nearly every art gallery in the United Kingdom and many abroad. Nor can I name the private collectors because so many wish to remain anonymous. Nevertheless I am grateful to them all.

Many dealers' galleries, as well as those mentioned above, have investigated their records on my behalf and I must thank: Crane Kalman; Andrew Leslie (the Leva Gallery); the Piccadilly Gallery; and the Rutland Gallery.

I have, of course, depended upon the services of several institutions and wish to thank in particular: Camden Library, local history section; the Courtauld Institute of Art, its library and the Witt library; the G.L.C. Maps and Prints Archive; the Tate Gallery, its library and archives; and the Society of Authors.

My publishers have throughout encouraged and advised me.

Finally, I thank my husband for reading and re-reading the various drafts of my text, and my children Richard and Susannah for their help and forbearance.

W.B.

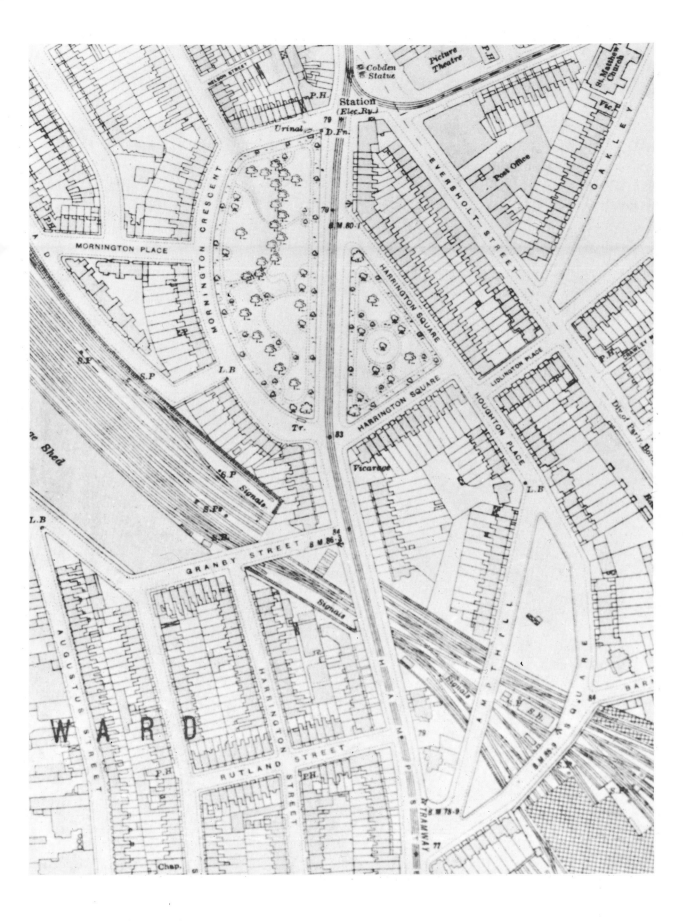

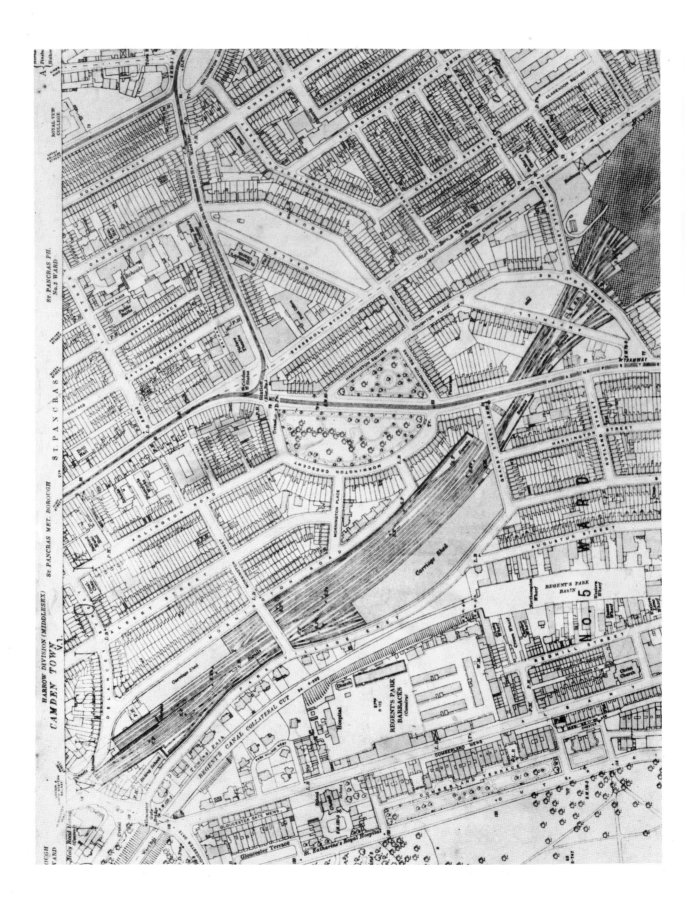

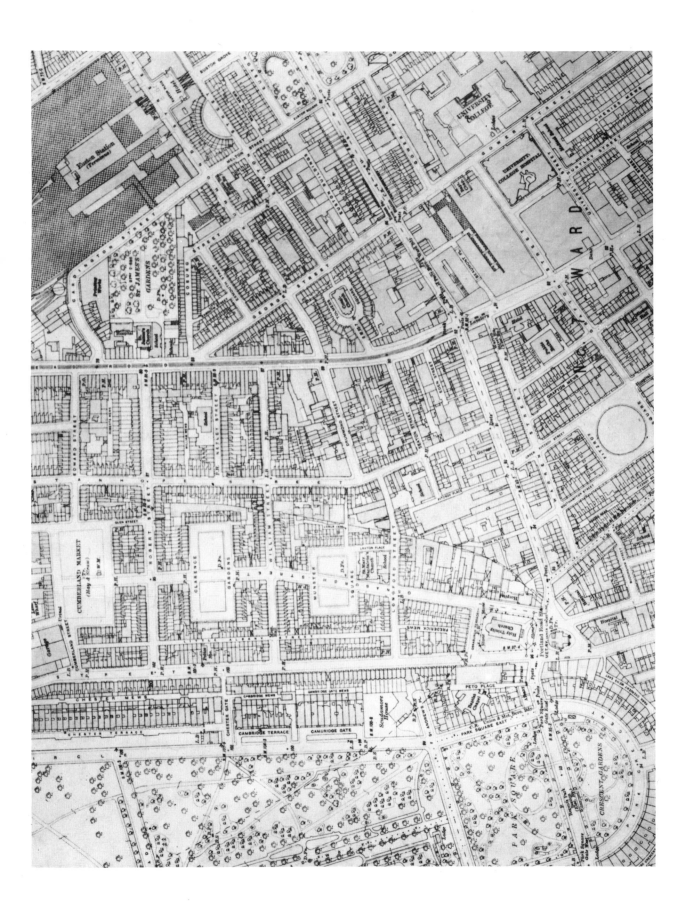

Introduction

Abbreviations used in running titles:

C.T.G. Camden Town Group

F.S.G. Fitzroy Street Group

L.G. London Group

Sickert in Camden Town

Camden Town, in north-west London, gave its name both to a style of painting and to a society of artists. The story begins soon after Walter Sickert came back to London in 1905 after nearly seven years' residence abroad. On his return he rented two studios in the neighbourhood long favoured by artists around Fitzroy Street. Thackeray, for instance, had celebrated the character of this district by housing his fictional artist hero, Clive Newcome, in Fitzroy Square. In real life one of Sickert's studios (at 76 Charlotte Street) had formerly been used by Constable; the other (at 8 Fitzroy Street) was in the house where Whistler had once rented a studio. The northern boundary of the district was defined by a broad avenue constructed in the mid-eighteenth century to serve as a London bypass. A hundred years later this 'New Road', renamed along its course as the Marylebone, Euston and Pentonville Road, no longer circumvented London but divided the Fitzroy Street area in the borough of St Marylebone from densely populated Camden Town in the borough of St Pancras.

Camden Town was named after Lord Camden who in 1791, as ground landlord, had leased the pleasant fields north of the New Road for the building of 1,400 houses. John Nash was among several architects and builders who planned the layout of streets and buildings. The fine curve of Mornington Crescent, which faced leafy gardens until the Carreras factory was built on the site in 1926, marked the northern edge of the area conceived in outline by Nash and rapidly developed during the early years of the nineteenth century. Nash envisaged this area as a service background for his elegant terraced residences facing Regent's Park. Between Albany Street running behind the park on the west, and Hampstead Road on the east, Nash planned shops, three markets (Clarence, York and Cumberland) served by the Canal basin, and a criss-cross network of little streets lined with well-proportioned but relatively modest houses. The area on the opposite eastern side of Hampstead Road was developed soon afterwards. Almost as soon as the handsome houses were completed the district was blighted by the arrival of the railways. The construction of three great termini near by, Euston completed in 1838, King's Cross in 1852 and St Pancras in 1870, brought dirt, noise and a shifting population of navvies into the area. Houses built as substantial middle-class homes were divided into temporary lodgings for a working-class population. The railway lines, particularly those serving Euston, swallowed up large tracts of residential land. Property in neighbouring streets fast declined in value.

The railway track passed the end of the garden at 6 Mornington Crescent where Sickert acquired lodgings and a studio towards the end of 1905. During the next six years he rented many more premises in Camden Town to use for studios, private art schools and living purposes. He had a studio in 247 Hampstead Road, set astride the rail tracks on the corner of Granby Street, a building better known as Wellington House Academy where Charles Dickens had been educated from 1824–6. He ran schools for etching at 31 Augustus Street and 209 Hampstead Road. He lived for a

time in Harrington Street and on his second marriage, in 1911, set up home with his wife in Harrington Square. In 1910 he took over the whole of an end-of-terrace house at 140 Hampstead Road to establish 'Rowlandson House', his most ambitious private school; once again the trains to and from Euston passed just outside his garden walls.

When Sickert took rooms in Mornington Crescent he was no stranger to this unfashionable area. His favourite music hall, studied in countless paintings and drawings between 1888 and 1898, had been the Bedford in Camden High Street. A statue of his first wife's father, the prominent advocate of Free Trade Richard Cobden, dominated the busy intersection of roads outside Mornington Crescent station. During the early years of his career Sickert had studios in Chelsea, as well as using the top floor of the house in Broadhurst Gardens, West Hampstead, where he lived following his marriage in 1885 to Ellen Cobden.[1] However, in 1894 he abandoned Chelsea to take a studio in Robert Street which, linking Hampstead Road and Albany Street, passed between Clarence Gardens (the residential square which quickly replaced the original market) and Cumberland Market. William Rothenstein, who inherited Sickert's studio in Glebe Place, Chelsea, was ever amazed by his friend's 'taste for the dingy lodging-house atmosphere' and his 'genius for discovering the dreariest house and most forbidding rooms in which to work'.[2] After separating from his wife in 1896 Sickert went to live as well as work in Robert Street. Although most of his landscapes were painted on summer visits to Dieppe and during a long stay in Venice from 1895–6, Sickert painted Munster Square (the former York Market) and Cumberland Market in the later 1890s. When he moved to Dieppe in the winter of 1898 he retained his Robert Street studio, giving it up only after his divorce in the summer of 1899. By then he had decided that his future career depended upon working abroad for an indefinite period.

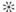

Sickert, the New English Art Club and the 'London Impressionists'

The central rôle played by Sickert in both the Fitzroy Street and Camden Town Groups is best understood against the background of much earlier efforts to urge his contemporaries towards professional collaboration. In 1888 Sickert joined the New English Art Club (N.E.A.C.) where, in April, his four-foot-high portrayal of *Katie Lawrence* behind the footlights at Gatti's Hungerford Palace of Varieties shared the honours with Philip Wilson Steer's even larger evocation of bathers on a beach entitled *A Summer's Evening*. In a letter to Jacques-Emile Blanche, Sickert enthusiastically predicted that the N.E.A.C. 'will be the place I think for the young

school of England'. However, the idealistic impetus, which had inspired the creation of the club in 1886 as an exhibiting body prepared to accept the work of painters aware of recent innovations in France, was already foundering. Its members split up into mutually antagonistic factions of which the most progressive centred around Steer. The brilliant colours and increasingly broken touch of Steer's light-drenched visions of young girls at the English seaside were derived from French Impressionism, a source disapproved of by most critics and by many of Steer's fellow-members at the N.E.A.C. Whereas Steer's *avant-garde* reputation was earned by his handling rather than by his subject-matter, the reverse was true of Sickert. He was vilified for finding the bawdy cockney music hall a proper subject for painting. Trained by his master Whistler in the arts of political manoeuvring and polemics, Sickert was a valuable addition to the Steer clique. While tactfully lying low at official club meetings and exhibiting only one picture in 1889 (*Collin's Music Hall, Islington Green*), he busied himself behind the scenes, trying to recruit sympathetic new members and conspiring to secure control of the selecting jury by his own faction. He also organized the independent exhibition of this group at the Goupil Gallery in December 1889 under the title 'London Impressionists'.[3] As author of the catalogue preface he acted as their spokesman.

The ten exhibitors were friends, sympathetic to each other's aims. They were not members of a common movement and the term 'Impressionist' could properly be applied only to Steer. D. S. MacColl, pointing out that 'Impressionism' was then 'the nickname for any new painting that surprised or annoyed critic or public', suggested that the group was christened by their dealer as 'a rough and ready means of attracting popular attention'.[4] However, it is more likely that the exhibition was christened by Sickert, whose keen appreciation of the publicity value of catchy, even if misleading, appellations is amply demonstrated by the titles of both his pictures and his written articles. Indeed 'London Impressionists', as a description of the artists showing at the Goupil Gallery, merely anticipates the inaccuracy of 'Camden Town' as a definition of the group of sixteen who exhibited at the Carfax Gallery in 1911 and 1912. Certainly neither the management of Goupil's (who in April 1889 had exhibited twenty 'Impressions by Claude Monet') nor Sickert was in any doubt about the true meaning of the term 'Impressionism'. How Sickert delicately evaded coming to grips with this issue in his catalogue preface is not relevant here. It is of interest, in view of critical reaction to later developments in Camden Town, that he rejected 'realism', which he defined as the wish to record something 'merely because it exists' thus involving the artist in 'a struggle to make intensely real and solid the sordid or superficial details of the subjects it selects'. Nevertheless, he urged the painter to seek beauty in his everyday urban surroundings. He also articulated his passionate belief that what mattered above all in a painting was 'quality', the fitness of its execution (even if this seemed 'ragged' or 'capricious') in expressing the artist's response to his subject. His lifelong creed was already formulated.

Although the 'London Impressionists' never again exhibited as a self-contained group, Sickert did not relax his attempts to publicize their activities. Two or three years later, in his Glebe Place studio, Sickert held the first one-man exhibition of

Steer's work. He wrote the catalogue preface to the first exhibition of another 'London Impressionist' colleague, the watercolourist Francis James, held at the Dudley Gallery in 1890. Sickert cited both these early efforts as precedents ('I have accomplished a great deal in that way') when he prophesied in a letter to Nan Hudson in 1907 that the group of painters he was then organizing into concerted activity in Fitzroy Street would 'slowly do very useful things in London'.

Prelude to emigration

As the 1890s progressed Sickert and his colleagues gradually drew apart, separated as much by their different temperaments as by their different preoccupations as painters. None possessed Sickert's restless energy, nor his fierce professionalism. Moreover, the motive for their struggle was gone. The Steer faction gradually gained control of the New English jury and, with the resignation or defection of other groups, came to dominate the club. Their prestige and authority were boosted when Fred Brown, Steer's original champion and one of the 'London Impressionists', was appointed Slade Professor in 1892. Writers sympathetic to their ideals, George Moore, D. S. MacColl and R. A. M. Stevenson, were appointed art critics to the *Speaker*, the *Spectator* and the *Pall Mall Gazette* respectively.

Only Steer and Sickert among the 'London Impressionist' group had ever been innovators. As the decade moved on Steer abandoned the dazzling stippled handling of his early works. He painted landscapes, portraits and (long before Sickert) informal figure studies, including nude subjects. However, from about 1894 onwards, he turned from Impressionism and from the direct spontaneous observation which informed his intimate figure subjects and began to pillage a bewildering range of largely traditional pictorial sources. To quote Dr Laughton, 'in his figure paintings . . . there is a continuous regressive change, as it were, back through evocations of Manet and Velasquez to a rather dusty version of French rococo. The landscapes . . . become inhibited and old-masterish.'[5] Sickert found himself isolated as the only one of the group who was still experimenting and exploring in an effort to discover and develop his independent artistic personality. While faithful to the tonal tradition in which he had been reared by Whistler, Sickert recognized its dangerous tendency towards over-simplification. Many experiments during the 1890s, in both his landscapes and his portraits, were directed to discovering means of avoiding Whistlerian slightness of form and content. Monumental design; the use of deep, opaque colours; an extension of his tonal scale with the intermediate gradations excised (particularly in his night scenes of Venice, Dieppe and the Cumberland Market region); the broad, untidily slashed

brushwork of some of his portraits and landscapes later in the decade: these were among his methods of rejecting the subdued, refined effects favoured by Whistler and his followers. Although Sickert tackled only one major music hall subject during the 1890s, the *Gallery of the Old Bedford, Camden Town*, his several versions of this scene demonstrate that he could transcend the influence of Degas as well as of Whistler. His earlier Degas-inspired representations of a floodlit stage seen behind silhouetted heads in a darkened auditorium (revived by Gore in the next century) were forgotten as Sickert concentrated on the rapt occupants of the gallery. He omitted all reference to the stage. The sophistication of his design produced compositional and psychological tensions which did not need explicit support or explanation. When Sickert returned to the music hall as a subject for painting in 1906 it was the spectators, often in the gallery, who recaptured his attention.

In spite of Sickert's essential independence, he did not relish isolation. Personal difficulties contributed to his depression and disillusion in the latter half of the 1890s. His marriage broke down. He was publicly slighted by his former master Whistler.[6] In the winter of 1898 he decided that he could no longer tolerate the apathetic insularity which characterized his professional colleagues in Britain. He escaped across the Channel, gave up portrait painting, and settled down to paint the architecture of Dieppe.

Sickert's residence abroad, 1898–1905

Dieppe remained Sickert's base until 1905. He punctuated his residence there with several long visits to Venice, and Venetian landscapes helped relieve the monotony of his concentration on the topography of Dieppe. Then, at the age of forty-three, on his visit to Venice of 1903–4, Sickert discovered a new and consuming interest in painting figures in his shabby rooms on the Calle dei Frati. Back in Dieppe he continued to paint intimate figure subjects, posing his mistress, the doyenne of the fishmarket Madame Villain, nude on the tousled sheets of an iron bedstead.

During his absence Sickert maintained some contact with England, and even made fleeting visits to London. He occasionally sent his work over for exhibition at the N.E.A.C., although he had resigned his membership in 1897. Ernest Brown of the Fine Art Society arranged to exhibit some of his landscape drawings in London. However, Sickert's main link with London was sustained through his friendship with William Rothenstein. Rothenstein, who had attended Sickert's evening classes in The Vale, Chelsea, in 1893 and had taken over Sickert's studio in Glebe Place in 1894, now worked in an advisory capacity for the Carfax Gallery which

began acquiring Sickert's work in 1899. The gallery had been started by a young painter and archaeologist, John Fothergill, in 1898; its staff then included Arthur Clifton (in charge of the business side) and Sickert's younger brother Robert. It was William Rothenstein's younger brother Albert (later Rutherston) who, on a painting trip in Normandy with Walter Russell and Spencer Frederick Gore, took Gore to visit Sickert in Dieppe in 1904. Sickert's reputation as the *enfant terrible* of British art during the later 1880s and the 1890s had survived his absence. Gore had probably seen his pictures at the N.E.A.C. Sickert for his part was hungry for news and presumably questioned his visitor about the talent of the new generation of Slade-trained painters. Gore had studied at the Slade from 1896–9, coinciding or overlapping not only with Albert Rothenstein, but also with Harold Gilman, Wyndham Lewis and Augustus John.

It is probable that Gore's account of these young painters' gifts encouraged Sickert to consider returning to London. He had exhausted his interest in painting the architecture of Dieppe. It may also have occurred to him that London, with its drab and sleezy suburbs, its forbidding tenement houses full of dusty high-ceilinged rooms barely letting the cold grey light filter through begrimed windows, was the ideal setting for the kind of figure pictures he longed to paint. He was later to advise Nina Hamnett to exploit the unique flavour of English subjects in her painting: 'aren't we canaille enough for you?' he asked: 'Didn't Doré and Géricault find English life sordid enough?'[7] Almost certainly Sickert envisaged and welcomed the probability that in London he might once again orchestrate the careers of his colleagues. Gore and his generation evidently needed the support of a mature, established, but nonetheless independent and original, artist. Steer, who now taught at the Slade, was not prepared to enter the fray on behalf of his young pupils. By 1905, as J. B. Manson, the future secretary of the Camden Town Group, was later to recall, the N.E.A.C. 'had already found its respectable level; it had reached a point of safety. It was too tired or too wise to venture further.'[8] The club had indeed become almost as tame and conservative in its approach to young talent as the Royal Academy. An active rôle awaited Sickert in London.

Sickert's return to London
and his relationship with Gore

Sickert's return to London in 1905 was provisional. He spent the year partly in England and partly in France. He kept his house in Neuville, on the outskirts of Dieppe. He exhibited at the *Salon d'automne* in Paris but not at the N.E.A.C. in London. However, by 1906 he had fully committed himself to London. He had

rooms at 6 Mornington Crescent, he kept on his studio at 8 Fitzroy Street (but gave up Constable's studio in Charlotte Street), and he rejoined the New English Art Club. Just as his introduction to the club's exhibitions in April 1888 had been effected with a major music hall picture, so he chose to re-introduce himself in June 1906 with *Noctes Ambrosianae* (Pl. 1), an expressive evocation of the dark gallery at the Middlesex Music Hall, with faces glimmering weird and lop-sided between the rails. In the winter he exhibited some of his Venetian figure studies of 1903–4. His pictures were greeted with relief by the critic of the *Athenaeum*: 'May we look to Mr Sickert for a revival of that diablerie which we associate with his name, and which is a little wanting in the heavier-handed New English artists of this generation?'[9]

The author of this remark was probably Walter Bayes, a painter in oils and watercolour who since 1890, when he was still a student, had exhibited with the Royal Academy. Bayes had to wait two years for Sickert to reciprocate this recognition. In 1906 Sickert's closest associates were the Rothenstein brothers and, above all, Gore.

The earliest paintings by Gore to survive are a few tentative Normandy landscapes of 1904 which reveal the influence of Corot. In 1905 he went to central France where the constructive perspective of his wide-ranging views around Billy on the river Allier suggests that he was grafting knowledge of seventeenth-century Dutch landscape on to his training by Steer at the Slade. The only startling picture of this period is *The Mad Pierrot Ballet, The Alhambra* (Pl. 2).

The coincidence that Gore took up the popular theatre as a subject for painting just when he began to be friendly with Sickert is perhaps over-emphasized. Frederick Gore has told[10] how early drawings prove his father's fascination with Goya's carnival scenes. A visit to Madrid with Wyndham Lewis in 1902 may have reinforced Gore's attraction to the romantic expressionism of Spanish art. While the compositional scheme of *The Mad Pierrot Ballet* could refer to Sickert's music halls of the 1880s (many presumably available for study in his studios some sixteen years later), Gore's attraction to a stage scene so weird and wonderful as an elephant and absurdly dressed cavorting dancers suggests an emotional response to his subject very different from Sickert's. In this, as in many of his later music halls, Gore betrayed a streak of fantasy and licence hardly ever found in Sickert's work. While Sickert's example no doubt encouraged Gore to persevere with music hall pictures, his influence on their style and conception was minimal. *The Mad Pierrot Ballet*, with its romantic sense of colour, its impasto, and the lunacy of its subject, points perhaps to an alternative source of inspiration in Adolphe Monticelli's paintings of itinerant troupes of players. Monticelli, a French painter of Piedmontese origin, had died in 1886 but his work enjoyed something of a vogue, especially among painters, in both France and England during the late nineteenth and early twentieth centuries.

Gore continued to revel in the riot of colour at his favourite music hall, the Alhambra in Leicester Square, which specialized in spectacular ballet displays with luscious backdrops and ornate costumes. Sickert never painted there. Occasionally the older man's influence surmounted Gore's more exotic taste. Once Gore sat by Sickert's side at the New Bedford in Camden Town and sketched the view Sickert

was studying intensively as preparation for a painting (Pls 3, 4). He also painted a few New Bedford subjects, although he did not pursue this particular Sickert composition any further. Ironically, Gore's most Sickertian music hall interior is thought to have been studied at the Alhambra. In *Rinaldo* (Pl. 5) Gore forsook his own preference for pure colours in favour of Sickert's more muted and muddy range of browns and ochres. The heads of the audience, silhouetted large on the surface, and the free, slashed application of thin paint, also refer to Sickert, although Gore's personality is declared by his choice of a mad violinist as subject. Moreover, soon after Gore painted *Rinaldo* he produced *The Balcony at the Alhambra* (Pl. 6), which in style and treatment announces a total break with Sickert. *The Balcony* introduces the brilliant phase in Gore's career, cut short by his premature death, during which he explored a novel combination of Post-Impressionist sources to produce pictures of everyday life ruthlessly reduced to their essential formal components of constructive design and colour.

Pictures of music halls did not become a part of the vocabulary of Sickert's Camden Town associates other than Gore and, as we have seen, Gore might well have come to this subject without Sickert's help. Remembering the disparity in their ages, Sickert forty-six in 1906 and Gore twenty-eight, it is arguable that Gore might independently have developed his interest in all sorts of Sickertian subject-matter. However, as it happened, Sickert was directly responsible for taking Gore straight from his relatively conventional landscape painting into the Camden Town bedrooms he used as studios, and there introduced him to the themes which established the identity of Camden Town painting.

Sickert had himself been painting intimate interiors only since 1903. In London from 1905–6, besides continuing with his series of nudes on metal bedsteads (Pls 7, 29) begun in Dieppe in 1904, he had been developing his ability to integrate figures (clothed and unclothed) and their settings into pictures which appeared convincing as an aspect of ordinary life. In 1906 he worked at this problem in his Mornington Crescent studio with Gore at his side. Sickert's *Mornington Crescent Nude: Contre-Jour* and Gore's *Behind the Blind* demonstrate their close collaboration (Pls 8, 9).

In the summer of 1906 Sickert lent his house at Neuville to Gore and joined him there for a few weeks. Four years later[11] Sickert attributed his own effort to recast his painting 'and to observe colour in the shadows' partly to the influence of Gore. Writing in 1910 Sickert stated that this process of revision had begun 'about six or seven years ago', that is in 1903–4. Obviously Gore's influence on Sickert's development could only have begun when they were working in close association from 1906 onwards. *Behind the Blind* is much lighter in tonality and more varied in colour than Sickert's contemporary interiors. Similarly, Gore's Dieppe landscapes of 1906, painted while he stayed in Sickert's house, tended to be brighter in colour and more broken in execution than Sickert's landscapes. Nevertheless, Gore's observation of colour in the shadows was still haphazard at this date, and he was not yet using the pure colours on a white ground, the constructive *pointilliste* brushwork and the divided tones which became general in his work from 1907 onwards. He was indeed swaying in a variety of directions in 1906, sometimes adopting the attractive *plein-air* style favoured by the New English Art Club as in *The Cross-Roads, Neuville*

(Pl. 10), and sometimes imitating the Sickertian approach to the sketching of landscape as is seen in the objective statement, the sharply drawn accents and the reddish-brown tonality of his small-scale panoramic studies of Dieppe (Pl. 11).

Sickert went on to Paris from Neuville in 1906. He spent the autumn and part of the winter painting nudes in his hotel room and, for the first time, studying the music halls of Paris. Because he lingered in Paris Sickert could not serve, as promised, on the N.E.A.C. jury that winter, although he did send over for exhibition the Venetian pictures welcomed by Bayes. Gore, who had shown two French Billy landscapes with the club in the summer, had one of his Neuville landscapes accepted for the winter exhibition. Meanwhile, in Paris, Sickert prepared for a big one-man show of his work at Bernheim Jeune to open in January 1907 and he exhibited ten pictures at the *Salon d'automne*. When viewing this *Salon* Sickert was much impressed by a painting of Venice, *Le Canal de la Giudecca*, by a lady listed as Mme Hudson with an address in Paris. He contemplated writing to the unknown artist to request an exchange of pictures. In the spring of 1907 he discovered that Mme Hudson was the American Miss Anna Hope (Nan) Hudson whom he had already met in Paris and in London where she lived with the American-born Miss Ethel Sands.

Formation of the Fitzroy Street Group

On his return from Paris, in the spring of 1907, Sickert decided to implement the scheme he had been considering for some time. He had formed the habit of keeping open house in his studio at 8 Fitzroy Street on Saturday afternoons. His circle had not much altered since he had settled again in London in 1905 and his most regular Saturday visitors were William and Albert Rothenstein, Walter Russell and Gore. In February 1907[12] Sickert met Harold Gilman who had been a friend of Gore during their art-student days at the Slade. Gore and Gilman had then gone their separate ways, although it is possible that they met when Gore and Wyndham Lewis visited Spain in 1902. Gilman spent about a year in Spain, largely occupied with studying and copying the paintings of Velazquez and with wooing an American girl whom he married in Madrid in February 1902. In 1903 he was back in England, and in the spring of 1904 a *Still Life* by him was exhibited at the N.E.A.C. However, living in the country[13] with family responsibilities, Gilman's art developed during these early years free from the influence of his Slade contemporaries. He painted portraits of his wife and children and charming Edwardian interiors (Pl. 12) in a smoothly blended range of cool tones and colours. In 1907, although he still lived outside

London, he evidently began visiting the capital more frequently. He was certainly one of the painters (the others being the Rothenstein brothers, Russell and Gore) who, under Sickert's direction, rented a first floor and a store room at 19 Fitzroy Street. There they hoped to show pictures to anyone who cared to come, every Saturday, year in, year out, under the formula 'Mr Sickert at Home'. When Sickert discovered that Miss Sands and Miss Hudson were not amateur lady-painters, but had their work on sale, he asked if they would join his group (Pls 13–17). He explained the practical arrangements – the equal division of the rent at £50 a year – and his motives:

> I do it for 2 reasons. Because it is more interesting to people to see the work of 7 or 9 people than one and because I want to keep up an incessant proselytizing agency to accustom people to mine and other painters' work of a modern character. Every week we would put something different on the easels. It is agreeable sometimes to show something 'lucky' you have done *at once* to anyone it may interest. All the painters interested could keep work there and would have keys and could show anything by appointment to any one at any time . . . I want to create a Salon d'automne milieu in London and you could both help me very much.[14]

Ethel Sands and Nan Hudson accepted the invitation, although their busy social lives did not permit attendance each Saturday. Nineteen Fitzroy Street was not immediately ready for use and the first selected gatherings of the Fitzroy Street Group were still held at Sickert's studio at 8 Fitzroy Street. Urging Ethel Sands and Nan Hudson to send two pictures each for the last of the 'At Homes' at No. 8, Sickert expanded on his aims for the future:

> Accustom people weekly to *see* work in a different notation from the current English one. Make it clear that we all have work for sale at prices that people of moderate means could afford. (That a picture costs less than a supper at the Savoy.) Make known the work of painters who already are producing *ripe* work, but who are still elbowed or kept out by timidity etc. . . .
>
> And of course no one will feel we are jumping at the throats to buy. That comes of its own accord. People pay attention to things seen constantly and judiciously explained a little.
>
> Further I particularly believe that I am sent from heaven to finish *all* your educations!! And, by ricochet, to receive a certain amount of instruction from the younger generation.

It is interesting that Sickert felt that his group represented the younger generation; that he felt their work, within an English context, was modern; and that he believed them to be struggling against the establishment. At forty-seven Sickert was the oldest of the group, but Russell was only seven years his junior. All except Gore and Albert Rothenstein were over thirty. Furthermore, of the eight original members three belonged to the N.E.A.C. establishment (Sickert, Russell and William Rothenstein), serving on its juries and committees. Albert Rothenstein was a member of the N.E.A.C. and Gore usually had his work accepted for exhibition. Russell, a close friend of Gore, had exhibited at the Royal Academy since 1898, and had been Assistant Professor at the Slade School since 1895. Nothing in his fresh and charming portraits or landscapes could possibly have offended public and critics in 1907. Sickert seems to have been tilting at windmills. Perhaps his memories of the 1880s led him to identify the N.E.A.C. with the modern movement

in British art. Recollection of his early battles inspired him to approach George Thomson, one of the 'London Impressionists' of 1889 and now a teacher of perspective at the Slade and head of the Department of Art at Bedford College, but Thomson seems to have resisted recruitment. Lucien Pissarro, another respected member of the N.E.A.C., was invited to join the group and accepted in the autumn of 1907. Sickert was delighted when, as he told Nan Hudson, the £2 collected from each member enabled him to buy not only gas-fittings but also chairs 'like at the New English 21 shillings a dozen'. He busied himself with the practical arrangements, such as the layout of furnishings (Fig. 1). Nan Hudson was again the recipient of Sickert's views on how the group should conduct itself:

I want, (and this we can all *understand* and never *say*) to get together a milieu rich or poor, refined or even to some extent vulgar, which is interested in painting and in the things of the intelligence, and which has not . . . an *aggressively* anti-moral attitude. To put it on the lowest grounds, it interferes with business.

At this early stage Sickert clearly envisaged the Fitzroy Street Group as a co-operative commercial enterprise, run by a partnership of socially acceptable friends who broadly represented an off-shoot of the N.E.A.C. It soon attracted a small but faithful clientele. The virtuoso collector Sir Hugh Lane, Steer's patron Cyril Butler, Hugh Hammersley, Judge William Evans, Sir Louis Fergusson, Walter Taylor (a watercolourist as well as an avid collector of contemporary British art), and several discerning ladies including Mrs Charles Hunter, Mrs Donaldson Hudson and Mrs Salaman, talked, drank tea, sometimes listened to an informal concert and, bypassing the dealers, bought pictures at these Saturday meetings in 1907. It has been thought that Ethel Sands and Nan Hudson, the lady members of Fitzroy Street, were sleeping partners, neither exhibiting nor selling work with the group. This is not correct. Like everyone else in 1907 they contributed an easel (light-weighted, of dark wood). These were arranged to form a screen with a picture by each artist displayed on his or her own easel. In 1908 this method was altered; the easels stood empty with pictures in the stacks behind and visitors were taken through each artist's stock (Pl. 18). Nan Hudson's Venetian picture from the 1906 *Salon d'automne*, which had been acquired by Sickert, was removed from his rooms in Mornington Crescent in 1907 to hang at Fitzroy Street where it could be 'seen and slowly rubbed in, week by week, to all our congregation'. Henry Tonks, the painter, draughtsman and notable teacher at the Slade, particularly admired another of Nan Hudson's pictures (showing a bed, green quilt and a chair) displayed during her absence one Saturday. Very occasionally one of their pictures sold. Sickert would send them 'the report due to partners', detailing the sales made on Saturdays they had missed. In May 1907, for example, he reported:

one Gore	£10 to Mrs Donaldson Hudson
one watercolour Russell	£10 to Walter Taylor
one panel by me	£5 to Mrs Donaldson Hudson
one sketch by me	£5 a present from Mr Taylor to Miss Russell.

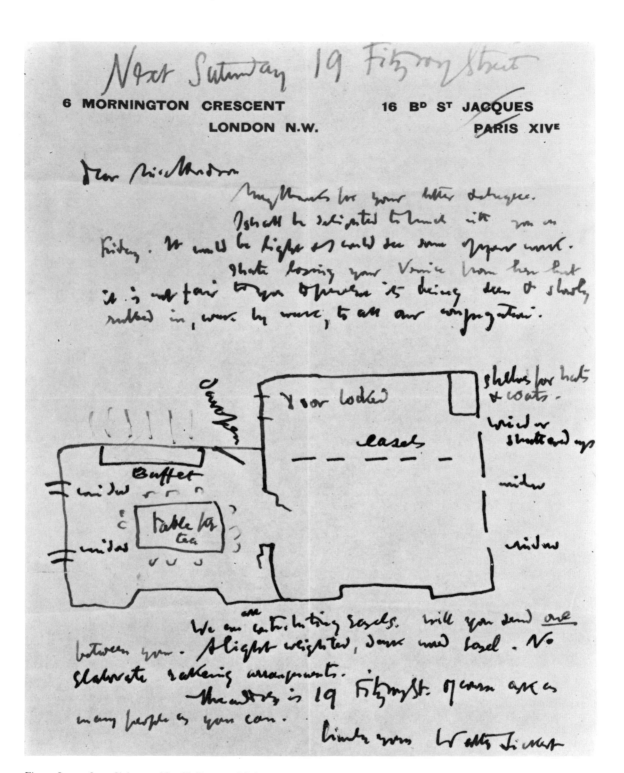

Fig. 1: Letter from Sickert to Nan Hudson explaining
 layout of 19 Fitzroy Street

Camden Town painting

Although the Fitzroy Street Group was never intended to represent a movement or school it did come to nurture a distinct and important episode in the history of British art which is most suggestively described as Camden Town painting. What is thought of as Camden Town painting is compounded of several characteristics. The pictures tended to be small: 'little pictures for little patrons', to quote one of the latter.[15] Its favourite themes established an unmistakable vocabulary: nudes on a bed, at their toilet, or just naturally inhabiting their shabby bed-sitters in Camden Town; informal portraits of friends and coster models in humble interiors; mantelpiece still-lifes of cluttered bric-à-brac rather than tasteful arrangements of *objets d'art*; and landscapes of commonplace London streets, squares and gardens. It shunned the pretentious. Pompous exhibition pictures on an inflated scale, paintings of august sites, of drawing-room beauties and idealized nudes were rejected. Sickert, but not the others of his group, developed a peculiar brand of conversation piece. He embellished his two-figure subjects with spurious anecdotal interest by adding piquant titles. The titles were afterthoughts and therefore interchangeable. For example, paintings of a reclining nude woman, her form dissolved into myriad particles by the filtered light which throws the figure of a clothed man seated at her side into *contre-jour* silhouette, have been variously known as *The Camden Town Murder*, *'What shall we do for the Rent?'* and *Summer Afternoon* (Pl. 106).

Another characteristic of Camden Town painting is closely related to its vocabulary. Every theme was treated with objective perceptual honesty. The method taught by Sickert, and adopted by many of his close colleagues, was to work from drawings in which the relationships of figures and objects to their settings and to each other were recorded with dispassionate accuracy. The objective approach did not imply indiscriminate transcription of everything before the painter's eye. 'Realism' as defined by Sickert in his 'London Impressionists' catalogue preface (the 'struggle to make intensely real and solid the sordid or superficial details' of its subjects) was not its aim. On the contrary, selection was essential so long as it was dictated by the individual temperament of the painter and reflected his honest visual response to the subject rather than his preconceptions of picture-making. Only deliberate artifice was discarded.

Sickert, virtually single-handed, inspired both the vocabulary and the objective perceptual approach of Camden Town painting. In his 'London Impressionists' catalogue he had asserted that magic and poetry were to be found in the everyday urban surroundings of the artist. He himself found beauty in the cockney music halls. Although he preferred to paint the bustling port and narrow streets of Dieppe, as a disciple of Whistler he presumably accepted limpid views of the Thames and Chelsea as pictures of everyday subjects. However, in 1908 he published his mature re-assessment of Whistler's production which he now believed to have been vitiated by the infiltration of the artist's ultra-refined taste and dandified personality: 'Taste

is the death of a painter. He has all his work cut out for him, observing and recording. His poetry is the interpretation of ready-made life. He has no business to have time for preferences.'[16]

In a series of articles Sickert inveighed against the tastefulness and the 'puritan standards of propriety' to which he attributed the 'insular decadence'[17] of British painting. In 1910 he wrote perhaps his most quoted dictum:

> The more our art is serious, the more will it tend to avoid the drawing-room and stick to the kitchen. The plastic arts are gross arts, dealing joyously with gross material facts . . . and while they will flourish in the scullery, or on the dunghill, they fade at a breath from the drawing-room.[18]

In the same year he advised the artist to follow the typical little drab, quaintly christened 'Tilly Pullen', into the first shabby little house, into the kitchen or better still into the bedroom.[19]

The fact that pictures of less than beautiful nudes on iron bedsteads have come to personify Camden Town painting is an historical distortion directly attributable to the dominant position Sickert held within the Fitzroy Street Group. Besides Sickert only Gore, Gilman from about 1910, and very occasionally Malcolm Drummond, painted intimate, as opposed to idealized, nude subjects. However, Sickert's treatment of the subject was so powerful that even his contemporaries tended to overlook the rest of his production. With his flair for publicity Sickert borrowed the title 'The Camden Town Murder' (as the press christened the murder of Emily Dimmock in September 1907) for many of his pictures representing a nude woman and a clothed man (Pls 28, 106). None of these pictures, even the most dramatically composed and brutally treated variant (Pl. 28), was a recreation of the event as it actually happened. Sickert's juxtapositions of naked and clothed figures were primarily dictated by aesthetic principles. He declared that *Le Bain Turc* by Ingres, a composition consisting entirely of nude figures, suggested 'an effect like a dish of spaghetti or maccheroni'.[20] He expressed his own preferences in 1910:

> The nude occurs in life often as only partial, and generally in arrangements with the draped . . . Perhaps the chief source of pleasure in the aspect of a nude is that it is in the nature of a gleam – a gleam of light and warmth and life. And that it should appear thus, it should be set in surroundings of drapery or other contrasting surfaces.[21]

Sickert's love of the contrast of living flesh and inanimate drapery explains why so many of his single-figure nude paintings show the model in bed, gleaming amid the crumpled bedclothes (Pl. 29). The locations, poses and relationships of his figures were chosen not so much for their suggestive innuendoes as for their pictorial possibilities. Yet Fred Brown, professor at the Slade and formerly one of the 'London Impressionists', felt impelled during the First World War to write and tell the artist that the sordid nature of his pictures since the Camden Town Murder series made it impossible to continue their friendship.[22] The powerful image of Sickert's pictures even coloured the retrospective memory of Fitzroy Street participants. Miss Ethel Sands remembered how news that Gore's uncle, the Bishop of Oxford, was expected one Saturday caused a scramble to find pictures

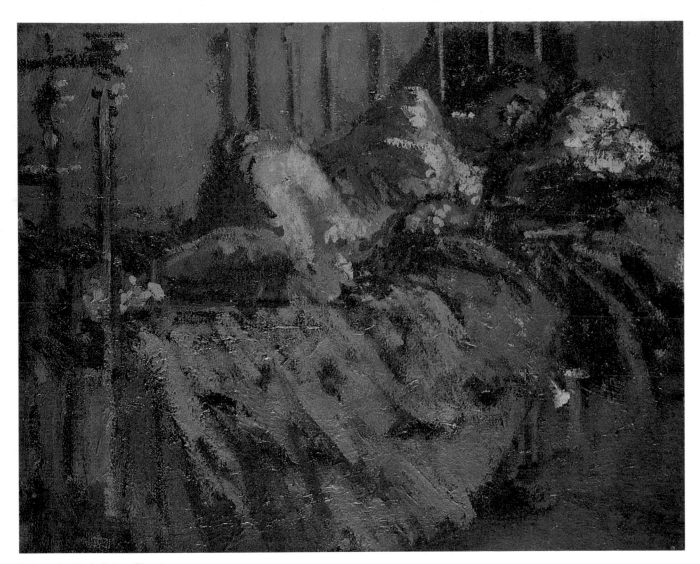

Sickert: *Le Lit de Cuivre* (Pl. 29)

more suited to the episcopal eye than the naked women in bed everyone had painted.[23] It is inconceivable that all the members of Fitzroy Street had painted nudes. The only explanation is that Sickert's pictures, perhaps supported by Gore's and Gilman's, wiped all sorts of acceptable subjects from her memory.

The last major characteristic of Camden Town painting was the handling developed by a nucleus of Fitzroy Street artists whose work represents a late flowering of English Impressionism. This characteristic is both the simplest to define and the hardest to confine to Camden Town. Several artists who may be called Camden Town painters, such as Drummond and Sickert, flirted only temporarily with this handling. To others, such as Bevan, Gore and to a lesser extent Gilman, it was an important stage in their development. Pissarro and Manson used it consistently but their almost exclusive concentration on rural landscape rather than on figure or townscape subjects sets them apart from the central core of Camden Town painters. Despite qualifications, interest in colour analysis and the development of a broken touch were characteristics of handling typical of many painters belonging to the Fitzroy Street Group between 1907 and 1911.

Lucien Pissarro, eldest son of the classic French Impressionist Camille Pissarro, was the chief inspiration behind this development. The debt to Pissarro was recognized and acknowledged at the time. As Sickert wrote in 1914:

Pissarro, holding the exceptional position at once of an original talent, and of the pupil of his father, the authoritative depository of a mass of inherited knowledge and experience, has certainly served us as a guide, or, let us say, a dictionary of theory and practice on the road we have elected to travel.[24]

Lucien had settled in England in 1890 but for many years devoted his main energies to the design, illustration and printing of books for the Eragny Press which he created in 1894. His paintings were seldom seen in England until he began exhibiting at the N.E.A.C. in 1904. He became a member in 1906. His suburban and rural landscapes were deeply influenced by his father. While his pictures of railway cuttings at Acton (Pls 30, 100) hark back to Camille Pissarro's *Lordship Lane* (until recently mistitled *Penge Station, Upper Norwood*) of 1871, most of his sensitive, scrupulously realized landscapes (e.g. Pl. 31) were executed in solid pigment, applied in separately coloured touches of light-toned pure colour, a handling closely based upon his father's later, more Neo-Impressionist, treatment. Like his father, Lucien Pissarro ignored the rigid scientific basis of Neo-Impressionism which pre-determined the colour of each touch of paint, yet adopted the characteristic disciplined *pointilliste* execution developed to express this theory. By temperament he preferred the constructed design of Neo-Impressionism to the more haphazard and spontaneous compositions of the original Impressionists.

Lucien Pissarro's painting deeply impressed Gore just when he needed guidance to help him emerge from the influence of Steer, Corot and the Dutch landscape tradition. He was already naturally inclined to the use of brighter, purer colour than many of his contemporaries. Lucien Pissarro's example showed him how to manipulate his colours and control his touch. Although Pissarro did not join the Fitzroy Street Group until the autumn of 1907 Gore's ready assimilation of the elder

artist's method was already demonstrated in the landscapes he painted during the summer of 1907 (Pl. 32) on a trip to Yorkshire with Albert Rothenstein and Mr and Mrs Walter Russell. Gore's response was also sufficiently sensitive to allow him to adapt his new execution to the painting of music halls and portraits. It is possible that Gore's *Woman in a Flowered Hat* (Pl. 33) of 1907, showing the model in front of a window with Sickert's figure glimpsed in the street outside, influenced Sickert's several portraits of *Little Rachel* (Pl. 34) by a similar window painted in Mornington Crescent during the summer of 1907.

Sickert's position was curious. Unlike Gore he had known Lucien Pissarro since the 1890s, and he had first-hand knowledge of French Impressionism and Neo-Impressionism. Also unlike Gore, he was a mature artist who had long since found his own ways of outgrowing dependence on his early training. From time to time since the 1890s, Sickert had experimented with broken brushwork, and in his landscapes and figure pictures of 1906 he had begun to use small dabbed touches of thicker paint. His colours were, however, still based on blacks, browns and greens. When, in 1910, Sickert gave the retrospective account already quoted of how he recast his painting 'to observe colour in the shadows', he acknowledged three influences: Camille Pissarro in France and Lucien Pissarro as well as Gore in England. Certainly, his decision to invite Lucien to join the Fitzroy Street Group occurred just at the time when, early in 1907, Sickert became increasingly preoccupied with the problem of expressing reflected light on figures and objects.

Sickert's interest in reflected light coincided with a period of critical self-examination which led him to the conclusion that he had done too much sketching and too little 'considered, elaborated work'. As a 'punching-ball' he settled down to paint 'a life-sized head of myself in a cross-light which will I think become something in time'.[25] This head is *The Juvenile Lead* (Pl. 35), a title given to the picture by Sickert at a later date when he perhaps looked back with ironic humour at his rôle in 1907 as the middle-aged actor-manager of Fitzroy Street. Although *The Juvenile Lead* is still deeply sombre in tone and colour, the modelling, especially where the obliquely falling light is reflected in the face, is more consistently and constructively built up in small overlapping dabs and smears of rough, crusty paint. Soon afterwards he painted another self-portrait in the studio (Pl. 36) which, when exhibited at the N.E.A.C. in the summer, caused Walter Bayes as critic of the *Athenaeum* to remark that its consistently crumbling facture made 'this kind of handling a formal decoration'.[26] By the summer Sickert was so engrossed in a series of Mornington Crescent *contre-jour* interiors, which he described to Nan Hudson as 'Studies of illumination', that he put off going to France. He lent his Neuville house to the Gilmans and settled down to paint from a nude model (Pls 37, 38) and from a 'little Jewish girl of 13 or so with réd hair' (Pl. 34), on alternate days. It was in these Mornington Crescent interiors that Sickert introduced a brighter and more varied range of colours into his palette, including the violets and greens typical of Impressionism. The tones, though subtly muted, are less sombre than previously. The quality of the paint, applied in disciplined but delicate stippled touches, is rich and sensuous. Gore and Lucien Pissarro were undoubtedly the primary influences behind this development in Sickert's handling. However, such was the reciprocal

nature of relationships within Fitzroy Street, that Sickert's sensitive adaptation of the method to suggest *contre-jour* effects of light on a figure in turn inspired Gore to paint similar pictures, for example *Morning. The Green Dress* (Pl. 39).

This type of handling never became a formula for Sickert. He merely assimilated the use of thicker paint, applied in broken touches of lighter and brighter colour, into his technical repertoire. In his pictures of 1907–10 he made free use of the variety of texture, brushwork and colour it afforded to paint such pictures as *Sally—the Hat* (Pl. 40), a scintillating study of a nude bathed in shimmering light, and *The New Home* (Pl. 41), the quintessence of Camden Town portraiture and the direct prototype of pictures like Gore's *North London Girl* (Pl. 42) and Gilman's *Contemplation* (Pl. 43).

In 1910 Sickert attributed the evolution of the method of painting 'with a clean and solid mosaic of thick paint in a light key' to the combined efforts of a group of artists ('for these things are done in gangs, not by individuals') belonging to the New English Art Club.[27] He was probably thinking of the Fitzroy Street offshoot of the N.E.A.C. rather than the club proper. In the first year of the Fitzroy Street Group this handling developed in a direct line from Lucien Pissarro to Gore, and then in modified form to Sickert. In his Brittany landscapes of 1907 (Pl. 44) J. B. Manson, Paris-trained but as yet unknown to Fitzroy Street, had developed an Impressionist execution independently. Gilman, meanwhile, remained unaffected by his colleagues and continued to paint gentle domestic interiors (Pl. 46) and occasional landscapes (Pl. 47) in a smoothly blended range of cool tones. The wider spread of the use of 'a clean and solid mosaic of thick paint in a light key' awaited the capture of new recruits by the Fitzroy Street Group rather than a contagious response within the New English Art Club.

The expansion of the Fitzroy Street Group 1908–10. The Allied Artists' Association

The character and composition of the Fitzroy Street Group altered fundamentally in 1908. Without official records it is impossible to distinguish definitively its members (that is those who contributed to the rent of 19 Fitzroy Street and who were thus entitled to store and show their pictures there) from the many painters who attended the Saturday gatherings to discuss art and its politics. Moreover, membership of the group was fluid. We may assume that the artists who made up the Camden Town Group were primarily selected from members of the Fitzroy Street Group in 1911, but several of the Camden Town painters were new recruits to the parent society. A more discerning clue is found in the *New Age* of 27 January

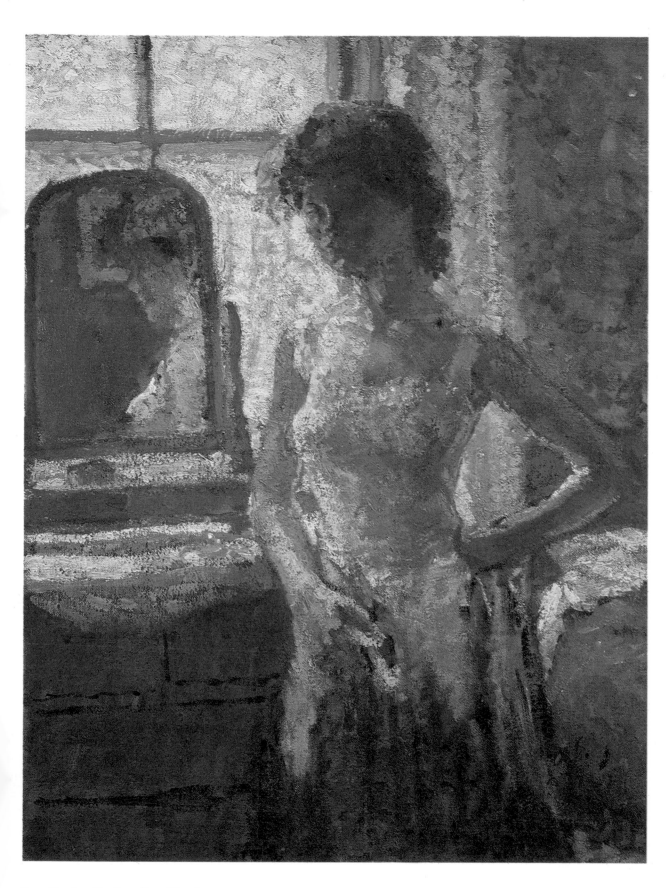

Gore: *Morning. The Green Dress* (Pl. 39)

1910 when the formation of 'a London Group', composed of Bevan, Gilman, Gore, Lucien Pissarro, Augustus John, Albert Rothenstein, Walter Sickert, Miss Hudson and Miss Sands, was announced. The prophetic title of this group in fact described no more than the old activities: 'It exhibits every Saturday afternoon in Sickert's studio at 19 Fitzroy Street and will be glad if anyone will call in an informal way and become acquainted with its pictures and with the members.' Two founder-members, William Rothenstein and Walter Russell, are lacking from this 1910 list, and it is probable that they had ceased to be active members long before this date. Albert Rothenstein's inclusion is surprising and perhaps represents no more than a temporary resurrection, for he too seldom participated in group activities after 1908. Augustus John is listed. His name, like that of Sickert, lent prestige to the group, but his involvement in its activities was limited. From time to time, in the intervals between his travels, he attended meetings; presumably he contributed to the rent.

A cryptic note sent by Sickert to Pissarro asking for the rent due for two quarters[28] provides another, less definitive, clue. The note is undated, but spring 1908 is the most likely time of its expedition. The rent still stood at £50 a year, as it had been when the group was formed, but this sum was now divided among eleven members. Who the eleven were, at the uncertain date of the note, is not known. Even if we accept that all the original members (that is including William Rothenstein and Walter Russell) were still paying partners in the enterprise, and add Pissarro to their number, only nine are accounted for. The explanation could be that John had already joined the group, and that James Dickson Innes was the eleventh member. Innes was not included in the 1910 announcement, but at that time he was living away from London. His close friendship and artistic collaboration with John dates from 1910; in 1907 they were no more than acquaintances. However, Innes could have become known to members of the Fitzroy Street Group independently because in the winter of 1907, while still studying at the Slade, he moved to Fitzroy Street. In spite of frequent absences in 1908 he retained an address in Fitzroy Street, and some of his paintings of about this date, uncharacteristic interiors such as *Resting* (Pl. 48), support the suggestion that he was in contact with the group.

Any defections, whether temporary or permanent, that occurred within the Fitzroy Street Group during 1908 were offset by the new recruits discovered at the first exhibition of the Allied Artists' Association. Frank Rutter, then art critic of the *Sunday Times* and the force behind the creation of the A.A.A., has detailed its history.[29] London lacked a non-jury exhibiting platform of the kind provided in Paris by the *Salon des Indépendants*. Foreign artists were weary of paying for the transport of their pictures to London only to have them rejected by the various exhibiting societies. They pressed for a subscription organization which entitled them to exhibit. Native artists also suffered from restrictive selection procedures. Rutter promised to canvass opinion in London. By Christmas 1907 he had been promised active support from a reasonably wide circle, including Sickert, Gore and Lucien Pissarro from the Fitzroy Street Group.[30] Walter Bayes was won over when Rutter disarmingly admitted that the exhibitions would be bigger and worse than the Royal Academy: 'Why pay a shilling to see two thousand works at the Academy

when for the same money you can see four thousand at our exhibition?' During the winter of 1907–8 Rutter met Jan de Holewinski who had been sent to London to organize an exhibition of Russian arts and crafts. Rutter decided that, like the Paris *Salon des Indépendants*, a foreign section should be a feature of his creation. They joined forces to look for a location, found and booked the Albert Hall for July 1908, and formally registered the society in February. The name Allied Artists' Association was chosen for a variety of reasons, including its alphabetical advantages. Sickert took a leading part at the meeting to decide its rules. He pressed for total impartiality, even insisting that the catalogue order should be decided by ballot rather than printed in the alphabetical order used by their Parisian prototype. He made the famous retort to one founder-member who thought that the best pictures by the best artists should be hung in the best places: 'In this society there are no good works or bad works: there are only works by shareholders.' Every subscriber was entitled to show five works, reduced to three the following year because of the overwhelming response. The 1908 catalogue lists 3,061 works, not counting the Russian section; more works were submitted too late for publication. Forty founder-members, among them Sickert, were allotted sections to hang. Exhaustion overcame all the supervisors except Sickert who had the sense to superintend from a chair placed in the middle of his section. Rutter, with overall responsibility, covered an enormous mileage round and round the vast hall; the following year he had the happy idea of conducting his operations on a bicycle.

When the exhibition opened, members of the Fitzroy Street Group picked on pictures by two artists in particular. Sickert noticed the work of Walter Bayes who had submitted some decorative panels large enough (and at £157.10s. expensive enough) to attract notice whatever the competition. The whereabouts of very few pictures exhibited and/or painted by Bayes between 1908 and 1911 are known, but we may infer from his earlier and later work,[31] as well as from his idiosyncratic critical writings, that they possessed a strong sense of design and possibly an element of humour. It is strange that Sickert and Bayes, both active supporters of the creation of the A.A.A., did not meet before the exhibition. Moreover, in his art reviews, admittedly published anonymously, Bayes had been singling out Sickert's work for especial praise since 1906. Rutter, however, reports Sickert's reaction on first sighting Bayes's work at the Albert Hall: 'Who is this man Bayes? His paintings are very good.' In 1951[32] Bayes recalled their first meeting: 'I found him eloquently holding forth to a group of bemused spectators before one of my pictures.' The omission of Bayes's name from the *New Age* announcement in January 1910 of the members of 'a London Group' suggests that he was not at that date a true member of Fitzroy Street. Sickert, however, certainly adopted him as a protégé (this relationship was acknowledged by Bayes in 1951) and undoubtedly brought him to Saturday meetings. It is, indeed, probable that Bayes became a member of the group in 1908 but temporarily allowed his membership to lapse early in 1910 when the announcement appeared. Rutter even credits Bayes with the introduction of Robert Bevan to the Fitzroy Street Group in 1909. In that year it was decided that all members should be eligible to serve on the Hanging Committee of the A.A.A., and that invitations should be issued on an alphabetical basis. Bayes chaired the

committee on which Robert Bevan served and, according to Rutter, this fortuitous circumstance led to Bevan's recruitment. However, all other writers, including R. A. Bevan in his *Memoir* of his father,[33] state that Gore and Gilman spotted Bevan's pictures at the 1908 A.A.A. show and invited him to join their group in that year.

Bevan was only five years younger than Sickert. He too had lived and worked abroad. Having trained in Paris, he had visited Pont Aven in Brittany from 1893–4 and there met, and been influenced by, Gauguin. He also had first-hand knowledge of the work of the earlier generation of Impressionists. In 1900 he had settled in London with his wife, the Polish painter Stanislawa de Karlowska. His work remained almost unknown for another eight years, having been displayed only in one virtually unnoticed show in 1905 in the Baillie Gallery, then off the beaten track in Bayswater. In 1908 a second exhibition at the Baillie Gallery, now more centrally placed in Baker Street, attracted little more attention than the first although it included one of his finest paintings of this period, *Ploughing on the Downs* (Aberdeen Art Gallery, see Pl. 49).

None of the pictures exhibited by Bevan at the 1908 A.A.A. can be identified with certainty. Nevertheless, it is safe to assume that they were strongly-coloured poetic landscapes, executed in a broken technique, possibly in the considered divisionist touch which Bevan had recently been developing. With his firm drawing, his confident and educated handling, and his uninhibited approach to colour, Bevan was a valuable addition to the Fitzroy Street Group.

The cross-Channel relationships of Fitzroy Street were further strengthened when Charles Ginner entered the group in 1910. Gore is said to have noticed Ginner's pictures at the 1908 Allied Artists' exhibition (three illustrations to the work of Edgar Allan Poe, a study of a *Head*, and a river landscape) but was unable to seek him out because Ginner lived in Paris. Ginner did not exhibit at the A.A.A. in 1909. However, having settled in London late in 1909, he not only submitted his work in 1910 but his surname brought him to serve on the Hanging Committee alongside Gore and Gilman.

Ginner, the French-born son of British parents who lived in Cannes, had trained in Paris and knew the work of the Post-Impressionists. *The Sunlit Wall* (Pl. 84a) of 1908 is one of his few pre-London pictures to survive and betrays, in its thick paint and vivid colour, an immature admiration for Van Gogh. When Ginner included it among his four contributions to the first Camden Town Group exhibition it eclipsed, in the eyes of some reviewers, nearly all the other pictures in the show. The critics were dazzled by its sense of colour. To quote just one example of the kind of comment it elicited: 'One hesitates to use the phrase "crushed jewels", which has been so often applied to Monticelli, but "The Sunlit Wall" really glows like jewels themselves. It is quite Bacchic in its voluptuous beauty.'[34] Another work of 1908 (Pl. 50), a rare survivor of a series of still-life paintings entitled by the artist *Tâches Décoratives*, although smaller in scale, illustrates the extraordinary violence of Ginner's execution. Rutter remembered that he answered Gore's questions about the unknown by saying that 'his pictures were a nuisance to handle because the paint stood out in lumps and was still wet.' The example of Ginner's prodigal use of paint was new to London. By the time he arrived in the winter of 1909 the basis of his

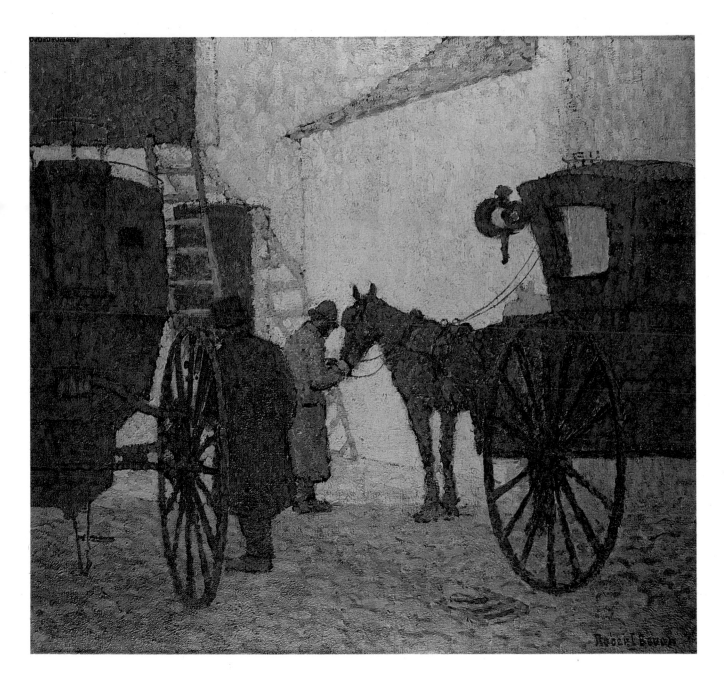

Bevan: *The Cabyard, Night* (Pl. 77)

life-long style was already established, although the small, tight touch and the strong feeling for pattern which discipline his meticulously observed transcriptions of nature were not fully developed for another year or so. Worms of paint still trail in haphazard fashion across his famous interior of *The Café Royal* (Pl. 85) first exhibited at the A.A.A. during the summer of 1911. The patterning of this interior is also less emphatic and constructed than in the Dieppe views (e.g. Pl. 86) painted later in the year and exhibited at the second Camden Town Group exhibition.

None of Ginner's pictures from the 1910 A.A.A. is extant. They were *A Classical Dancer* – probably a portrait of the artist's sister; *A Portrait* – of the artist's mother; and *A Corner in Chelsea*. All were painted in 1910 and were relatively large-scale works. The biggest, *A Corner in Chelsea* (55 × 38 inches),[35] depicted the neighbourhood where Ginner first settled in London before moving closer to his colleagues. Its title, suggesting that Ginner followed Whistler's example and was captivated by the picturesque architecture of Chelsea or by the Thames, is misleading. In fact, Ginner approached the much-painted landscape with the innocence of a primitive and depicted a totally new aspect of the scene around him. *A Corner in Chelsea* was an atmospheric 'roofscape'.[36] Presumably it grew out of the little sketches on panel, such as *Battersea Roofs* and *Chelsea Chimneys* (both in private collections), made by Ginner in 1909. This painting introduced a distinctive theme into Ginner's vocabulary (he was later to paint the roofs of Leeds, of Hampstead, and of Belfast among other cities). It perhaps also encouraged members of the Fitzroy Street Group to study the urban scene more intently and thus to find subjects in unusual aspects of their immediate environment.

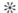

London landscapes in Camden Town painting

Until 1910 the nucleus of Camden Town painters within the Fitzroy Street Group had tended to concentrate on figure subjects when working at home and on landscapes on painting trips in the country or abroad. Ginner's arrival in their midst may have helped to break this routine. From 1910 onwards London landscapes occupied an increasingly prominent place in the activities of Camden Town painters. In that year Bevan began to paint his own Swiss Cottage neighbourhood (Pl. 55) and tackled a series of cab-yard subjects (Pls 56, 75, 77) which, together with his pictures of horse sales (Pl. 118), became so distinctive a feature of his *oeuvre*. Bevan, a keen horseman, had often included horses in his landscapes (see Pl. 49), but it is possible that the belief fundamental to Sickert and his circle, that the painter could find beauty in every aspect of his environment, encouraged him to paint his equine London subjects.

In 1910 Gore, who had previously painted a few street scenes from his studio windows (e.g. Pl. 27), began to paint more extensive views of the architecture of Camden Town (Pl. 87). Most of his landscape paintings before this date were painted away from London, in Yorkshire (Pl. 32), Somerset and Hertingfordbury (Pl. 57). He had occasionally painted Mornington Crescent Gardens before 1910, but his pictures of this locality then tended to resemble idyllic scenes of leisure pursuits (Pl. 58) unrelated to the life outside the garden railings. Most of Gore's pictures of the architecture of Camden Town were painted between 1911 (when he spent the entire summer in London and had the use of Rowlandson House during the school's vacation) and 1913 (when he went to live in Richmond). In 1911, breaking away from straightforward street prospects, Gore often depicted glowering rows of terrace houses glimpsed over garden walls (Pl. 59). In the winter of 1912–13, he found inspiration in the house backs and dreary rectangular back gardens seen from an upper window of the house at 2 Houghton Place where he moved after his marriage (Pl. 60). Although his method and his style were totally different from Ginner, he too was excited by the patterns which could be extracted from the most unpromising architectural subjects.

Sickert and Gilman, almost certainly inspired by Gore's example, also painted landscapes of Camden Town at this period. Sickert was a master of townscape. In his paintings of Dieppe between 1898 and 1905 he had produced one of the most complete records of an urban environment ever created by an artist. Yet he seldom painted London. He had occasionally studied his Cumberland Market area during the 1890s but he did not pick up this theme again until about 1911. Even then, almost all Sickert's paintings and drawings of the scene outside his studios were confined to the view from and of his own back garden at 140 Hampstead Road (Pl. 61). Gilman had not tackled London subjects since painting his Whistlerian views of the Thames (Pl. 47) in 1907–8. Although he often lived in London, he had no permanent address there until 1914 when he took a studio in Maple Street near Fitzroy Street. However, like Sickert, in 1911–12 he too painted several Camden Town landscapes in which the freedom of his execution matched the informality of his subject-matter. These pictures include two views of *Clarence Gardens* (Ferens Art Gallery, Hull and Odin's Restaurant, London) where he may have gone to paint with his friend and protégé, William Ratcliffe, who also produced two paintings of this square in 1912 (Pl. 128). Another Gilman townscape of this period known (perhaps incorrectly) as *Mornington Crescent* (Pl. 62) shows Gilman, like Gore in his Houghton Place pictures, studying the bleak prospect of a row of terrace houses seen from the back. Malcolm Drummond, who entered the Fitzroy Street circle in 1910–11, was also to make house backs a subject for painting when, around 1914, he executed *Backs of Houses, Chelsea* (Southampton Art Gallery). The inclusion of *Paddington Station* (present whereabouts unknown) among the four pictures Drummond showed with the Camden Town Group in June 1911 suggests that Drummond's enthusiastic adoption of urban architectural themes developed as soon as he entered the Fitzroy Street Group.

✻

The Fitzroy Street Group in 1910

By the end of 1910 the Fitzroy Street Group meetings were patronized by a huge circle of painters. Every progressive artist in London came, at least sometimes, to their Saturday afternoons. The gatherings were composed of a jigsaw of strands based on friendship and professional relationships.

When the Camden Town Group was created in the following year its members became, *ipso facto*, members of the parent society. It is, however, impossible to list with any accuracy which members of the new society were recent recruits to the old. Many of the old-established members of the Fitzroy Street Group introduced their colleagues, friends, protégés and pupils to the Fitzroy Street circle in 1910–11, but whether as welcome visitors or paying members is not known.

Manson, hoping to write an article on Pissarro, was brought to view paintings at Fitzroy Street in November 1910.[37] As their friendship ripened, Pissarro brought Manson on further occasions, although it is probable that the future secretary of the Camden Town Group had to wait some six months before he was accepted as a full member of Fitzroy Street. Henry Lamb, perhaps persuaded by Augustus John, visited Fitzroy Street and may or may not have become a formal member at this period. Sickert, who had been teaching night classes at the Westminster School of Art since 1908, introduced his more promising pupils to the Saturday meetings. Chief among these was Malcolm Drummond who had exhibited his work for the first time with the Allied Artists' Association in 1910. Frank Rutter greeted the new arrival with enthusiasm: 'His grasp of form and keen sense of full colour are best displayed in his "Sculptor's Studio"..., a painting to be raved about a few years hence if his name becomes widely known'[38] (Pl. 63). Once admitted to the Fitzroy Street circle Drummond, with his innate attraction towards strong, tidy patterns running counter to his training by Sickert at the Westminster, must have found Ginner's example particularly encouraging. They became close friends and developed independently, but in parallel, ways of expressing the bustle of London streets and the shapes of urban architecture so as to emphasize both the decorative and the atmospheric qualities of their subjects (Pls 121, 124, 138, 139). The depth of their understanding is revealed in Drummond's remarkable *Portrait of Charles Ginner* (Pl. 79) of 1911.

Gore acquired a pupil in 1908, a deaf stockbroker's clerk in his middle thirties J. Doman Turner, to whom he gave instruction by correspondence in the art of drawing. However, it may be assumed that Doman Turner, sensitive and talented as both his extant watercolours prove (Pl. 108), was too shy and retiring often to intrude on the lively gatherings.

Gilman, a free man since his wife had deserted him in 1909, became an ever stronger voice in the discussions at Fitzroy Street. Under the influence of his colleagues he abandoned his liquid, tonal handling and quickly developed confidence in the use of richly impasted paint and full colour, qualities already fully demonstrated in his *Portrait of Elène Zompolides* (Pl. 64) exhibited at the N.E.A.C. in

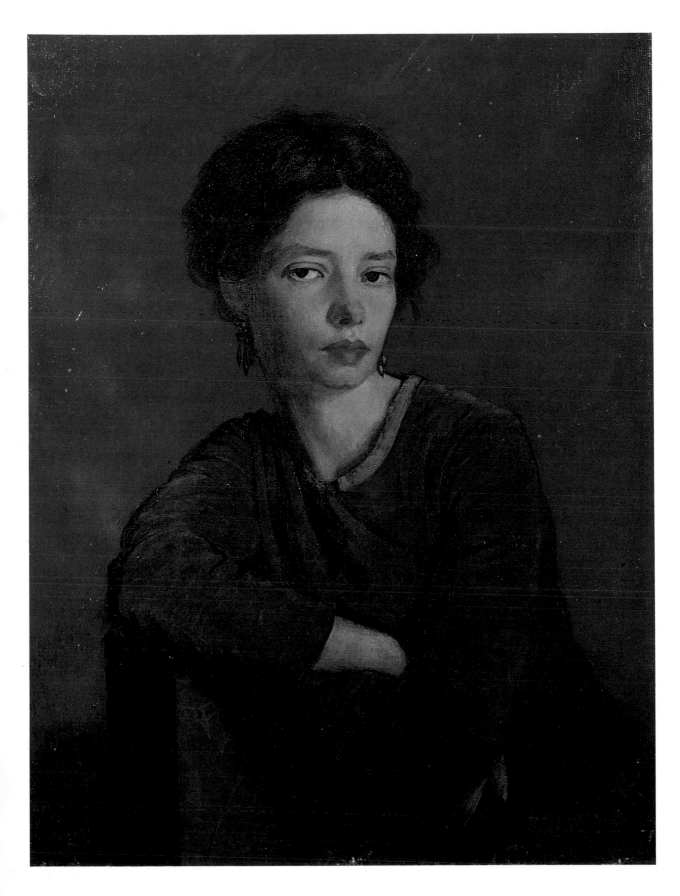

Lamb: *Portrait of Edie McNeill. Purple and Gold* (Pl. 94)

the summer of 1910. He too introduced a newcomer to his London circle: William Ratcliffe. Ratcliffe, who had studied at Manchester School of Art, had been working as a wallpaper designer for nearly twenty years when, probably in Letchworth, he met Gilman in 1908. It tells much of the power of Gilman's personality that he persuaded Ratcliffe, at the age of fifty, to take up painting again by studying part-time at the Slade in 1910 and by spending his Saturday afternoons in the Fitzroy Street Group studio.

As the Fitzroy Street Group increased in size, influence and prestige it gained entry to the N.E.A.C. exhibitions. Sickert, Pissarro and John had been members since the inception of the group and their pictures were always hung. Gore's work had been regularly accepted for exhibition since 1906. Pictures by Innes and Lamb were sometimes included and once, in the spring of 1904, a *Still Life* by Gilman had been exhibited. However, it was not until 1909 that a real change in the attitude of the N.E.A.C. establishment towards the Fitzroy Street painters became apparent. In that year Gore was elected a member of the club. Gilman's work was re-admitted after an interval of five years, and pictures by Walter Bayes, Nan Hudson and Manson (not yet a member of Fitzroy Street) were accepted for the first time. The process of liberalization continued in 1910, in spite of Sickert having resigned his membership of the N.E.A.C. meanwhile. Pictures by the same non-members were again accepted for both the summer and winter shows and Robert Bevan's paintings were included for the first time.

At the N.E.A.C. exhibition in the winter of 1910 the Fitzroy Street artists may have noticed three works by Maxwell Gordon Lightfoot who had finished his training at the Slade a year before. His N.E.A.C. pictures cannot be certainly identified but they probably included a painting of *Conway* (Pl. 65) executed in a delicate stippled touch, and examples of his strongly expressive and individual drawings from nature of trees. However, Lightfoot did not become a member of the Fitzroy Street Group. He joined the Friday Club, founded by Vanessa Bell in 1905 to hold meetings, lectures and annual exhibitions. Its membership sometimes overlapped that of the Fitzroy Street Group (Henry Lamb and Innes) but on the whole it incorporated artists of different temperament and aesthetic ideals. These included Roger Fry, Duncan Grant, Derwent Lees, and from 1910 Mark Gertler who, together with Stanley Spencer, Eric Wadsworth and C. R. W. Nevinson, had been among Lightfoot's closest friends at the Slade.

❊

'Manet and the Post-Impressionists' at the Grafton Gallery

In the winter of 1910–11 Roger Fry, hitherto known as a mediocre painter, a respected connoisseur of Old Masters, and a brilliant lecturer and critic, staged the exhibition 'Manet and the Post-Impressionists' at the Grafton Gallery. The exhibition and its effects are discussed in almost every survey of British art during this period. All that need be said here of its contents is that Manet served as an introduction to the main body of the show – a large selection of pictures by the most noted French Post-Impressionists. There were paintings by living artists, including Matisse, Picasso and Vlaminck, but the main emphasis was on the great trio, Van Gogh, Cézanne and Gauguin.

The visual impact of this exhibition on English artists has perhaps been overstressed at the expense of proper emphasis on its political consequences. By 1910 there were few progressive painters working in England who were completely unaware of the French achievements illustrated by Fry's exhibition. As an assembly of stunning pictures the exhibition undoubtedly confirmed and accelerated the direction in which many of these painters were developing. A few painters, like Gore and Gilman, had never before had an opportunity to study so comprehensive a review of French Post-Impressionist art. Chronologically the exhibition was well-timed to provide the necessary stimulus to the natural evolution of their style and handling.

Ginner, with his feeling for strong pure colour and the unified decorative quality evident in the construction of his pictures, was already taking over from Sickert as Gilman's mentor. The sight of a fine group of Post-Impressionist paintings must have encouraged Gilman towards this change of allegiance.[39] A visit to France in 1911 with Ginner, who acted as his guide around the galleries of Paris, confirmed the new direction in which Gilman's art was beginning to develop. In *Le Pont Tournant* (Pl. 83), painted while they were both in Dieppe in 1911, Gilman was already reaching out towards his vision of nature seen in terms of the relationships of pure and brilliant colours. Wyndham Lewis's report of Gilman's later rejection of Sickert is no doubt exaggerated, but nonetheless illuminating:

He would look over in the direction of Sickert's studio, and a slight shudder would convulse him as he thought of the little brown worm of paint that was possibly, even at that moment, wriggling out onto the palette that held no golden chromes, emerald greens, vermilions, *only*, as it, of course, should do.[40]

Gore's reaction to the Post-Impressionist exhibition was less delayed than Gilman's. In 1910 his vibrant *pointilliste* application had already begun to give place to a smoother handling. In some of his paintings of 1911 (e.g. Pl. 5) the broad, summary execution is similar to Sickert's work of about the same date, but in others he began to group the colours into self-contained areas. When staying in Sickert's house at Neuville in 1906 it is possible that Gore visited Paris to see the large Gauguin

retrospective on show at the *Salon d'automne*. If so, an understanding of Gauguin's art may have been simmering in Gore's mind awaiting only fresh contact to trigger off an immediate reaction. Gauguin's effect on Gore's vision is clearly demonstrated in *The Balcony at the Alhambra* (Pl. 6) with its strong pattern of flat areas of colour, its slight sense of distortion in the drawing, and its high-angled viewpoint. In another *tour de force*, *Gauguins and Connoisseurs at the Stafford Gallery* of 1911–12 (Pl. 66), showing the gallery during an exhibition of paintings by Gauguin and Cézanne held in November 1911, subject and treatment were united by Gore in an explicit gesture of homage.

If Fry's exhibition inspired the younger and less travelled British artists, it held no surprises for such Fitzroy Street members as Bevan, Ginner, Pissarro and Sickert. Sickert lectured on the exhibition at the Grafton Gallery, and wrote the substance of his exuberant criticism in an article for the *Fortnightly Review*.[41] He could not see what all the fuss was about. He had known the work of the artists shown for many years. He then proceeded to treat them neither as gods nor devils, but as ordinary painters subject to successes, failures and external influences just like anyone else. He allowed himself to wonder, 'since "post" is Latin for "after", where are Bonnard and Vuillard?' However, Sickert's attempt to restore a sense of perspective failed. The public, most of the critics, and the figure-heads of the art world, united to condemn the exhibition as an outrage. The old guard of the N.E.A.C., led by Tonks, Steer and D. S. MacColl, were among the most hostile. It was obvious that the grudging tolerance recently displayed by the N.E.A.C. towards Fitzroy Street and its allies would be abruptly withdrawn. In the backlash following the exhibition any younger painter not yet firmly established, whose work betrayed non-traditional foreign allegiances, would almost certainly be rejected by the club. As the critic of *The Times* was to write in 1913, the N.E.A.C. had become 'one of the strongest conservative forces in the country. What was an adventure had become an institution.'[42] This political fact of life was the main impetus behind the creation of the Camden Town Group.

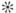

Formation of the Camden Town Group

Disaffection with the New English Art Club was the chief topic of discussion among the members and satellites of the Fitzroy Street Group early in 1911. The relative merits of capturing control of its jury, or setting up a rival exhibiting society, were hotly debated both at general meetings and in private conversation. Pissarro and Manson talked of a new society in March. Although not yet a member of the Fitzroy

Street Group,[43] Manson was kept informed of developments by Pissarro and took a keen personal interest. On 22 March 1911 he wrote to Pissarro:

> I am preparing a list of people I might approach with regard to the formation of a Society such as we spoke of.
>
> You will, of course, have a number of names. I shall, I expect, see you on Saturday when we might discuss how many people it would be possible to start with, etc.

Perhaps abashed at his temerity, Manson was less pushing in his next letter to Pissarro, written on the following day:

> I should like to join the N.E.A.C. but can't afford it at the moment.
>
> If you do manage to form a new society I should like to be in it and anyhow I would support it.

Pissarro's reply reflects the vacillating opinions and decisions current in Fitzroy Street.[44]

> I feel I owe you an explanation. For the present our new society is given up for want of gallery and funds. At the same time the N.E.A.C. like a better known club in the house of Lords is very anxious to reform itself. We, unlike the house of Commons have kindly consented to allow them to do so by admitting a certain number of members with advanced tendencies. I am not very pleased with the turn things have taken, but I dont see what else to do. I hope that at some future time we may manage to form the new Society.

Manson's answer was written immediately (24 March):

> Under the circumstances, I will avail myself of yr. kind offer to propose me for the N.E.A.C.
>
> I couldn't afford to subscribe to that and to the New Society which I hoped you would be able to form. So if the N.E.A.C. is trying to reform itself I should like to be in it (if they'll have me!)
>
> Of course, the advanced society *must* someday come into existence. We must work for it. It ought to be and it must be.

Events did not rest. Pissarro's reservations were felt more strongly by other members of the Fitzroy Street Group. Sickert and Gore temporized, but on the whole they had little faith in the ability of the N.E.A.C. to reform itself, and less in the practicability of their capturing control of its jury. Gilman argued fiercely and powerfully for a total break with the club.

The precise circumstances which resulted in the formal foundation of the Camden Town Group have been related by Ginner.[45] A nucleus of Fitzroy Street members used to eat together after their Saturday meetings. Dining at Gatti's, probably in April, Sickert, Ginner, Bevan, Gore and Gilman made their decision. They would indeed create a new society. Sickert, playing the *grand maître*, exclaimed, 'We have just made history.' Discussion continued at 19 Fitzroy Street and then at a larger dinner at the Criterion when such mundane matters as who to invite as members were decided. A full meeting took place in a restaurant in Golden Square. Walter Bayes, in his account of the group,[46] told how Sickert 'invented the name Camden Town Group, averring that that district had been so watered with his

E. M. CUDAHY
LOYOLA
UNIVERSITY
MEMORIAL LIBRARY

tears that something important must sooner or later spring from its soil.' Gore, rather than the more truculent Gilman, was elected president. Manson, by now a member of Fitzroy Street, was made secretary.

Although the reactionary attitude displayed by the controlling faction of the N.E.A.C. was the main impetus behind the creation of the Camden Town Group, Ginner recorded another ideal. The Fitzroy Street friends wanted to collect 'a group which was to hold within a fixed and limited circle those painters whom they considered to be the best and most promising of the day'. Naturally there were arguments as to who these painters were. Pupils and disciples gained relatively easy entry. Just as Pissarro had secured Manson's membership of the Fitzroy Street and thus the Camden Town Group, Gore may have proposed Doman Turner, Gilman proposed Ratcliffe, and Sickert and Ginner proposed Drummond for membership of one or both groups. The suggestion that Wyndham Lewis be invited to join the Camden Town Group caused most dissension, for he was already leaning towards the angular distortions of Cubism and his temperament was uncomfortably fiery. Gilman, probably supported by Gore, pressed in his favour and won the day.

Sickert and Gilman agreed on one key rule: that there should be no women members. Dr Malcolm Easton has quoted a letter written by Manson to Lucien Pissarro's wife in answer to pressing demands that her friend, Diana White, should be elected to the Camden Town Group.[47] In his letter Manson explained that the bar against women arose 'from the disinclination of the Group to include Miss S. and Miss H. of Fitzroy Street in the list of members'. This explanation helped Manson out of a delicate situation vis à-vis Mrs Pissarro; it probably also reflected his own and Pissarro's views. Indeed, Pissarro was later to accuse Sickert of destroying the art value of Fitzroy Street by diluting the group 'in a sea of amateurs and pupils of his'.[48] However, Ginner's accurate factual account gives a different, and psychologically more convincing, reason for the ban on women:

Gilman, strongly supported by Sickert, . . . contended that some members might desire, perhaps even under pressure, to bring in their wives or lady friends and this might make things rather uncomfortable between certain of the elect, for these wives or lady friends might not quite come up to the standard aimed at by the group.

Miss Sands and Miss Hudson qualified as neither wife nor mistress, but the convenient blanket ban excluded them. Sickert bluntly explained the situation:

As a matter of fact, as you probably know, the Camden Town Group is a male club, and women are not eligible. There are lots of 2 sex clubs, and several one sex clubs, and this is one of them.

It was left to find a gallery in which to exhibit. Sickert, who had recently held an exhibition at the Carfax Gallery, persuaded Arthur Clifton (who had taken charge of the gallery) to lend them his premises in June.

The Camden Town Group had sixteen members: Bayes, Bevan, Drummond, Gilman, Ginner, Gore, Innes, John, Lamb, Lewis, Lightfoot, Manson, Pissarro, Ratcliffe, Sickert and Doman Turner. It is evident that the originators of the Camden Town Group felt that the best and most promising painters of the day were,

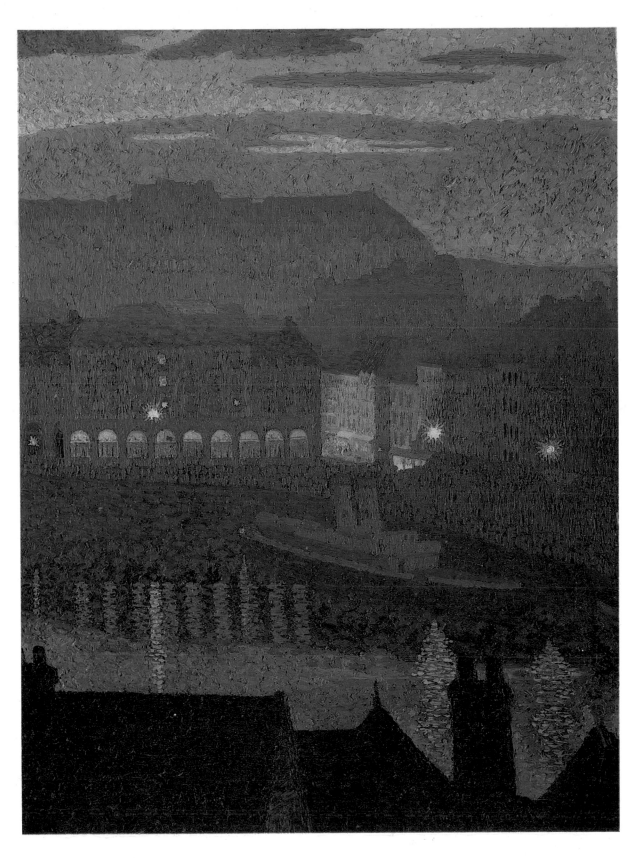

Ginner: *Evening, Dieppe* (Pl. 86)

on the whole, members or satellites of their own Fitzroy Street Group. Lewis and Lightfoot were the only recruits from outside their immediate circle. Following Lightfoot's resignation and subsequent suicide in September 1911, the policy of recruiting from the Friday Club was repeated and Duncan Grant became a member. While developing as an artist Grant had, on occasion, succumbed to the influence of Sickert and Fitzroy Street (Pl. 67). However, by 1911 Grant's art was evolving in a totally different direction and his energies, both artistic and political, were bound up with Roger Fry and Clive Bell. He took little part in the group, sending only one picture to the second exhibition in December 1911 (Pl. 89) and nothing at all to the third and last exhibition a year later in December 1912.

Ginner's explanation of the ban on women stressed the qualitative standard the Camden Town Group wished to sustain. Manson, on the other hand, suggested that the group in 1911 'represented a coherent homogeneous school of expression; differing in degree as to the work of individual members, but with the unity of a common aim'.[49] It is difficult to pinpoint the nature of this common aim in artistic terms. Manson probably had in mind what he had characterized in 1911 as 'that quiet but persistent and virile movement of English impressionism of which Messrs Lucien Pissarro, Walter Sickert, Spencer Gore, Harold Gilman, and some others are the bright and shining lights'.[50] A review by Manson of the second Camden Town Group exhibition[51] reveals that he saw the Camden Town Group primarily as a challenge to Burlington House. Unlike that 'concentrated block of bourgeois sentimentality known as the Royal Academy', the Group found its subjects in everyday life; its members were blessed with gifts of perception in front of nature which each expressed in his different way, through colour, tone, design and so on.

The Camden Town Group was, in fact, even less representative of a particular movement in painting than the Fitzroy Street Group. Drummond and Ratcliffe were broadly aligned with the nucleus of Camden Town painters, Bevan, Gilman, Ginner, Gore and Sickert. However, by 1911 this nucleus was rapidly losing its self-contained identity as each of its members began to outgrow the teaching of Sickert and Pissarro to explore new stylistic avenues. If we define Camden Town painting as the objective record of aspects of urban life in a basically Impressionist-derived handling, and recognize it as a distinct movement in British art, then we must accept that the heyday of Camden Town painting was over by the time the Camden Town Group was born.

The core of the group retained the subject-matter, if not the handling, evolved within Fitzroy Street. Manson and Pissarro remained painters of Neo-Impressionist landscape. The imagery of John, Innes and Henry Lamb (Pls 68–70) was more romantic, and their style, with its fluent draughtsmanship and lyrical sense of colour, totally at variance with those painters who had evolved their handling through Impressionism. Walter Bayes's painting was closer in style and subject matter to this last group. He too painted figures in a landscape (Pl. 71), but his approach was cooler, conditioned more by his sense of design than by a subjective emotional response to his subject. Doman Turner as a non-painter in oils, Lewis as an embryonic Vorticist, and Lightfoot whose uniquely sensitive revival of the best academic traditions of draughtsmanship and tonal painting defy

Fig 2: Sickert and Gore (seated) in the garden of
Rowlandson House reading press cuttings of the
first Camden Town Group exhibition, June 1911

classification within a twentieth-century context, each stood on his own. Contemporary critics soon recognized that the group was 'not a school, but only a convenient name for a number of artists who exhibit together',[52] and that basically what they had in common was 'the Carfax Gallery in which they exhibit'.[53]

＊

The first two exhibitions
of the Camden Town Group
(Pls 73–108)

The basement in Bury Street, St James's, which housed the Carfax Gallery imposed its own limitations on the Camden Town Group exhibitions. Each of the sixteen members was entitled to show four, reasonably-sized works which were hung together, rather than mixed at random on the walls. In fact only fifty-five, instead of the maximum of sixty-four, pictures were shown in June 1911; Innes did not exhibit, while Lamb with three, and Lewis and John with two pictures each, did not take up their full quota. The second exhibition in December 1911 included fifty-three pictures, and the third in December 1912 only forty-five pictures.

The support given to the group by such established artists as John and Sickert was largely motivated by their desire to help less renowned colleagues. Gore's counsel had prevailed against Gilman's demand that membership of the new society should entail breaking totally with the New English Art Club. Nevertheless, John refrained from exhibiting with the N.E.A.C. in the summer of 1911, but sent two Welsh landscapes to the Camden Town Group. His choice of small, informal pictures (Pl. 92) may perhaps be interpreted as an effort to indicate his support while not thereby outshining less recognized and popular talents. Having made this gesture he did not exhibit again with the group, nor did he attend Camden Town committee meetings.

Sickert did exhibit with the N.E.A.C. in the summer of 1911, as did Bevan, Gore, Lamb and Pissarro. In the first Camden Town Group exhibition he included two related two-figure subjects (Pl. 106), undoubtedly given the *Camden Town Murder* title for publicity reasons. However, his choice of a Venetian picture of 1903–4, an early Dieppe landscape, a very dark and sketchy portrait study, and a charming but tiny coster mother and daughter painting (see Pl. 107) to send to the second exhibition, may have been deliberately calculated to attract as little press comment as possible away from his fellow-members.

On the whole the press reacted favourably from the beginning; as one critic remarked, their nerves had been steeled by 'recent experiences'.[54] Compared with the more radical distortions of form and colour demonstrated by the French

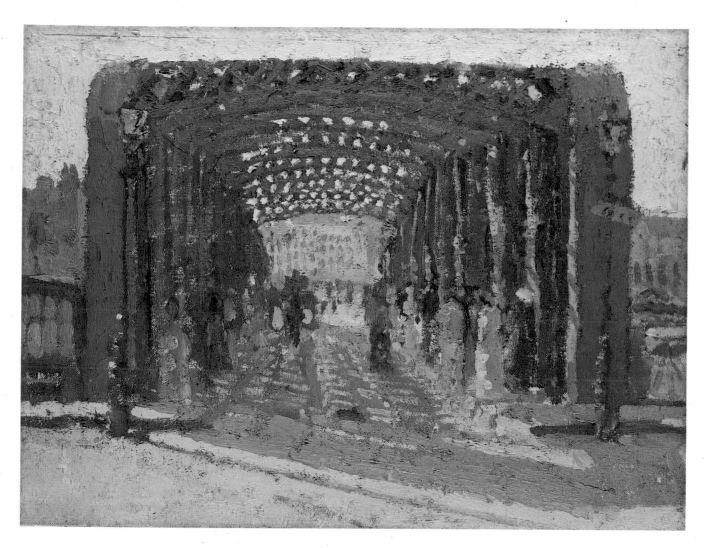

Gilman: *Le Pont Tournant (The Swing Bridge) Dieppe* (Pl. 83)

Post-Impressionists at the Grafton Gallery, the pictures decorating the Carfax Gallery in June 1911 presented little to disturb even an insular critic. There were fresh landscapes of both rural and urban scenes, Camden Town figures in interiors, two music hall subjects by Gore and two cab-yards by Bevan. However idiosyncratic were Sickert's contributions to an exhibition, and however unappealing his subject-matter, critics had learned that he was a master to be respected and praised for his craft. John's presence was reassuring, and every reviewer could recognize and admire the qualities of design, draughtsmanship, and the technical fluency of Lightfoot and Lamb. The conservative *Morning Post*, under the title 'The Camden Wonders', intended a facetious review but ended up with grave, if somewhat plodding and predictable, assessments of the different artists' work.[55] Only one artist, Wyndham Lewis, excited almost unanimous derision. He had contributed two angular pen and ink drawings of a man's head, both entitled *The Architect* (Pl. 95). They were the first works Lewis had exhibited in London since the N.E.A.C. in 1904. The critic of the *Morning Post* conveys the pain, which had replaced fury, of popular reaction to such advanced art:

As an imaginary portrait of the man who designed most of the modern buildings in London, it may be welcomed as a caricature nearer the truth than perhaps the artist intended. But what was the aim of the draughtsman? ... Mr Lewis, who enjoys a high reputation among his friends as poet and draughtsman, introduces a note of insincerity that is well enough in criticism but regrettable in serious art, and entirely foreign to the present exhibition.

Lewis remained the chief thorn to reviewers of the next two exhibitions. He also caused dissension within the Camden Town Group. The Pissarro archives in the Ashmolean Museum contain the undated draft of a letter from Pissarro to Gore, as president of the group. The references within it to 'pictures' and 'canvases' in the plural suggest it was penned in December 1911, on the occasion of the second exhibition:

I am quite upset by what I saw this afternoon at the Camden Town Group exhibition. The pictures of Lewis are quite impossible! Either ours is a serious movement or else a farce! I dont feel inclined [to] let my pictures remain if he persists in showing these particular canvases. I was not consulted when he was asked to join our society – we all took him from Gilman's recommendation without knowing his work. If the principle of the group were like the A.A.A., I would say nothing, but as we are quite a closed society I dont see why we should put up with such rubbish.

Pissarro asked Gore to meet him at the Carfax Gallery the following day. If this draft was sent we can only assume that Gore managed to unruffle Pissarro. Certainly apart from Lewis, the Camden Town Group was accepted by the press as a band of 'intensely serious artists who ... show neither eccentricity nor a desire to épater le bourgeois but are clearly inspired by the longing for self-expression in what each considers the most suitable language'.[56]

✳

First ideas for expansion
of the Camden Town Group

It is claimed that after the December 1912 exhibition Clifton refused to play host to yet another of the Camden Town Group's financially disastrous shows, thus forcing them to look for alternative accommodation. The group was then adopted by William Marchant, of the commodious Goupil Gallery, provided they expanded their membership and changed their name. This claim is partly true, partly false.

The question of new membership of the Camden Town Group had already been raised by the time their second exhibition was on view. Indeed, the election of Duncan Grant to fill the vacancy created by Lightfoot's resignation in 1911 may have triggered off consideration of this matter. The idea of increasing the size of the group was formally tackled at a meeting on 2 December 1911, attended by all the members except Grant, John and Innes. Sickert opened the discussion. He, Manson and Doman Turner preferred a small, exclusive society, but most members were in favour of expansion. Their opinions ranged from Gilman's belief that anyone whose work was interesting to the group should be elected, to Bayes's cautious view that there were disadvantages in keeping the size of the group permanently the same, although under present conditions at the Carfax Gallery he saw no alternative to the *status quo*. Voting procedures for new members were then discussed. Pissarro had taken the precaution of preparing a draft of his proposals and rules in advance.[57] His suggestion that candidates should show their work on probation at Fitzroy Street prior to election was vetoed by Sickert who felt this use of the parent society's premises at number 19 was improper. Pissarro also proposed that women be eligible for election, and that at each exhibition four members in turn should have the right to invite a guest, man or woman, to contribute two pictures. Pissarro may have taken this opportunity to satisfy his wife's ambition that Diana White should show with the group. Finally, he suggested an escape clause whereby if two-thirds of members felt the work of another member was out of harmony with the aims of the society, that member should be asked to retire. Like Manson, Pissarro seems to have had a clear, if personal, concept of the nature of such aims. However, while discussion of these matters was under way, Gilman intervened to propose that there should be no increase in membership under the present conditions of exhibition at the Carfax Gallery. He had perhaps been pondering Bayes's earlier point that an increase in the number of members involved a decrease in the number of works each could show. He may also have been alarmed at Pissarro's attempt to re-open the question of women members. Gilman's motion, oddly enough seconded by Pissarro, was carried by eight votes to three. Gilman then proposed that a new and larger gallery should be found as soon as possible. This motion was carried unanimously. As it happened it took two years to find satisfactory alternative accommodation, so the membership problems were shelved. However, far from withdrawing his support for the group, Arthur Clifton held a series of exhibitions of work by individual members in 1913.

1912. Members' activities

The Camden Town Group's decision to seek new premises delayed active consideration of their next exhibition. Twelve months elapsed between the second and third showing of the group's work at the Carfax Gallery. Nevertheless, however dormant the society as a whole, several of its individual members enjoyed an exceptionally stimulating year.

Gilman boldly experimented with his handling and subject-matter. Emulating Ginner's theme, he painted the interior of the *Café Royal* (Pl. 109), laying out the design of the complex setting with free, confidently drawn strokes of the brush and modelling his forms in closely integrated flat planes of rich colour, pinks and blues and greens. During the summer he broke new ground by painting landscapes and interiors in Sweden. There he drew liberally on a wide range of styles and treatments, extending from the flat colours and almost childishly simple drawing of *A Swedish Village* (Pl. 110) to the striated paint of his Van Gogh-inspired *The Reapers* (Pl. 122).

While Gilman was away he lent his house in Letchworth to Gore, who responded vigorously to the novel environment of garden city, burgeoning industry and domesticated landscape in a series of brilliant experimental canvases (Pls 111–115) to be discussed below.

Existing friendships were consolidated this year. Innes and John again spent some time together in North Wales. The sympathy between Manson and Pissarro grew stronger. And new allegiances were formed. During the late summer and autumn Gore (for the third time), Bevan and Ginner (both for the first time) all stayed at Applehayes, Clayhidon, home of the hospitable H. B. Harrison. Each produced his own version of their host's Somerset landscape. Temporarily, Bevan seems to have reacted to Ginner's influence. His *Evening in the Culme Valley* (private collection, reproduced in colour R. A. Bevan, Pl. 41) is not only close compositionally to Ginner's *West Country Landscape* (Pl. 116), it has the same feeling of swirling movement (in spite of Bevan's larger, looser stroke) and it is similar in colour. This kind of treatment represents an unexpected interlude in the natural evolution of Bevan's style. His affinities as a painter were much closer to Gore than to Ginner. For example, the firm structured pattern, the schematic drawing and the angular modelling of such Bevan landscapes as *The Town Field, Horsgate* (Pl. 143) of 1914 echo qualities found in Gore's *The Footpath, Letchworth* (Pl. 111) of 1912, a painting which belonged to Bevan. A comparison of their self-portraits of *c.* 1914 (Pls 144, 145) underlines the depth of their innate stylistic affinity.

The interlude in Somerset occurred several months after the close association of Gore and Ginner in what was probably the most exciting, and certainly the most exacting, collaborative venture of 1912. Madame Frida Strindberg, briefly the second wife and by 1912 the widow of the Swedish dramatist, indulged her passion for the bohemian life of advanced art and letters by launching the Cabaret Theatre Club in Heddon Street, Soho. This establishment, better known by the alternative

and more evocative title 'The Cave of the Golden Calf', opened on 26 June 1912. Its decorations were designed and executed by Wyndham Lewis, Gore, Ginner and Jacob Epstein. Additional decorations by other artists were envisaged but never fulfilled. In 1914 the night club went into liquidation. During the war Madame Strindberg and all the transportable decorations disappeared, reputedly together, to America. The paintings by Lewis, Gore and Ginner have yet to re-emerge.

The general character, if not the detail, of the decorative scheme can be deduced from personal reminiscences, documents, and above all from surviving studies by Gore and Ginner for their contributions. Lewis painted 'a huge and hideous raw meat drop curtain',[58] some screens and wall paintings. As a friend of Madame Strindberg, Lewis had probably suggested that Gore and Ginner be commissioned to provide more wall decorations and that Epstein should provide the reliefs which decorated the columns supporting the interior. Gore, no doubt because of his extraordinary ability to remain on good terms with everybody and thus mediate between the most conflicting temperaments, was appointed to guide and supervise the whole scheme.

The existing evidence suggests that this scheme had little iconographic structure. Gaiety was the chief requirement and each artist was left to react individually to the hedonistic concept of the total environment. Lewis referred to his murals as 'somewhat abstract hieroglyphics'.[59] His extant designs for the prospectus, programme and menu (reproduced Michel, Pls 14–16) are nonetheless figurative, although the drawing is distorted to convey kinetic frenzy. Both Gore and Ginner, probably working in close co-operation, chose exotic jungle and hunting scenes to convey the necessary atmosphere of hedonism. Ginner made three, highly stylized, decorative panels: *Chasing Monkeys* (over eight feet by six); *Birds and Indians* (an irregular picture, with a segment cut out in the centre of the lower half, measuring nine feet by six overall); and *Tiger Hunting* (some six feet square flanked by two narrow side panels). Ginner's notebooks record what he was paid for such yardage: £12 for the three, intended as an advance but not settled until 1913, plus another £6. 10s. 3d. obtained as a percentage of moneys due to him after the liquidation. He also sold two posters in distemper to the club. Their themes suggest they were executed independently (and then bought as decorations for £2. 10s. each) rather than commissioned as advertisements by Madame Strindberg. Both are lost but one, entitled *Piccadilly Circus*, perhaps anticipated the composition of the painting (Pl. 124) exhibited by Ginner later in the year with the Camden Town Group.

Whereas Ginner's animals were presented as two-dimensional patterns, Gore's surviving sketches suggest his huntsmen on horseback and his racing animals peopled imaginary landscapes (Pl. 117). His confident integration of landscape and figures into a synthetic pattern in which the basic forms are translated into simplified, brightly coloured, flat shapes, each strongly demarcated with dark outlines, reveals that he had assimilated, and could exploit at will, a variety of Post-Impressionist sources. Gauguin, Matisse and possibly the German *Blaue Reiter* group, in particular the Russian-born Wassily Kandinsky who had been known in England since the first exhibition of some of his paintings in 1909 with the Allied Artists' Association, may all have contributed to Gore's inspiration.

Ginner's experience with these night-club decorations seems to have had little effect on his future work. Jungle scenes emanating from the imagination had no place in the development of an artist increasingly devoted to the most scrupulous study of the external detail of nature. Wyndham Lewis's designs for the club probably contributed towards the evolution of *Danse* painted during 1912, but unfortunately this large picture is another of Lewis's lost early works. In Gore's case, however, the decorations can be positively assessed as relevant to his future development. The strong patterning, the synthetic organization and the brilliant colours of the paintings he did in Letchworth in the summer must have drawn part of their impetus from the night-club decorations so recently completed.

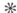

The third Camden Town Group exhibition (Pls 118–129) and the second Post-Impressionist exhibition

At the third and last Camden Town Group exhibition at the Carfax Gallery in December 1912, thirteen members showed a total of forty-five pictures. Grant, John and Innes abstained. Each had exhibited only once with the group to whom they had never felt deeply committed. Grant was more closely involved politically and artistically with Roger Fry, Vanessa Bell and the Friday Club; John and Innes were members of the N.E.A.C. and allied commercially to Jack Knewstub of the Chelsea Chenil Gallery, rather than to Arthur Clifton of the Carfax.

The absence of these three artists meant that the overall character of the paintings on view at the Carfax Gallery was more uniform than in 1911. Only Bayes, Lamb and Lewis remained to represent artistic styles developed outside the influence of the original nucleus of Fitzroy Street Group painters. Yet paradoxically, this 1912 exhibition appeared to be less 'Camden Town' orientated than those of 1911. There were no music hall pictures. Only Drummond and Sickert contributed interiors with figures, and of these only Sickert's three paintings represented humble models in humble surroundings. One of Sickert's pictures, *Summer in Naples* (Pl. 129), contained the sole nude in the entire show. The bulk of the exhibition was made up of colourful rural landscapes characterized by 'a common liking for undertones of a purplish tinge'.[60] In the face of this display, Manson's outrageously partisan review of the exhibition, under the title 'London Impressionists',[61] can almost be excused. Manson composed a panegyric on Lucien Pissarro, 'the leader of the movement in England . . . honoured . . . by the small band of modern artists who are producing the work of which posterity will take account.' Sickert, described as 'the pill in the jam of modern art', was consigned to the tailpiece of Manson's review, a position justified if apparent signs of his influence in the paintings on view at the Carfax Gallery were used as the criterion for judging his place within the Camden Town Group.

There were only two distinctly provocative paintings in the exhibition. One was Sickert's *Summer in Naples*, representing a fat and ugly nude woman seated on a metal bedstead back to back with a shabbily dressed man. This painting now bears the more appropriate title *Dawn, Camden Town*. It is probable that Sickert chose both to exhibit this unusually brutal painting and to designate it with an exceptionally perverse title, in order to remind critics and his fellow-exhibitors that this was the kind of subject which, under his guidance, the Fitzroy Street Group had introduced into English art.

The other provocative, and much more obviously nonconformist, work was Wyndham Lewis's (now lost) painting *Danse*. However, although critics of the popular press continued to huff and puff when confronted with the angular distortions of Lewis's design, others were gradually becoming reconciled to this new mode of vision. For example, while the *Star*[62] dismissed *Danse* as 'a piece of "cubism"' which might more properly be exhibited in the Zoo or Madame Tussaud's, *The Times*[63] commented that 'though we see no dance in it, we do see a kind of geometrical logic in the design, which gives us more pleasure than we get from a quite commonplace and intelligible picture.'

Several critics again found Walter Bayes's paintings equally out of character with the main body of work on exhibition, but at the opposite extreme to Lewis. Reassuring echoes of Poussin were recognized in the rhythmic designs and simplifications of Bayes's land and seascapes with figures.

In spite of the preponderance of English (plus a very few French) rural landscapes, there were some more exciting pictures to reflect the new departures in subject-matter made by their painters during 1912. Bevan showed paintings of the London horse sales (Pl. 118), instead of his former cab-yards. His son has recorded[64] how he gave up cab-yard subjects because he did not wish 'to be accused of sentimentalizing about an almost vanished feature of London life', and indeed the critic of the *Globe*[65] in praising *The Cabyard, Night*, in the second Camden Town Group show, had remarked that nevertheless his technique seemed 'antiquated, as will his subject in a year or two, when the last hansom has disappeared'. The horse-sale subjects, filled with hard-faced traders, studied instead one of the toughest aspects of a great commercial city. Aspects of central London were also presented by Ginner, Drummond and Ratcliffe. Ginner showed *Piccadilly Circus* (Pl. 124), one of his earliest brilliantly coloured, tautly constructed London street scenes filled with a bustling throng of traffic and figures. Gilman, meanwhile, included three pictures studied during the summer of 1912 in Sweden, a country previously unexplored by Camden Town Group artists.

The year between shows had allowed time for the talents of less experienced exhibitors to mature. For example, among the paintings which survive and can be identified from this third exhibition are Drummond's *St James's Park* (Pl. 121) and Ratcliffe's *Clarence Gardens* (Pl. 128). These two London prospects represent highpoints within the context of each artist's development. The tidy geometry and the tightly stippled application of high-toned colours used by Ratcliffe in *Clarence Gardens* reveal that he had already developed the disciplined approach which supported him throughout 1913, his most productive and successful year as a

painter. In *St James's Park* Drummond achieved a consummate balance between prose and poetry. The skilful, almost pedantic, perspective construction provided a prosaic framework within which Drummond set free his poetic imagination to express his subject in an arbitrary range of rich, confectionery tints. The product is an idyllic vision of Londoners at leisure which recalls, albeit on a smaller and less ambitious scale, Seurat's description of Parisians enjoying Sunday afternoon on *La Grande Jatte*.

Drummond and Ratcliffe undoubtedly sent their most important pictures of the year to the Camden Town Group in December 1912. Other members, whose work was seldom accepted for exhibition elsewhere in London except in the annual Allied Artists' Association jamboree, probably did likewise. Among these members were Gilman and Ginner, although the latter also exhibited each year with the *Salon des Indépendants* in Paris and had been, in May 1912, among the small group of artists selected by Roger Fry to represent contemporary British art at the Galerie Barbazanges in Paris. However, a few members of the Camden Town Group in 1912 clearly reserved their more radical work for an alternative showplace.

Roger Fry's second Post-Impressionist exhibition opened at the Grafton Gallery in October 1912. Unlike the first exhibition, this one incorporated an 'English Group' selected by Clive Bell. Four members of the Camden Town Group, Gore, the Australian-born Lamb, the half-American Lewis, and the Scot Duncan Grant, were among the painters invited to exhibit under this heading. Lewis and Grant had both been included in the Galerie Barbazanges show, but Bell dropped Ginner in favour of Gore and Lamb. The Grafton Gallery exhibition ran on into the new year, thus totally overlapping the Camden Town Group show. Duncan Grant, as we have seen, sent nothing to the Carfax Gallery, but the three painters who contributed to both exhibitions had to choose which context was more appropriate to particular paintings.

Lamb's priorities were slightly weighted towards the Grafton Gallery. Whereas he sent two studies of heads (probably representing Irish girls just painted in Donegal) to the Carfax Gallery, he chose to exhibit a recent *Portrait of Lytton Strachey* and a picture from Lady Ottoline Morrell's collection with the Post-Impressionists. He cared enough about the Grafton Gallery show to complain bitterly that the wrong picture was collected, in his absence, from Lady Ottoline's house.[66]

Wyndham Lewis, who showed only *Danse* at the Carfax Gallery, had eight important drawings and two major paintings on view at the Grafton Gallery. One of his paintings, *Creation* (another lost work), was illustrated in the catalogue.

Neither Lewis nor Lamb belonged to the nucleus of artists responsible for creating the Camden Town Group. Gore, on the other hand, was its president. His choice of which pictures to exhibit where thus indicates the shifting balance in the structure of anti-establishment politics in the London art world. He showed his full complement of four paintings at the Carfax Gallery. One was a Camden Town landscape of 1911, *Euston from the Nursery* (Pl. 125), remarkable not so much for its style and handling as for the effective use of a grid of vertical bars through which the railway tracks and station are seen. *The Pond*, described in the press as 'gold and

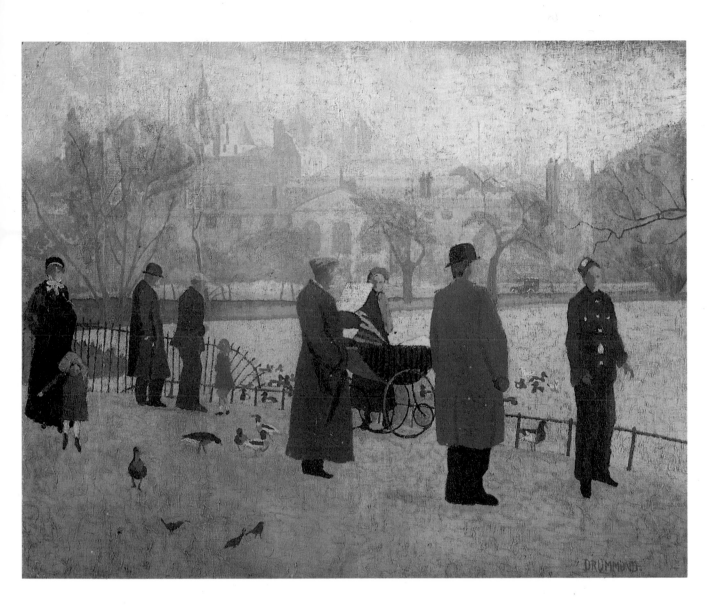

Drummond: *St James's Park* (Pl. 121)

green . . . rhythmical in design',[67] may be the painting of that title and colouring in the Worthing Art Gallery, a somewhat dour work in which the angular handling of the landscape and cloud forms, as well as the Derain-derived colour harmony, recall Roger Fry's landscapes. Press descriptions of *Letchworth Common* and *The Broken Fence* imply that they were pleasant, unexceptional studies from nature. The former may be the painting in the Tate Gallery, one of Gore's least radical Letchworth subjects of 1912. The latter may be an impressionist Panshanger landscape of 1908–9. Evidently Gore did not exhibit his more daring, experimental paintings of 1912 at the Carfax Gallery.

Gore exhibited *The Tree* and *Letchworth Station* (Pl. 114) at the Grafton Gallery. When the exhibition was unexpectedly extended from December 1912 to January 1913 he added *The Cinder Path* (Pl. 113) to help fill gaps on the walls caused by some artists having to withdraw their exhibits. *The Tree* can not be certainly identified. It might have been one of two pictures of a fig tree (one in a private collection as *The Tree*; the other in the Tate Gallery as *The Fig Tree*) painted from a back window of 2 Houghton Place where the Gores lived in 1912. *The Cinder Path*, showing the track crossing the fields outside Letchworth towards Baldock, clearly illustrates Gore's increasing preoccupation with the underlying three-dimensional structural relationships of his subject and the two-dimensional pattern of his picture surface. He expressed the component volumes of his scene – trees, fields, sky and clouds – as separate rhomboidal blocks of distinct colours. The path itself, plunging down at right angles to the picture plane and coloured a deep violet, both defines the spatial recession and articulates the flat pattern on the surface. Gore processed his perception of nature even more radically in other contemporary Letchworth subjects, such as *The Beanfield* (Pl. 112) in which the rows of beans are condensed into zig-zag coloured stripes, *The Icknield Way* (Pl. 115), and *Letchworth Station* (Pl. 114). *Letchworth Station* was illustrated in the Grafton Gallery catalogue. It could be a scene from Toytown. The bright and varied colours emphasize the unreal aspect of the picture. Gore had long understood the emotive force of colour as used by French Post-Impressionist painters like Gauguin and Matisse. However, his use of colour was not arbitrary. It sprang rather from his training as an objective student of nature. He took the colours he perceived, organized them into family groups and heightened them in tone. Thus in *The Beanfield* the zig-zag stripes of greens and reds are inspired by the actual colours of a plot of beans in flower. The colours of *Letchworth Station* are also based on nature, except that the inclusion of clothed figures gave Gore more leeway in his harmonic choice of accents.

The way in which Gore orchestrated his response to nature, grouping, patterning and organizing what he saw into a structure of shapes and colours, accorded with Clive Bell's statement in his preface on 'The English Group' for the Grafton Gallery catalogue: 'We expect a work of plastic art to have more in common with a piece of music than with a coloured photograph.' Nevertheless, Gore was not one of the painters singled out by Bell for special mention in this preface. Perhaps Gore's rejection of the 'descriptive' art so much abominated by Bell was not sufficiently explicit to ratify his total commitment to the kind of modernism advocated by the Grafton Gallery clique. Gore was, after all, still politically and artistically very much

a member of the Camden Town Group which constituted, to quote from Sir Claude Phillips's review of their third exhibition,[68] 'a sort of link between the extremism of the Grafton Galleries and the more sober modernity of Suffolk Street' (the latter address being the headquarters of the New English Art Club). However, while the coincidence of these two exhibitions served to polarize their respective characters in the eyes of critics and public, the overlap of exhibitors tended to blur such distinctions in the eyes of the participants and their colleagues. The Camden Town Group had not been created to act as a neutral buffer between conservatives and radicals: invidious comparisons threatened its continued viability.

<div align="center">✳</div>

<div align="center">

1913. One-man exhibitions by members of the Camden Town Group

</div>

When the third Camden Town Group exhibition closed, Arthur Clifton continued to sponsor the work of its members in a series of exhibitions at the Carfax Gallery in 1913. He launched his programme with a joint show by Gore and Gilman in January. Gore had already held a one-man exhibition of twenty-nine paintings at the Chenil Gallery in March 1911. He showed twenty-six pictures at the Carfax Gallery where *The Beanfield* (modestly priced at twelve guineas) and another, probably smaller, version of *The Cinder Path* were among several Letchworth landscapes. This joint exhibition was Gilman's first opportunity to show a substantial body of his work. His twenty-four paintings included four nudes, seven Swedish subjects (three previously exhibited with the Camden Town Group a month before), and his two paintings of the interior of *The Café Royal* (Pl. 109). Nearly all the paintings in this joint show were recent works, although Gilman included *Cave Dwellers, Dieppe* (Pl. 45) of 1907, and Gore *The Mad Pierrot Ballet* which may be the music hall of *c.*1905 now known by that title (Pl. 2). It is possible that the individual and uncharacteristic expressionism of both these early paintings secured their selection by artists primarily concerned to demonstrate the results of the more daring, Post-Impressionist orientation of their current work.

In March the Carfax Gallery mounted an exhibition of studies and etchings by Sickert, one of many Sickert shows held at the gallery between 1911 and 1916. Forty-eight paintings and drawings by Bevan occupied the Carfax Gallery in April in an exhibition which amounted to a retrospective survey covering all aspects of Bevan's style and subject-matter. Lucien Pissarro's first one-man exhibition, incorporating thirty-six paintings executed from the 1880s onwards, followed in May. The last of these 1913 exhibitions at the Carfax Gallery by Camden Town Group members was held in October, when Walter Bayes showed forty-five

paintings which, from their titles, seem to have been relatively recent works (for example *View from the Hôtel des Bains, Locquirec, Brittany*, Pl. 130).

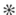

Politics and the Fitzroy Street Group in 1913

As in previous years, 19 Fitzroy Street remained a central meeting-point where members of the Camden Town Group were joined by a wide spectrum of visitors to the weekly gatherings of the parent society. Whereas membership of the Camden Town Group remained static and closed, that of the Fitzroy Street Group was open to expansion. In April 1913 Sickert, with some misgiving, decided not to veto Epstein's admission to the group: 'We shall see what we shall see', Sickert commented darkly to Ethel Sands. For the time being he allowed himself to be swayed by Gore's opinion of his erstwhile colleague at the Cabaret Theatre Club, that the 'danger' was exaggerated and that the other members would be able 'to insist on not having anything too too'. As a counterbalance to potential subversion Sickert immediately lobbied on behalf of two of his former pupils, Madame Renée Finch and Sylvia Gosse. Miss Gosse's bid for membership failed, but Renée Finch and her husband Harald Sund both became members at some time between the spring and the autumn. It is possible that Madame Finch's election was materially aided by the furore caused by her submission of a male nude, with blue pubic hair, to the 1913 Allied Artists' Association. Accused of immorality, and threatened with police action, the artist had to withdraw the offending picture although, under the title *Reginald*, it was duly displayed in the 1914 A.A.A. exhibition.

Roger Fry and his friends occasionally came to Fitzroy Street gatherings. It seems that when the second Post-Impressionist exhibition was extended in December 1912 there was even talk current in Fitzroy Street of transferring the Camden Town Group show at the end of its run to the Grafton Gallery. This is the only possible explanation of two letters written to each other by Manson and Pissarro on 19 December 1912.[69] Manson tried to persuade Pissarro to overlook his distaste if such a course were settled: 'You are very loyal to the C.T.G. but I think that you ought to benefit by any opportunity which might be useful to you. Of course, one does not care to accept anything from Roger Fry.' In a postscript Manson added: 'You see the rest of the C.T.G. are young and probably would not consider you in the same way. I fancy Sickert can look after himself!' The wind must have been taken out of Manson's sails by Pissarro's reply:

I am afraid you give me credit for more loyalty than I have. I don't feel it would be an advantage to be among the 'Posts', but if the C.T. were to exhibit at the Grafton en bloc, I should of course be glad to join as one of them tho' I think we are all better out of it.

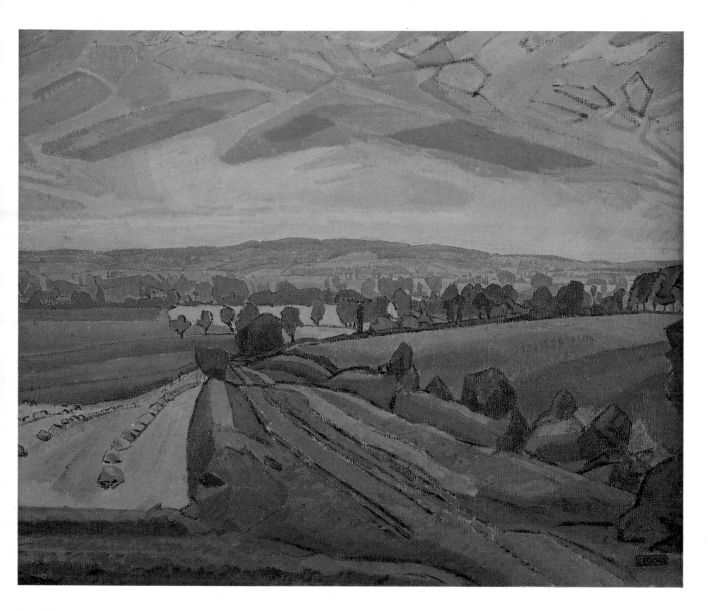

Gore: *The Icknield Way* (Pl. 115)

These loyalties were not put to the test in an exhibition, but relations grew more cordial between the two cliques. On one Saturday afternoon 'At Home' in the spring of 1913 Sickert brought a distinguished French visitor to 19 Fitzroy Street, Théodore Duret, friend and historian of the French Impressionists, and introduced him to Fry and Vanessa and Clive Bell. Fry, who had been up at Cambridge with Sickert's brother Oswald during the early 1890s, was a long-standing friend of the whole Sickert family and a one-time pupil of Walter Sickert. Mutual respect and much affection also existed between Sickert and Vanessa Bell. Nevertheless, the cluster of artists most intimately associated with Fry tended to keep themselves aloof from the Fitzroy Street Group. Besides divergences in their artistic tastes, their own political activities left little spare time to attend alternative assemblies. The Friday Club survived to hold annual exhibitions. However, while it had attracted several of the most adventurous young artists trained at the Slade in these years, including Mark Gertler, Edward Wadsworth, Christopher Nevinson and David Bomberg, it had by 1913 also gathered together a large and amorphous crowd of lesser talents. The old-guard of the club, Fry, Grant, Frederick Etchells and Vanessa Bell, therefore established a splinter society, the Grafton Group, and abstained from exhibiting with the Friday Club from 1913 onwards.

The first exhibition of the Grafton Group, at the Alpine Club Gallery, was held in March 1913. In anticipation of the imminent creation by Fry of the Omega Workshops, the exhibits were displayed anonymously and several items of applied art were included. The Camden Town Group was represented at the Grafton Group show by Lewis and Gore, besides Duncan Grant. In April, Fry leased 33 Fitzroy Square to house the Omega Workshops, a fascinating co-operative venture in which artists could be employed on a regular, though part-time, basis to design, execute and decorate objects of applied art. Fry, Grant and Vanessa Bell were co-directors, and among the artists working for Omega by the time of its formal opening in July were Lewis, Etchells, Cuthbert Hamilton and Wadsworth.

Radical art politics were in a state of constant flux by 1913. Factionalism and cross-fertilization were rife as groups formed, overlapped, and re-formed. Work by Gore, Lewis and Grant could be seen in nearly every context. Both the Friday Club and the Fitzroy Street Group had been created at a time when young, unrecognized artists had almost no opportunity either to exhibit and sell their work or to congregate in congenial company to discuss common concerns. This situation had since changed, largely through the efforts of the activists in both societies. Although their work was still unacceptable to the establishment, young artists could now exhibit in shows which were widely, if not always flatteringly, reviewed in the press. A small, but faithful and ever-growing, band of clients collected contemporary art. If we except Frank Rutter's efforts on behalf of the broad majority, Roger Fry and Sickert were the two individuals most responsible for creating these conditions more favourable to progressive art, and there were similarities in their practical approach to the task. They both realized that the first priority was to educate the public towards appreciation of different methods of artistic expression; each tackled this problem head-on: Fry in his writings, lectures and exhibitions, Sickert primarily in his writings and teaching but also through gatherings at Fitzroy Street.

Both keenly appreciated that artists must earn a living, and the various groups and enterprises each created existed chiefly to promote the work of artists in whom they believed. Ironically, both Fry and Sickert were later to be accused of destroying the value of their creations. In his autobiography, Nevinson charged Fry with ruining the Friday Club, 'a remarkable little clique', by his 'amateurish dilettantism'.[70] In December 1913, Pissarro was to write, with something of the same emphasis, to Manson:

As you know Sickert tries to dilute the little art elements of Fitzroy Street in a sea of amateurs and pupils of his – with probably the intention of destroying the art value of Fitzroy Street as he has destroyed the art value of the Camden Town Group.[71]

Neither attack should be taken as representing a general view. Nevinson wrote retrospectively and his account was coloured by future animosities. Pissarro, on the other hand, satisfied with things as they had been during the early days of Fitzroy Street and Camden Town, found the turmoil of artistic developments and temperaments around him infinitely disturbing. He had never liked Sickert, and was perhaps a trifle jealous of Sickert's position of authority within Fitzroy Street. He was, therefore, more ready to blame Sickert who, as chairman at meetings, seemed to be the man in charge.

As usual, the Fitzroy Street Group went into recess during the summer of 1913. Most members left London. Sickert, for example, was in Envermeu near Dieppe where he briefly ran across Wyndham Lewis. Ginner painted in Dieppe and also joined Bevan and Gore at Applehayes, Clayhidon. Pissarro and Manson painted together at Rye. Bayes went to Brittany. Gilman's visit to Norway probably took place in the summer, and Ratcliffe, who may have first accompanied Gilman to Norway, went on to Sundsholm in Sweden. John passed the summer between Paris and Wales. Their summer break over, members returned to face decisions which could no longer be delayed.

The Camden Town Group were still seeking larger exhibition premises so that they could increase their numbers. The coincidence of their December 1912 exhibition and Fry's second Post-Impressionist exhibition suggested that, as it stood, the Camden Town Group was no longer politically viable. As we have seen, the Camden Town Group had even toyed with the idea of joining Fry's show. Early in the autumn of 1913 Sickert considered recognizing a *fait accompli* by amalgamating the Fitzroy Street and Camden Town Groups with the Grafton Group. He wondered if a floor at 33 Fitzroy Square might be set aside to house this combination. And, as he told Nan Hudson, 'Any rules about the sexes ipso facto lapse distinctions having become, not only invidious, but impossible!' He was in two minds about the idea. On the one hand he maintained that: 'Fry-Bell, in their critical capacity, have tried to edit film, pick and choose pictures (a disintegrating and impossible attitude), have created Ginner Post-Imp in Paris but not in London . . .' (a reference to Ginner's inclusion in the Barbazanges show in Paris but his rejection from the 'English Group' at the Grafton Gallery). On the other hand, he accepted that Gore and Lewis already fraternized (*découcher* to quote Sickert's more picturesque word) with Fry's group. In conclusion he decided 'It would make *the* only interesting crowd in London.'

Events fast overtook the birth of this plan. In October a bitter and irreconcilable quarrel occurred between Lewis and Fry. To summarize the well-known story:[72] Lewis believed that Roger Fry had wilfully appropriated an exciting commission, to decorate a complete 'Post-Impressionist Room' for the Ideal Home Exhibition in October 1913, which had originally been intended for himself and Gore – presumably as a result of their successful collaboration at the Cabaret Theatre Club. Gore had apparently been approached personally by the *Daily Mail* organizers who had also suggested that the room might contain Omega furniture. Gore, not himself an Omega artist, had left a message to this effect at Fitzroy Square for Lewis and Fry. Without telling Lewis, Fry received the message, approached the organizers, and accepted the entire commission for Omega. Fry later asked Lewis to carve a mantelpiece for the room. Shortly afterwards Lewis learned, through Gore, that the *Daily Mail* commission had been intended primarily for himself and Gore, not for Omega. In retaliation Lewis circularized a virulent letter among his friends and among the customers and shareholders of Omega, denouncing Fry as dishonest in his management. He also accused Fry of having withheld letters of invitation to himself and Etchells to show work in the 'Post-Impressionist and Futurist' exhibition being organized at the Doré Galleries by Frank Rutter. This abusive letter was signed not only by Lewis, but also by Etchells, Hamilton and Wadsworth. All four walked out on Omega. Gore supported Lewis's case. Even Sickert favoured Lewis rather than Fry in this matter. He wrote to Nan Hudson: 'I do not wish to send you the Lewis circular because I do not wish mine to be the hand to give it to you. I don't approve of its wording, though I think they were quite justified in leaving.' Obviously amalgamation with the Grafton Group was now impossible.

'Post-Impressionists and Futurists' at the Doré Galleries

The rift between the Grafton Group-Omega artists and Fitzroy Street was emphasized, perhaps unintentionally, by the Doré Galleries exhibition in October 1913. No works by Fry, Grant or Vanessa Bell were included in an otherwise remarkably comprehensive survey of 'Post-Impressionist and Futurist' art in Britain and abroad. The show was frankly didactic. Its organizer, Frank Rutter, wrote a catalogue preface outlining the developments in art which sprang from, or occurred after, Impressionism. He was anxious to explain that the umbrella definition 'Post-Impressionism' embraced a variety of movements, and he selected his exhibition accordingly. Paintings by Camille Pissarro represented classic Impressionism, and works by Cézanne, Van Gogh and Gauguin classic Post-

Impressionism. Neo-Impressionism (Signac, Henri Edmond Cross and Theo van Rysselberghe), Intimism (Bonnard and Vuillard) and Fauvism (Matisse) were likewise demonstrated in what amounted to an illustrated lecture on modern art. Three photographs of works by Picasso stood in for Cubism. There were no paintings by the Italian Futurists but a work by Delaunay, illustrating the parallel French development christened Orfeism, was included. Twentieth-century German art was represented by loans from Professor Sadler's outstanding collection. Rutter then illustrated the developments, at home and abroad, inspired by these principal movements. His selection of contemporary British art ranged much wider than Fry's and Bell's partisan choices for the Barbazanges and Grafton Gallery exhibitions in 1912. There were, for example, pictures by Alfred Wolmark; the Scot J. D. Fergusson was chosen together with the American Anne Estelle Rice to represent an individual offshoot of Fauvism; pictures by Renée Finch and Harald Sund were included; and Epstein exhibited two works in a small sculpture section containing three pieces by Zadkine and one by Brancusi. Ten members of the Camden Town Group exhibited (the absent six being Baycs, Grant, Lamb, Innes, John and Turner), nine as the 'Intimists' of England and the tenth, Lewis, as the spearhead of the Futurist-Cubist orientated movement in London. Important pictures by Nevinson (among them *The Departure of the Train de Luxe* inspired by Severini), Wadsworth, Etchells and Hamilton vigorously supported the impact of this section and justified the distinction conferred by the separate mention of Futurism in the exhibition title.

The only precedents for so comprehensive and diverse a display of contemporary talent were the non-selected Allied Artists' Association exhibitions, also organized by Rutter. However, the A.A.A. shows suffered from their size and lack of quality-control. The catholic taste demonstrated by Rutter in his selection for the Doré Galleries must have impressed members of the Fitzroy Street and Camden Town Groups. Moreover, this proof that non-partisan groupings were possible occurred just at the moment when William Marchant's offer of his commodious Goupil Gallery for their exhibitions made the immediate expansion of the Camden Town Group imperative.

Formation of the London Group (Fig. 3)

As we know, expansion of the Camden Town Group had been considered in 1911. When the group was first formed a newspaper report[73] had announced that one of its

rules was 'the unusual one that the Society shall be dissolved and reformed every five years in order to prevent the growth of undesirable "traditions".' However, the first formal consideration of what, for the time being, was called 'the New society' is recorded in the minutes of a Fitzroy Street meeting on 25 October 1913.[74] The substance of this meeting was known in advance, at least to some members. Ginner, unable to attend, wrote a note to Manson (secretary of the group) on 23 October expressing his regret at missing a meeting on the important subject of a new society; he appointed Gilman his proxy.[75] Nan Hudson feared that the business might be conducted as an attack on Roger Fry, and Sickert wrote to reassure her on 21 October:

> No demonstration against Roger will be permitted by me either. That is understood. Unless forming a society of which he is not a founder-member is a demonstration. As he has not included you in his group and I have, I think your bread is buttered on my side. Personally I should later wish Roger and anyone interesting to be elected. But we needn't put that forward while the Roger-Lewis quarrel is acute.

Duncan Grant, perhaps to forestall such an offensive, braved Lewis and Gore to make one of his rare appearances at Fitzroy Street for this meeting. He took no active part in the proceedings and never attended again. It is possible that he resigned from the group, although this is not recorded in the minutes. He was certainly not a member of the new society launched at this meeting. Nor were Innes and John. Advanced consumption was about to drive Innes abroad to the sun, but disinterest as well as ill-health had long caused his participation in the Camden Town and Fitzroy Street Groups to cease. On 3 January 1914 Innes's membership was formally rescinded, and in August he died. John's membership of both groups had also lapsed but whether he took the trouble to resign is uncertain. The other Camden Town absentees on 25 October were Lamb, Pissarro, Ratcliffe, and the deaf, diffident Doman Turner who found meetings such a strain that he attended none over the winter of 1913–14. Ethel Sands, Nan Hudson and Epstein, as members of the Fitzroy Street Group if not of Camden Town, were present. The main outcome of this meeting was that henceforth these two groups were amalgamated to form the new society. There was, besides, much discussion of how new members should be elected, and it was decided to limit membership to residents of the United Kingdom.

The next meeting at 19 Fitzroy Street of which minutes survive was on 15 November. Interesting things had happened during the intervening three weeks. Because the new society represented an amalgamation of the Fitzroy Street and Camden Town Groups, a back door into founder-membership was to storm the more flexible defences of Fitzroy Street and thus bypass the potentially stringent, although as yet undecided, election procedures. In any event six, possibly eight, new members were present. Renée Finch and Harald Sund explain this numerical discrepancy. They were absent from the meeting on 25 October. While it is probable that they were already members by this date, no proof of the time of their election exists and their first documented appearance at Fitzroy Street was on 15 November. The other six new members were Bernard Adeney and Harold Squire,

	CTG EXH June 1911	CTG EXH Dec 1911	2 P-I EXH Oct to Jan 1912-13	CTG EXH Dec 1912	DORÉ EXH Oct 1913	FSG 25 Oct 1913	FSG 15 Nov 1913	FSG 22 Nov 1913	FSG 29 Nov 1913	FSG ELECT LG 6 Dec 1913	BRIGHTON EXH Dec to Jan 1913-14	FSG ELECT LG 3 Jan 1914	FSG ELECT LG 7 Feb 1914	LG EXH Mar 1914	FSG ELECT LG 7 Mar 1914	FSG 14 Mar 1914
Bayes	●	●		●		○	○	○	○	○	●	○		●	○CH	
Bevan	●	●		●	●	○	○	○	○	○	●	○		●	○	○
Drummond	●	●		●		○				PR	●			●		
Gilman	●	●		●	●	○	○	○	○	○	●	○		●	○	○
Ginner	●	●		●	●	PR	○	○	○	○	●	○		●	○	○
Gore	●	●	●	●	●	○	○	○	○	○	●	○	○CH	●	○	○CH
Grant		●	●			○										
Innes		●										NM				
John	●															
Lamb	●	●	●	●			○			PR		PR				
Lewis	●	●	●	●	●	○	○	○	○	○	●	PR	○	●	○	
Lightfoot	●	dead														
Manson	●	●		●	●	○	○	○	○	○	●	○		●	○	○
Pissarro	●	●		●	●					PR	●	○				R
Ratcliffe	●	●		●	●		○	○	○	○	●	○		●	○	○
Sickert	●	●		●	●	○CH	○CH	○CH	○CH	○CH	●	○CH			R	
Turner	●	●		●												
E Sands						○	○	○	○	○				●		
A H Hudson						○	○	○	○	○				●		
Epstein					●	○	○	○	○	○	●	○		●	○	○
R Finch					●		○	○	○	○	●	○		●	○	○
Sund					●		○	○	○		●	○		●		
Adeney			●				○	○		○	●	PR	○	●	○	
Etchells			●	●						○	●	○		●		
Hamilton			●	●			○	○	○	PR	●	PR	○	●		
Nevinson				●		○			○	○	●	○	○	●		○
Squire							○	○		○	●	○		●	○	
Wadsworth			●	●		○	○	○	○	○	●	PR	○	●		
Bomberg			●							F	●	ED		●	○	○
J Etchells			●							F	●	ED	○	●		○
Fox-Pitt										F	●	ED				
Gill			●								ED	R				
S Gosse										F	●	ED		●		
S de Karlowska					●					F	●	ED	○	●	○	○
T Lessore										F	●	ED	○	●		
J Nash											●	ED		●	○	
Taylor										F	●	ED				
Gaudier-Brzeska										ED	●				○	○
S Spencer												ED				

Right-side brackets: Camden Town Group; Fitzroy Street Group; Founder members of the London Group [NB Grant and John probably resigned before March 1914]; Elected Members of London Group by March 1914.

KEY

● = exhibited
○ = present
CH = chairman
PR = assigned proxy
NM = declared non-member
F = failed in election
ED = elected
R = resigned
CTG = Camden Town Group
EXH = exhibition
2 P-I = 2nd Post-Impressionist
FSG = Fitzroy Street Group
LG = London Group

NB Artists who stood as candidates but failed to secure election to the London Group between 6 December 1913 and 7 March 1914 were:

Geoffrey Allfree	E Forbes-Robertson	Miss Lancaster	William Roberts	Hilda Trevelyan (2)
Horace Brodzky	Mark Gertler (2)	Mervyn Lawrence	A Rothenstein (2)	E Verpilleux (2)
S Currie	Hilda Hassell	Miss Middleton	W Rothenstein (2)	C Winzer (3)
Miss Davison	Hamilton Hay (3)	Paul Nash (2)	Joseph Simpson	Alfred Wolmark
Fanny Eveleigh (3)	Darsie Japp (2)	C Maresco Pearce	H S Teed (2)	

The numbers in brackets are the number of times some artists submitted themselves for election. Otherwise each artist stood once only.

Fig. 3

who both exhibited with the Friday Club, and Nevinson, Hamilton, Wadsworth and Etchells. This invasion from Lewis's camp significantly altered the political and artistic balance of the society. It marks the moment when the two original leaders of the Fitzroy Street Group. Pissarro and Sickert, lost control of the enterprise.

Pissarro had missed the meeting when the new members were elected. Manson wrote to him on 5 November[76] to tell him the results were not 'entirely satisfactory'. A week later he tried to reconcile Pissarro to the *fait accompli*: 'Judging from the exhibition at the Doré I think we gain rather than lose by the presence of these outrageous cubists.'

Pissarro stayed away from the meeting on 15 November. Indeed he and Nan Hudson were the only active founder-members absent when, with Sickert as usual in the chair, the new society settled on a title. According to Ginner[77] it was Epstein who suggested that 'The London Group' was a fitting banner to embrace the more broadly-based membership. Gilman replaced Gore as president, Bevan was appointed treasurer, and Manson continued as secretary (Pl. 72). Following the precedent set by the Camden Town Group it was resolved that the pictures exhibited by each artist should hang in groups. Arrangements for a first exhibition in the spring of 1914 were initiated. The difficult problem of how new members should be elected was not considered, except to decide that a special meeting was necessary for voting.

Three days later Manson again summoned up the courage to try to win Pissarro over to acceptance of the way in which the new society was evolving:

I feel that by denying these new movements a right to express themselves, we should be acting exactly as the Academicians did with regard to the Impressionists and precisely as the N.E.A.C. does when it says with regard to Fitzroy St: 'You may be alright from your own point of view but we shan't show yr. work.'

I have no sympathy with that attitude and I do not want to support it, so I think that I shall stay with the 'London Group'.

I feel the other attitude of intoleration is rather narrow.

I don't think we have any reason to be afraid of a few extreme young men; nor ought we to run away from them.

Perhaps to soften his intransigence, Manson suggested that Pissarro propose Diana White as a candidate for the next election. Pissarro composed a long and detailed reply on 20 November:

You are right in a way, but I must say that your attitude is much more concerned with philanthropy than with Art.

Of course the N.E.A.C. is conducted by a clique, so are the Academy and the Camden Town Group! There is only one society which is not supposed (?) to be cliquy [*sic*] and that is the A.A.A. Whatever one does, things *always* turn to be governed by a clique. I think the N.E.A.C. constitution is the most perfect I ever heard of, and really done honestly with the intention to admit all possible developments, and you see the result! I do not believe for a moment that the London Group will be more liberal and fair than any of the other societies – What I object to is that it is the wrong clique that has gained influence.

Things being so, I maintain that the real force of a group is to be cliquy, without shame, to claim highly and openly to be cliquy, and to make a glory of it! and so form a small society of tendance rather than of numbers.

Fancy people joining with the idea of forming a teetotaller society and coming to the conclusion that in order not to be narrow minded, they should admit some drunkards!

My dear Manson, there is only one thing to consider, that is our ideal in Art. Others with different ideas may fight their battle, that is not our business, we must fight ours. I firmly believe that our friends have some broad aim in common with us which is quite wide enough to permit all individual developments and at the same time to allow us to join together – that broad principle is that they do not turn their backs to Nature. The new members are looking for something different (I dont say that they wont arrive at some fine things in time) but what I say is that we, worshippers of nature, are not concerned with their aim. It may be that our friends want to follow that lead, because it is the fashion – or perhaps are they more in sympathy with them than with us – but then, I fail to understand why some of them have taken the title of Neo-Realist – I fear they dont quite know where they are going and as true opportunists want to be ready to turn with the wind.

Well, as I can not form a group all alone I will stay until I see more clearly in what direction things will go, and then I will act according to my *interest*, for I see now that interest is the only thing to be considered, conviction seems to enter so little in all these considerations.

P.S. Dont trouble about proposing Miss White, she would not now care to belong.

Pissarro's letter demanded a reply. On 22 November Manson wrote back to justify his own position as an active supporter of the London Group and to persuade Pissarro, whose rejection of the London Group was still in the balance, back into the fold:

My attitude may be more concerned with philanthropy than with art, but I must say exhibitions and societies are more concerned with business than with art: more concerned with selling pictures, with advertising painters etc. I detest exhibiting and exhibitions except one-man shows. When I see beautiful, refined, delicate, subtle pieces of painting looking their worst in exhibitions I feel extremely sorry that they have to be shown in that way and in an environment which demands an unusual degree of discrimination on the part of the onlooker before he can really *see* the good picture so I do not think we can adopt any very idealistic attitude or imagine that any art society exists primarily for the benefit of art. Therefore, speaking very broadly, it does not matter much where one exhibits. . . .

The new members – the young mathematical painters – are still young and foolish. They have not gained influence. They are in a minority of 7 to 19![78] You are quite content to be a member of the N.E.A.C. where you are practically all alone among a whole crowd of reactionaries: while as a member of the London Group you would have at least 11 followers, you would be among friends, people who honour and admire, a few who love you. I know, because I have talked to them intimately about it.

If we take that standpoint, what possible good service does one do to Art by exhibiting at the New English? Its very name is a mockery. I cannot feel that I should be considering my ideal in art by exhibiting with them. I have nothing in common with any other member but yourself. On the other hand I am in sympathy (more or less) with nearly $\frac{3}{4}$ of the London Group.

Of course my ideal would be a group like the original splendid French Impressionist group; but that appears to me to be impossible here. How could we form a society that would be important enough to justify its existence? If you see a way or see a way later I should like to

be in it. . . . the London Group seems to be the best thing going at the moment. . . . don't do anything hastily. The A.A.A. is no good because it opens its doors to reactionary bad old stuff. 98% of it is very bad. And after its treatment of Mrs Finch I shall leave it.

I think a society might open its doors to admit a certain amount of work representing new movements for I think that new thought and new ideas should be allowed to say what they have to say, that is all.

The mathematical-cubists are in a proportion of about 1 to 3 and quite harmless. Believe me, they have very few admirers besides themselves among the members of the London Group. I think it a *positively* good thing to give these new movements a chance of displaying themselves. They will soon cease to beg them.

Manson wrote this letter on the day of a meeting from which Pissarro was obviously again absent, as were Lamb, Nevinson and Etchells. Several practical resolutions were passed (about proxy votes, the annual subscription and such like). It was also decided that candidates for membership should now be invited to submit work for inspection, and that the possibility of two exhibitions a year should be explored. The only political decision taken was that members of the London Group should become, *ipso facto*, members of the Fitzroy Street Group. This resolution recognized the fact that the London Group took over the functions of the Camden Town Group as an exhibiting society, but left unsatisfied the needs of artists to store their work, show it to clients and meet together for informal discussion; all these privileges were conferred by membership of the Fitzroy Street Group.

The meeting on 29 November was mainly concerned with voting procedures. One adverse vote should cancel one favourable vote, and to secure election a candidate must secure the votes of at least half the total number of members. Manson's draft of the Rules and Constitution of the London Group must have been made after 29 November because it incorporates rules passed at this and all the preceding meetings. However, he inscribed the date '25/10/1913' at the top.

Every active member of the London Group turned up, or assigned a proxy, for the all-important meeting on 6 December when, for the first time, an election for new members was held. Manson had taken the precaution of asking if he could stand proxy for Pissarro on 28 November, when he already knew that 'one or two objectionable people' were to be put up for election. All fourteen candidates failed to pass the test. Just as the founder-members of the London Group represented a wide range of artistic styles and allegiances, so the candidates included artists as various as William Rothenstein, the watercolourists Walter Taylor and Douglas Fox-Pitt, Stanislawa de Karlowska (Mrs Bevan), Sickert's disciple Sylvia Gosse, as well as Jessie Etchells (sister of Frederick), Gertler and Bomberg. It became obvious that the political complexions represented by both voters and candidates made a majority consensus impossible. Therefore Epstein proposed that the votes of one-third rather than one-half of the total number of members be sufficient to secure election.

On 3 January, the next election date, every active participant except Drummond either attended or assigned a proxy. Twenty-six candidates put themselves forward and nine secured election. The unsuccessful candidates included Gertler and the Rothenstein brothers, Albert and William. William Rothenstein secured the

impressive total of minus ten votes, only surpassed by two complete outsiders. On the whole friends and relations of the old guard of Camden Towners did best. Stanislawa de Karlowska became a member, as did three of Sickert's disciples and friends, Sylvia Gosse, Fox-Pitt and Taylor; Thérèse Lessore, to become the third Mrs Sickert in 1926 but currently the wife of Bernard Adeney, was also elected. The other successful candidates were Jessie Etchells, John Nash (his brother Paul failed), Bomberg and the sculptor Eric Gill.

Pissarro had actually attended the 3 January meeting in person, the only time he did so. In December he had evidently decided to revise his policy of aloofness and began to busy himself behind the scenes. He concentrated his efforts upon Fitzroy Street rather than the London Group. On 16 December he wrote to Manson:

> I shall be glad to talk to you about Fitzroy St. I think we must make an effort to keep it alive, for if the London Group comes to grief, as I expect it will, our own little center will again be able to spring in another direction. We ought to take this excellent opportunity, now that we have a pretext, to get rid of W. Bayes. If we want some new members to help the financial part Miss White, Conway and perhaps Mrs Finch, will be willing to join.

The background to this letter, in particular the 'pretext' for reorganizing Fitzroy Street by purging it of unwanted members, is undocumented. It sounds as if a suggestion to disband Fitzroy Street altogether, and then to reconstitute it, was afoot. Why else should Pissarro suggest that Mrs Finch (already a member) might join? It is within this context that Pissarro's letter to Manson of 22 December (quoted above), complaining of Sickert's destruction of the 'art value' of Fitzroy Street, must be understood. The letter did not refer to developments within the London Group, where Pissarro objected primarily to Wyndham Lewis and his followers; nor did it refer to the admission of several of Sickert's friends and disciples to this group, because it was written nearly two weeks before their election. It reflects Pissarro's fundamental antagonism to Sickert as a man and an artist, and his consequent inability to reconcile himself to the fact that Sickert commanded respect and loyalty within Fitzroy Street from such odd quarters as Walter Bayes.

Pissarro found allies in his endeavours to oust Sickert and his friends from their hold upon Fitzroy Street. Gilman arranged an unofficial meeting to discuss the situation, attended by Pissarro, Ginner and Bevan. The outcome of their talk, whether they even agreed, is unknown. If, as is probable, the pretext they were to use to secure the disbandment of the Fitzroy Street Group was that this group would lose its identity and purpose when the entire London Group was admitted to its bosom, then they were outmanoeuvred. At the meeting on 3 January Bayes anticipated objections by proposing that the rule relating to amalgamation of the London and Fitzroy Street Groups be rescinded. Etchells seconded the motion, which was carried unanimously. Thus the privileges of Fitzroy Street were preserved for a slightly less motley crew of members, although from Pissarro's point of view undesirables remained. A week or so later Pissarro went to Eragny and did not return to London until April 1914. In March he resigned, by letter, from the London Group and the Fitzroy Street Group.

At the next election on 3 February 1914, ten candidates were proposed for

election of whom only Gaudier Brzeska (at his first attempt) was successful. A few days earlier Eric Gill had declined to take up his membership, explaining in a letter to Manson that he disliked exhibitions and exhibition societies.[79] A more significant absentee from this meeting was Sickert, who until then had always taken the chair. For reasons shortly to be explained he stayed away from subsequent meetings and resigned his membership of both Fitzroy Street and the London Group before the exhibition opened in March. Henry Lamb's participation in the group also ceased after January. Manson himself withdrew from the London Group towards the end of March, disheartened by Pissarro's resignation and perhaps by the animosities within the group. Unlike Pissarro, he contributed to the first exhibition but, as secretary, he kept minutes of only two more meetings.

From these minutes we learn that Stanley Spencer was the only successful candidate out of six at the election of 7 March, with Horace Brodzky (a friend of Gaudier Brzeska) and Wolmark among the failures. The first London Group exhibition had by then already opened in the upstairs room at the Goupil Gallery, so that no work by Spencer could be included.

The most significant absentees among the exhibitors were Sickert and Pissarro. Their withdrawal evidently worried Marchant. He had originally agreed to sponsor the exhibitions of a new society formed from, and by, the Camden Town Group. He was now supporting a group from which the two leading figures were missing, besides other notable artists such as Henry Lamb. The meeting on 7 March was, therefore, faced with a letter from Marchant asking for some guarantee of the constitution of the London Group for the spring 1915 exhibition. Puzzled by the ambiguous import of this document the members resolved to find out just what Marchant meant. Their answer came a week later, at the meeting on 14 March, when a letter from Marchant suggested that a total of five resignations should liberate him from his agreement. In fact another matter altogether finally led Marchant to terminate his agreement with the London Group during the war. In October 1916 Marchant announced that he would not house exhibitions which included work by conscientious objectors. The London Group by then included two objectors, one being Adrian Allinson. They stood down for the winter 1916 exhibition while the London Group sought alternative premises. The 1917 exhibition, however, was removed to Heal's Mansard Gallery.

＊

1913–14. Brighton exhibition of
'English Post-Impressionists, Cubists and others'
arranged by the Camden Town Group

The history of resolutions, elections and resignations recorded in the minutes of London Group meetings between October 1913 and March 1914 reflects private reactions to more public events. Chief among these events was a large exhibition held at the Brighton Art Gallery from 16 December 1913 to 14 January 1914. The Camden Town Group under the presidency of Gore was invited to select this exhibition and thus, on paper at least, enjoyed a brief reprieve from extinction. In fact suggestions for selection were probably made by the entire Fitzroy Street Group, in other words by the founder-members of the London Group. Because exhibitors did not have to pass the stringent election processes used by the London Group, the Brighton exhibition included many artists who failed on one, more or all of their attempts to be admitted to the new society. It was obviously difficult to find a title appropriate to such a mixed exhibition of contemporary art. As the director of the Art Gallery wrote in an introductory catalogue note, the chosen title, 'Work of English Post-Impressionists and Cubists', was 'hardly sufficiently explanatory, as there are many works exhibited which do not come under either of these titles. It is, however, sufficiently indicative of the general tendency of the exhibition.'

All eleven active members of the Camden Town Group exhibited at Brighton (those absent being Doman Turner, Grant, Innes, John and Lamb). All eleven non-Camden Town members of the Fitzroy Street Group exhibited, as did eight of the nine artists to be elected to the London Group on 3 January (the absentee, Eric Gill, was neither to seek nor accept his election to the Group). These thirty exhibitors were joined by six more artists of whom four (Mervyn Lawrence, Paul Nash, Hamilton Hay and Fanny Eveleigh) were unsuccessful candidates for election to the London Group on one or more occasions before March 1914. The remaining two were Martin Ogilvie and Ruth Duckett (the latter almost certainly Ruth Doggett, a talented pupil of Sickert and later of Gilman).

A rift divided these exhibitors from the start. Not only were the exhibits physically separated, but two separate catalogue introductions were found to be necessary. Manson wrote the introduction to Rooms I and II; Wyndham Lewis introduced Room III, subtitled 'The Cubist Room'. Manson's introduction gently traced the history of the Fitzroy Street and Camden Town Groups – incidentally antedating the institution of the former by some two years. He acknowledged Sickert's original realization that scope must be given to the 'free expression of newer artistic thought', that Gore and Gilman led the movement forward, and that Lucien Pissarro provided the crucial link with traditional art. Stressing the right of free speech in art he referred to the current formation of the London Group which would extend 'the means of free expression . . . to other artists who were experimenting with new methods'. In a glowing appreciation of what the London Group could achieve Manson wrote:

More eclectic in its constitution, it will no longer limit itself to the cultivation of one single school of thought, but will offer hospitality to all manner of artistic expression provided it has the quality of sincere personal conviction. The Group promises to become one of the most influential and most significant art movements in England.

To conceive a limit to artistic development is an admission of one's own limitations. Nothing is finally right in art; the rightness is purely personal, and for the artist himself. So, in the London Group, which is to be the latest development of the original Fitzroy Street Group, all modern methods may find a home. Cubism meets Impressionism, Futurism and Sickertism join hands and are not ashamed, the motto of the Group being that sincerity of conviction has a right of expression.

This vision of a Messianic age was immediately put to the test in the exhibition, although not specifically in Wyndham Lewis's introductory text. The only mildly combative statement in Lewis's highly charged account of his own relationship with Futurism and Cubism was his description of himself, Nevinson, Etchells, Hamilton and Wadsworth as 'a vertiginous, but not exotic, island in the placid and respectable archipelago of English art'. Because no other sculptors exhibited, little exception could be taken to his remark that Epstein was 'the only great sculptor at present working in England'. Nevertheless, Lewis's essay amounted to a credo announcing the imminent birth of Vorticism, and its tone was fundamentally rejectionist.

One artist, Adeney, exhibited in both the Camden Town-Fitzroy Street rooms and the Cubist room. Otherwise segregation was total. Both the artistic content and critical reaction to this Cubist room, containing major works by Epstein, Hamilton, Wadsworth, Etchells, Bomberg, Nevinson and Lewis, supported by contributions from Jessie Etchells, Fanny Eveleigh and Adeney, have been fully discussed by Richard Cork[80] and are outside the scope of this text. The response to the Brighton exhibition by the old Camden Town Group members is relevant here. Pissarro's disgust with the Cubist room must have encouraged his decision to resign from the London Group, although he was perhaps equally disillusioned with the hotchpotch miscellany hung elsewhere. Sickert's reaction was more forthright, but delayed. He had opened the exhibition with a speech. However, as he told Nan Hudson two months later: 'At Brighton the Epstein-Lewis-Etchells room made me sick and I publicly disengaged my responsibility.' This disengagement must have been verbal and probably contained within his opening speech, because Sickert did not publish his attack on the Cubist room exhibits until March.

✳

The London Group.
Factions and Sickert's resignation

For once Gore's attempts to heal the breach between his colleagues failed. Gilman also made efforts to reconcile opposing factions when, in an interview published in the *Evening Standard* on 3 February 1914,[81] he was at pains to define the common aims possessed by 'realists' and 'formulists' in the London Group: 'They both arise from the revolt against naturalism, and they support one another in the sense that one can learn from the other.' Demonstrating with a small potted cactus he explained that if he were a formulist 'he would simply paint a very obviously heartshaped object with a sort of elliptic circle underneath it to represent the pot and it wouldn't matter what colour it was. "That is to say, I am rendering so much of it as consists of planes and curves . . . On the other hand, if I am a realist I want the object to remain a cactus after I have painted it."' Gilman ranked himself with the realists. Indeed, when they exhibited in the Goupil Gallery Salon in the autumn of 1913 he and Ginner had already inserted the sub-title 'Neo-Realist' after their names in the catalogue.

What Ginner and Gilman meant by this epithet was explained on 1 January 1914 when Ginner published 'Neo-Realism' in the *New Age*; the essay reappeared as the catalogue preface to their joint exhibition at the Goupil Gallery in April to May 1914. It is a very personal document. Like Gilman in his *Standard* interview, Ginner rejected 'Naturalism' as 'the production of a Realist with a poor mind'. The Naturalist merely copies nature, 'with a dull and common eye', but possesses 'no personal vision, no individual temperament . . . no power of research'. However, the main object of his article was to attack those English Post-Impressionists (in particular the Fry-Bell clique) who had adapted a formula, or a series of formulae, from methods personal to Van Gogh, Gauguin and Cézanne. These formulists, whom Gilman in his interview was more ready to accept, were rejected by Ginner as the new Academics:

> The Academic painters merely adopt the visions which the creative artists drew from the source of nature itself. They adopt these mannerisms, which is all they are capable of seeing in the work of the creative artist, and make formulas out of them.
> They are copyists. They are the poor of mind.

Thus Ginner articulated his opposition both to English Post-Impressionism as practised by most of his colleagues, and to Naturalism which, he maintained, dominated such establishment institutions as the Royal Academy and the Paris *Salon*. His own doctrine of Neo-Realism was basically a dogmatic assertion that original and great works can only be produced by an artist who intimately and searchingly studies an aspect of nature which especially appeals to him, and then deliberately and objectively transposes what he sees on to canvas. Regarding subject-matter he wrote:

Each age has its landscape, its atmosphere, its cities, its people. Realism, loving Life, loving its Age, interprets its Epoch by extracting from it the very essence of all it contains of great or weak, of beautiful or of sordid, according to the individual temperament.

Ginner also had something to say on the handling of paint. He disliked 'slap-dash, careless, and slick painting', and despised the sketch as a finished product. 'Good and sound craftsmanship', he maintained, necessarily resulted from a Neo-Realist approach to nature. He added, 'Furthermore, in this matter of medium, it is only out of a sound and solid pigment that good surface and variety can be got, and durability in ages to come.'

Gilman, in his February interview, had assumed that the main breach within the London Group lay between the realists (the old guard of Camden Town) and the formulists (the Wyndham Lewis gang). Ginner's article threw into relief less clear-cut, but no less divisive, factions within the old guard. Sickert and Pissarro, for different reasons, rejected Neo-Realism.

In his letter to Manson of 20 November Pissarro had disparaged the term Neo-Realist adopted by some of 'our friends' (i.e. Ginner and Gilman at the Goupil Gallery Salon) within Fitzroy Street. As far as doctrine is concerned, Ginner's emphasis on the intimate study of nature must have been approved by Pissarro. However, it is probable that he objected to Ginner's slighting references to naturalism, even though Ginner was at pains to stress that the Impressionists were great realists, not naturalists. Moreover, Ginner had gone on to say that Neo-Impressionism had sunk 'into the Formula Pit'; Camille Pissarro in his later years and Lucien Pissarro had both derived their handling from this development of Impressionism.

When Ginner's article was republished for the Goupil Gallery catalogue Sickert answered in an essay in the *New Age* entitled 'Mr Ginner's Preface'.[82] He agreed with the main drift of Ginner's argument that (to quote Sickert's paraphrase): 'Art that is based on other art tends to become atrophied, while art that springs from direct contact of the artist with nature at least tends to be alive.' His few criticisms were trivial and pedantic. He disparaged Ginner's adoption of a label:

I dislike the prefix 'Neo'. It is better for a painter not to call himself 'new'. Time alone will show how his work will wear. He had also better not call himself a realist. Let us leave the labels to those who have little else wherewith to cover their nakedness. Charles Ginner is a very good name, and has gathered already around it associations of achievement and respect. 'Harold Gilman' calls up to the mind a definite tendency in painting, and both names are only obscured when they are covered by a uniform domino which would tend to merge their identities.

Sickert also quarrelled with Ginner's inclusion of Poussin in a list of the 'quagmire' of derivative painters, and with Ginner's apparent confusion of the word 'academic' with the word 'academy'. But in the main he heartily endorsed Ginner's 'sound and coherent manifesto'.

It was, in fact, the products rather than the doctrine of Neo-Realism to which Sickert took exception. In his review of the N.E.A.C. exhibition, published in the *New Age* in June 1914,[83] Sickert praised Henry Lamb for understanding the 'strict

limit to the advantages of impasto'. Lamb, according to Sickert, knew that impasto was 'not in itself a sign of virility'. As he explained:

Intentional and rugged impasto, from the fact that each touch receives a light and throws a shadow, so far from producing brilliancy, covers a picture with a grey reticulation and so throws dust in the eyes of the spectator, and serves, to some extent, to veil exaggerations of colour or coarseness of drawing. It is a manner of shouting and gesticulating and does not make for expressiveness or lucidity.

Although no reference was made here to Ginner or Gilman these two had been expressing Ginner's advocacy of 'sound and solid pigment' by using ever thicker small touches and blobs of lumpy paint. There was also, perhaps, deliberate provocation intended by Sickert when he chose to praise Lamb who, like himself, had resigned from the London Group before the first exhibition. Gilman and Ginner, in any event, read the terms in which Sickert praised Lamb as a disguised attack, and said as much in two separate letters to the *New Age*.[84] Gilman headed his letter 'The Worst Critic in London'. Sickert replied in yet another article, reserving his unkindest cut for the title 'The Thickest Painters in London',[85] which in turn sparked off an acrimonious correspondence in subsequent issues of the *New Age*.[86] This debate, conducted in the main from April to June 1914, that is, after Sickert had resigned from the London Group of which Gilman was president, nevertheless reflects the animosities and personal irritations current earlier in the year. However, compared with Sickert's chief quarrel within the Fitzroy Street Group, it was a mere diversionary skirmish.

Sickert's disillusion and disgust with both the London and the Fitzroy Street Groups were much more directly occasioned by the persistent and growing influence of Lewis and his colleagues on the activities of both groups. At a Fitzroy Street 'At Home', probably in Febuary 1914, he received the *coup de grâce*. He wrote to tell Nan Hudson:

I am afraid you will think me more 'swing of the pendulum' than ever. But like the lady in bridal attire who bolts at the church door the Epstein-Lewis marriage is too much for me and I have bolted. I have resigned both Fitzroy Street and the London Group. You who have watched the stages will not think me merely frivolous. I now see the stages which led to this. First Gilman forced Epstein on me, as you know against my will. But I was in a minority. At Brighton the Epstein-Lewis-Etchells room made me sick and I publicly disengaged my responsibility. On Saturday Epstein's so-called drawings were put up on easels and Lewis's big Brighton picture. The Epsteins are pure pornography – of the most joyless kind soit-dit and the Lewis is pure impudence. Then I left, once for all, but *never again for an hour* could I be responsible or associated in any way with showing such things. I don't believe in them, and, further, I think they render any consideration of serious painting impossible.

I hope you don't think my conduct, to Gore and Gilman chiefly, cowardly or treacherous. You know that they have dragged me step by step in a direction I don't like, and it was only a question of the exact date of my revolt. It is, after all, they who believed in this thing and I who suffered it to please them, weakly I admit. But I was in a minority. It is only just that I should say to them '*You* believe in this. *You* must digest and defend it. I can't and won't.'

. . . I shall not set foot in Fitzroy Street again after my sensations when the Epsteins were on the easels and various charming and delightful people open-mouthed looking to me for explanations or defence.

Like Pissarro, Sickert felt driven out of Fitzroy Street, his own creation, by an alien invasion. Unlike Pissarro, he decided to conduct an active campaign of extermination from the outside. He felt admirably placed to do this because the *New Age*, a periodical which thrived on controversy, gave him a free hand to publish articles on whatever subjects he chose. With great optimism he told Nan Hudson: 'being a weekly I influence all the other critics. I really become the conductor of the critical orchestra in London.'

Sickert's articles were a regular feature in the *New Age* from March to June 1914. He blasted off this series with 'Mesopotamia-Cézanne',[87] an appreciative review of Clive Bell's book, *Art*, with a sting in its lengthy tail. Commending Bell's exposition of the doctrine of significant form, Sickert attacked Bell for having 'got hold of the wrong end of the wrong Messiah'. Cézanne, Sickert maintained, 'when Cubism has gone as lightly as it has come', would only be remembered 'as a curious and pathetic by-product of the Impressionist group'; the drawings of Sir Edward Poynter were more likely to guide painters of the future. In fact Sickert felt a healthy respect for some of Cézanne's qualities and adopted this extreme position, as he told Ethel Sands, 'to counter the folly of the *soi-disant* followers of Cézanne'.

It has often been maintained that, from the time of Fry's first Post-Impressionist exhibition at the Grafton Gallery in the winter of 1910, Sickert watched the desertion of his own former disciples with ever-increasing dismay as they found new guides among the artists, dead and alive, promoted by Roger Fry and Clive Bell. However, jealousy formed no part of Sickert's make-up. He may sometimes have thought his younger friends' experiments misguided, but he never grudged them the chance of self-expression in whatever language they chose to adopt. Never, that is, until he was faced with Wyndham Lewis's maturing style, and Sickert had not counted Lewis as an artist from his own stable. Sickert's admission to Ethel Sands of his motive for adopting an extreme position when discussing Cézanne, hints at the reasons behind the ultra-conservative attitudes he assumed in general at this period. Temperamentally and intellectually he was an independent. In less tolerant times he had led the campaign for progressive art; now that modern art at home and abroad had a large and articulate following he felt impelled to find another unfashionable cause, the forceful defence of the academic tradition. Moreover, he felt no compunction about overstating his case.

Readers of the *New Age* were thus prepared for the flamboyant wit of 'On Swiftness', an article published on 26 March dealing, as he told Nan Hudson, 'delicately but firmly, with the pornometric aspect of Cubism':

We hear a great deal about non-representative art. But while the faces of the persons represented are frequently nil, non-representation is forgotten when it comes to the sexual organs. Witness Mr. Wyndham Lewis's 'Creation' exhibited at Brighton, Mr. Gaudier-Brzeska's drawing in last week's New Age, and several of Mr. Epstein's later drawings. That such intention is not read into the works by me, but is deliberate, we may gather from the Cubists' own defence of themselves. Mr. Lewis writes in the preface of the Brighton catalogue of December 16 1913, 'Hung in this room as well are three drawings by Jacob Epstein, the only great sculptor at present working in England. He finds in the machinery of procreation a dynamo to work the deep atavism of his spirit.' So that the Pornometric Gospel

amounts to this. All visible nature with two exceptions is unworthy of study, and to be considered pudendum. The only things worthy of an artist's attention are what we have hitherto called the *pudenda*!

Sickert was fighting a losing battle. T. E. Hulme was also employed by the *New Age* and produced *avant-garde* counterblasts to all Sickert's attacks. For instance, in December 1913 Sickert had been commissioned by the *New Age* to edit a series of illustrations called 'Modern Drawings'. His weekly selection began on 1 January 1914 and included several of his own drawings, one by Ginner (*Leicester Square*), one by Bayes, and many by his little known Rowlandson House pupils. On 19 March, instead of Sickert's choice, Gaudier–Brzeska's geometrical *Dancer* appeared, as the first in a series edited by Hulme and nicely distinguished from Sickert's selection by the title 'Contemporary Drawings'. Hulme's series, including drawings by Bomberg, Roberts, Wadsworth and Nevinson, gradually ousted Sickert's. Similarly, the issue of the *New Age* containing Sickert's 'On Swiftness' also contained Hulme's brilliantly reasoned explanation and appreciation of the works of Lewis, Bomberg, Wadsworth, Hamilton and Epstein on view at the London Group exhibition.

Sickert did not turn his personal objection to associating himself with the art of Lewis, Etchells and Epstein into an issue of loyalty, and thus he did not expect less established colleagues to follow him into the wilderness. Ethel Sands and Nan Hudson, among others, exhibited with his explicit approval. Visiting the Goupil Gallery when the show opened in March, Sickert decided that they stood to gain by the 'universal reaction' to the exhibition. Artists like Drummond and Ratcliffe remained aloof from all dissension and treated the London Group for what it was, a convenient exhibition society where they could show their recent work. Gilman and Ginner gave a preview of their forthcoming exhibition in the same gallery by presenting a varied selection of their best paintings.

The year 1914 was crowded with exhibition opportunities for the president of the London Group and his Neo-Realist colleague. Apart from their two-man show, the first London Group and, as usual, the Allied Artists' Association display, their work was also on view at the New English Art Club exhibitions. Having presided over the warring factions within the London Group, Gilman had perhaps decided that conciliation was more practical than schism. Although he had been the most urgent advocate of a total break with the N.E.A.C. in 1911, he evidently revised this policy in 1914 when in a position of greater public responsibility. In the summer he showed *Girl with coral necklace* (Pl. 133) and in the winter a portrait and a Norwegian landscape.

Progressive artists from every faction were drawn together in a vast display of 'Twentieth Century Art' at the Whitechapel Art Gallery from May to June 1914. This exhibition purported to review all the modern movements and as a rough guide the work on view was divided into four groups. The first group, according to the catalogue introduction, 'has been influenced by Mr. Walter Sickert and Mr. Lucien Pissarro. It treats common or sordid scenes in a sprightly manner and excels in a luminous treatment of landscape.' The generous representation of this group amounted to a retrospective survey of the achievements of the Fitzroy Street and

Camden Town Groups. Paintings by artists (such as Lamb, Pissarro and Sickert) who had not made the transition from the Camden Town to the London Group, were again hung among the work of their former colleagues. Lightfoot's paintings and drawings reappeared in a Camden Town context, as did the work of Duncan Grant and Innes. This exhibition also provided the last opportunity for the contemporary public to appreciate paintings by Gore, the president of the Camden Town Group, side by side with those of his friends.

Four paintings by Gore had been exhibited at the London Group in March, but on the 27th of that month he died of pneumonia. Sickert had visited him in Richmond a few days before: 'We saw him lying on his bed very emaciated. One of the last things he said was "Ask the doctors to have some tea". In his delirium it was paintings and effects. The bottles were still lifes and then crowds.'[88] Everyone who had known Gore as a man and an artist grieved. Sickert took time off from polemics to publish an appreciation in the *New Age* under the title 'A Perfect Modern'.[89] In a private letter to Nan Hudson and Ethel Sands he confessed that Gore's example 'always gave me a kind of renewal of youthful courage'. 'It is like losing a son to me which is less natural than losing a father', he wrote in another letter. Influenced perhaps by current prejudices he blamed overwork, particularly the stress of his involvement in the Cabaret Theatre Club decorations, for Gore's lack of resistance to infection. But he reflected:

Death in a case like Gore's is devoid of the worst sting. He has never been unhappy, or old or ill and has escaped the only intolerable things deterioration of intellect or the sufferings of self-contempt or the state when nothing has a savour. He seems to have set up with every person he met of all degrees of intelligence a personal relation of the most definite and binding kind. A wonderful gift. He was everybody's man while being the most discriminating.

The last vestige of the co-operative family spirit which had bound the principal members of the Camden Town Group together died with Gore.

Conclusion

The London Group has survived as an exhibition society until today. When the early passions surrounding its formation cooled, artists who had been blackballed were admitted. Thus Roger Fry became a member in 1917, active as ever and the spearhead of Bloomsbury penetration. Duncan Grant and Vanessa Bell joined in 1920. Sickert acquired a more philosophical perspective and rejoined the group in

1916, explaining to Nan Hudson: 'I daresay it was a mistake to refrain from exhibiting because dear Epstein's drawings made me sick. One is only responsible for what is in one's own frames.' Even Doman Turner briefly overcame his diffidence to exhibit with the London Group in 1918. While the glorious potential of Manson's Messianic vision was never fulfilled, the London Group did eventually manage to unite disparate artistic elements and provide a useful alternative to the Royal Academy and the New English Art Club.

Nonetheless, the London Group did not repress factionalism. From the beginning its eclectic membership left various members unsatisfied. The need to establish more selected and mutually congenial groupings led to the manifold creation of splinter societies. Wyndham Lewis and his colleagues banded together to found the Rebel Art Centre in March 1914. Pissarro and Manson founded the Monarro Group in 1919, having celebrated their secession from the London Group by holding an exhibition of their own at the Carfax Gallery in June 1914. Also included in this exhibition were Harold Squire, Malcolm Milne and Diana White whom Pissarro continued to champion. According to Sickert,[90] Pissarro's insistence on Miss White's inclusion caused Arthur Clifton, the only dealer in London who had so far given him a one-man show, to terminate his professional relationship with the artist. Bevan, Gilman and Ginner founded the Cumberland Market Group in 1914; joined by John Nash they held an exhibition under this title at the Goupil Gallery in the spring of 1915. Their meetings were attended by McKnight Kauffer and by Nevinson, whose relationship with the Rebel Art Centre had been strained by their repudiation of the 'Futurist Manifesto: Vital English Art' which he and the Italian Futurist Marinetti had published in June 1914. Until William Marchant lent them his Grey Room, up a steep flight of dark stairs over the Goupil Gallery, the Cumberland Market Group held Saturday 'At Homes' in Bevan's Cumberland Market studio. Hence their chosen title. Besides this Camden Town address, the close-knit character of the group, their habit of drinking strong tea, and their methods of showing pictures to visitors, were firmly based on the early Fitzroy Street model. Following their joint exhibition as Neo-Realists, Gilman and Ginner remained particularly sympathetic to each other's aims, although Gilman developed a means of expression closer to Gore's radical paintings of 1912 than to Ginner's increasingly meticulous transcriptions of the detail of nature. However, in February 1919 Gilman died in mid-career, a victim of the devastating post-war influenza epidemic.

Duncan Grant lived until 1978, his longevity contrasting with the premature deaths of Lightfoot and Innes (in their twenties), of Gore (in his thirties) and of Gilman (in his early forties). Bevan died a month before his sixtieth birthday in 1925.

The historical significance of the Fitzroy Street and Camden Town Groups must be assessed both in general and in particular. Membership of these groups greatly affected the careers of some painters, but meant nothing or little to others. The Camden Town Group was of no consequence to the subsequent careers of Grant and John, nor did it influence the truncated careers of Lightfoot and Innes. For Lamb, Bayes and Lewis it presented well-timed opportunities to publicize their work, but

the evolution of their styles and handling were in no way conditioned by corporate ideals.

On the other hand, the careers of the remaining members were profoundly affected professionally, artistically or both, by the existence of these two groups. Doman Turner's only claim to fame is his membership of the Camden Town Group. Ginner might never have stayed in England if he had not found sympathetic friends and an exciting atmosphere of expansionist activity in Fitzroy Street. It is doubtful whether the art of Manson and Ratcliffe would have matured without the example of more self-assured colleagues. In fact, removed from their influence when the Camden Town Group dissolved and the war encouraged geographical separations, Ratcliffe's painting at once lost its impetus, never to recover. Drummond's original talent undoubtedly developed more swiftly and surely because of his friendship with Ginner. Participation in the Fitzroy Street and Camden Town Groups was of crucial importance to the careers of Gore, Gilman and to a lesser extent Bevan. Although Bevan might have developed his style, handling and subject-matter independently, the vocabulary of much of Gore's and Gilman's painting was evolved within Fitzroy Street. Similarly their handling during important episodes of their brief careers was developed in the collaborative and mutually sustaining atmosphere of the group studio. Professionally, the Camden Town Group exhibitions did much to establish the reputations of all these artists.

Neither Pissarro nor Sickert, the acknowledged leaders of the Fitzroy Street Group, had a professional need of unofficial societies. Nevertheless, Fitzroy Street drew Pissarro, who had tended to work isolated from his fellow-painters in England, into the mainstream of British art. His self-confidence and sense of purpose were greatly boosted by realizing that he could teach young artists some of the lessons of French Impressionism. Even Sickert's handling at this period owed something to Pissarro and something to Gore, although within the wider context of Sickert's lifelong struggle to solve his technical problems and master his medium this episode was of but passing interest. The main significance of the Fitzroy Street and Camden Town Groups for Sickert was that they served to channel his enormous energies towards a worthwhile cause and satisfied his real psychological need to teach and direct his juniors. When Sickert retired, disenchanted, from the London Group in 1914 he could afford to abandon ship. The existence of the new society as an entity, and the factions it stimulated, represented the successful culmination of his ambition, first expressed in Fitzroy Street in 1907, to create an ambience in London wherein young painters could encourage each other towards independence and professional self-confidence. The incentive they provided to create these conditions represents the chief contribution made by the Fitzroy Street and Camden Town Groups to the general history of British art in this century.

※

Notes and References

1 Before his marriage Sickert lived and worked in Claremont Square, off the Pentonville Road, and in 1884 he had rooms at 13 Edwardes Square, Kensington. There is no evidence that Sickert ever had a studio in Cleveland Street, as has been claimed by Stephen Knight, *Jack the Ripper. The Final Solution*, London, Harrap, 1976.

2 *Men and Memories*, vol. 1 (*Recollections of William Rothenstein 1872–1900*), London, Faber, 1931, p. 167.

3 The exhibitors were: Francis Bate, Fred Brown, Francis James, Paul Maitland, Théodore Roussel, Bernhard Sickert (a brother of Walter), Walter Sickert, Sidney Starr, Philip Wilson Steer and George Thomson.

4 *Life Work and Setting of Philip Wilson Steer*, London, Faber, 1945, p. 31.

5 *Philip Wilson Steer*, Oxford, Clarendon Press, 1971, p. 57.

6 In April 1897 when Whistler appeared as a witness for Joseph Pennell in the libel suit against Sickert and Frank Harris. Sickert, in an article on 'Transfer Lithography' published in December 1896 in the *Saturday Review* edited by Harris, had written that the prints made by Pennell, using transfer paper applied to stone, were not true lithographs. Pennell won the case.

7 Letter of 1918, quoted more fully in Baron, 1973, p. 184.

8 Introduction to catalogue of exhibition of 'Work of English Post-Impressionists, Cubists and others', Brighton Art Gallery, 1913–14.

9 15 December 1906.

10 *Spencer Gore: a Memoir by his Son*, catalogue preface to the exhibition of Gore's work held at the Anthony d'Offay Gallery, 1974.

11 The *New Age*, 26 May 1910, 'The Spirit of the Hive'.

12 John Woodeson, *Spencer F. Gore*, M.A. Report, typescript, University of London, 1968, documents this first meeting with an unpublished letter from Gilman's wife to her mother in America.

13 Gilman's address in 1904 was The Rest, The Moors, Pangbourne, Berks. The Gilmans then seem to have stayed for some time in his family home, the Rectory at Snargate, Kent, before moving late in the summer of 1908 to 15 Westholme Green, Letchworth.

14 The letters to Miss Hudson and Miss Sands written by Sickert are in a privately owned archive. The extracts quoted here, and others, were published in *Miss Ethel Sands and her Circle*, London, Peter Owen, 1977, by Wendy Baron.

15 Sir Louis Fergusson, *Harold Gilman: An Appreciation* (by Wyndham Lewis as well as Fergusson), London, Chatto & Windus, 1919, p. 19.

16 The *Fortnightly Review*, December 1908, 'The New *Life of Whistler*'.

17 Phrases taken from 'A Critical Calendar', the *English Review*, March 1912.

18 *Art News*, 12 May 1910, 'Idealism'.

19 The *New Age*, 16 June 1910, 'The Study of Drawing'.

20 The *English Review*, April 1912, 'The Futurist Devil among the Tailors'.

21 The *New Age*, 21 July 1910, 'The Naked and the Nude'.

22 Sickert quoted this incident in a letter to Miss Ethel Sands. It is, however, possible that Brown used the unpleasantness of Sickert's subjects as an excuse to terminate their friendship. In the autumn of 1915 Sickert, after a three-year break, resumed his teaching post at the Westminster Technical Institute and thus displaced Gilman who had held the post in Sickert's absence. Not only was Gilman much embittered by Sickert's action, but many of his fellow-painters and teachers, including Brown and the staff at the Slade, felt that Sickert had dealt treacherously in the matter.

23 Letter to Quentin Bell written in 1954. I am indebted to Professor Bell for giving me a copy of Miss Sands's letter.

24 The *New Age*, 28 May 1914, 'Whitechapel'.

25 Phrases taken from a letter of Sickert to Nan Hudson.

26 1 June 1907.

27 The *New Age*, 2 June 1910, 'The New English – and After'.

28 Pissarro archives, Ashmolean Museum, Oxford.

29 *Since I was Twenty-Five*, London, Constable, 1927. This book is the main source for the following summary and quotations.

30 Rutter names Gilman among the artists from Sickert's circle who promised him active support. However, in later catalogues Gilman is not asterisked as a founder-member.

31 The most accessible and finest of his early works is *Top o' the Tide* (Walker Art Gallery, Liverpool), exhibited at the Royal Academy in 1899. A striking example of his work just after the period covered in this book is *Oratio Obliqua* (City Art Gallery, Manchester) of 1917, a cinema interior.

32 Introductory note to the catalogue of Bayes's exhibition at the Leicester Galleries, in which the catalogue preface written by Sickert for the Leicester Galleries exhibition of Bayes's work in 1918 was reprinted.

33 *Robert Bevan 1865–1925. A memoir by his son*, London, Studio Vista, 1965, p. 16.

34 *Art News*, 15 June 1911.

35 Ginner kept notebooks in which he recorded the titles, dates, sizes (usually), exhibition history and sales of his paintings and drawings. Thus details of his works are known, even if the pictures themselves are lost. The notebooks are unpublished.

36 Frank Rutter so described the picture in his review of the A.A.A. exhibition, *Sunday Times*, 17 July 1910.

37 Letter from Manson to Pissarro in the Ashmolean Museum archives.

38 *Sunday Times*, 17 July 1910.

39 Ginner, in *Studio*, November 1945, 'The Camden Town Group', records that at first Gilman liked Gauguin's work best and did not admire Van Gogh. After renewed study of the pictures Gilman altered the order of his preferences thus: Cézanne, Van Gogh, Gauguin.

40 *Harold Gilman: An Appreciation*, op cit., p. 14, of which Lewis was co-author with Louis F. Fergusson.

41 January 1911, 'Post-Impressionists'.

42 1 December 1913.

43 In his letter of 23 March 1911 to Pissarro, Manson wrote of 'yr. group of painters at Fitzroy St.'. He was at the time trying to persuade *Studio* to accept a series of articles about the group. However, on 24 March, still in connection with these articles, he wrote of 'our group of painters'. Nevertheless, the tenor of the letters suggests that Manson was still outside the group and dependent on Pissarro for information and admittance to the group's premises. By May Manson's tone had changed and he sounds as if he were involved with the group from the inside. The son of the editor of *Studio* had called at Fitzroy Street to select twenty-three paintings to illustrate four articles: 'It will be a good advertisement to monopolise The Studio for four months.' The scheme came to nothing and the articles never appeared. All these letters from Manson to Pissarro, and vice versa, quoted here and in the text, are in the archives of the Ashmolean Museum, Oxford.

44 This reply exists as a draft, written by Pissarro on Manson's letter to him. It is roughly scribbled, lacks punctuation and some of the verbs are not properly constructed. I have corrected these minor errors in the interests of clarity.

45 *Studio*, November 1945, 'The Camden Town Group'. This article, the fullest factual first-hand account of the birth of the group, is the main source for the following summary and quotations.

46 *Saturday Review*, 25 January 1930, 'The Camden Town Group'.

47 '"Camden Town" into "London": some intimate Glimpses of the Transition and its Artists 1911–1914', Appendix to catalogue of 'Art in Britain 1890–1940', an exhibition held at the University of Hull, 1967, p. 66.

48 Letter of December 1913 in the Ashmolean Museum archives, quoted by Dr Easton, ibid., p. 68.

49 Catalogue introduction to the exhibition 'Work of English Post Impressionists, Cubists and others', held at the Brighton Art Gallery from December 1913 to January 1914.

50 The *Outlook*, 25 November 1911, in a review of 'The Goupil Gallery Salon'.

51 The *Outlook*, 9 December 1911.

52 *The Times*, 11 December 1911.

53 *The Times*, 19 December 1912.

54 *Observer*, 18 June 1911.

55 3 July 1911.

56 *Observer*, 18 June 1911.

57 Two letters from Manson to Pissarro of 29 and 30 November 1911 (collection Ashmolean Museum, Oxford) concern Manson's reception of Pissarro's suggestions.

58 Michael Holroyd, *Augustus John*, vol. 2: *The Years of Experience*, London, Heinemann, 1975, p. 54.

59 See Walter Michel, *Wyndham Lewis. Paintings and Drawings*, London, Thames & Hudson, 1971, p. 334, where Lewis's references to the club in his autobiography *Rude Assignment*, pp. 124–5, and other relevant documents are quoted.

60 *Queen*, 14 December 1912.

61 The *Outlook*, 14 December 1912.

62 10 December 1912.

63 19 December 1912.

64 *Robert Bevan. A memoir by his son*, op. cit., p. 17.

65 6 December 1911.

66 Sandra Jobson Darroch, *Ottoline*, London, Chatto & Windus, 1976, p. 129.

67 *Pall Mall Gazette*, 12 December 1912.

68 *Daily Telegraph*, 17 December 1912.

69 Ashmolean Museum, Oxford.

70 *Paint and Prejudice*, London, Methuen, 1937, p. 29. Richard Shone's article on 'The Friday Club', *Burlington Magazine*, May 1975, pp. 279–84, contains much valuable information about the art and politics of the club.

71 Ashmolean Museum, Oxford.

72 For a fuller discussion of the quarrel see Quentin Bell and Stephen Chaplin, 'The Ideal Home Rumpus', *Apollo*, October 1964, pp. 284–91.

73 The *Daily Graphic*, 13 June 1911.

74 I am deeply indebted to Dr Malcolm Easton for giving me copies of all Manson's minutes of Camden Town Group and Fitzroy Street meetings. He himself drew on these sources for the Appendix to his 'Art in Britain' catalogue, op. cit.

75 Text of letter published by Dr Easton, Appendix to 'Art in Britain', op. cit., p. 65.

76 Ashmolean Museum, Oxford, as are all the letters between Manson and Pissarro quoted in this account of the London Group formation.

77 *Studio*, November 1945, 'The Camden Town Group'.

78 Manson's mathematics are a little difficult to interpret here. To make up his total of 26 members he must have counted the 11 members of Fitzroy Street elected in 1913 together with 15 Camden Town Group members. Whether Grant or Innes was the member excluded is uncertain. In order to present his case to Pissarro he evidently ranged 14 of these 15 Camden Town members on one side and added Ethel Sands, Nan Hudson, Renée Finch, Harald Sund and Harold Squire to their number. The seven in the opposite camp were Lewis, Nevinson, Hamilton, Wadsworth, Etchells, Epstein and perhaps Adeney. In the course of his letter he distorts his numerical case at will. For instance, he wrote that he was in sympathy with Pissarro alone in the N.E.A.C., yet he counts other N.E.A.C. members among those with whom he was in sympathy belonging to the London Group.

79 See Dr Easton, Appendix to 'Art in Britain', op. cit., p. 69.

80 In the catalogue of the Arts Council exhibition, 1974, 'Vorticism and its allies', and in *Vorticism and Abstract Art in the First Machine Age*, vol. 1, London, Gordon Fraser, 1976.

81 Dr Easton, op. cit., p. 68.

82 30 April 1914.

83 4 June 1914.

84 11 June 1914.
85 18 June 1914.
86 25 June and 2 July 1914.
87 5 March 1914.
88 Letter to Nan Hudson.
89 9 April 1914.
90 Letter to Nan Hudson. 'Chivalrous but stupid' was Sickert's comment.

Literature

Writings on individual members of the Camden Town Group are listed separately under the biographical notes provided for each artist. The following is a selection of the most useful general literature on the Fitzroy Street and Camden Town Groups. For ease of reference I have divided this literature into two broad categories: source material and retrospective history. However, it should be noted that these categories overlap in later writings by some of those involved (e.g. Frank Rutter's books), while several more recent historical studies have drawn on published and unpublished source material.

⊙

Source Material. Published

BAYES, Walter, *Saturday Review*, 25 January 1930, 'The Camden Town Group'.
FRY, Roger, *Letters*, ed. Denys Sutton, 2 vols, London, Chatto & Windus, 1972.
GINNER, Charles, *New Age*, 1 January 1914, 'Neo-Realism'.
GINNER, Charles, *Studio*, November 1945, 'The Camden Town Group'.
LEWIS, Wyndham, and MANSON, James Bolivar, introductions to The Cubist Room and to Rooms I and II respectively at the Brighton Art Gallery exhibition of 'Work by English Post-Impressionists, Cubists and others', 1913–14.
RUTHERSTON, Albert, *Burlington Magazine*, LXXXII, 1943, pp. 201–5, 'From Orpen and Gore to the Camden Town Group'.
RUTTER, Frank, *Some Contemporary Artists*, London, Leonard Parsons, 1922.
RUTTER, Frank, *Since I was Twenty-Five*, London, Constable, 1927.
RUTTER, Frank, *Art in my Time*, London, Rich & Cowan, 1933.
SICKERT, Walter Richard, *A Free House! or The Artist as Craftsman*, an anthology of Sickert's writings selected and edited by Osbert Sitwell, London, Macmillan, 1947.

NOTE: Press reviews of exhibitions are perhaps the most useful of all published source material and publication details of many such reviews are cited in the notes on the plates. Bayes, Manson and Sickert regularly published art criticism. Most of Sickert's contributions at this period are included in *A Free House!* Manson wrote for the *Outlook* in 1911 and 1912 under the initials J. B. M. Bayes often wrote for the *Athenaeum* but art criticism in that periodical was published anonymously. It is

doubtful whether Bayes was the author of the reviews of the three Camden Town Group exhibitions in the *Athenaeum* (24 June 1911; 9 December 1911; 14 December 1912). These seem to have been written by an outsider, probably from Roger Fry's camp, and although not helpful for the purpose of identifying pictures they are among the most intelligent analytical assessments of Camden Town painting as it appeared to a well-informed outsider.

◉

Source Material. Unpublished

GORE, Spencer Frederick, Letters to Doman Turner (to be published, ed. Frederick Gore, 1979).

MANSON, James Bolivar, Minutes of Camden Town, Fitzroy Street and London Group meetings. Copies lent to me by Dr Malcolm Easton who used the material for the appendix to his catalogue 'Art in Britain 1890–1940' (see below).

MANSON, James Bolivar, and PISSARRO, Lucien, Correspondence, Ashmolean Museum, Oxford.

RUTHERSTON, Albert, Letters (family collection) at present deposited for copying in the Archives Department, Tate Gallery, London.

SICKERT, Walter Richard, Letters to Nan Hudson and Ethel Sands (private collection). This material was used for my book on Miss Sands (see below).

◉

Retrospective History

BARON, Wendy, *Miss Ethel Sands and her Circle*, London, Peter Owen, 1977.

BELL, Quentin, *Motif* 10, 1962–3, 'The Camden Town Group I: Sickert and the Post Impressionists'; *Motif* II, 1963–4, 'The Camden Town Group II: Opposition and Composition'.

BELL, Quentin, 'The Camden Town Group. Sickert among Friends and Heretics', unpublished article lent to me in proof by Professor Bell.

BELL, Quentin, 'Sickert and the Post Impressionists', chapter in *Victorian Artists*, London, Routledge & Kegan Paul, 1967.

CORK, Richard, 'Vorticism and its allies', catalogue to Arts Council exhibition, 1974.

CORK, Richard, *Vorticism and Abstract Art in the First Machine Age*, vol. I, *Origins and Development*, London, Gordon Fraser, 1976.

EASTON, Malcolm, '"Camden Town" into "London": some intimate Glimpses of the Transition and its Artists 1911–1914', Appendix to catalogue 'Art in Britain 1890–1940', exhibition held at the University of Hull, 1967.

EASTON, Malcolm, *Gazette des Beaux-Arts*, November 1968, 'Lucien Pissarro and his Friends at Rye, 1913'.

FARR, Dennis, and BOWNESS, Alan, 'Historical note', and FORGE, Andrew, 'Appreciation', incorporated as introductions to catalogue 'London Group 1914–1964. Jubilee Exhibition. Fifty Years of British Art', Tate Gallery, 1964.

HALL, B. Fairfax, *Paintings and Drawings by Harold Gilman and Charles Ginner in the collection of Edward le Bas*, London, privately printed in a limited edition, 1965.

ROTHENSTEIN, Sir John, *Modern English Painters*, vol. I (*Sickert to Smith*), vol. 2 (*Lewis to Moore*), London, Eyre & Spottiswoode, 1952 and 1956, revised ed., London, Macdonald & Jane's, 1976.

SAUSMAREZ, Maurice de, *Leeds Art Calendar*, Spring 1950, 'Camden Town Group Pictures in the Leeds Collection'.

SEABROOKE, Eliot, *Studio*, February 1945, 'The London Group'.

SHONE, Richard, *Burlington Magazine*, CXVII, May 1975, 'The Friday Club'.

SHONE, Richard, *Bloomsbury Portraits*, London, Phaidon, 1976.

SHONE, Richard, *The Century of Change. British Painting since 1900*, London, Phaidon, 1977.

SUTTON, Denys, *Country Life Annual*, 1955, 'The Camden Town Group'.

TATE GALLERY, Catalogue of *Modern British Paintings, Drawings and Sculpture*, London, Oldbourne, 1964.

⊙

Catalogues of Camden Town Group Exhibitions since 1930

In 1930 the Leicester Galleries mounted an exhibition under the title 'The Camden Town Group. A Review' in which they gathered together a comprehensive selection of paintings executed during the relevant period by members of the group. Frank Rutter wrote the preface outlining the history. The exhibition itself inspired critical reassessment of the Camden Town Group. T. W. Earp, for example, discussed the

group and its painting in the *New Statesman*, 1 February 1930, and the newspapers devoted generous space to the exhibition.

Since 1930 there have been many exhibitions entitled 'The Camden Town Group' but none until 1976 ('Camden Town Recalled') limited the selection to pictures executed during the brief existence of the society or of its forerunner, the Fitzroy Street Group. Several of these exhibitions contained informative catalogue prefaces as noted below. The most important of these exhibitions since 1930 were:

1939. Redfern Gallery, London. 'The Camden Town Group'. Sale exhibition supported by a few loans.

1944. C.E.M.A. London. 'The Camden Town Group'. 36 paintings by Bevan, Gilman, Ginner, Gore and Sickert. Introduction by Lillian Browse.

1950. Lefevre Gallery, London. 'Paintings by some members of the Camden Town Group'. Preface by Maurice de Sausmarez. Sale exhibition, with two paintings borrowed from Leeds Art Gallery.

1951. Southampton Art Gallery (in association with the Arts Council of Great Britain). 'The Camden Town Group'. Introduced by Eric Westbrook.

1953. The Arts Council of Great Britain. 'The Camden Town Group'.

1961. The Arts Council of Great Britain. 'Drawings of the Camden Town Group'. Introduction by J. Wood Palmer.

1961. The Minories, Colchester. 'Camden Town Group'. Preface by R. A. Bevan.

1965. Hampstead Festival. 'Camden Town Group'. Preface by Frederick Gore.

1967. William Ware Gallery, London. 'The Camden Town Group & English Painting 1900–1930's'.

1969. Cecil Higgins Art Gallery, Bedford. 'The Camden Town Group'.

1974. Laing Art Gallery, Newcastle.

1974. City Museum and Art Gallery, Plymouth. 'The Camden Town Group and related pictures'.

1976. Fine Art Society Ltd, London, and Graves Art Gallery, Sheffield. 'Camden Town Recalled'. Introduction and catalogue notes by Wendy Baron. The starting-point for this book.

1976–7. Norwich Castle Museum, Southampton Art Gallery and Oxford Museum of Modern Art. 'A Terrific Thing. British Art 1910–16'. Section on the Camden Town Group.

◉

Biographies of
Camden Town Group artists

NOTE: Major retrospective exhibitions are indicated by an asterisk unless (as in Sickert and John) presented as a separate paragraph.

Walter Bayes 1869–1956

Born in London, son of painter and etcher A. W. Bayes and brother of sculptor Gilbert Bayes. Studied art at evening classes in Finsbury 1886–1900 and briefly full-time at the Westminster School of Art under Frederick Brown c. 1902. Exhibited watercolours and oils at the R.A. from 1890. Wrote art criticism for the *Outlook* (late 1890s), the *Athenaeum* (1906–16) and later for the *Saturday Review* and the *Week End Review*. Founder-member A.A.A. (1908), the Camden Town Group (1911) and the London Group (1913), resigning from the last-named 1915. Member of the Fitzroy Street Group (perhaps from 1908) and the Royal Watercolour Society. Held many teaching posts, was Headmaster of the Westminster School of Art 1918–34 and Director of Painting at the Lancaster School of Arts and Crafts 1944–9. Especial interest in decorative and mural painting and author of *The Art of Decorative Painting* (1927). Also wrote *Turner, a Speculative Portrait* (1931) and an autobiographical sketch of a painting trip abroad *A Painter's Baggage* (1932).

Exhibitions within his lifetime
Chenil Gallery 1911; Carfax Gallery 1913; Carfax Gallery 1915; Leicester Galleries 1918; Leicester Galleries 1919; Goupil Gallery 1928; Goupil Gallery 1931; Fine Art Society 1932; Salford Art Gallery 1948; Leicester Galleries 1951.

Exhibitions since his death
Parkin Gallery 1978. No loan exhibitions.

Literature
No literature except Sickert's brief catalogue preface to the 1918 Leicester Galleries exhibition, reprinted for the 1951 catalogue which also incorporated a biographical note on the artist.

Robert Polhill Bevan 1865–1925

Born in Hove, Sussex. Studied at the Westminster School of Art and at the Académie Julian in Paris. Worked in Tangier with Joseph Crawhall in 1892, and at Pont Aven in Brittany 1893–4 where he met Gauguin. Married Stanislawa de Karlowska, the Polish painter, in 1897 and visited Poland many times thereafter. Settled in London, near Swiss Cottage, 1900. Exhibited at the A.A.A. in 1908 and soon afterwards joined the Fitzroy Street Group. Founder-member of the Camden Town Group (1911), the London Group (1913) and the Cumberland Market Group (1914). Member N.E.A.C. 1922.

Exhibitions within his lifetime
Baillie Gallery 1905; Baillie Gallery 1908; Carfax Gallery 1913.
Exhibitions since his death
Memorial exhibitions Goupil Gallery and Brighton Art Gallery 1926; Lefevre
Gallery 1944 (catalogue foreword by R. A. Bevan, the artist's son); Arts Council
1956* (catalogue introduction by J. Wood Palmer); Colnaghi 1961; Ashmolean
Museum, Oxford, and Colnaghi 1965* (centenary exhibition with full catalogue);
d'Offay Couper Gallery 1967 (Drawings and Watercolours); Anglo-Polish Society
1968 (with Stanislawa de Karlowska); d'Offay Couper Gallery 1968 (Early Paint-
ings 1895–1908).
Literature
R. A. Bevan, *Robert Bevan 1865–1925. A memoir by his son*, London, Studio Vista,
1965.

Malcolm Drummond 1880–1945

Born at Boyne Hill, Berkshire. Graduated in history from Oxford in 1903. Trained
at the Slade School 1903–7 and at Sickert's class at the Westminster School of Art
1908–10. Pupil at Sickert's etching class 1909 and founder-pupil at Sickert's
Rowlandson House 1910. First exhibited at the A.A.A. in 1910. Member Camden
Town Group, founder-member London Group (1913). Taught at the Westminster
School of Art 1925–31. Settled in Berkshire 1932 where he died in 1945 after three
years total blindness.
No exhibitions within his lifetime.
Exhibitions since his death
Redfern Gallery 1946; Grant's Gallery, Edinburgh, and Aberdeen Art Gallery
1948; Municipal Art Gallery, Reading 1950; Flint House Galleries, Norwich 1955;
Arts Council 1963–4* (catalogue introduction by Quentin Bell); Maltzahn Gallery
1974 (catalogue introduction by Charlotte Haenlein).

Harold Gilman 1876–1919

Born at Rode, Somerset. Trained at Hastings School of Art 1896, Slade School
1897–1901. Visited Spain *c*.1902–3. Founder-member Fitzroy Street Group
(1907), Camden Town Group (1911), London Group (1913) and its first president,
Cumberland Market Group (1914). Exhibited at first A.A.A. exhibition in 1908 but
possibly not a founder-member (see text, note 30). Visited Paris with Ginner 1911,
Sweden in 1912 and Norway in 1913. Taught at the Westminster School of Art
1912–15 but displaced when Sickert resumed his post there. Died during influenza

epidemic in London having just completed a picture of *Halifax Harbour*, commissioned by the Canadian Government for the War Memorial at Ottawa.

Exhibitions within his lifetime

(Jointly with Gore) Carfax Gallery 1913; (jointly with Ginner) Goupil Gallery 1914.

Exhibitions since his death

Memorial exhibition Leicester Galleries 1919; Tooth 1934; Reid & Lefèvre 1943; Lefèvre 1948; Arts Council 1954–5* (catalogue introduction by J. Wood Palmer); Reid Gallery 1964; The Minories, Colchester (and at Oxford and Sheffield) 1969*.

Literature

Wyndham Lewis and Louis F. Fergusson, *Harold Gilman: an Appreciation*, London, Chatto & Windus, 1919; Charles Ginner, *Art and Letters*, vol.2, No.3, 1919, 'Harold Gilman: an Appreciation'; R. A. Bevan, *Alphabet and Image*, No.3, December 1946, 'The Pen Drawings of Harold Gilman'; John Rothenstein, chapter on Gilman in *Modern English Painters*, vol.1 (*Sickert to Smith*), London, Eyre & Spottiswoode, 1952; J. Wood Palmer, *Connoisseur*, April 1964, 'The Drawings of Harold Gilman'; B. Fairfax Hall, *Paintings and Drawings by Harold Gilman and Charles Ginner in the collection of Edward le Bas*, London, privately printed, 1965.

Charles Ginner 1878–1952

Born at Cannes, France, of Anglo-Scottish parents. Worked in an architect's office in Paris 1899–1904 before studying painting until 1908, first at the Académie Vitti under Gervais, then at the Ecole des Beaux-Arts, and again at the Vitti under Anglada y Camarasa. First exhibited in England at the A.A.A. in 1908. Late 1909 settled in London, exhibited at the A.A.A. 1910 and entered the Fitzroy Street Group. Founder-member Camden Town Group (1911), London Group (1913) and Cumberland Market Group (1914). 1912 painted murals for Madame Strindberg's 'Cave of the Golden Calf' and included in exhibition of contemporary British art selected by Fry for the Galerie Barbazanges, Paris. Official war artist both world wars. Member N.E.A.C. 1922, A.R.A. 1945, Royal Watercolour Society 1945. Awarded C.B.E. 1950. Published 'Neo-Realism', a manifesto of his aesthetic beliefs, in the *New Age*, 1 January 1914.

Exhibitions within his lifetime

Salon Costa, Buenos Aires 1909; (jointly with Gilman) Goupil Gallery 1914; (jointly with John Nash and Frank Dobson) Birmingham Repertory Theatre 1920 (catalogue foreword by Walter Bayes); Leicester Galleries 1920 (Drawings in Colour); Goupil Gallery 1922; Goupil Gallery 1924 (Watercolours); (jointly with Randolph Schwabe) St George's Gallery 1926; Godfrey Phillips Gallery 1929 (catalogue introduction by Hubert Wellington); (jointly with Ethelbert White) Everyman Theatre 1931; Leger Galleries 1933; Leger Galleries 1935.

Exhibitions since his death

Arts Council 1953–4* (introduction by Hubert Wellington and extract of 'Neo-

Realism' printed); Piccadilly Gallery 1969 (preface by Fairfax Hall).
Literature
Charles Ginner, *Notebooks*, unpublished; John Rothenstein, chapter on Ginner in *Modern English Painters*, vol. 1 (*Sickert to Smith*), London, Eyre & Spottiswoode, 1952; B. Fairfax Hall, *Paintings and Drawings by Harold Gilman and Charles Ginner in the collection of Edward le Bas*, London, privately printed, 1965; Malcolm Easton, *Apollo*, March 1970, 'Charles Ginner: Viewing and Finding'.

Spencer Frederick Gore 1878–1914

Born at Epsom, Surrey. Trained at the Slade School 1896 9. Visited Spain with Wyndham Lewis *c.* 1902 and met Sickert in Dieppe in 1904. Founder-member Fitzroy Street Group (1907), A.A.A. (1908), Camden Town Group (1911) and its president, London Group (1913), but his death from pneumonia in March 1914 meant his works were included only in the first London Group exhibition. Included in the 'English Group' who contributed to the second Post-Impressionist exhibition, Grafton Gallery 1912–13. Supervised decorations for Madame Strindberg's 'Cave of the Golden Calf' 1912. Painting trips out of London during the summers and early autumns: Normandy 1904; Billy, France 1905; Dieppe 1906; Yorkshire and Hertingfordbury 1907; Hertingfordbury 1908; Hertingfordbury and Somerset 1909; Somerset 1910; Somerset and Letchworth 1912; Somerset 1913. Moved to Richmond 1913.
Exhibitions within his lifetime
Chenil Gallery 1911; (jointly with Gilman) Carfax Gallery 1913.
Exhibitions since his death
Memorial exhibition Carfax Gallery 1916 (catalogue preface by Sickert); Carfax Gallery 1918; Paterson and Carfax Gallery 1920; Leicester Galleries 1928 (prefatory note to catalogue by Manson); Arts Council 1955* (catalogue introduction by J. Wood Palmer); (jointly with his son Frederick Gore) Redfern Gallery 1962; The Minories, Colchester (and at Oxford and Sheffield) 1970* (catalogue compiled and introduced by John Woodeson); Anthony d'Offay Gallery 1974.
Literature
W. R. Sickert, *New Age*, 9 April 1914, 'A Perfect Modern'; John Rothenstein, chapter on Gore in *Modern English Painters*, vol. 1 (*Sickert to Smith*), London, Eyre & Spottiswoode, 1952; Frederick Gore, *Spencer Gore: a memoir by his Son*, catalogue introduction to 1974 d'Offay Gallery exhibition; John Woodeson, *Connoisseur*, March 1974, 'Spencer Gore'.

Duncan Grant 1885–1978

Born at Rothiermurchus, Inverness-shire, Scotland. Trained at Westminster School of Art 1902–5, under Jacques-Emile Blanche at the Ecole de la Palette, Paris 1906–7, Slade School 1907 and 1908 but spent much of his time until 1909 in Paris where he met Matisse. Closely associated from 1909 onwards with Roger Fry and Vanessa and Clive Bell. Exhibited at the Friday Club 1910–12. Member of the Camden Town Group after Lightfoot's death, autumn 1911, but only exhibited once with the group, in December 1911. Included in exhibition of contemporary British art at the Galerie Barbazanges, Paris 1912, and in the 'English Group' at the second Post-Impressionist exhibition at the Grafton Gallery 1912–13. 1913–19 co-director with Fry and Vanessa Bell of the Omega Workshops. Conscientious objector during First World War. Member London Group 1919. Carried out many decorative schemes in private houses with Vanessa Bell, and executed murals for R.M.S. *Queen Mary* in 1935. Besides designing textile patterns and pottery decorations also designed the décor and costumes for several ballets.

Exhibitions within his lifetime

Carfax Gallery 1920; Independent Gallery 1923; London Artists' Association Gallery 1931; Agnew 1933 (Drawings); Agnew 1937; Leicester Galleries 1945; Leicester Galleries 1957; Tate Gallery 1959* (full retrospective, catalogue introduction by Alan Clutton-Brock); The Minories, Colchester 1963; Wildenstein 1964* (Duncan Grant and his World, catalogue introduction by Denys Sutton); (jointly with Vanessa Bell) Royal West of England Academy, Bristol (catalogue introduction by Denys Sutton); Arts Council 1969* (Portraits, with an introduction by Richard Shone); Anthony d'Offay Gallery 1972 (Watercolours and Drawings); Fermoy Gallery, Kings Lynn 1973 (Recent Paintings); Anthony d'Offay Gallery 1975 (Recent Paintings and Early Paintings); Scottish National Gallery of Modern Art, Edinburgh 1975* (Ninetieth Birthday exhibition, introduction by David Brown); Fine Art Society, Edinburgh 1975 (Duncan Grant and Bloomsbury, with an introduction by Richard Shone); Tate Gallery 1975 (Ninetieth Birthday display, catalogue notes by Richard Morphet); Davis and Long, New York 1975 (Drawings and Watercolours).

Literature

Roger Fry, *Duncan Grant*, London, Hogarth Press (Living Painters series), 1923; Raymond Mortimer, *Duncan Grant*, London, Penguin Books (Modern Painters series), 1944; John Rothenstein, chapter on Grant in *Modern English Painters*, vol.2 (*Lewis to Moore*), London, Eyre & Spottiswoode, 1956; Richard Shone, *Bloomsbury Portraits*, London, Phaidon, 1976.

James Dickson Innes 1887–1914

Born at Llanelli, Carmarthenshire, Wales. Studied painting at Carmarthen 1904-5 and at the Slade School 1906–8. Occasional visitor at 19 Fitzroy Street 1907–8. Exhibited at N.E.A.C. for first time in 1907, member 1911. Exhibited at A.A.A. 1908. Member Camden Town Group but only contributed to second exhibition in December 1911. Travelled extensively in France from 1908 onwards, worked in southern Spain spring 1912 and spent the winter of 1913–14 in north Africa and the Canary Islands. Often worked in Wales from 1910–12, sometimes in the company of John in north Wales in 1911 and 1912. Died of consumption in August 1914.

Exhibitions within his lifetime

Chenil Gallery 1911; Chenil Gallery 1913.

Exhibitions since his death

National Gallery 1921*; Chenil Galleries 1923 (containing 'A Short Appreciation' by John, 'James Dickson Innes' by Fothergill, and a reprint of the anonymous preface to the National Gallery exhibition); Leicester Galleries 1928; (jointly with John and Derwent Lees) Redfern Gallery 1939*; Leicester Galleries 1952; Graves Art Gallery, Sheffield (and at Swansea and Aberystwyth) 1961* (containing an introduction by John); Southampton Art Gallery (and at Cardiff, London and Manchester) 1977–8* (a full scale retrospective).

Literature

John Fothergill, *James Dickson Innes*, London, Faber, 1946 (reproductions collected and edited by Lillian Browse); John Rothenstein, chapter on Innes in *Modern English Painters*, vol.2 (*Lewis to Moore*), London, Eyre & Spottiswoode, 1956; A. D. Fraser Jenkins, 'J. D. Innes at the National Museum of Wales', 1975; John Hoole, *James Dickson Innes*, catalogue of Southampton Art Gallery exhibition 1977–8 containing a chronology, introduction essay, full notes and many illustrations of Innes's work.

Augustus John 1878–1961

Born at Tenby, Wales, brother of Gwen John. Trained at the Slade School 1894-8. Taught painting at the University of Liverpool 1901–4. Co-principal with William Orpen of the Chelsea Art School (a private establishment). Travelled and worked in Ireland, Dorset, Wales and France until 1914, often, from 1911, in the company of Derwent Lees or Innes. (In later life he continued to travel abroad frequently, journeying as far afield as Jamaica in 1937.) Began exhibiting with N.E.A.C. 1900, member 1903. Member Camden Town Group but contributed only to the first exhibition in June 1911. Member London Group 1940. President National Portrait Society 1914. Elected A.R.A. 1921, R.A. 1928, resigned 1938, re-elected 1940. Awarded Order of Merit 1942. Author of *Chiaroscuro, Fragments of Autobiography* (1952) and its sequel *Finishing Touches* published posthumously (1964).

Exhibitions until 1914

Carfax Gallery 1899; Carfax Gallery 1903; (jointly with Orpen) Chenil Gallery 1905 (Drawings); Chenil Gallery 1906 (Etchings); Carfax Gallery 1907 (Drawings); Chenil Gallery 1910 (including Provençal Studies); Chenil Gallery 1911; Goupil Gallery 1913.

For complete list of the numerous exhibitions of John's work since 1914 consult the chronology in Easton and Holroyd (see literature references below).

Major retrospective loan exhibitions

Temple Newsam House, Leeds 1946; Arts Council 1948; Royal Academy Diploma Gallery 1954; Graves Art Gallery, Sheffield 1956; University of Hull 1970 (Portraits of the Artist's Family); Colnaghi's 1974 (Early Drawings and Etchings, part sale, part loan); National Portrait Gallery 1975.

Literature

Charles Marriott, *Augustus John*, London, John Lane, 1918; Campbell Dodgson, *A Catalogue of Etchings by Augustus John 1901–1914*, London, Chenil, 1920; A. B. [ertram], *Augustus John*, London, Ernest Benn, 1923; T. W. Earp, *Augustus John*, Edinburgh, Nelson, 1934; Lillian Browse (ed.), *Augustus John: Drawings*, London, Faber, 1941; John Rothenstein, *Augustus John*, London, Phaidon, 1944; Lord David Cecil (ed.), *Augustus John: Fifty-two drawings*, London, George Rainbird, 1957; John Rothenstein, *Augustus John 1878–1961*, London, Beaverbrook Press, 1962; John Rothenstein, *Augustus John* (The Masters series No. 79), London, Purnell, 1967; Malcolm Easton and Michael Holroyd, *The Art of Augustus John*, London, Secker & Warburg, 1974; Michael Holroyd, *Augustus John. A Biography*, vol. 1: *The Years of Innocence*, London, Heinemann, 1974, vol. 2: *The Years of Experience*, London, Heinemann, 1975.

Henry Lamb 1883–1960

Born in Adelaide, Australia, but brought up in Manchester. Studied medicine until 1904 (and again 1914–16). Trained as a painter at John and Orpen's Chelsea Art School until 1907, and then at Jacques-Emile Blanche's Ecole de la Palette, Paris 1907–8. Closely involved in formation of the Friday Club 1905–6. Worked in Brittany 1908, 1910 and 1911, and in Ireland 1912–13. First exhibited at the N.E.A.C. in 1905 (a portrait of Euphemia, soon to be his first wife and later to be beloved by Innes and many artists in his circle). Exhibited regularly at N.E.A.C. 1909–14. Contributed to first A.A.A. show in 1908. Had a studio in Fitzroy Street 1909–11 and probably began to attend Fitzroy Street Group meetings. Member Camden Town Group, founder-member London Group (1913) but withdrew his support before the first exhibition in March 1914. Associated with the Bloomsbury circle of artists and writers. Medical officer and official war artist 1916–18 (awarded M.C.). Exhibited R.A. from 1921, elected A.R.A. 1940, R.A. 1949. Official war artist 1940–5. Trustee National Portrait Gallery 1942–60, Tate Gallery 1944–51.

Exhibitions within his lifetime
Alpine Club Gallery 1922; Leicester Galleries 1927, 1929, 1931, 1933, 1935, 1938, 1940, 1945, 1949, 1956.
Exhibitions since his death
Memorial exhibition Leicester Galleries 1961*; New Grafton Gallery 1973 (part loan).
Literature
G. L. K[ennedy], *Henry Lamb*, London, Ernest Benn, 1924.

Wyndham Lewis 1882–1957

Born, of an American father and a British mother, on his father's yacht off Amherst, Nova Scotia. Studied at the Slade School 1898–1901. Travelled widely in Europe 1902–8, including a visit to Madrid with Gore c. 1902. Settled in England 1909 and soon afterwards met the poet Ezra Pound. Member of the Camden Town Group, founder-member of the London Group (1913). Included in the Galerie Barbazanges exhibition of contemporary British art in Paris in 1912, and in the 'English Group' at the second Post-Impressionist exhibition at the Grafton Gallery 1912–13. Involved in decorations and publicity designs for the 'Cave of the Golden Calf' in 1912. Exhibited with, and wrote catalogue preface for, the 'Cubist Room' at the 1913–14 Brighton exhibition of work by 'English Post-Impressionists, Cubists and others'. Exhibited with the first Grafton Group exhibition in 1913 and joined the Omega Workshops when they opened, but quarrelled with Roger Fry and withdrew from the enterprise three months later. Founded the Rebel Art Centre in 1914. Contributed to and edited the Vorticist magazine *Blast* 1914 and 1915. Exhibited in Vorticist exhibitions at the Doré Galleries 1915 and the Penguin Club, New York 1917. Official war artist 1917–18. Founded Group X and organized their exhibition at Heal's Mansard Gallery 1920. Prolific writer of art criticism, short stories, novels (the first, *Tarr*, published in 1918) and autobiography. His writings include: *Blasting and Bombardiering* (1937); *Wyndham Lewis the Artist: from Blast to Burlington House* (1939); *Rude Assignment: A Narrative of My Career Up-to-Date* (1950) and *The Demon of Progress in the Arts* (1954).
Exhibitions within his lifetime
Goupil Gallery 1919 (War pictures, exhibition entitled 'Guns'); Adelphi Gallery 1920 (Drawings); Leicester Galleries 1921 ('Tyros and Portraits'); Lefevre Galleries 1932 (Portrait Drawings); Leicester Galleries 1937; Beaux Arts Gallery 1938; Redfern Gallery 1949* (retrospective); Tate Gallery 1956* (Wyndham Lewis and Vorticism, including work of Lewis's artistic associates during the period under review).

Exhibitions since his death
Zwemmer Gallery 1957; d'Offay Couper Gallery 1969 ('Abstract Art in England 1913–15' including works by Lewis); Arts Council 1974* ('Vorticism and its Allies'

studying the work of Lewis and his associates); Mayor Gallery 1974.

Literature

Wyndham Lewis's autobiographical books listed above, and the catalogue prefaces he wrote for nearly all the exhibitions during his lifetime listed above. Also Lewis's *Letters*, ed. W. K. Rose, London, Methuen, 1963.

The major works on Lewis by other authors are: Charles Handley-Read, *The Art of Wyndham Lewis*, London, Faber, 1951; Walter Michel, *Wyndham Lewis Paintings and Drawings*, London, Thames & Hudson, 1971; Richard Cork, catalogue introduction and notes to Arts Council catalogue of 'Vorticism and its Allies', 1974; Richard Cork, *Vorticism and Abstract Art in the First Machine Age*, 2 vols, London, Gordon Fraser, 1976.

Maxwell Gordon Lightfoot 1886–1911

Born in Liverpool. Studied at Chester Art School *c*. 1901–2 until *c*. 1905. Apprenticed as a chromolithographer 1905–7 and also attended evening classes at the Sandon Studios, Liverpool under Gerard Chowne and Herbert MacNair. At the Slade School 1907–9. Exhibited at the N.E.A.C. 1910 and with the Friday Club 1911. Member of the Camden Town Group but resigned after first exhibition. Killed himself September 1911. No exhibition within his lifetime.

Exhibition since his death

Walker Art Gallery, Liverpool 1972*. The well-illustrated catalogue of this exhibition, by Gail Engert, the only literature on Lightfoot, contains a general introduction and also lists and details all the works by Lightfoot known to the compiler.

James Bolivar Manson 1879–1945

Born in London. Studied part-time at Heatherley's School of Art 1896, later at Lambeth School of Art, and 1903 at the Académie Julian in Paris where Jacob Epstein was one of his close friends. Spent summers painting in Brittany 1905–7, sometimes on Tom Robertson's sketching parties. Was in Douélan, Brittany, in 1907. Met Lucien Pissarro late in 1909 and introduced by him to the Fitzroy Street Group 1910–11. First exhibited at the A.A.A. in 1911. Member Camden Town Group and its secretary, founder-member London Group (1913) and its first secretary but resigned in March following the first exhibition, founder-member Monarro Group (1919) and its secretary. First exhibited with the N.E.A.C. in 1909, member 1927. Exhibited at the R.A. from 1939. Joined the staff of the Tate Gallery in 1912, Assistant Keeper 1917–30, Director 1930–8. Author of numerous articles

and books on art, including *The Tate Gallery* (1930) and monographs on Degas, Rembrandt and Sargent.

Exhibitions within his lifetime

Informal show at his home in Adelaide Road, Swiss Cottage 1904; Dickinson's, New Bond Street 1905; Leicester Galleries 1923 (Flower Paintings); Galérie Balzac, Paris 1924; Reid Gallery, Glasgow 1925; Wildenstein's 1937; Leicester Galleries 1944.

Exhibitions since his death

Memorial exhibition at Wildenstein's 1946; Maltzahn Gallery 1973* (part loan); New Grafton Gallery 1979.

Literature

Malcolm Easton, *Gazette des Beaux Arts*, November 1968, 'Lucien Pissarro and his friends at Rye, 1913'; David Buckman, *James Bolivar Manson, An English Impressionist*, produced for the Maltzahn Gallery exhibition 1973, also incorporating a chronology and list of paintings by Manson in public and some private collections. Well illustrated.

Lucien Pissarro 1863–1944

Born in Paris, eldest son of Camille Pissarro. Studied under his father and influenced by friendship with Seurat, Signac and other Neo-Impressionists. Also studied wood-engraving under Lepère. Exhibited at the eighth and last Impressionist show in Paris 1886, and with the *Salon des Indépendants*, Paris 1886–94 (serving on hanging committee in 1888). Frequently in London 1883–4 and settled in London 1890 (naturalized 1916). Married Esther Bensusan in 1892 and together they ran the Eragny Press 1894–1914. Concentrated on wood-engraving, book illustrations and printing until 1900. Exhibited with the N.E.A.C. from 1904, member 1906. Joined Fitzroy Street Group autumn 1907. Founder-member Camden Town Group (1911), London Group (1913) but resigned before first exhibition, and Monarro Group (1919) who exhibited together in 1920 and 1921. Visited France frequently before and after First World War, often staying at Eragny where his father had built a studio in 1889. Exhibited at the R.A. from 1934. Author of *Notes on the Eragny Press, and a letter to J. B. Manson*, ed. Alan Fern and published posthumously (1957).

Exhibitions within his lifetime

(Jointly with Ricketts) Ricketts and Hacon's shop 1896 (Wood-Engravings); Carfax Gallery 1913; Goupil Gallery 1917 (English Landscapes); Hampstead Art Gallery 1920; Leicester Galleries 1922, 1924, 1927; Manchester, Jackson's Gallery 1928; Birmingham, Ruskin Gallery 1928; Leicester Galleries 1929, 1934; Manchester City Art Gallery 1935 (also Lincoln and Blackpool 1935, Belfast 1936); Leicester Galleries 1936, 1943 (three generations of Pissarro family, Lucien, Camille and Orovida).

Exhibitions since his death
Memorial exhibition Leicester Galleries 1946 (catalogue introduction by Raymond Mortimer); Leicester Galleries 1950; O'Hana Gallery 1954 (three generations), 1955; Leicester Galleries 1963 (Landscapes); Arts Council 1963* (centenary retrospective, catalogue introduction by Ronald Pickvance); Lee Malone Gallery, New York 1964; New Grafton Gallery 1977 (Orovida and her ancestors, Lucien and Camille); Anthony d'Offay 1977 (with introductory essay by John Bensusan-Butt, 'Recollections of Lucien Pissarro in his Seventies').

Literature
J. B. Manson, *Imprint*, April 1913, 'Lucien Pissarro's Wood-Engravings'; J. B. Manson, *Studio*, 15 November 1916, 'Lucien Pissarro as painter'; Clément-Janin, *Gazette des Beaux-Arts*, November-December 1919, 'Peintres-Graveurs Contemporains – Lucien Pissarro'; John Rothenstein, chapter on Pissarro in *Modern English Painters*, vol.1 (*Sickert to Smith*), London, Eyre & Spottiswoode, 1952; W. S. Meadmore, *Lucien Pissarro – Un Coeur Simple*, London, Constable, 1962; Malcolm Easton, *Gazette des Beaux-Arts*, November 1968, 'Lucien Pissarro and his Friends at Rye, 1913'.

William Ratcliffe 1870–1955

Born near King's Lynn, Norfolk. Studied design at Manchester School of Art under Walter Crane and then worked for nearly twenty years as a wall-paper designer. Moved to Letchworth 1906 and there met Gilman *c*. 1908 who encouraged him to resume painting. Studied at the Slade School, part-time for one term, in 1910 and attended Fitzroy Street meetings *c*. 1910–11. Member of the Camden Town Group, founder-member London Group (1913). First exhibited at the A.A.A. in 1911. Lived from about 1912 for some years in Hampstead Garden Suburb. Visited Sweden in 1913. After 1921 painted little in oils but continued watercolours and wood-engravings.

Exhibitions within his lifetime
Roland, Browse & Delbanco 1946; Letchworth Art Gallery 1954.
No exhibitions since his death and no literature.

Walter Richard Sickert 1860–1942

Born in Munich, eldest son of Oswald Adalbert Sickert, painter and illustrator of Danish descent, and an Anglo-Irish mother. The Sickert family settled in England 1868 and Oswald later acquired his wife's nationality. 1877–81 worked as an actor in

repertory companies. Studied at the Slade School 1881–2 and then became Whistler's assistant and pupil. Independent of Whistler by 1888. Met Degas in Paris 1883 and again in Dieppe 1885. Exhibited with *Les XX* in Brussels 1887. Member (Royal) Society of British Artists 1884–8, and its president 1927–9. Member N.E.A.C. 1888, thereafter frequently resigning and re-joining until final resignation 1917. Membership of other societies included Society of Twelve (1912), National Portrait Society (1914). Organized and wrote catalogue preface for 'London Impressionists' exhibition at the Goupil Gallery 1889. Founder of Fitzroy Street Group (1907), founder-member of A.A.A. (1908), Camden Town Group (1911) and London Group (1913) but resigned before the first exhibition. Re-joined London Group 1916 and (with periodic resignations) remained a member until 1936. Occasionally exhibited with the *Salon* and the *Salon des Indépendants*, Paris, and 1905–9 with the *Salon d'automne* (*sociétaire* 1907). 1885–1922 spent part of each year (except 1915–18) in Dieppe, living there permanently (with visits to Venice) 1898–1905, and (with visits to London) 1919–22. Prolific writer of art criticism. Teacher at numerous private schools 1893–1923, the most important in the present context being Rowlandson House at 140 Hampstead Road 1910–14. Also taught at local government-sponsored schools until 1939, the most notable being the Westminster School of Art 1908–12 and 1915–18. Elected A.R.A. 1924, R.A. 1934 but resigned 1935. Hon. LL.D. Manchester University 1932, Hon. D.Litt. Reading University 1938. Left London 1934 to live in Thanet until 1938, then in Bathampton until his death. Sickert married three times: Ellen Cobden (1885 until divorce 1899); Christine Angus (1911 until her death 1920); the painter Thérèse Lessore (1926 until his death).

Exhibitions until 1914

Dowdeswell's Gallery 1886; (jointly with his brother Bernhard Sickert) Dutch Gallery 1895; Durand-Ruel, Paris 1900; Bernheim-Jeune, Paris 1904, 1907, 1909 (the last being a preview of a sale of the pictures at the Hôtel Drouot); Carfax Gallery 1911; Stafford Gallery 1911; Carfax Gallery 1912, 1913 (Studies and Etchings), 1914.

For complete list of the numerous exhibitions of Sickert's work from 1914 until his death consult the chronological biography published as an introduction to the Fine Art Society 1973 Sickert exhibition; a selected list of posthumous one-man exhibitions is also included in the 1973 catalogue. A more stringent selection follows.

Major retrospective loan exhibitions

National Gallery 1941; Temple Newsam House, Leeds 1942; Arts Council 1949 (Notes and Sketches from the collection of Sickert's work acquired by the Walker Art Gallery, Liverpool, from the Sickert Trust, catalogue compiled by Gabriel White); Roland, Browse & Delbanco 1951; Arts Council, Edinburgh 1953; Musée de Dieppe 1954 (from local public and private collections); Graves Art Gallery, Sheffield 1957; Agnew 1960 (all borrowed from private collections); Arts Council 1960; Royal Pavilion, Brighton 1962; Arts Council 1964 (Midlands Tour); Hirschl & Adler Gallery, New York 1967 (part sale, part loans from public and private collections in the U.S.A.); Art Gallery of South Australia, Adelaide 1968; University

of Hull 1968 ('Sickert in the North', work borrowed from northern English collections, essay by Malcolm Easton published as catalogue appendix); Islington Town Hall 1970 ('Our Own Sickerts', the collection of Sickert's work belonging to the Islington collection); Fine Art Society, London and Edinburgh 1973 (catalogue incorporates Sickert biography and notes on pictures by Wendy Baron); Towner Art Gallery, Eastbourne (also Guildford) 1975 ('Sickert in Dieppe', catalogue introduction and notes by Wendy Baron); Arts Council touring exhibition 1977–8 (catalogue includes essays by Wendy Baron and Gabriel White and reprints Gabriel White's article on Sickert's drawings, first published *Image*, No. 7, 1952).

Literature

(Monographs only; more complete bibliographies are published by Wendy Baron and Denys Sutton, see below): Virginia Woolf, *Walter Sickert: a Conversation*, London, Hogarth Press, 1934; W. H. Stephenson, *Sickert: the Man: and his Art: Random Reminiscences*, Southport, Johnson, 1940; Robert Emmons, *The Life and Opinions of Walter Richard Sickert*, London, Faber, 1941; Lillian Browse (with an essay on Sickert's art by R. H. Wilenski), *Sickert*, London, Faber, 1943; Walter Richard Sickert (ed. Osbert Sitwell who also contributed an introduction 'A Short Character of Walter Richard Sickert'), *A Free House! or The Artist as Craftsman being the Writings of Walter Richard Sickert*, London, Macmillan, 1947; Anthony Bertram, *Sickert*, London and New York, Studio Publications, 1955; Lillian Browse, *Sickert*, London, Rupert Hart-Davis, 1960; Sir John Rothenstein, *Sickert*, London, Beaverbrook Newspapers, 1961; Ronald Pickvance, *Sickert* (The Masters series No. 86), London, Purnell, 1967; Marjorie Lilly, *Sickert. The Painter and his Circle*, London, Elek, 1971; Wendy Baron, *Sickert*, London, Phaidon, 1973; Denys Sutton, *Walter Sickert*, London, Michael Joseph, 1976.

John Doman Turner *c.* 1873–1938

A stockbroker's clerk and amateur draughtsman. Probably introduced to Gore by Frank Rutter. Pupil of Gore 1908–13. Because Turner was deaf Gore's tuition took the form of letters criticizing the drawings Turner sent to him by post. Member of the Camden Town Group. First exhibited at the A.A.A. 1911. Founder-member of the London Group but resigned almost immediately and did not even exhibit in the Brighton 1913–14 'Work of English Post-Impressionists, Cubists and others' show arranged by the Camden Town Group. Exhibited one drawing in the summer of 1918 with the London Group. Whereabouts of only two drawings known today. No exhibitions. No literature.

Catalogue of Plates

Explanation of selection and arrangement of illustrations

The selection and arrangement of the pictures reproduced have been guided by different objectives.

In Section I the plates have mainly been chosen:
(i) to demonstrate the interacting artistic relationships within the Fitzroy Street and Camden Town Groups;
(ii) to outline the development of 'Camden Town' painting;
(iii) to illustrate its characteristic themes.
In general the plates represent work executed from 1906–11, but the chronological limit is broken to illustrate examples of specific types of subject-matter common to members of the Fitzroy Street and Camden Town Groups.

In Section II, whenever possible, the paintings reproduced are those included in the Camden Town Group exhibitions of June and December 1911. A list of the works exhibited by each artist in these two shows, with a note discussing the whereabouts, identification and critical reaction to pictures not reproduced here, precedes the plate notes to the illustrations in this section. These illustrations are grouped together by artist, just as each member's work was hung together (rather than mixed at random) on the walls of the Carfax Gallery. The plate notes quote samples of contemporary criticism.

Section III broadly covers the period 1912–14 and can be subdivided as follows. Section III(a) illustrates the work of different Camden Town Group members in 1912. This representation is expanded in Section III(b) which presents a selection of pictures exhibited at the third Camden Town Group show in December 1912 (the plate notes are again preceded by lists and notes on each member's contributions). Section III(c) illustrates pictures of 1913–14. The selection in this section has been heavily influenced by my wish to publish paintings by artists whose work is little known and seldom reproduced.

The different emphasis of each section has determined different balances in the representation of work by individual artists. For example, Sickert is more heavily represented in the early section when he influenced the vocabulary of Camden Town painting, than in later sections when his artistic influence had waned, even though he remained a politically powerful figure. Moreover, reproductions of his work during this later period are readily available in monographs by Lillian Browse and Wendy Baron.

Artists whose style evolved and changed within the period 1906–14, or who tackled many different types of subject-matter, demanded more reproductions than those whose style and subject-matter seldom varied during these years (e.g. Bayes, Lamb, Pissarro).

The small number of plates devoted to Grant, Innes and John reflects the fact that they were only nominal members of the Camden Town Group. Reproductions of the work of all three are readily available in the literature (see lists appended to biographical notes).

Wyndham Lewis remains a problem. Although he was a very active political member of the Camden Town Group his art developed independent of their influence. Moreover, almost all the early works relevant to the present context are lost. A token representation could have been made here, but the reader would certainly obtain a better understanding of Lewis's aims and style at this period by studying the fully illustrated catalogue provided by Walter Michel. Lewis's activity in relation to that of his artistic associates is best studied in Richard Cork's Arts Council catalogue, 'Vorticism and its allies', and his subsequent two-volume book.

⊙

Note on cataloguing method

Measurements: height before width, inches stated first, centimetres in brackets.

Provenance: interim ownership by dealers and sale-room histories are not cited.

Literature: Literature and reproduction references (abbreviated) are confined to monographs cited in the lists appended to the biographical notes on individual artists. However, an exception is made to indicate reproductions in colour in exhibition catalogues or articles if the picture is illustrated here in black and white.

Exhibitions: early group shows, one-man (or joint) exhibitions, and retrospective Camden Town Group exhibitions only are cited. Titles are not given for one-man exhibitions.

Ownership. Private Collections: in a few cases the last sale-room appearance of a picture is a more helpful guide to its present whereabouts than the non-specific designation to a private collection.
 Public Collections: the date in brackets indicates when the picture was acquired by a particular art gallery or public institution. Whether the picture entered the collection by bequest, gift or purchase is not cited.

Pictures by Gore. Gilman labels: after Gore's sudden death in 1914 his widow and Gilman together sorted out all the paintings left in his studio. They stamped the artist's name on each picture and placed handwritten informative labels on the back. Each label was numbered according to the presumed chronological sequence of the paintings. Gilman was not infallible, and perhaps too much credence has been

given to the accuracy of his dating. Nevertheless, the numbers provide an excellent rough guide to the dates of Gore's work. Pictures already sold or otherwise dispersed before Gore's death never had Gilman labels. The labels on other pictures have vanished over the years. However, a fair proportion survive and where these are known to me they are cited in the catalogue as G. (for Gilman label) followed by the number. The number is sometimes followed by the letter 'A', which denoted either that Gilman and Mrs Gore considered the painting to be an important work, or that they needed from time to time to insert extra pictures into their sequence. John Woodeson, in his 1970 catalogue for the Gore exhibition at Colchester and in his M.A. thesis, cited the numbers of Gilman labels and in several cases I have used his information.

Abbreviations:

A.A.A.	Allied Artists' Association
A.R.A.	Associate of the Royal Academy
N.E.A.C.	New English Art Club
R.A.	Royal Academy/Academician

Catalogue : List of Illustrations

Section I : Introductory (1906–11)

Section II: Camden Town Group Exhibitions 1911

Section 1:
Introductory (1906–11)

Sickert

Portrait of Harold Gilman *c.* 1912

Oil on canvas, 24 × 18 (61 × 45.7)

Provenance: Mrs Sylvia Gilman

Literature: Lilly, p. 54, rep. Pl. 12; Baron, pp. 117, 354, C. 299, rep. Fig. 207

Exhibited: Lefevre Gallery 1950, 'Camden Town Group' (45); Southampton 1951, 'The Camden Town Group' (115); Arts Council 1953, 'The Camden Town Group' (41); Arts Council, Edinburgh 1953 (24); Arts Council 1960 (122); Fine Art Society 1976, 'Camden Town Recalled' (147)

Collection: The Tate Gallery, London (1957)

Gilman often modelled for Sickert in 1912 but only in this painting and in the drawing '*Mr Gilman Speaks*' (Victoria and Albert Museum) is his identity acknowledged. Gilman's habit of preaching to his colleagues on art and its politics is ironically indicated in the title of the drawing. The painting, although supported by no secondary figures or explanatory title, communicates the earnest fanaticism of Gilman's character even more powerfully.

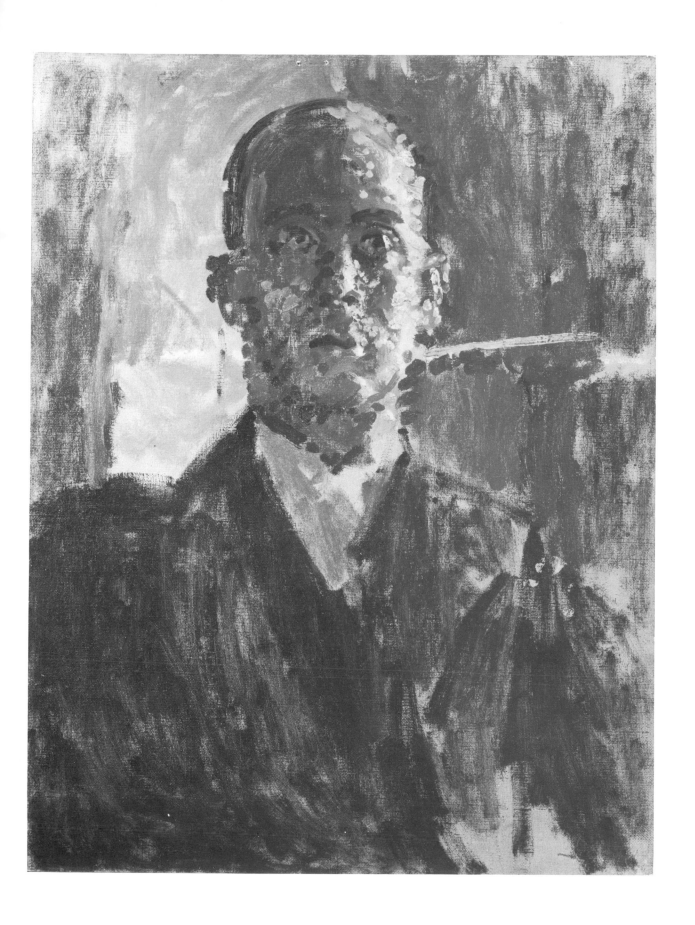

Sickert

1 **Noctes Ambrosianae** 1906
Oil on canvas, 25 × 30 (63.5 × 76.2)
Signed 'Sickert' bottom right
Provenance: Walter Taylor; J. B. Priestley
Literature: Browse 1943, p. 34; Browse 1960, pp. 19, 59, 63, 107, rep. Pl. 11; Baron, pp. 90–1, passim 93–102, 340–1, C. 230, rep. Fig. 159
Exhibited: N.E.A.C. summer 1906 (123); Paris, Salon d'automne 1906 (1545); Arts Council 1960 (18); Arts Council 1964 (14); Adelaide 1968 (28); Fine Art Society 1973 (54); Fine Art Society 1976, 'Camden Town Recalled' (128); Arts Council 1977–8 (25)
Collection: Castle Museum and Art Gallery, Nottingham (1952)

A view of the gallery of the Middlesex Music Hall (or Mogul Tavern as it was affectionately known to its familiars) where Sickert, in 1906, rediscovered the fascination of music hall audiences, particularly the eager boys in the gods, as a subject for painting. In this picture Sickert experimented with the expressive shorthand notation also used in *Le Lit de Cuivre* (Pl. 29) and *La Hollandaise* (Pl. 7). Its very dark tonality (Sickert himself termed it 'black') is deceptive in that it has been built up from many layers of lively colours, including a strong lilac. Sickert considered the picture to be one of his best works and referred to it with great pride in letters written to William Rothenstein in 1906. In 1907 he recommended Nan Hudson to go and see it hanging in Walter Taylor's house: 'I reflect, not without shame, that it is one of, perhaps, not more than half a dozen museum-pieces that I have done in twenty-seven years.' Sickert's choice of title deserves comment. While it appropriately suggests a rough translation as 'nights of divine pleasure', the adjective *'ambrosianae'* (as opposed to *'ambrosiae'*) does not exist in Latin. On the other hand Sickert's precise title was used by the authors of a series of imaginary conversations published in *Blackwood's Magazine* from 1822 to 1835. These conversations were supposed to have taken place in the convivial atmosphere of Ambrose's Tavern – hence the licence with the Latin.

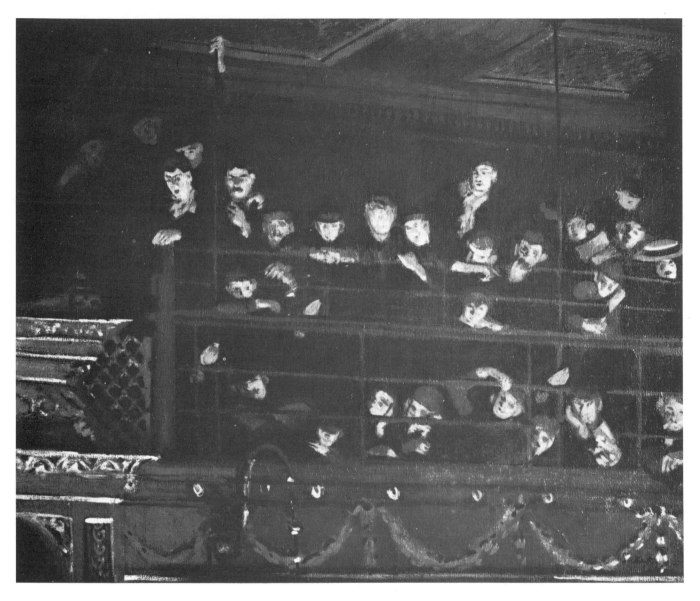

I

Gore

2 **The Mad Pierrot Ballet, The Alhambra** *c.* 1905
Oil on canvas, 17 × 21¼ (43.2 × 54); G.5
Stamped 's. f. gore' bottom right
Provenance: the artist's family
Exhibited: possibly Carfax Gallery December 1911, 'The Camden Town Group'
(15) and Carfax Gallery 1913 (48); Redfern Gallery 1962 (2) as *Oriental Ballet*;
Anthony d'Offay 1974 (1) rep. in colour; Fine Art Society 1976, 'Camden Town
Recalled' (47)
Collection: Anthony d'Offay Gallery

The composition recalls the Degas-derived formula used by Sickert in his music
halls of the 1880s, with the floodlit stage seen behind the silhouetted heads of figures
in the darkened orchestra and auditorium. However, in spite of this echo and in
spite of the fact that Gore probably painted this picture shortly after first meeting
Sickert, his son Frederick Gore has contradicted the assumption that it was Sickert
who introduced Gore to theatrical subjects. In a memoir published as the catalogue
introduction to the 1974 exhibition at Anthony d'Offay's gallery, Mr Gore told how
his father was a keen amateur stage performer in his youth and how Gore's early
drawings reveal a fascination with Goya: 'a strange, dark world of characters from
Lenten carnival and Commedia dell'Arte; clowns, circus animals and sylphides riot
and posture across an undefined stage or in front of an Italianate backcloth.' The
absurdity of the performers in this picture can be seen to evolve naturally from such
drawings although (as noted in the text) the influence of Monticelli may also have
contributed to its romantic sense of colour, its impasto, and its lunatic expression-
ism. When this painting was exhibited at the Redfern Gallery as *Oriental Ballet* it
was dated 'before 1904', but this date now seems improbably early. Frederick
Gore's later identification of the painting as *The Mad Pierrot Ballet* is plausible but as
yet unsupported by external evidence. The Gilman label is numbered but otherwise
bears no information about title, location or date. Gilman placed it between a more
tentatively drawn and thinly painted theatrical scene with masked figures and
acrobats (G.4) which must be a pre-1905 work, and another theatrical scene (G.6)
similar in subject and technique to the painting illustrated here. Neither of these
labels has any useful information about date or subject. At this period, around 1905,
Gilman was out of touch with Gore. Nevertheless, if G.5 was *The Mad Pierrot Ballet*
Gilman would certainly have known the work well from its exhibition at the Carfax
Gallery in 1911 and 1913 (when he himself shared the gallery with Gore). It is
possible that Gilman took the title for granted, and certainly his labels do not
generally concern themselves with titles but merely state when and where pictures
were painted. Press descriptions of the Camden Town Group exhibition neither
confirm nor refute the identification of this painting as *The Mad Pierrot Ballet*.
Frank Rutter (*Sunday Times*, 3 December 1911) noted 'an exquisite draught of
colour in [Gore's] iridescent "Mad Pierrot Ballet".' On the other hand Sir Claude
Phillips (*Daily Telegraph*, 14 December 1911) was immune to Gore's charm: '"The
Mad Pierrot Ballet," a very deliberate improvisation that has nothing in it of

madness, or of that imaginativeness which is next door to a fine frenzy, is not even good as mere visual impression.'

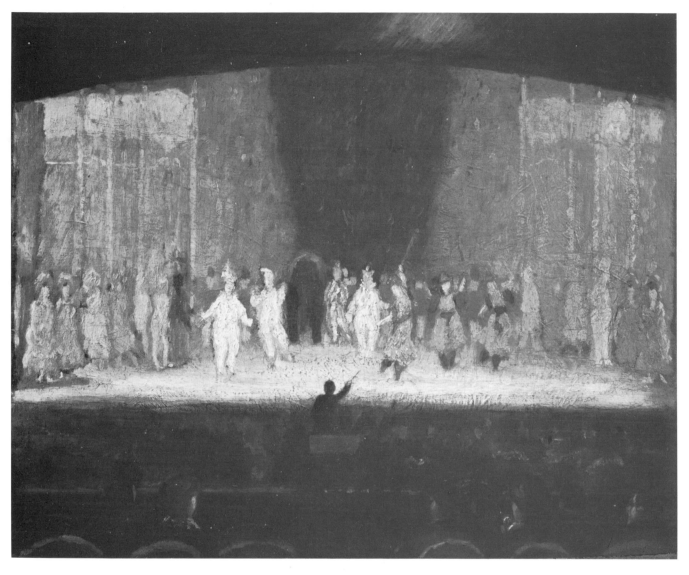

2

Gore

3 **Interior of the New Bedford** *c*. 1908–9
Black and white crayon on mauve paper, 13½ × 9 (34.3 × 22.9)
Provenance: K. T. Powell
Exhibited: Redfern Gallery 1962 (128) as *Interior at the Alhambra*; Fine Art Society
1976, 'Camden Town Recalled' (55)
Collection: The Fine Art Society Ltd

Previously identified as an Alhambra interior this squared drawing is, in fact, an
aspect of the New Bedford seen from exactly the same viewpoint that Sickert
explored in drawings of 1908–9 while preparing his painting of the subject (Pl. 4).
Gore probably made this sketch when visiting the Bedford in Sickert's company. A
few paintings with Bedford titles were included in early exhibitions of Gore's work
(e.g. *Chinese Sketch at 'The Bedford'* at the Chenil Gallery in 1911; *Bedford Music
Hall* at Paterson and Carfax in 1920), but these are greatly outnumbered by
Alhambra subjects. No painting by Gore of this view of the Bedford is known.

Sickert

4 **The New Bedford** *c*. 1908–9
Oil on canvas, 36 × 14 (91.5 × 35.5)
Signed 'Sickert' bottom left
Provenance: Hugh Hammersley; Robert Emmons; A. D. Peters
Literature: Emmons, p. 51; Browse 1943, pp. 25, 29, 32, 45–6, rep. Pl. 26; Browse
1960, pp. 19, 78; Baron, pp. 112–13, 115, 153, 343, 370, C. 238, rep. Fig. 166
Exhibited: probably A.A.A. 1909 (240); probably N.E.A.C. winter 1909 (9);
National Gallery 1941 (97); Leeds 1942 (153); Southampton 1951, 'The Camden
Town Group' (110); Agnew 1960 (55); Fine Art Society 1973 (63)
Collection: Private

The Bedford Music Hall, Sickert's favourite haunt of the 1880s and 1890s, had been
burnt down in 1899 and rebuilt during his residence in Dieppe. On his return to
London Sickert did not immediately transfer his full affection to the splendid New
Bedford, preferring the Middlesex in 1906 (Pl. 1) and the Paris halls in 1906–7. He
first drew and painted in the New Bedford *c*. 1907, exhibiting a drawing of the
subject at the N.E.A.C. in the summer. The painting illustrated here was almost
certainly exhibited two years later at the N.E.A.C. where it was noted by the critic of
the *Saturday Review* as 'one of the most original pictures in the gallery' (11
December 1909). Frank Rutter (*Art in my Time*, London, Rich and Cowan, 1933, p.
122) was mistaken when he implied that this painting was shown at the N.E.A.C. in
1907. He clearly remembered the picture well: 'an unquestionable masterpiece, as
brilliant in the flashing, glittering polychrome of its highlights, as it is magnificently
original and arresting in design'; he remembered it in the context of an N.E.A.C.
exhibition. However, he must have consulted a catalogue to refresh his memory as
to the year of its exhibition. The 1907 catalogue did not acknowledge *The New*

Bedford as a drawing, and we know that its medium was pencil and charcoal only from an annotation, accompanied by a thumbnail sketch, in the copy of the catalogue belonging to the Tate Gallery library. The dramatic vertical compositional conception of this painting, absent from the 1907 drawing and from a related painting of the same date, was new to Sickert's music halls and new to the tradition of theatrical interiors. Sickert himself used it as the basis for several paintings, drawings and etchings of the same music hall done from 1914–16; Malcolm Drummond translated Sickert's idea when, in 1910, he painted the interior of the Brompton Oratory (Pl. 119). The crusty, but now much darkened, polychrome of Sickert's painting is characteristic of his execution when he was working in close association with colleagues in Fitzroy Street.

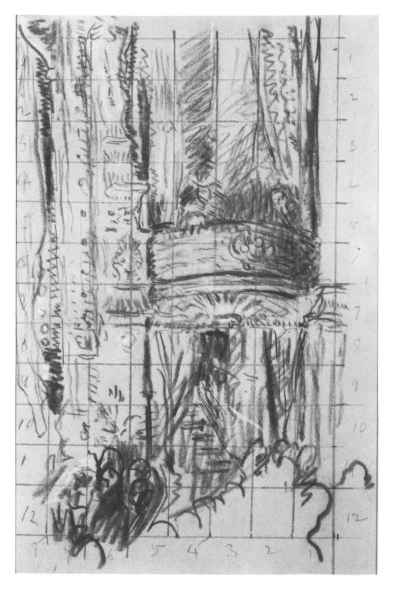

3

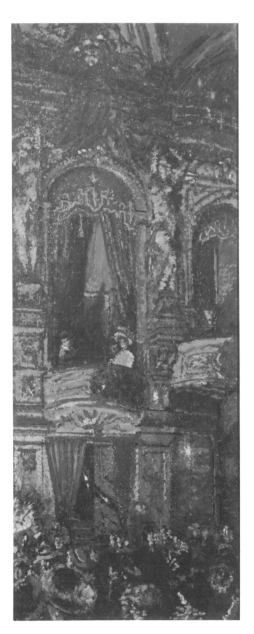

4

Gore

5 Rinaldo, the Mad Violinist, at the Alhambra *c.* 1911
Oil on canvas, 16 × 12 (40.6 × 30.5); ?G.122
Stamped 's. f. gore' bottom right
Provenance: the artist's family
Exhibited: Carfax Gallery 1916 (32); Arts Council 1955 (27); Redfern Gallery 1962
(81); Anthony d'Offay 1974 (16); Fine Art Society 1976, 'Camden Town Recalled'
(68)
Collection: Anthony d'Offay Gallery

When exhibited in 1916 this picture was simply called *Rinaldo*, and dated 1911. The later identification of the music hall as the Alhambra may not be correct. The pillar at the side of the stage lacks the ornate decoration seen in other paintings of the Alhambra incorporating this feature. It is, indeed, possible that this distinctly Sickertian interior by Gore was painted at Sickert's haunt, the New Bedford.

Gore

6 The Balcony at the Alhambra *c.* 1911–12
Oil on canvas, 19 × 14 (48.2 × 35.5); G. 120
Stamped 's. f. gore' bottom left
Provenance: Lord Killanin
Exhibited: Anthony d'Offay 1974 (19) rep. in colour; Fine Art Society 1976,
'Camden Town Recalled' (70)
Collection: Anthony d'Offay Gallery

Gore probably saw the retrospective exhibition of Gauguin's work held in Paris in 1906 but, still having to work his way through Impressionism and Neo-Impressionism, he was not then ready to assimilate later French developments. He did respond to the art of Gauguin when he had another opportunity to see his paintings well represented in the exhibition organized by Roger Fry, 'Manet and the Post-Impressionists', held at the Grafton Gallery during the winter of 1910–11. However, *The Balcony at the Alhambra* suggests so strong and compelling an influence from Gauguin that it was probably painted after Gore visited the exhibition of Gauguin's and Cézanne's work held at the Stafford Gallery in November 1911. It is just as radical, if less explicit in acknowledging its source, as Gore's elaborate tribute to that exhibition in *Gauguins and Connoisseurs at the Stafford Gallery* (Pl. 66). *The Balcony* is a masterpiece of Gauguinesque synthesis. The spatial representation is manipulated to make the picture read on the surface as a pattern of brilliantly-coloured stylized shapes. The distortions in the drawing and the high-angled viewpoint are typical Gauguin devices.

The Balcony is one of Gore's last music hall paintings. Having abandoned the dazzling, colourful stippled touch of Impressionism, the music hall was no longer the ideal vehicle for his style. The picture is also unusual for Gore in that it represents the audience only, with no reference to the stage. In conception and

composition, but not in style, *The Balcony* harks back to such Sickert examples of music hall interiors as *The Old Middlesex* (rep. Baron, Fig. 160).

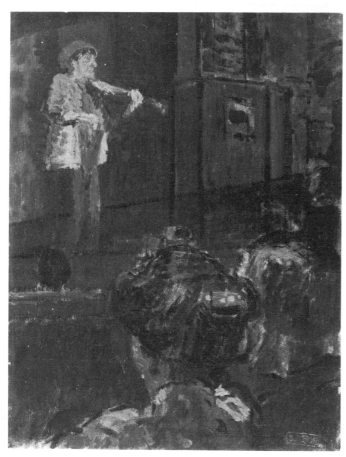

5

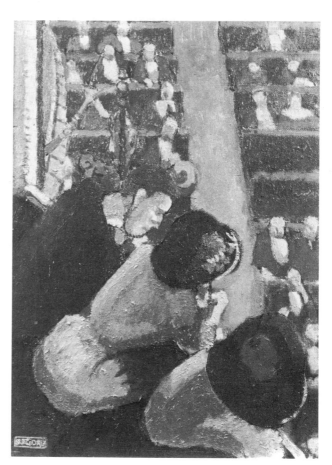

6

Sickert

7 **La Hollandaise** *c.* 1906
Oil on canvas, 20 × 15¾ (50.8 × 40)
Signed 'Sickert' bottom right
Provenance: Mark Oliver; Hart Massey
Literature: Browse 1960, pp. 72–3, rep. Pl. 46; Rothenstein 1961, rep. Col. Pl. 7;
Pickvance 1967, rep. Col. Pl. VIII; Baron, pp. 86–7, 101, 110, 338, C. 211, rep. Fig.
144
Exhibited: Bernheim-Jeune, Paris 1907 (33); Bernheim-Jeune, Paris 1909 (54);
Roland, Browse & Delbanco 1957 (24); Roland, Browse & Delbanco 1960 (30);
Arts Council 1960 (100); Fine Art Society 1973 (49)
Collection: Private

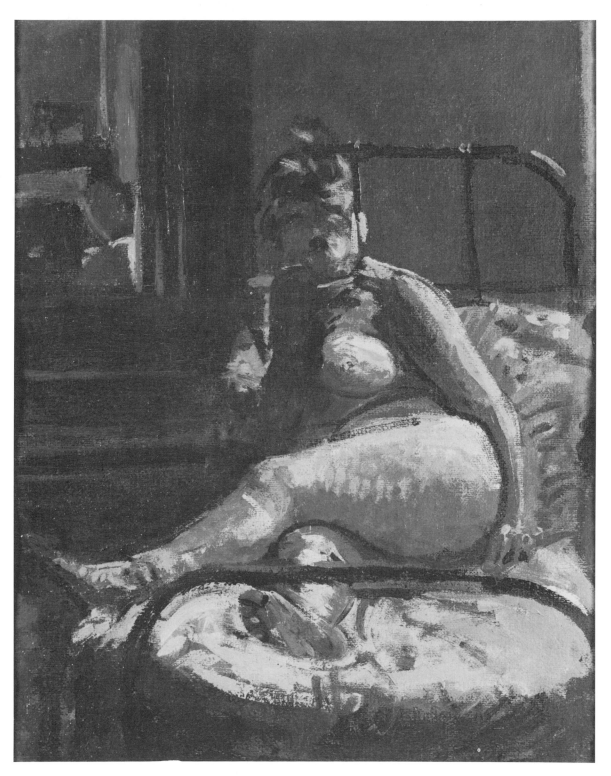

7

Sickert

8 **Mornington Crescent Nude: Contre-Jour** *c.* 1906
Oil on canvas, 20 × 18 (50.8 × 45.7)
Signed 'Sickert' bottom right
Provenance: Judge William Evans
Literature: Browse 1943, pp. 49–50, rep. Pl. 33; Bertram, rep. Pl. 22; Rothenstein 1961, rep.; Pickvance 1967, rep. in colour Pl. x; Baron, pp. 86–7, 105, 338, C. 213, rep. Fig. 146
Exhibited: National Gallery 1941 (95) and Leeds 1942 (164) as *Granby Street*; Agnew 1960 (62); Arts Council 1960 (113)
Collection: Private

Painted at 6 Mornington Crescent. The *Granby Street* title was a mistake, as was Miss Browse's inference that Sickert's Mornington Crescent studio was in a house on the corner of Granby Street. There are interiors by Sickert which properly bear the title *Granby Street* because they were painted at 247 Hampstead Road, on the corner where the two roads meet.

Gore

9 **Behind the Blind** *c.* 1906
Oil on canvas, 20 × 16 (50.8 × 40.6); ?G.34
Stamped 's. f. gore' bottom right
Provenance: J. W. Freshfield
Exhibited: Carfax Gallery 1916 (8); Leicester Galleries 1928 (19); Colchester 1970 (4); Fine Art Society 1976, 'Camden Town Recalled' (48)
Collection: Private

Almost certainly painted in Sickert's Mornington Crescent studio at about the same time as Pl. 8. The compositional layout and the furnishings are identical in both paintings. However, Gore's figure is pretty, clothed and seen in artificial light, whereas Sickert's gaunt nude is darkly silhouetted against the light filtering through the slats of the blind behind her. While Gore adopted intimate Sickertian themes, he never adopted the uncompromising brutality of Sickert's treatment of such subjects.

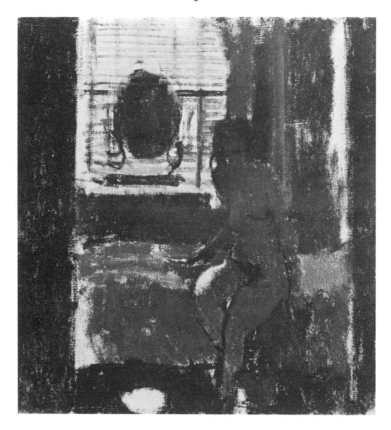

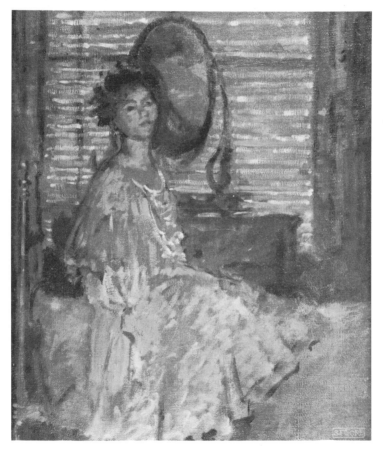

9

Gore

10 **The Cross-Roads, Neuville** *c.* 1906
Oil on canvas, 29½ × 19½ (75 × 49.5)
Exhibited: N.E.A.C. summer 1907 (147) as *The Cross Road*; Carfax Gallery 1918 (14)
Collection: Sotheby's sale, 10 November 1976, lot 21

The annotation in the copy of the N.E.A.C. catalogue in the Tate Gallery Library proves this to be the painting exhibited in 1907. Its size and finish suggest Gore deliberately painted it as an exhibition work likely to satisfy the New English jury.

Gore

11 **View of Dieppe** 1906
Oil on canvas, 9½ × 12¾ (24 × 32.3); G.18
Stamped 'S. F. GORE' bottom right
Exhibited: Fine Art Society 1976, 'Camden Town Recalled' (49)
Collection: Private

One of several studies, all the same size, painted by Gore in 1906 of Dieppe and its environs. Four were exhibited at the Redfern Gallery in 1962 (Nos 5, 7, 9 and 76); this picture may be No.9 in that exhibition.

Section I: Introductory (1906–11) 123

Gilman

12 **Edwardian Interior** *c.* 1907
 Oil on canvas, 21 × 21¼ (53.3 × 54)
 Signed 'H.Gilman' bottom right
 Provenance: Hubert Wellington
 Exhibited: Lefevre Gallery 1943 (10); Colchester 1969 (11); Bedford 1969, 'The
 Camden Town Group' (11)
 Collection: The Tate Gallery, London (1956)

 An interior at Snargate Rectory showing the artist's youngest sister, Irene. The
 Tate Gallery catalogue, *Modern British Paintings, Drawings and Sculpture*, p.237,
 quotes a letter from Hubert Wellington tentatively dating the painting 1905. A later
 date is suggested by John Woodeson in the Colchester catalogue.

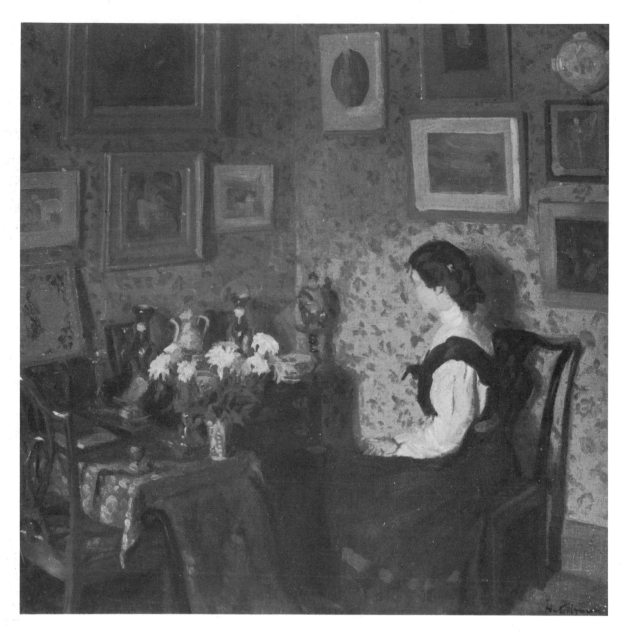

12

(Sir) William Rothenstein (1872–1945)

13 A Farm in Burgundy 1906
Oil on canvas, 22 × 30 (55.9 × 76.2)
Signed with initials and dated 'W.R. 1906' bottom right
Provenance: Charles Rutherston (the artist's brother); Edward le Bas
Literature: H.W[ellington], *William Rothenstein*, London. Ernest Benn, 1923,
rep. Pl. 9
Exhibited: Art Institute, Chicago 1912 (8); Tate Gallery 1950 (35); Fine Art
Society 1976, 'Camden Town Recalled' (118)
Collection: Private

Rothenstein recalled his summer of 1906 in the Burgundian village of St Seine
l'Abbaye near Dijon as 'one of the finest I have ever known' (*Men and Memories*,
vol.2, p.102). The confident handling of his views of the abbey church and nearby
farm reflect this happiness. In these paintings he approached nearer to Impression-
ism than at any other time in his painting career. Indeed, the painting illustrated
here was included in the 'Impressionism' exhibition at the Royal Academy in 1976.
His palette lightened to express sunlight in creamy tones and blue is used for some
small areas of shadow. The paint is built up in little touches to a crusty texture.
However, Rothenstein took only what he needed from Impressionism and still
composed his subject-matter in traditional terms around the interplay of solid
architectural forms.

Albert Rothenstein (Rutherston) (1881–1953)

14 Laundry Girls 1906
Oil on canvas, 36 × 46 (91.4 × 116.8)
Signed and dated 'Albert R. 06' bottom left
Provenance: John Spiegelberg; Humbert Wolfe
Literature: R. M. Y. G[leadowe], *Albert Rutherston*, London, Ernest Benn, 1925,
rep. Pl.5
Exhibited: probably N.E.A.C. summer 1906 (62) as *The Linen Markers*; Leicester
Galleries 1934 (71); N.E.A.C. winter 1935 (83)
Collection: The Tate Gallery, London (1939)

The artist reproduced this painting in an article he wrote for the *Burlington
Magazine*, LXXXII, 1943 entitled 'From Orpen and Gore to the Camden Town
Group'. This article is accurate in its account of the author's relationship with
Orpen and Gore and tells the story of how Rutherston introduced Gore to Sickert.
However, the later section of the article dealing with the evolution of the Fitzroy
Street Group and mentioning the creation of the Camden Town Group is totally
unreliable and confused, and must be discounted as history. Nevertheless, Ruther-
ston's memory that the models for this picture were coster girls, one named Emily
who also sat for Sickert, is presumably correct. Nothing in the treatment of this
carefully observed and scrupulously realized picture is owed either to Gore or to

Sickert. The carefully spaced composition is closer to William Rothenstein's arrangements of figures in interiors. Albert was somewhat overshadowed by William as a painter. His style changed radically in about 1910 to become frankly decorative and often frivolous. He used his talents to great effect in book illustrations and stage design.

(Sir) Walter Russell (1867–1949)

15 **Donkeys and Kites** *c.* 1909
Oil on canvas, 30 × 40 (76.2 × 101.6)
Signed 'W.Russell' bottom left
Provenance: Francis Howard
Exhibited: N.E.A.C. summer 1909 (56); Goupil Gallery 1910 (49)
Collection: The Tate Gallery, London (1914)

13

14

15

Anna Hope (Nan) Hudson (1869–1957)

16 **San Giorgio Maggiore** *c.* 1906
Oil on cardboard, 15 × 13⅛ (38.1 × 33.3)
Signed 'A. H. Hudson' bottom right
Provenance: Mrs Ralph Peto (Ruby Lindsay)
Literature: Wendy Baron, *Miss Ethel Sands and her Circle*, London, Peter Owen,
1977, p. 79
Exhibited: N.E.A.C. winter 1910 (93); Fine Art Society 1976, 'Camden Town
Recalled' (72); Fine Art Society 1977, 'Miss Ethel Sands and her Circle' (23)
Collection: Private

Nan Hudson's Venetian landscape admired by Sickert at the 1906 *Salon d'automne*
is now lost. This picture is of about the same date. Miss Hudson's preference for a
absorbent cardboard base for painting was perhaps influenced by Vuillard whom
she knew and admired. The dry, broken square touch of this picture, and the
palette limited to a few colours subtly modulated in tone, are characteristic of Nan
Hudson's landscapes throughout her life.

Ethel Sands (1873–1962)

17 **Woman at a Dressing Table** *c.* 1905–6
Oil on canvas, 21 × 18 (53.5 × 45.7)
Provenance: Mrs Ralph Peto (Ruby Lindsay)
Literature: Wendy Baron, *Miss Ethel Sands and her Circle*, London, Peter Owen,
1977, pp. 51–2
Exhibited: possibly A.A.A. 1910 (973) as *The Dressing Table*; Fine Art Society 1977,
'Miss Ethel Sands and her Circle' (2)
Collection: Private

This interior was probably painted in Paris where Ethel Sands and Nan Hudson
trained and worked from about 1894 until 1906. If it is the painting exhibited in
1910 then the figure represents Nan Hudson and the picture was on view at 19
Fitzroy Street.

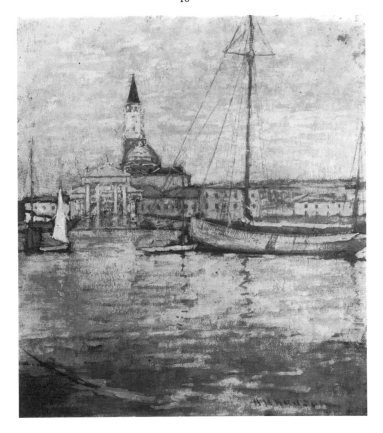

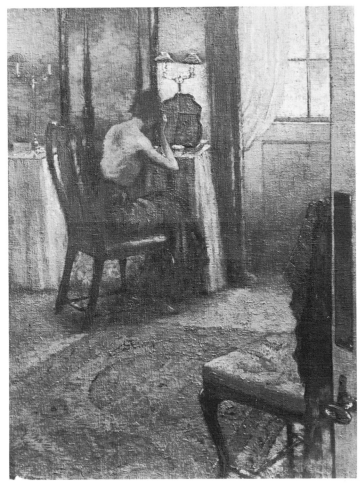

Drummond

18 **19 Fitzroy Street** *c.* 1913–14 (on cover in colour)
Oil on canvas, 28 × 20 (71 × 50.8)
Exhibited: London Group 1928, Retrospective exhibition (46); Fine Art Society
1976, 'Camden Town Recalled' (21)
Collection: Laing Art Gallery, Newcastle (1976)

A valuable document of the Fitzroy Street Group studio. Three men are examining
pictures taken from the stacks. The figures have been variously identified; I believe
they may represent (left to right) Manson, Gore and Ginner. Some of the paintings
can also be identified. These include (top left) Gilman's *The Verandah, Sweden* of
1912, (top right) Drummond's *Boyne Hill Church* and (bottom centre) Ginner's *The
Circus* of 1913. This selection suggests a date of 1913 for *19 Fitzroy Street* although in
the London Group Retrospective it was dated 1914. Little heed need be paid to this
date because Drummond's other exhibit in the 1928 show, *Paddington Station*
(present whereabouts unknown), was dated 1913 in spite of its previous exhibition
with the Camden Town Group in June 1911. Preparatory studies for this picture are
in the University of Hull Art Collection, and an etching also exists.

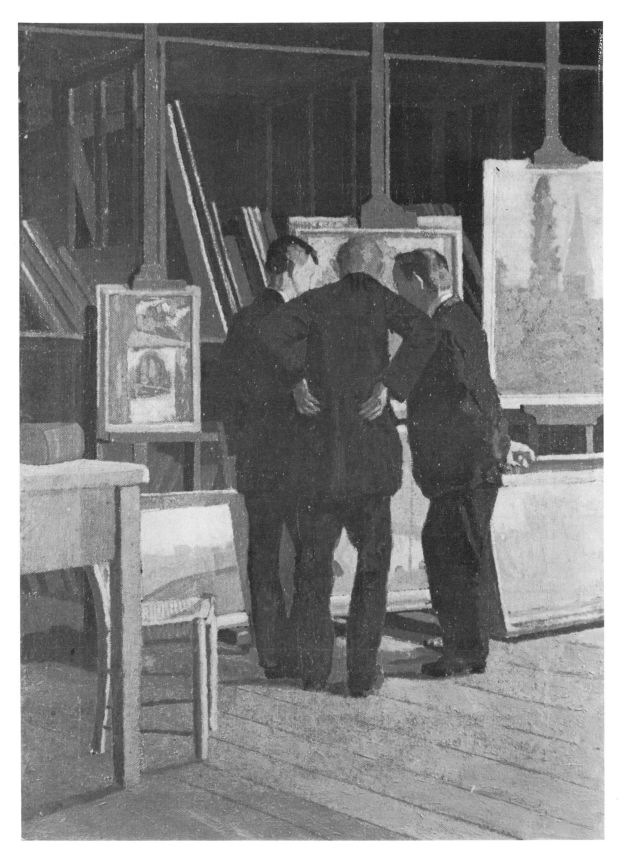

18

Gore

19 **Interior with Nude Washing** *c.* 1907–8
Oil on canvas, 24 × 18 (61 × 45.7); G.46
Stamped 's. f. gore' bottom left
Exhibited: possibly Chenil Gallery 1911 (22) as *Woman Washing*; Southampton
1951, 'The Camden Town Group' (56); Arts Council 1955 (9); Colchester 1970
(11); Fine Art Society 1976, 'Camden Town Recalled' (53)
Collection: City of Leeds Art Gallery and Temple Newsam House (1932)

The Gilman label gives 1907 as the date of this picture, one of the earliest examples
of Gore's intimate studies of the nude. The subject-matter was clearly inspired by
Sickert who insisted that the nude should always be represented in an appropriate
context. Following Sickert's example Gore has shown his model doing something
natural to her nudity, and he has provided typically Sickertian incidental detail in
the washstand, jug, basin and chamberpot. However, Gore's use of colour,
dominated by the brilliant green of his background wall-paper, gives this picture a
mood of gaiety totally at variance with Sickert's renderings of shabby bed-sitters in
Camden Town.

Gore

20 **Nude on a Bed** *c.* 1910
Oil on canvas, 12 × 16 (30.5 × 40.6); ?G.104
Signed 'f. g.' and stamped 's. f. gore' bottom right
Exhibited: Lefevre Gallery 1950, 'Camden Town Group' (26); Arts Council 1955
(23); Colchester 1970 (26); catalogued but not exhibited Fine Art Society 1976,
'Camden Town Recalled' (61); Norwich 1976, 'A Terrific Thing' (28)
Collection: City Art Gallery, Bristol (1950)

The Gilman label gives the date 1910 and places the interior in 31 Mornington
Crescent. The handsome brass bedstead features in several paintings by Gore
including *The Bedroom* (Art Gallery of Hamilton, Ontario) showing a standing
model wearing a shift. Mrs Gore informed John Woodeson, compiler of the
Colchester catalogue, that this picture used to hang in Gilman's Maple Street
studio.

19

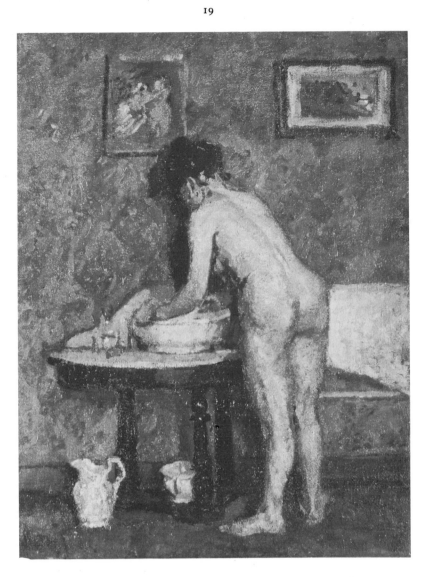

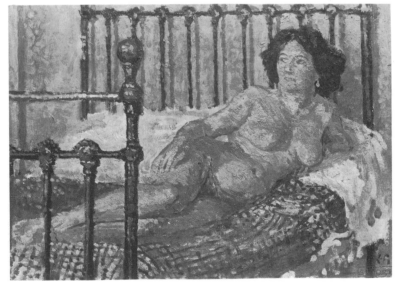

20

Section I: Introductory (1906–11) 133

Gilman

21 **Nude on a Bed** *c.* 1911–12
Oil on canvas, 24 × 18 (61 × 45.7)
Provenance: Edward le Bas; Benjamin Fairfax Hall (who presented it to the present owners, in memory of Edward le Bas)
Literature: Fairfax Hall, rep. in colour Pl. 6
Exhibited: Redfern Gallery 1939, 'The Camden Town Group' (31) lent by E. le Bas; Reid Gallery 1964 (19); Colchester 1969 (27); Fine Art Society 1976, 'Camden Town Recalled' (34)
Collection: The Fitzwilliam Museum, Cambridge (1967)

Gilman first tackled painting from the nude around 1910–11, soon after he became more deeply involved with Fitzroy Street and Camden Town. His wife had deserted him in the summer of 1909 and gone back to her native America with their children. Thereafter Gilman spent more time in London and both his themes and his handling were influenced by Fitzroy Street colleagues, especially by Sickert and Gore. The casual pose of this nude seated amid the rumpled bedclothes is closer to Sickert than to the tidier examples by Gore. The picture is usually dated *c.* 1914. However, the handling, with its firm but delicate modelling in rich smears of paint, suggests it was probably painted *c.* 1911–12. Moreover, the unforced naturalism of the pose supports this suggestion. In later examples Gilman tended to present his models in striking attitudes of arrested movement.

(Reproduced by permission of the Syndics of the Fitzwilliam Museum, Cambridge)

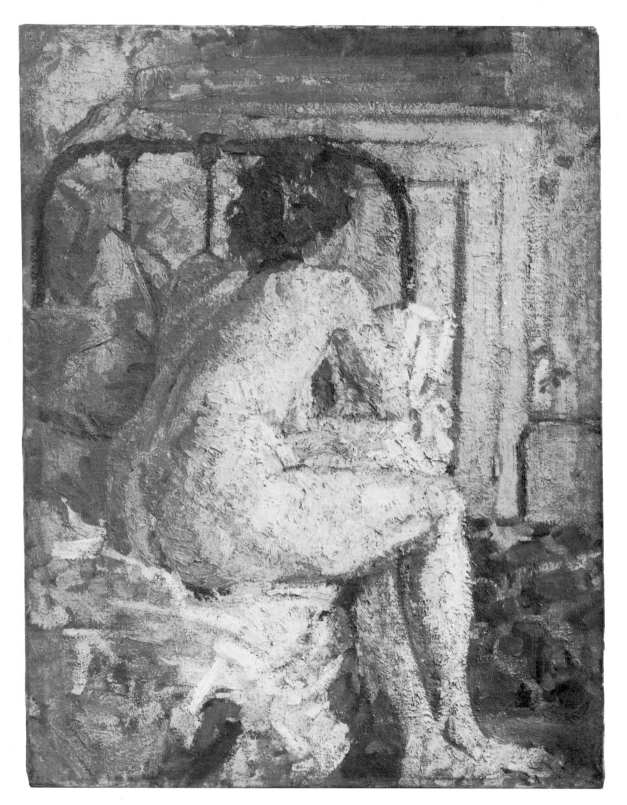

21

Gore

22 Interior. Fireside Scene *c.* 1910
Oil on canvas, 20 × 24 (50.8 × 61); G.98A
Stamped 'S. F. GORE' bottom right
Exhibited: possibly A.A.A. 1911 (121) as *Ballet* (see below); probably Carfax
Gallery 1918 (18) as *Interior*; Colchester 1970 (25); Fine Art Society 1976, 'Camden
Town Recalled' (63)
Collection: City of Leeds Art Gallery and Temple Newsam House (1950)

A contemporary annotation in the Tate Gallery library copy of the A.A.A. catalogue
proves that Gore substituted a portrait of a girl in blue, by a fireplace with a wicker
chair, for the *Ballet* listed. There is, however, another painting which fits this
description even better in the National Art Gallery, Wellington, New Zealand. It is
a close-up view of a woman (said to be the artist's wife) seated by the fire in the same
chair, and was probably painted in 1911. Both are interiors at 31 Mornington
Crescent although the rooms are not the same. An annotation in the Tate Gallery
copy of the Carfax exhibition catalogue of 1918 records 'Fig & fire cat', details
which fit only the painting illustrated.

John Woodeson, in the Colchester catalogue, notes that Mrs Gore identified the
model in the Leeds picture as Miss Archer, daughter of the Reverend O. A. Archer
who was Gore's landlord at 31 Mornington Crescent. The interior is the communal
sitting room of the house where Gore lived until his marriage in January 1912. It
should, therefore, be noted that the many paintings Gore executed in 1911 of his
bride-to-be are not quite accurate in their titles as *The Artist's Wife*.

While it was Sickert who encouraged his Fitzroy Street colleagues to paint
everyday domestic interiors, this picture illustrates how widely Gore (like other
members of the group, e.g. Ratcliffe Pl. 104) departed from the Sickertian
approach. Gore has depicted every detail of the interior with equal emphasis so that
his composition lacks focus. Sickert was always more selective. Although he too
remained objective in representing what he saw, he omitted much detail and
suggested others in summary fashion. His eye was never distracted by peripheral
objects but retained one consistent point of vision.

Sickert

23 Two Coster Girls *c.* 1908
Oil on panel, 14 × 10¼ (35.5 × 26)
Provenance: Vanessa Bell; Mrs A. V. Garnett
Exhibited: Fine Art Society 1976, 'Camden Town Recalled' (135)
Collection: Department of the Environment (1979)

Sickert seldom painted two-figure conversation pieces between the Easter of 1906
(when he had two Belgian sisters to model for him) and 1908. However, in the later
year, Sickert wrote to tell Nan Hudson that he had acquired as models 'two divine
coster girls' – perhaps the two pictured here. The original title of this painting is not

known, but it is related in theme to *The Passing Funeral*, studied in drawings and etched *c*. 1911. *The Passing Funeral* is dissimilar in its detail from this earlier painting, but it also represents a figure seated on a bed while another woman stands to look down at the street from a window. Although Sickert usually employed a thicker touch and brighter colour in his paintings of 1908, he never lost his natural inclination to sketch in the smoother scrubs and planes of darkly subtle tones found in *Two Coster Girls*.

22

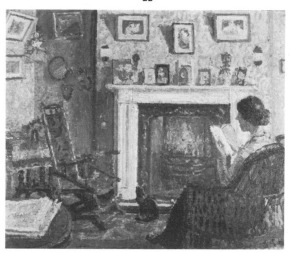

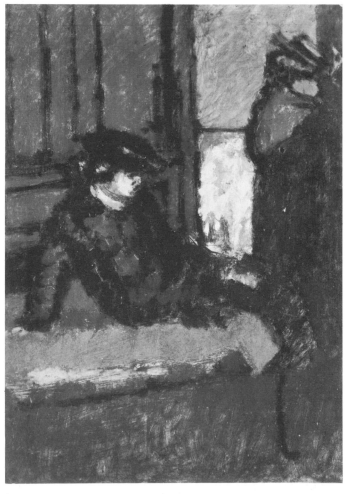

23

Gilman
24 **Portrait of Madeline Knox** *c.* 1910
Oil on canvas, 23 × 18 (58.4 × 45.7)
Signed 'H. Gilman' bottom right
Provenance: R. P. Bevan
Exhibited: Tooth 1934 (32) as *Interior with Standing Figure*; Arts Council 1955 (55) as *Margaret Knox*; Colchester 1961, 'Camden Town Group' (13); Ware Gallery 1967, 'Camden Town Group and English Painting 1900–1930's' (36); Colchester 1969 (18)
Collection: Private

Probably acquired by R. P. Bevan direct from the artist. It was lent to the Tooth's exhibition by Bevan's son. This painting is related in mood, handling and composition to *Meditation* (formerly in the Girling collection). Both pictures show a woman standing with her back to the wall, her head cast down. A portrait sketch of a seated woman, her head resting on her hand, in the National Gallery of Victoria at Melbourne may be related to both these standing portraits although it is different in composition and more broadly executed in scattered dabs and smears of paint. It is possible that Madeline Knox was the model for all three paintings, and if so *Meditation* and the Melbourne *Study* must have been painted in 1910–11. Madeline Knox was a pupil of Sickert at the Westminster School of Art from 1908–10. In 1909 she joined Sickert's etching class at 31 Augustus Street, together with Malcolm Drummond and Ambrose McEvoy, and in the winter helped Sickert establish an etching school at 209 Hampstead Road. She then gave financial and administrative assistance to Sickert when he moved the school to 140 Hampstead Road (Rowlandson House) and expanded the curriculum to cover painting and drawing. She withdrew from the enterprise later in 1910 having been made ill by Sickert's chaotic control. She left for Canada *c.* 1911 (hence the *terminus antequem* for any painting of her) and did not return to London again until 1914–15 when she met Arthur Clifton of the Carfax Gallery whom she later married. She settled in Mersham, Kent, in 1925, gave up painting and took up embroidery (the altar frontal in the Behrend-Stanley Spencer Chapel at Burghclere is her work). She died in 1975.

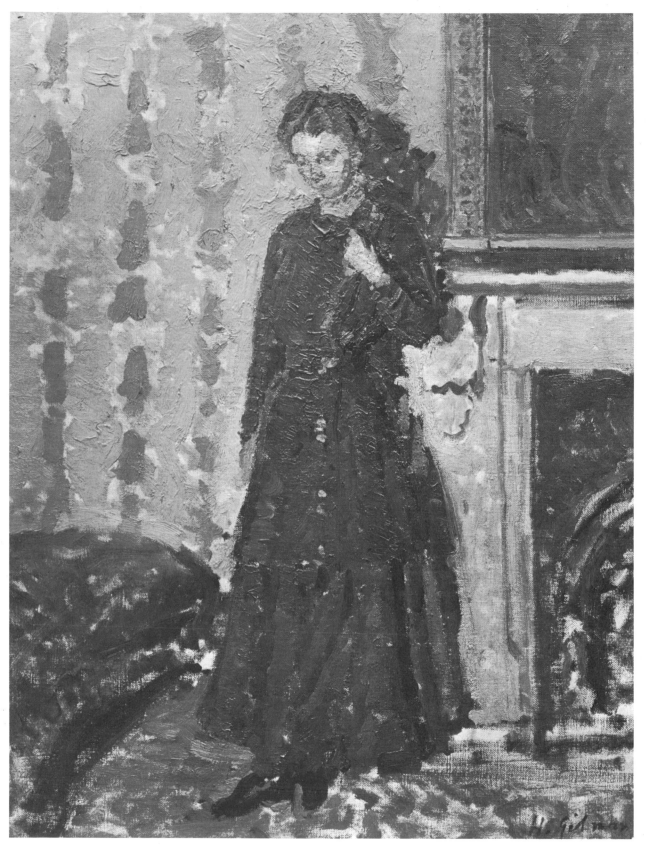

24

Gilman

25 Still Life. The Mantelpiece *c.* 1909–10
Oil on canvas, 12⅜ × 16⅜ (31.4 × 41.6)
Signed 'H. Gilman' bottom right
Provenance: the artist's mother; Capt. S. W. Sykes (who gave it to present owners)
Exhibited: probably Carfax Gallery 1913 (50) as *The Mantelpiece*; Lefevre Gallery 1948 (12); Bedford 1969, 'The Camden Town Group' (15); Fine Art Society 1976, 'Camden Town Recalled' (31)
Collection: The Fitzwilliam Museum, Cambridge (1948)

Overmantel mirrors, reflecting a clutter of bric-à-brac, were a theme of Camden Town painting inspired by Sickert. Sickert himself occasionally painted just the still-life and its reflection, but more usually he incorporated this subject within a wider setting of one or two figures in an interior (e.g. *The Mantelpiece*, Southampton Art Gallery, rep. Baron, Fig. 210). The smooth paint and the low-keyed colour harmony suggest the picture antedates the development of Gilman's broken, crusty touch and his use of brighter colours in 1910.

(Reproduced by permission of the Syndics of the Fitzwilliam Museum, Cambridge)

Gore

26 Conversation Piece and Self Portrait *c.* 1910
Oil on cardboard, 12½ × 14½ (31.8 × 36.8)
Signed with initials 's. f. g.' bottom right
Provenance: R. P. Bevan
Exhibited: possibly N.E.A.C. winter 1910 (137) and Chenil Gallery 1911 (2) as *The Mantelpiece*; Arts Council 1955 (22); Colchester 1961, 'Camden Town Group' (27) as *The Mantelpiece (with self portrait)*; Ware Gallery 1967, 'Camden Town Group and English Painting 1900–1930's' (93); Colchester 1970 (30)
Collection: Private

R. P. Bevan probably acquired this painting directly from Gore because it does not bear the studio stamp applied to the pictures still in the artist's possession at the time of his death in 1914. In this and in another self-portrait of about the same date (private collection), Gore exploited the fact (usually disguised by artists) that he was painting himself as reflected in a glass; in both paintings he deliberately emphasized the accidental nature of the image recorded. In the unillustrated picture the artist is glimpsed in the mirror on the background wall, while the foreground is occupied by a vase of flowers. In the picture reproduced here there are again two subjects, one real, one reflected, but the spatial and the imaginative conceptions have been inverted. Part of the artist's head, seen large in the glass, is blotted out by the card stuck in the frame, while the other cards are used to frustrate comprehension of the space in which he is placed. The central subject and the 'real' image, an exceedingly lifelike figure group, is in fact false, being made of china. Its small

scale, encompassing full-length representations, provides a disturbing contrast to the large scale of the severed portrait head. The painting can be interpreted on different levels. It can be seen either as a demonstration of how the artist can create a painting from his objective observation of the most casual relationships, or as a sophisticated exercise in conceptual picture-making.

25

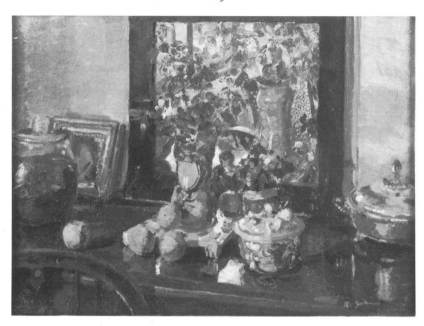

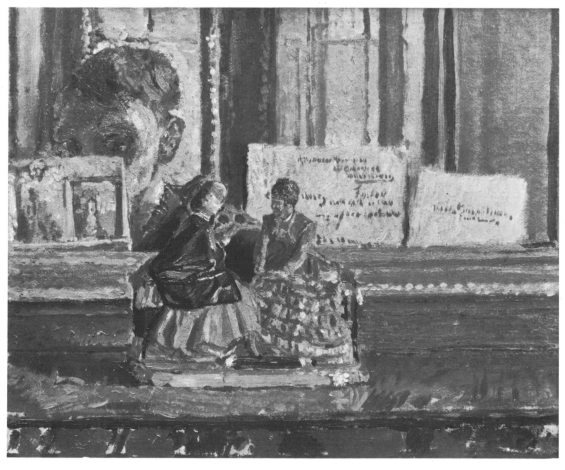

26

Gore

27 **View from a Window** *c.* 1908–9
Oil on canvas, 14 × 10 (35.6 × 25.4)
Provenance: R. A. Harari
Collection: Anthony d'Offay Gallery

Gore's natural sense of design and construction probably led him to develop the idea of painting views, urban and rural, from windows. It is possible that Sickert's *La Seine du Balcon* (private collection, rep. Baron, Fig. 196), painted in Paris in the autumn of 1906, provided his initial inspiration. However, whereas Sickert went outside on to the balcony to paint, Gore generally remained on the inside and made use of the window frames to articulate his compositions. In 1907 both Sickert and Gore (see Pls 33, 34) suggested the landscape behind their figures set before windows, but Gore alone took the next step of omitting the figure. Another more radical example, showing Euston Station through the bars of the nursery window at Rowlandson House, is reproduced on Pl. 125. The location of the view illustrated here is not identified, although the architecture suggests it is in the Camden Town, Hampstead Road neighbourhood.

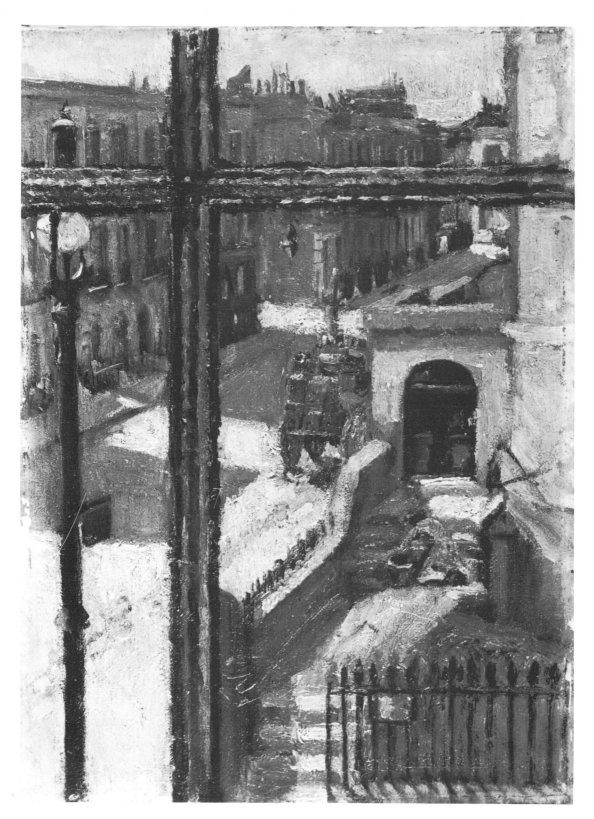

27

Sickert

28 **L'Affaire de Camden Town** 1909
Oil on canvas, 24 × 16 (61 × 40.6)
Signed 'Sickert' bottom right
Provenance: Paul Signac; Fred Uhlman
Literature: Browse 1960, p. 75, rep. Pl. 60; Baron pp. 110–12, 122, 184, 338, 349,
351, C.271, rep. Fig. 190
Exhibited: Bernheim-Jeune, Paris 1909 (15); Arts Council 1960 (117); Hampstead
1965, 'Camden Town Group' (63); Adelaide 1968 (37)
Collection: Private

Signac bought this, the most dramatic and convincing of all Sickert's paintings with
the Camden Town Murder title, from the auction sale at the Hôtel Drouot of the
works exhibited by Bernheim-Jeune in June 1909. It is the only picture on this
theme to have no alternative title. However, even this version is not a recreation of
the event as it happened. Emily Dimmock's naked body was found, in September
1907, lying face downwards; she was blonde and her hair was in curling pins; it was
assumed at the inquest, from lack of signs of resistance, that her throat had been cut
while she slept: all facts at variance with Sickert's picture. Moreover, the composi-
tional springboard for this disturbing work was a tender drawing of two women,
one standing by a bed in much the attitude of the male figure in the painting, the
other lying down and looking towards her; it is entitled *Conversation* (Royal College
of Art, rep. Baron, Fig. 189). Nevertheless, a macabre touch is introduced into this
and other pictures on the theme in that Sickert's male model is said to have been the
commercial artist accused, but finally acquitted, of the murder.

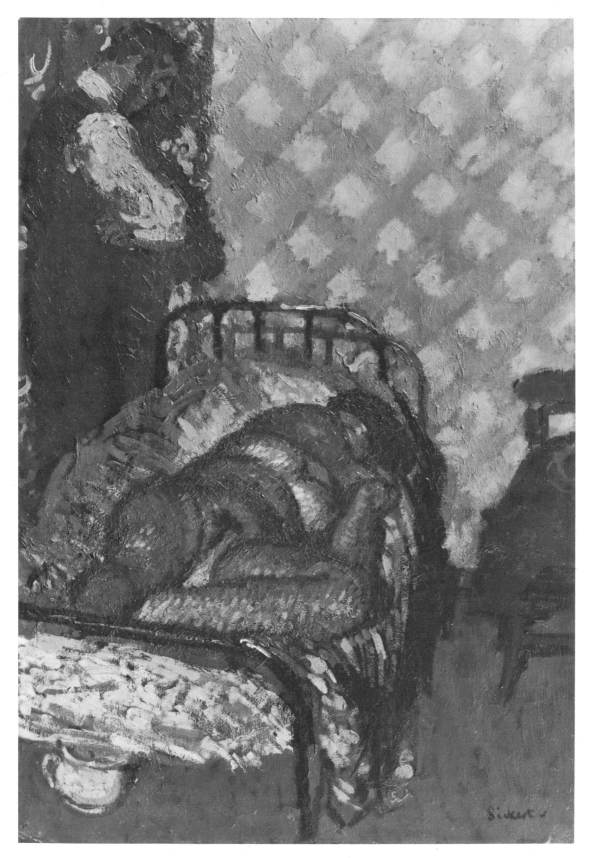

28

Sickert

29 Le Lit de Cuivre *c.* 1906 (colour p. 17)
Oil on canvas, 16 × 20 (40.6 × 50.8)
Signed 'Sickert' bottom left
Provenance: Michael Langworthy
Literature: Baron, pp. 84, 86–8, 337–8, C.209, rep. Fig. 142
Exhibited: possibly Bernheim-Jeune, Paris 1907 (55) and 1909 (40); Roland, Browse & Delbanco 1957 (16); Hirschl & Adler Galleries, New York 1967 (21); Adelaide 1968 (34); Sydney 1968 (27); Fine Art Society 1973 (48); Arts Council 1977–8 (29)
Collection: Private

Either this painting or another version (Royal Albert Memorial Museum, Exeter) was the picture exhibited in Paris in 1907 and 1909. Sickert had begun to draw nudes on metal bedsteads in Dieppe in 1902 and on his return to Dieppe from Venice in 1904 he began to paint such subjects as well. He continued to paint similar nudes when he settled in London, sometimes working from drawings made in France. *Le Lit de Cuivre*, for example, is very close to a pastel drawing called *Le Lit de Fer* (private collection, rep. Baron, Fig. 132) done in France *c.* 1904–5. In many of his post-Venetian paintings of the nude Sickert broke away from a horizontal planar emphasis by placing the bed in diagonal recession or even at right angles to the surface (Pl. 7). Gilman (Pls 21, 82) and Gore (Pl. 20) adopted the same device. *Le Lit de Cuivre* shows how Sickert began to develop a broken, crusty touch in 1906, perhaps under the influence of Gore, although his tones and colours remained dark.

29

Pissarro

30 **Shunting, Acton** 1908
Oil on canvas, $17\frac{1}{4} \times 21$ (43.9 × 53.3)
Signed in monogram and dated 'L P 08'; bottom right
Exhibited: A.A.A. 1908 (1359); Carfax Gallery 1913 (14); Brighton 1913–14,
'English Post-Impressionists, Cubists and others' (61); Fine Art Society 1976,
'Camden Town Recalled' (108)
Collection: the artist's family

In 1907 (see Pl. 100) and 1908 Pissarro painted several railway cuttings around
Acton. His inspiration came from his father's *Lordship Lane Station*, painted when
Camille Pissarro and his family sought refuge in London (1870–1) during the
Franco-Prussian war.

Pissarro

31 **Acton: Morning; Temps Gris** 1906
Oil on canvas, $15\frac{1}{8} \times 18$ (38.4 × 45.7)
Signed in monogram and dated 'L P 1906' bottom right
Provenance: J. B. Manson
Collection: Sotheby's, 19 July 1967, lot 17

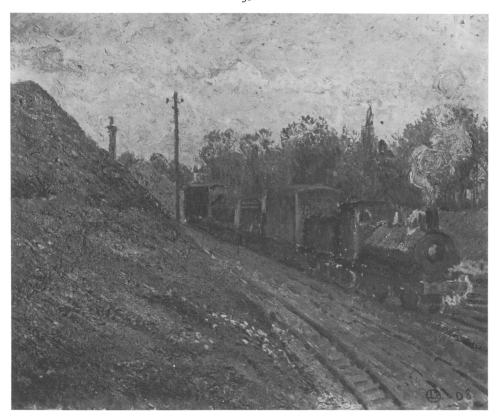

Section 1: Introductory (1906–11) 149

Gore

32 **Yorkshire Landscape with Cottages** *c.* 1907
Oil on canvas, 18 × 24 (45.7 × 61)
Provenance: possibly Sir Augustus Daniel
Exhibited: Fine Art Society 1976, 'Camden Town Recalled' (52)
Collection: Anthony d'Offay Gallery

Almost certainly painted when Gore spent the summer of 1907 with Albert
Rothenstein and Mr and Mrs Walter Russell on a painting trip in Brandsby,
Yorkshire, where they all shared a cottage. In a series of landscape paintings Gore
made extensive use of the divisionist technique he had recently learned from Lucien
Pissarro. He began to build up his pictures constructively, using separate small
touches of one colour at a time throughout his canvas. His colours were often
brilliant; orange, violets and greens are scattered in an ordered harmony that
nonetheless retains a lively, even spontaneous, flavour. The lack of a studio stamp
on this picture suggests it was sold before Gore's death. The 1951 Leicester
Galleries exhibition of the late Sir Augustus Daniel's collection included (No. 70) a
Gore picture with this title.

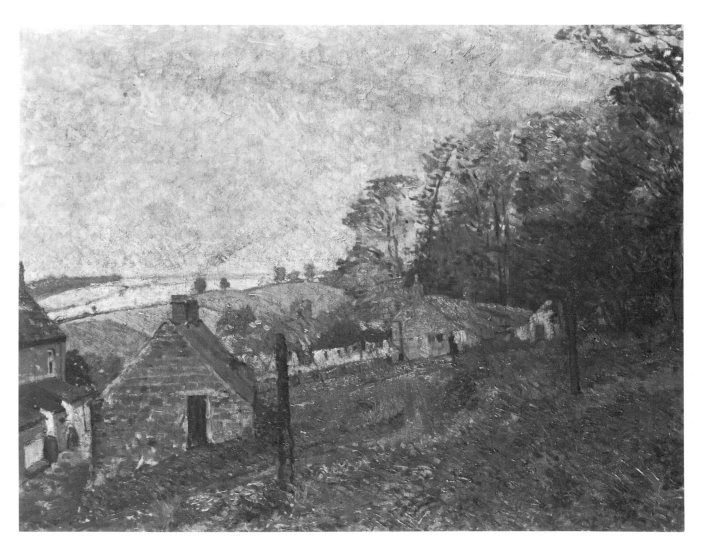

32

Gore

33 **Woman in a Flowered Hat** *c.* 1907
Oil on canvas, 20 × 16 (50.8 × 40.6); G.65
Stamped 's. f. gore' bottom left
Provenance: the artist's family
Exhibited: n.e.a.c. spring 1908 (62) as *Some-one waits*; Arts Council 1953, 'The
Camden Town Group' (28); Arts Council 1955 (8); Plymouth 1974, 'The Camden
Town Group' (15); Fine Art Society 1976, 'Camden Town Recalled' (51)
Collection: Plymouth City Museum and Art Gallery (1958)

Painted at 31 Mornington Crescent. The stretcher label identifies the little figure
glimpsed outside in the street as Sickert, and gives the date as 1907. It is impossible
to know whether Gore painted this picture before or after his summer in Yorkshire.
We do know that Sickert painted his series of pictures showing a young girl at a
window (Pl. 34) during the summer. If Gore painted *Woman in a Flowered Hat*
before leaving London he must undoubtedly have inspired Sickert's work on this
theme; if after, the influences were reversed. Both artists painted their models with
faces in shadow, their bodies framed by the natural light. The tonality of Sickert's
work is much darker but, like Gore, he applied the paint in small, broken touches.
Sickert's pictures are untidier and more suggestive of mood and atmosphere.
Gore's neat pointillism is accompanied by a stronger decorative interest conveyed
not only in the linear patterns but also in the use of colour; the salmon pinks in the
background, for example, are echoed in the flowers on the hat. Gore's constructive,
decorative qualities, as well as his execution, were probably encouraged by Lucien
Pissarro's example, and *Woman in a Flowered Hat* may be usefully compared with
Pissarro's *Orovida wearing a Turban* (Pl. 102) of 1907. The identification of Gore's
painting with *Some-one waits* is based on a contemporary annotation and thumbnail
sketch, indubitably of the Plymouth picture, in a catalogue of the n.e.a.c.
exhibition.

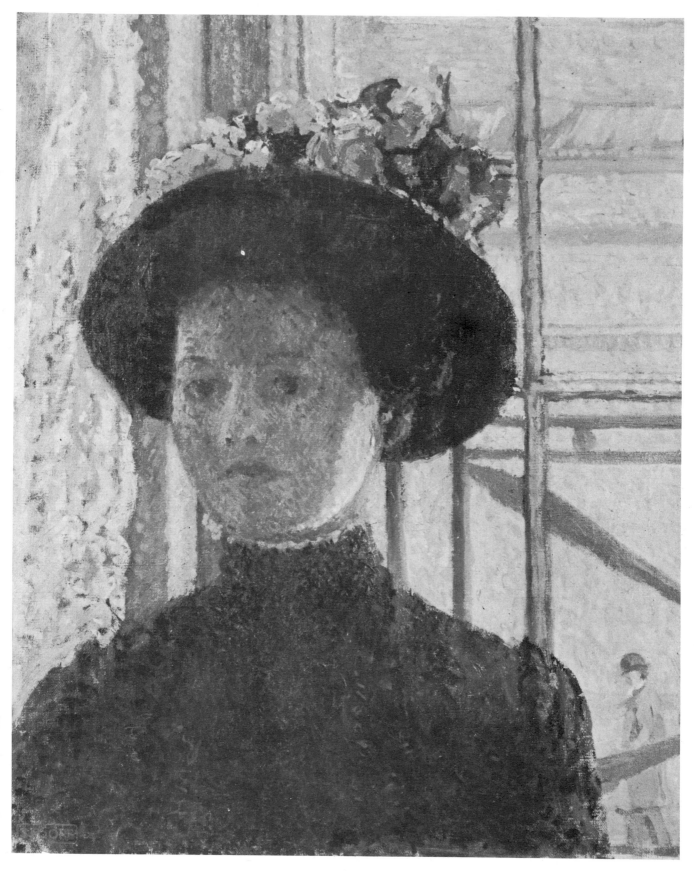

33

Sickert

34 Girl at a Window, Little Rachel 1907

Oil on canvas, 20 × 16 (50.8 × 40.6)
Signed 'Sickert' bottom right
Provenance: probably Hugh Hammersley; Robert Emmons; T. W. Strachan
Literature: Baron, pp. 104, 114, 347, C.263, rep. Fig. 182
Exhibited: Arts Council, Edinburgh 1953 (13); Roland, Browse & Delbanco 1960
(24); Brighton 1962 (31); Fine Art Society 1973 (60)
Collection: Private

In the summer of 1907 Sickert wrote to Nan Hudson that he had become 'entangled
in a batch of a dozen or so interiors' in his rooms at Mornington Crescent, a 'set of
Studies of illumination . . . A little Jewish girl of 13 or so with red hair and a nude
alternate days'. The little Jewish girl, known in paintings as Little Rachel, is
identified in the archives of Thomas Agnew & Sons as Miss Siderman who died aged
70 in 1963. These two series, the portrait studies of Little Rachel (for other versions
see Baron, p. 347, C.263–4) and the Mornington Crescent nudes (see Pls 37, 38),
constitute Sickert's best claim to be regarded as an English Impressionist. Their
real subject is natural light, filtered through dusty windows, and to express his
effects Sickert developed a more consistently broken touch. Nevertheless, his
method of working from drawings and his relatively dark palette (in this painting a
harmony of grey-greens to deep blue, in the nudes the same colours with the
addition of violets and dusty pinks), set him apart from Impressionism. The
landscape outside Sickert's window looks over Mornington Crescent gardens
towards the underground station and the church beyond (finally demolished 1977).
It may be noted that the pattern of Sickert's balcony railings at No. 6 differs from
the lighter arrangement at Gore's rooms in No. 31 Mornington Crescent. Hugh
Hammersley, a discerning collector of Sickert's work, acquired four of his pictures
in 1907. He bought *The Painter in his Studio* (Pl. 36) from the N.E.A.C. exhibition in
the spring, and then came to Sickert's studio to buy 'two nudes and a child at a
window'. The last-named is almost certainly the painting illustrated here. The two
nudes are illustrated as Pls 37, 38.

34

Sickert

35 **The Juvenile Lead. Self Portrait** 1907
Oil on canvas, 20 × 18 (50.8 × 45.7)
Signed 'Sickert' bottom left
Provenance: Mrs Wylde; David Niven
Literature: Browse 1943, p. 48, rep. Pl. 30; Bertram, facing p. 4; Browse 1960, pp.
22, 29, 74, 78, 109, rep. Pl. 55; Rothenstein 1961, rep. Col. Pl. 8; Pickvance 1967,
rep. Col. Pl. IX; Baron, pp. 102, 107, 114, 171, 346, 350, C.257, rep. Fig. 174
Exhibited: Salon d'automne, Paris 1907 (1535) as *L'Homme au Chapeau Melon*;
Savile Gallery 1928 (15); Redfern Gallery 1936 (10); Southampton 1951, 'The
Camden Town Group' (113); Arts Council, Edinburgh 1953 (62); Arts Council
1960 (114); Folkestone 1972 (73); Fine Art Society 1973 (59); Newcastle 1974,
'The Camden Town Group' (58); Fine Art Society 1976, 'Camden Town Recalled'
(131); Arts Council 1977–8 (32)
Collection: Southampton Art Gallery (1951)

This is the 'life-sized head of myself in a cross-light which will I think become
something in time' which Sickert used as 'a punching-ball' when he resolved to
paint more considered, elaborated works. Exhibited in Paris under the prosaic title
noted above, this self-portrait has also been known as *L'Homme à la Billicoque*,
However, the present title must have been invented by Sickert. The picture was
shown at the Savile Gallery in 1928 as *The Juvenile Lead* and it may be assumed that
the gallery acquired the picture directly from the artist, because one of Sickert's
pupils in his Highbury Place, Islington, school in 1927 was Mark Oliver who
helped R. E. A. Wilson run the Savile Gallery. Mrs Wylde, who as Wendela Boreel
had also been a pupil of Sickert, probably bought *The Juvenile Lead* from the 1928
exhibition, for she lent it to the Redfern Gallery show eight years later. The title
may be a piece of retrospective irony. Sickert no doubt remembered the exciting
period of its execution when, as the middle-aged actor-manager of Fitzroy Street,
he directed the efforts of a large cast of younger painters.

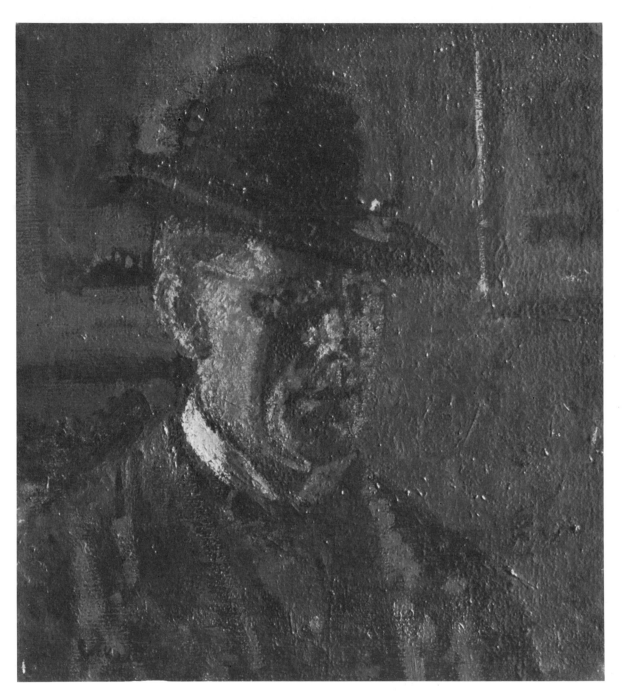

35

Sickert

36 The Painter in his Studio 1907
Oil on canvas, 20 × 24 (50.8 × 61)
Signed 'Sickert' bottom left
Provenance: Hugh Hammersley; Robert Emmons; Mrs George Swinton
Literature: Browse 1943, p. 48; Browse 1960, pp. 74–5, 78, rep. Pl. 58; Baron, pp. 102, 104, 114, 346, C.258, rep. Fig. 178
Exhibited: N.E.A.C. spring 1907 (73) as *The Parlour Mantelpiece*; Arts Council 1964 (16)
Collection: Art Gallery of Hamilton, Ontario (1970)

The evidence proving that this picture is the work exhibited with a somewhat misleading title at the N.E.A.C. is threefold. The Tate Gallery library copy of the catalogue is annotated 'blue specs in face and casts'. A letter from Sickert to Nan Hudson reported, 'the New English is open, and to my amazement and joy my friend Hammersley bought my autoritratto at once'. Another letter to Nan Hudson confirms that this *autoritratto* was indeed the painting now in Hamilton; Sickert, reporting further purchases by Hammersley, mentioned that the collector already had 'my portrait with the casts in the last New English'. The painting was influential. In his catalogue to the 1977–8 travelling exhibition of work by J. D. Innes, John Hoole remarked that Innes's *In the Mirror – Self Portrait* of 1907–8 was executed under the marked influence of Sickert's self-portrait. He also noted that the broken surface of Innes's picture (No. 20 in the exhibition and reproduced in the catalogue) indicated how Innes was, at this period, moving closer to the current techniques of the Fitzroy Street Group, notably Gore and Pissarro. Mr Hoole interpreted the exotic environment in which Innes chose to place himself, surrounded by plants with a curtain draped over the mirror, as a riposte to the austerity of Sickert's representation. It is probable that Malcolm Drummond's *A Sculptor's Studio* (Pl. 63), although not a self-portrait, was inspired by Sickert's work.

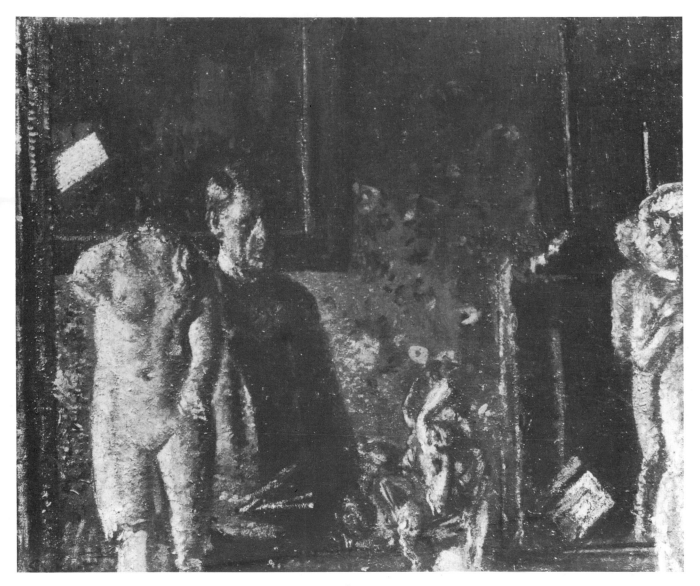

36

Sickert

37 **Mornington Crescent Nude** 1907
Oil on canvas, 20 × 16 (50.8 × 40.6)
Signed 'Sickert' bottom left
Provenance: Hugh Hammersley; Lord Cottesloe; T. W. Strachan
Literature: Browse 1943, p. 49, rep. Pl. 32; Browse 1960, p. 74, rep. Pl. 56; Baron,
pp. 103, 107, 111, 114, 346, C.259, rep. Fig. 175
Exhibited: National Gallery 1941 (not in catalogue); Leeds 1942 (163); Roland,
Browse & Delbanco 1951 (12); Arts Council, Edinburgh 1953 (27); Roland,
Browse & Delbanco 1960 (20); Arts Council 1960 (111); Brighton 1962 (32); Fine
Art Society 1973 (61)
Collection: Private

Drawings related to the preparation of this tender back view of a seated nude were
later developed into a two-figure man and woman group which Sickert etched in
1908 and called *The Camden Town Murder*. This shows how far from Sickert's mind
was any notion of actually illustrating the murder when he was juggling with his
figure compositions. Indeed when he made these first drawings and this painting
the murder had not yet occurred. When he turned the single figure into a two-figure
group his interest was primarily in the formal potential of their relationship. This is
not to say that Sickert's Camden Town figure pictures fail to convey the sense of a
real human situation with real emotional and psychological undertones. However,
the particular anecdotal titles with which Sickert christened his finished pictures
were often chosen as almost arbitrary afterthoughts. The nude illustrated here
– and Pl. 38 – have no such titles, perhaps because they were bought straight from
Sickert's studio as soon as they were painted, and therefore not exhibited.

Sickert

38 **Mornington Crescent Nude. Contre-Jour** 1907
Oil on canvas, 20 × 24 (50.8 × 61)
Signed 'Sickert' bottom left
Provenance: Hugh Hammersley
Literature: F. Wedmore, *Some of the Moderns*, London, Virtue, 1909 as *Camden
Town Interior*; Browse 1943, pp. 47–8, rep. Pl. 29; Baron, pp. 107–8, 114, 346,
C.260, rep. Fig. 179
Exhibited: Agnew 1960 (75); Adelaide 1968 (30); Sydney 1968 (9)
Collection: Art Gallery of South Australia, Adelaide (1963)

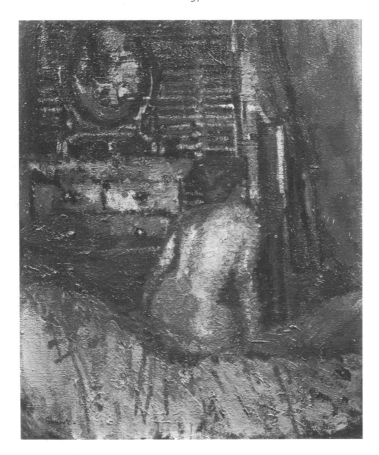

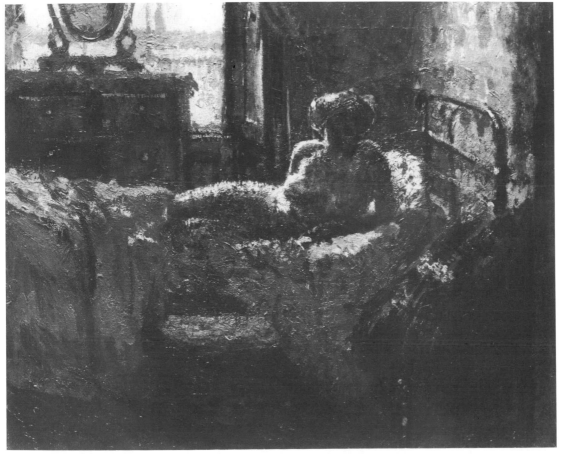

Gore

39 **Morning. The Green Dress** *c*. 1908–9 (colour p. 21)
Oil on canvas, 18 × 14 (45.7 × 35.5)
Provenance: Frank Rutter; J. W. Freshfield
Exhibited: Leicester Galleries 1928 (7) as *The Green Petticoat*; Bedford 1969, 'The Camden Town Group' (19); Colchester 1970 (17); Fine Art Society 1976, 'Camden Town Recalled' (58)
Collection: The Fitzwilliam Museum, Cambridge (1955)

Rutter probably bought this picture directly from the artist as it has no Gilman label and no studio stamp. He lent it to the 1928 exhibition and reproduced it in his *Modern Masterpieces* (published in parts in 1935 and as a whole, London, George Newnes, 1940, p. 198) as *The Green Petticoat*. This title, like the current modification, is not entirely appropriate because the model wears a white petticoat and a green skirt. The title *The Green Dress* more properly describes a smaller painting by Gore (private collection) of the same model, by the same mirror and window, executed in the same technique, this time wearing a green dress. A third picture, entitled *The Mirror* (formerly in Judge Evans's collection, now in the Tatham Art Gallery, Pietermaritzburg), shows the model, seated and seen half-length, in the same setting with the light again slanting in upon her face and figure from the window behind. All three of these paintings by Gore suggest that he had looked very closely at Sickert's Mornington Crescent *contre-jour* interiors of 1907, for example the paintings illustrated as Pls 34, 37, 38. Gore's compositional springboard may well have been Sickert's *Little Rachel at a Mirror* of 1907 now, like Gore's *The Green Dress*, also in the Fitzwilliam Museum collection.

(Reproduced by permission of the Syndics of the Fitzwilliam Museum, Cambridge)

Sickert

40 **Sally – the Hat** *c*. 1909
Oil on canvas, $19\frac{1}{2}$ × $15\frac{1}{2}$ (49.5 × 39.4)
Signed 'Sickert' bottom left
Provenance: Robin Sanderson
Literature: Baron, pp. 111–12, 349, C.274, rep. Fig. 186
Exhibited: probably Lefevre Gallery 1950, 'Camden Town Group' (50); Roland, Browse & Delbanco 1960 (6); Fine Art Society 1976, 'Camden Town Recalled' (142)
Collection: Private

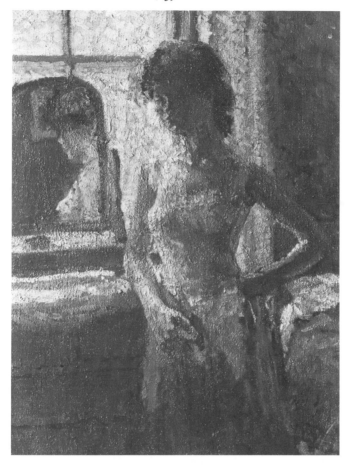

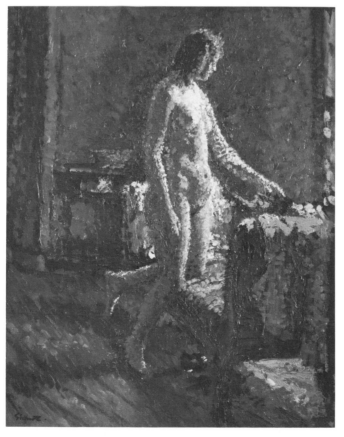

Sickert

41 **The New Home** 1908
Oil on canvas, 20 × 16 (50.8 × 40.6)
Signed 'Sickert' bottom left
Provenance: Judge William Evans; City Art Gallery, Leeds (exchanged 1938 for
another picture); A. J. L. McDonnell; F. A. Girling
Literature: Browse 1943, p. 52, rep. Pl. 39; Rothenstein 1961, Col. Pl. 16;
Pickvance 1967, Col. Pl. XI; Baron, pp. 108, 348, C.267, rep. Pl. 181
Exhibited: N.E.A.C. summer 1908 (59); Goupil Gallery 1918, 'The Collection of the
late Judge William Evans' (105); Redfern Gallery 1936 (20); Sheffield 1957 (97);
Arts Council 1960 (123); Fine Art Society 1976, 'Camden Town Recalled' (136)
Collection: The Fine Art Society Ltd

A sketch and description in a letter to Nan Hudson telling of Sickert's two new
coster models (see note to Pl. 23) identifies *L'Américaine* (Tate Gallery) as one of the
pictures he was currently painting early in 1908. His reference to another picture
suggests it was *The New Home*. He described his model as dressed 'in the
sumptuous poverty of their class. Sham velvet etc. They *always* wearing for
everyday dirty, old, worn clothes, but *Sunday* clothes.' The critic of the *Pall Mall
Gazette* (3 June 1908) also seized on the paraphernalia of the painting in his review of
the N.E.A.C. exhibition: 'Here is a young woman ill at ease, apparently her hat not
yet removed – her head and bust seen large against the mantelshelf – and she taking
very unkindly to the second-rate sordid lodging, to which she is condemned by an
unkindly Fate.' Although Sickert's title encouraged this literary interpretation, the
true subject of his picture is form, colour, light and shade. *The New Home* is the
perfect exemplar of Camden Town portraiture. It sums up Sickert's passionate
visual response to the area where he found the raw material of his art. The dingy
lodging-room, like the 'sumptuous poverty' of his model's dress, had seen better
times. Figure and setting are of equal importance. *The New Home* is not just a
portrait of an individual, but of a whole class and its way of life. In his article 'The
Language of Art' (*New Age*, 28 July 1910) Sickert maintained that the artist could
express 'the whole world of pathos, of poetry, of sentiment' only by his rendering of
the 'plastic facts'. These facts could not be expressed in words; they emerged from
the painter's total subservience to the image before his eye as a pattern of colour,
light and shade. The rich and juicy paint in *The New Home* is caressed and cajoled to
express this image – and everything irrelevant to the pattern, such as the definition
of one of his model's eyes, is excluded.

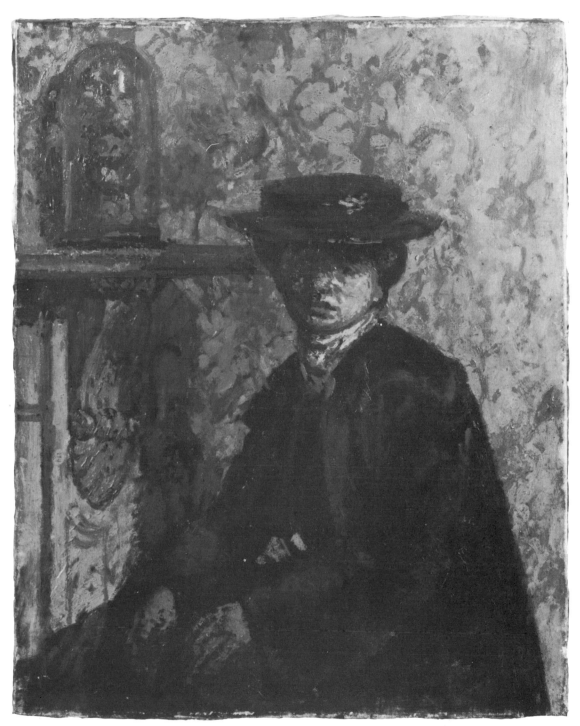

41

Gore

42 **North London Girl** *c.* 1911
Oil on canvas, 30 × 24 (76.2 × 61)
Stamped 's. f. gore' bottom right
Provenance: J. W. Freshfield
Exhibited: Southampton 1951, 'The Camden Town Group' (58); Colchester 1970
(39); Fine Art Society 1976, 'Camden Town Recalled' (66)
Collection: The Tate Gallery, London (1955)

The Tate Gallery catalogue (pp. 248–9) records that J. W. Freshfield bought this
picture from an exhibition of Modern Art at the French Gallery in 1928, and notes
that the model was the housekeeper who served tea at 19 Fitzroy Street on Saturday
afternoons. She also cleaned the studio and worked for the Gores when they lived
from 1912–13 at Houghton Place. As an embodiment of Camden Town portraiture
Gore's picture can be usefully compared to Sickert's *The New Home* (Pl. 41). This
comparison suggests the same differences between Gore's and Sickert's approach
as were noted when discussing Gore's *Interior. Fireside Scene* (Pl. 22). Once again all
parts of Gore's picture are treated with equal emphasis. The patterned materials,
especially the striped curtains, distract attention from the figure, whereas Sickert's
wall-paper, the volute of his mantelshelf, the glass-domed ornament, merely act as a
framework for the figure. The physiognomy of Gore's model is described in such
loving detail that, were we to meet her, we should instantly recognize her. Sickert's
figure, on the other hand, has a wider reality, epitomizing not so much a single
individual as the whole race of 'drabs' who inhabited Camden Town.

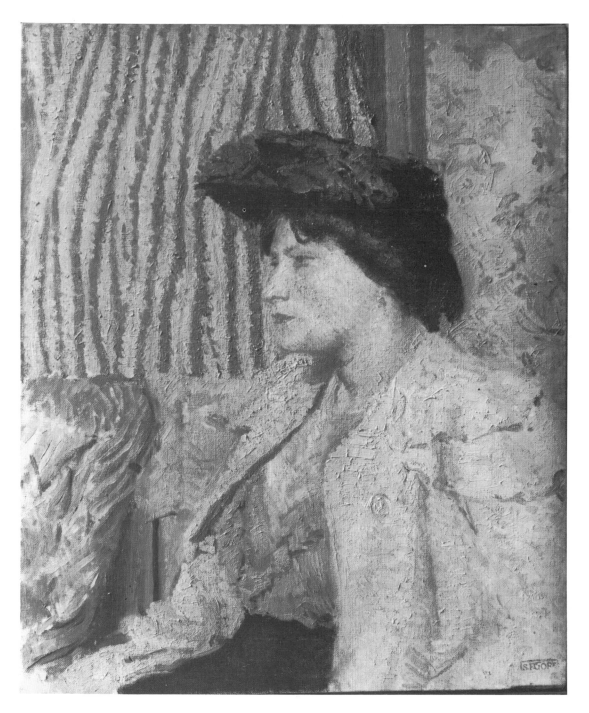

42

Gilman

43 **Contemplation** *c.* 1914
Oil on canvas, 14 × 12 (35.5 × 30.5)
Signed 'H. Gilman' bottom right
Provenance: F. A. Girling
Exhibited: Redfern Gallery 1939, 'The Camden Town Group' (56); Lefevre
Gallery 1948 (25)
Collection: City Art Gallery, Glasgow (1974)

Although exhibited under the title given above in 1939 and 1948, this picture has
since been described as *Contemplation Mary L.* It is a smaller, and probably
preliminary, version of *Girl with a Teacup* (formerly collection Edward le Bas, now
with Agnew & Sons). This larger picture was exhibited as *Girl at a Table* in the 1939
Redfern Gallery show. It is difficult to understand why the sitter has been identified
as *Mary L.* (said to have been an Austrian friend of the artist) because she does not
resemble the model in another portrait (also from the le Bas collection, Christie's, 3
March 1978, lot 115) called *Mary L.* This third picture has no alternative title and
thus may well represent Gilman's friend. *Contemplation* is more likely to represent a
model of humble class, as was the case in Sickert's *The New Home* (Pl. 41) and
Gore's *North London Girl* (Pl. 42). The traditional date for this portrait is 1915, but
stylistically an earlier dating is indicated. The paint surface has greater movement,
the outlines are less precise, and the colours less uniform than was common in
Gilman's work of 1915. In handling it is much closer to *The Coral Necklace* (Pl. 133),
a dated work of 1914 which is, incidentally, almost certainly a portrait of *Mary L.*

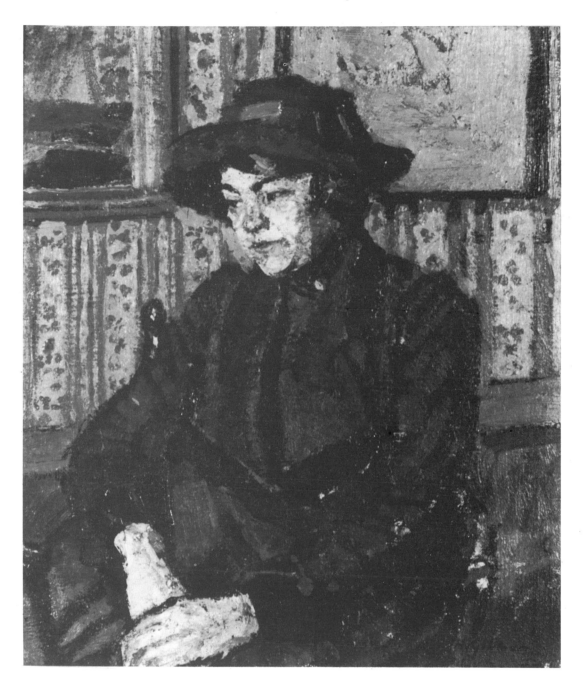

43

Manson

44 **Summer Day, Douélan, Brittany** 1907
Oil on canvas, 19½ × 23½ (49.5 × 59.7)
Signed 'J. B. Manson' bottom right
Provenance: Mrs Herbert Somervell; F. A. Girling
Exhibited: Leicester Galleries 1930, 'The Camden Town Group' (10)
Collection: sold Sotheby's, 18 July 1973, lot 38

Douélan, a small village set against an inlet of the sea, was a spot much favoured by English artists. Henry Lamb, for example, painted his portraits of Edie McNeill there (Pl. 70). From 1905 onwards, Manson often painted in Brittany and in 1907 he lighted upon Douélan. The paintings he did of the village and its surrounding landscape are among his most considered Impressionist works. Manson's development, however, was independent of the Fitzroy Street Group which he did not join until 1911, having been introduced by Pissarro whom he had met towards the end of 1909.

Gilman

45 **Cave Dwellers, Dieppe** 1907
Oil on canvas, 10 × 14 (25.4 × 35.5)
Signed and dated 'H. Gilman 1907' bottom right
Provenance: Sir Louis F. Fergusson; Rex Nan Kivell; R. A. Bevan
Literature: Lewis and Fergusson, p. 20, rep. p. 81
Exhibited: A.A.A. 1908 (1386); Carfax Gallery 1913 (38); Arts Council 1954 (10); Colchester 1969 (5); Fine Art Society 1976, 'Camden Town Recalled' (25)
Collection: Ashmolean Museum, Oxford (1957)

Louis Fergusson recalled telling Gilman how highly he prized this picture, and the artist's reply: 'There must be something in it . . . Sickert and Pissarro both liked it. But it all seems to me a very long time ago.' Gore thought this quaint scene looked like peasants in a work by the Le Nain brothers. Quentin Bell aptly described it (*Motif* II): 'these unhappy looking troglodytes stand aligned as though for inspection by a visiting anthropologist with a camera.' Gilman painted *Cave Dwellers* while staying in Sickert's house in Neuville. In subject-matter and composition it is unique, although the central figure of this odd family group anticipates Gilman's interest in portraying women in old age.

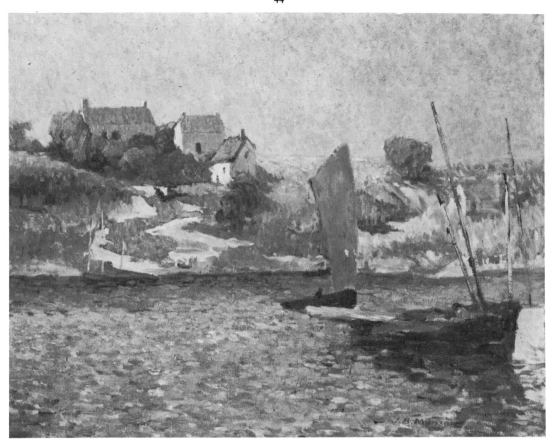

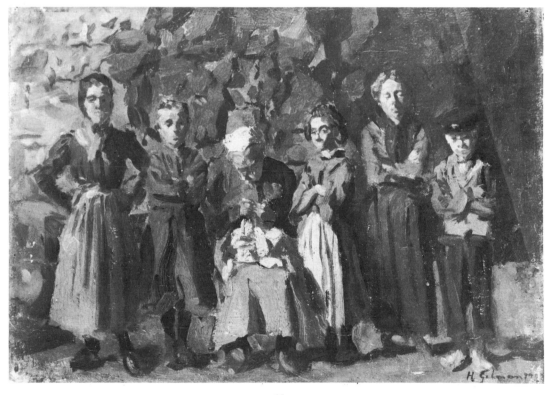

Section 1: Introductory (1906–11) 171

Gilman

46 **The Kitchen** *c.* 1908
Oil on canvas, 24 × 18 (61 × 45.7)
Signed 'H. Gilman' bottom right
Exhibited: probably Goupil Gallery 1914 (3) and Leicester Galleries 1919 (35);
Lefevre Gallery 1948 (1)
Collection: National Museum of Wales, Cardiff (1957)

The date 1905 was given for this work at the Lefevre Gallery exhibition in 1948, but this seems much too early. The interior is probably of 15 Westholme Green, Letchworth, where the Gilmans lived together from the summer of 1908 until Mrs Gilman left with the children for America a year later. Stylistically, the flat, oily paint surface, the cool tonal harmony and the tidy organization of the composition are related to such paintings of 1908 as *The Nurse* (City Art Gallery, Birmingham).

Gilman

47 **The Thames at Battersea** *c.* 1907–8
Oil on canvas, 23 × 35 (58.4 × 88.9)
Signed 'H. Gilman' bottom right
Exhibited: Southampton 1951, 'The Camden Town Group' (22) as *The Thames at Hammersmith*
Collection: Museum and Art Gallery, Kirkcaldy (1951)

Memories of Whistler and his followers perhaps inspired Gilman to treat this subject. When this picture was exhibited at Southampton in 1951 (lent by the Lefevre Gallery) a note stated that it had been previously shown in the Lefevre Gallery Gilman exhibition in 1948 as No. 9. However, the 1948 catalogue gave dimensions, and No. 9 in that show was *The Thames at Chelsea*, measuring only $10\frac{1}{2}$ × $14\frac{1}{2}$ inches. This smaller picture may well be the one sold from the D. Lutyens collection at Sotheby's, 15 December 1971, lot 27. These two pictures are uncharacteristic of Gilman's subject-matter at this period, and urban landscape did not re-enter his vocabulary until he became more closely involved with his colleagues in Fitzroy Street from 1909–10 onwards.

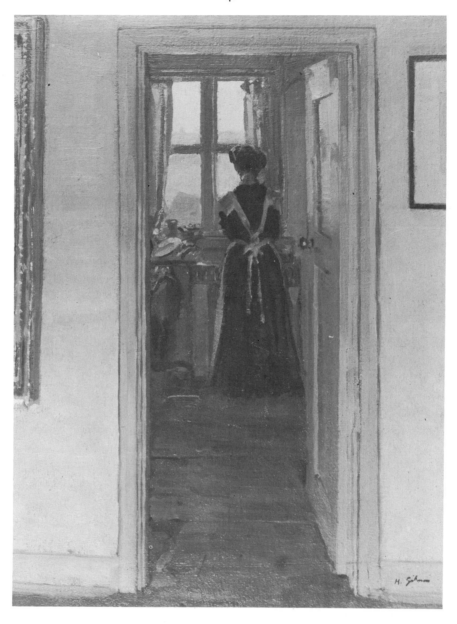

Innes

48 **Resting** *c.* 1908
Oil on canvas, 18 × 24 (45.7 × 61)
Provenance: Arthur Crossland
Literature: Fothergill, rep. Pl. 5
Collection: Private

By nature Innes was a painter of romantic landscape. However, at a few periods in his brief life, notably when he was in contact with the Fitzroy Street Group in London, he tackled interior scenes. The influence of Sickert on his self-portrait *In the Mirror* has been mentioned under Plate Note 36. *Resting*, together with a portrait of Innes's friend Derwent Lees called *Moonlight and Lamplight* (rep. Fothergill, Pl.4), are probably works of about the same date. Again Sickert's influence is apparent, especially in *Resting* where Innes sternly dispensed with exotic trappings. *Resting* harks back in particular to the interiors Sickert painted at 8 Fitzroy Street around Easter 1906 (e.g. *Easter Monday*, rep. Baron, Fig. 151). Innes constructed his picture from the same components as Sickert (a bed, chair, pictures on the wall, and a figure), although his choice of a model with gypsy features and wild black hair somewhat vitiates his attempt to recreate an aspect of everyday life. In 1911–12, when Innes was again in contact with members of the Camden Town Group, he flirted with another uncharacteristic theme to produce three theatrical interiors, *The Circus* (watercolour, Victoria and Albert Museum, London), *At the Theatre* (private collection) and *The Prize Fight* (City Art Gallery, Manchester). For details of these 1912 works see John Hoole's catalogue to the Innes exhibition 1977–8 where the two paintings are reproduced (as they are in Fothergill, Pls 31, 33).

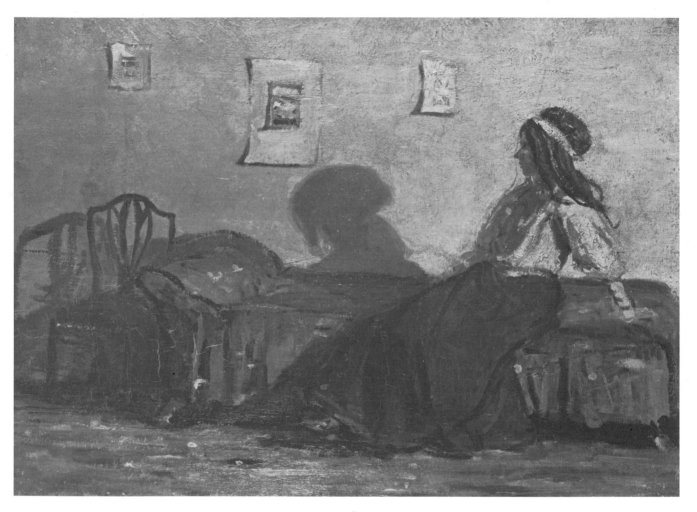

48

Bevan

49 **Ploughing on the Downs** *c.* 1906–7
Oil on canvas, 16½ × 20½ (41.9 × 52)
Provenance: Colonel M. V. B. Hill
Literature: mentioned R. A. Bevan, under Pl. 21
Collection: Christie's, 12 July 1974, lot 270, bought Hamet

A completely worked out study for the painting (Aberdeen Art Gallery) which
Bevan exhibited, under the title *Ploughing the Hillside*, at the Baillie Gallery in 1908.
The final painting is, however, executed in an even smaller, more deliberately
divisionist, touch. Until 1907 Bevan usually worked in the studio from oil sketches
made from nature. After this date, presumably encouraged by the practice of his
Fitzroy Street colleagues, he worked increasingly from squared-up drawings. The
location of Pl. 49 is in the Sussex Downs, near Lewes, where Bevan spent the
summers of 1905 and 1906. Apart from *Early Morning on Exmoor* (rep. R. A. Bevan,
Pl. 11) of 1897, which could be the *Early Morning* exhibited at the A.A.A. in 1908,
Bevan's Sussex pictures are his first major landscape paintings to depict English
subjects instead of scenes studied on his frequent visits to Poland following his
marriage to Stanislawa de Karlowska in 1897.

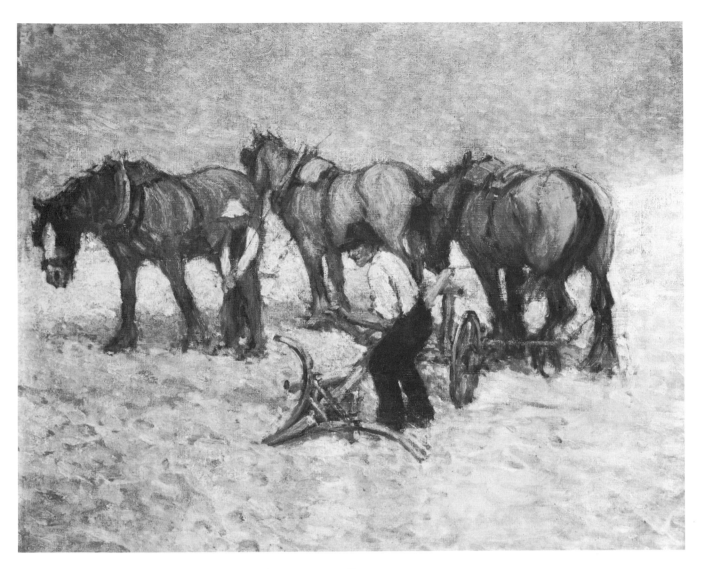

49

Ginner

50 **Tâche Décorative – Tulipes** 1908
Oil on panel, $8\frac{5}{8} \times 5\frac{1}{2}$ (22 × 14)
Signed with initials 'CIG' bottom right
Provenance: Judge William Evans
Literature: Ginner, Vol. 1, p. xxix
Exhibited: Salon Costa, Buenos Aires, 1909
Collection: Peyton Skipwith Esq.

Many of the paintings Ginner executed before coming to London at the end of 1909 were exhibited in Buenos Aires. Ginner also recorded in his notebooks that this little flower sketch was exhibited at 19 Fitzroy Street, meaning that it was on view on Saturday afternoons. Judge Evans, one of the best patrons of the Fitzroy Street Group, probably bought it direct from the studio at No. 19. The 'I' between the initials 'C' and 'G' (for 'Charles Ginner') in the signature on this picture denotes the artist's second name, Isaac; it is found only in his earliest works.

Ginner

51 **Still Life. Geraniums, Fruit and Flowers** 1911
Oil on canvas, $16\frac{1}{4} \times 21\frac{1}{4}$ (41.2 × 54)
Signed 'C. GINNER' bottom right, with 'I' (his middle initial) superimposed
Provenance: Judge William Evans; Hugh Blaker; Edward le Bas
Literature: Ginner, Vol. 1, p. xxxv; Fairfax Hall, rep. in colour Pl. 17
Exhibited: Goupil Gallery 1918, 'The Collection of the late Judge William Evans' (146 or 147); Arts Council 1953 (1); Fine Art Society 1976, 'Camden Town Recalled' (41)
Collection: Private

Judge William Evans commissioned this *Still Life* in 1911, having bought another (*Flowers, Fruit and Basket*) from 19 Fitzroy Street in the same year. Still-life painting, of a deliberately decorative kind, was one of Ginner's specialities. It is possible that his example encouraged several Fitzroy Street colleagues to forsake their casual arrangements of bric-à-brac in favour of artificial and explicitly ornamental subjects. Certainly, from about 1911 onwards, decorative still-lifes form a distinct, if minor, rôle in the vocabulary of Camden Town painters. Examples are given in Plates 52–54.

Section I: Introductory (1906–11) 179

Gilman

52 **Interior with Flowers** *c.* 1911
Oil on canvas, $24\frac{1}{8} \times 28\frac{1}{4}$ (61.3 × 71.8)
Signed 'H. Gilman' bottom right
Exhibited: Colchester 1961, 'Camden Town Group' (4); Colchester 1969 (30)
Collection: Walker Art Gallery, Liverpool (1945)

According to Julian Agnew the signature is stamped. There is doubt about the date of this painting and it has been placed as late as 1912–14. I feel that its frankly pretty quality, as well as the handling and texture of the paint, place it nearer in date to *Lady on a Sofa* (Pl. 81).

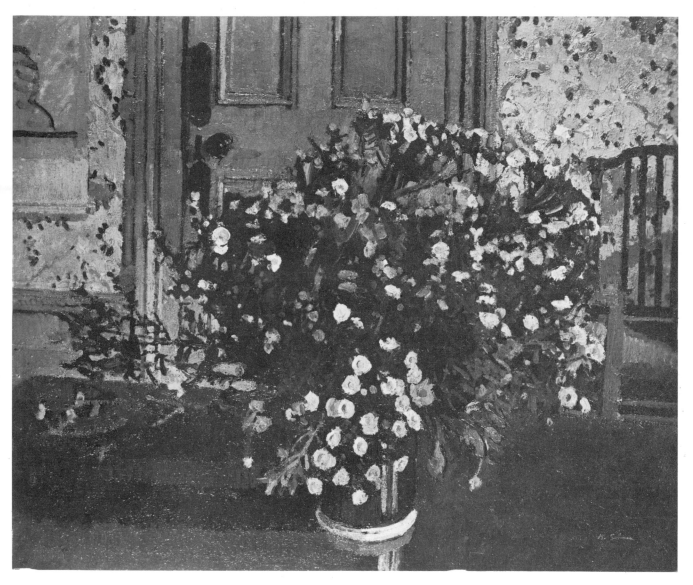

52

Gore

53 **Still Life with Apples** *c.* 1912
Oil on canvas, 15 × 20 (38.1 × 50.8)
Signed 'S. F. Gore' bottom right
Provenance: E. C. Gregory; John Gibbs; John Russell
Exhibited: Carfax Gallery 1913 (15) as *Apples*; Colchester 1970 (54)
Collection: Ferens Art Gallery, Kingston upon Hull (1961)

A rare still-life by Gore in which his interest in patterning the surface of his picture is especially explicit. Gauguin's example probably inspired the angled, high, close-up viewpoint, while the constructive modelling of the apples owes something to Cézanne's influence.

Ratcliffe

54 **The Window** 1913
Oil on canvas, 19½ × 15½ (49.5 × 39.3)
Signed and dated 'W. Ratcliffe 1913' bottom right
Provenance: Lewis Falk Ltd
Exhibited: London Group summer 1916 (77); Letchworth 1954 (26); Fine Art Society 1976, 'Camden Town Recalled' (117)
Collection: Anthony d'Offay Gallery

Bevan

55 **Adelaide Road in Sunlight** *c.* 1910
Oil on canvas, 19 × 24 (48.2 × 61)
Literature: R. A. Bevan, rep. Pl. 34
Exhibited: Colnaghi 1965 (22)
Collection: Private

Bevan settled at 14 Adamson Road, near Swiss Cottage, in 1900. Many of the streetscapes he painted from about 1910 onwards, like his cab-yard subjects, represented scenes close to where he lived. The dramatic design of this picture, articulated by a few carefully placed accents, is softened by its delicate broken handling. In 1922 Bevan returned to the subject of *Adelaide Road* (Museum of Fine Arts, Boston, rep. R. A. Bevan, Pl. 77). Although the later picture is not a version of the painting illustrated here, Bevan again chose to paint strong effects of sunlight and he retained the idea of showing the road disappearing over the brow of a hill. The sudden perspective and the harsh light are emphasized in the 1922 painting by the angular drawing and the application of the paint in flat, strongly contrasting planes of colour.

Bevan

56 **The Cab Yard – Morning** *c.* 1910
Oil on canvas, 24 × 29 (61 × 73.7)
Provenance: the artist's family
Exhibited: N.E.A.C. winter 1910 (82); probably Leicester Galleries 1930, 'The Camden Town Group' (39); Lefevre Gallery 1944 (7); Lefevre Gallery 1950, 'Camden Town Group' (6); Fine Art Society 1976, 'Camden Town Recalled' (7)
Collection: Private

According to R. A. Bevan (pp. 16–17) his father's first cab-yard picture was probably *The Hansom Cab*, formerly in the collection of Judge William Evans (present whereabouts unknown), of about 1907–8. However, most of Bevan's cab-yard, as opposed to his horse-sale, pictures were painted in 1910 (see also Pls 75, 77). They were all studied in the cab-yard in Ormonde Place, St John's Wood, a short walk from his house. Bevan was interested not only in the patterns created by the contrasting shapes of horses, men, buildings and cabs but also, most specifically in 1910, in the different effects of light on his scene. A picture complementary to this one, showing the cab-yard in the evening, is reproduced by R. A. Bevan as Pl. 33. Around 1912 Bevan ceased painting cab-yard scenes and thereafter his equine London subjects are all of horse markets. R. A. Bevan relates (p. 17) that his father told him he gave up painting hansom cabs because 'he was anxious not to be accused of sentimentalising about an almost vanished feature of London life'.

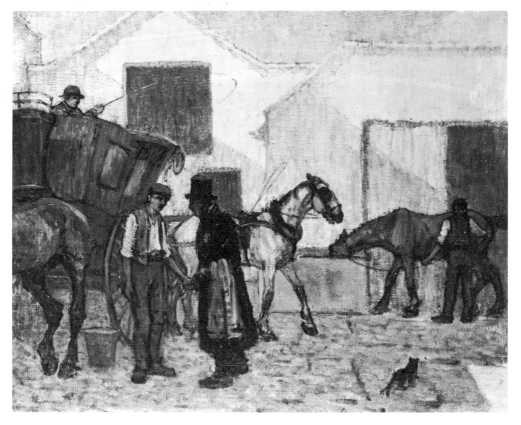

56

Gore

57 **The Cricket Match** *c.* 1908–9
Oil on canvas, 20 × 24 (50.8 × 61); ?G.82
Stamped 's. F. GORE' bottom right
Provenance: probably Mrs Smith Masters
Exhibited: A.A.A. 1911 (120) as *Landscape*; probably Leicester Galleries 1928 (60);
Southampton 1951, 'The Camden Town Group' (53); Arts Council 1953, 'The
Camden Town Group' (30); Arts Council 1955 (18); Colchester 1970 (14)
Collection: City Art Gallery, Wakefield (1945)

The Tate Gallery catalogue of the 1911 A.A.A. exhibition is annotated with the words
'cricket match' by Gore's *Landscape*. The scene was painted at Hertingfordbury,
near Garth House where Gore's mother lived. There is, perhaps, a memory of
Steer's early work in the delicate manner in which the figures are suggested, but on
the whole this painting is executed in the considered divided touch characteristic of
Pissarro and Bevan within the Fitzroy Street Group. Mrs Smith Masters lent a
picture entitled *The Cricket Match (1908)* to the Leicester Galleries exhibition in
1928. No other painting of this subject is known.

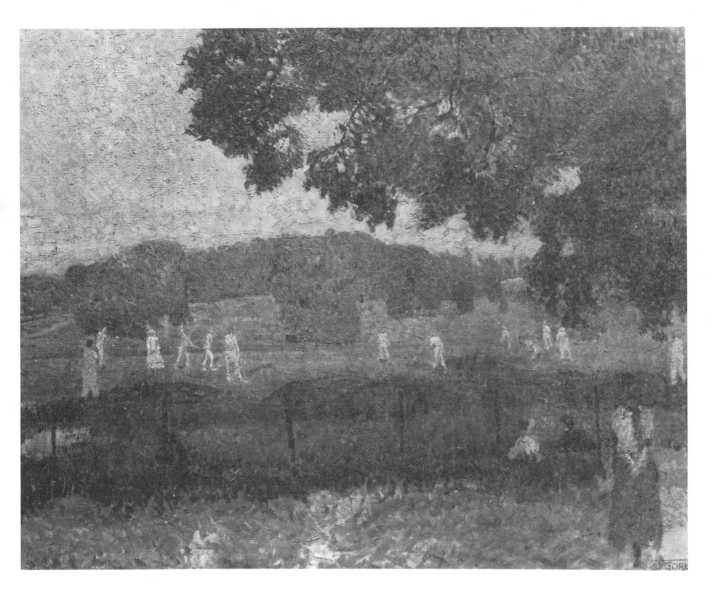

57

Gore

58 **Tennis in Mornington Crescent Gardens** *c.* 1909
Oil on canvas, 20 × 24 (50.8 × 61); G.93A
Signed 'S. F. Gore' and stamped 's. F. GORE' bottom right
Provenance: F. A. Girling
Exhibited: possibly Carfax Gallery 1918 (15); Colchester 1970 (18)
Collection: Sotheby's, 13 March 1974, lot 40, bought Roy Miles

Gore painted this subject several times in 1909 and 1910. Two pictures with this title were exhibited at the Leicester Galleries in 1928 (64, 80), one at the Redfern Gallery in their 1939 Camden Town Group exhibition (15) and two from the artist's family collection, each 16 × 20 inches, were included in the Redfern Gallery exhibition of 1962 (39, 46). These two smaller pictures may well be the ones shown at the Leicester Galleries. The Art Gallery at Auckland has another version. The site of the gardens is now occupied by the building originally erected in 1926 for the Carreras cigarette factory.

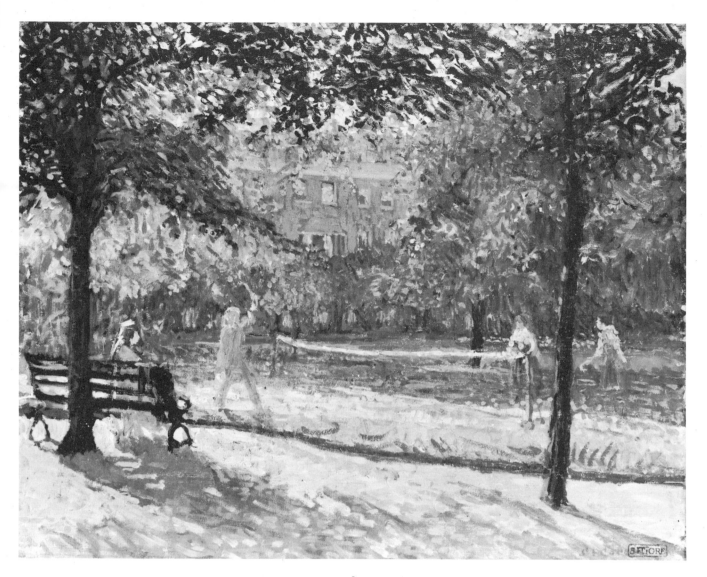

58

Gore

59 **From the Garden of Rowlandson House** 1911
Oil on canvas, 25 × 30 (63.5 × 76.2)
Provenance: Lady Ottoline Morrell; Wilfrid A. Evill; Samuel Carr
Exhibited: possibly Carfax Gallery December 1911, 'The Camden Town Group'
(16) as *The Garden*
Collection: Toledo Museum of Art, Ohio (1952)

This picture has no studio stamp and therefore probably entered Lady Ottoline
Morrell's collection before Gore's death. Its early exhibition history is unknown. It
could be the *Landscape* exhibited (89) at the A.A.A. in 1912 which, according to an
annotation in the Tate Gallery copy of the catalogue, showed a view of a street from a
London garden in summer. However, other pictures by Gore fit this description.
Similarly, it could be *The Garden* exhibited in the second Camden Town Group
exhibition. For a discussion of this possibility see the note appended to the list of
Gore's work on this occasion. The problem of identification is complicated because
the painting had lost its original title when acquired by the Toledo museum as
Mornington Crescent. It is not Mornington Crescent. The terrace houses in the
background represent the west side of Hampstead Road as far as Rutland Street, as
seen from the side of 140 Hampstead Road (all now demolished). 140 Hampstead
Road, a substantial end of terrace house, was taken over by Sickert in 1910 as the
headquarters of his most ambitious private art school. The name Sickert gave the
school has no historical basis. It marks no more than his admiration for the great
comic draughtsman, Thomas Rowlandson (1756–1827). He closed the school in
June 1914. Gore taught a children's class at Rowlandson House and during the
summer vacation of 1911 Sickert gave him the use of the entire premises. Gore used
this opportunity to paint many pictures, including views from its upper windows
(e.g. Pl. 125) and scenes of the garden taken from different angles. His future wife
was often represented in this wild and luxuriant context. The balustrade of the
garden staircase, described in the Toledo painting, reappears in several other
pictures including *The Garden, Rowlandson House* (exh. Anthony d'Offay 1974,
No. 14, rep. in catalogue in colour) and *The Garden of Rowlandson House* (National
Gallery of Victoria, Melbourne). Gore painted the Melbourne picture from the
opposite side to represent part of the back, rather than the front, garden of the
house. This Melbourne painting, showing benches against the garden walls, may
well be *The White Seats* first exhibited at the Carfax Gallery in January 1913 and
again at Brighton in the winter. Another version of *The Garden of Rowlandson House*
(Art Collection of Hull University) represents much the same view as in Sickert's
painting illustrated here as Pl. 61.

59

Gore

60 **The Back Gardens, from 2 Houghton Place** *c.* 1912–13
Oil on canvas, 24 × 26 (61 × 66); G.163
Stamped 'S. F. GORE' bottom right
Provenance: the artist's family
Exhibited: possibly N.E.A.C. summer 1913 (169) and London Group 1914 (8);
Lefevre Gallery 1950, 'Camden Town Group' (29); Hampstead 1965, 'Camden
Town Group' (44); Colchester 1970 (55); Anthony d'Offay 1974 (25) rep. in colour
Collection: Anthony d'Offay Gallery

One of several views of the back garden of 1 Houghton Place (next door to Gore), the
back of a facing house in Eversholt Street, and the gardens of a terrace in Lidlington
Place which joined Houghton Place and Eversholt Street. It is not possible to sort
out which pictures were exhibited in early exhibitions. The 1918 Carfax Gallery
exhibition included two paintings *From Houghton Place* (10, 17) but these could
have been views from a front window of the house such as the painting now in the
Art Gallery of Perth, Australia. An annotation in the Tate Gallery copy of the
catalogue of the Paterson and Carfax Gallery exhibition in 1920 describes *Houghton
Place* (19) as 'back gardens & tree trunk', but which version it is impossible to say.
The Leicester Galleries 1928 exhibition included two paintings of gardens from the
same address (33, 69). A painting called *The Back Garden*, not necessarily a
Houghton Place subject, was shown at the Carfax Gallery in January 1913 (12). The
artist lived at Houghton Place from 1912–13. The bare trees seen in this and other
paintings of the subject prove they were studied in the winter. Other versions
include a painting in the Museum of Fine Arts, Boston, and a painting called *The
Chicken Run*, sold from Miss Ethel Sands's collection at Christie's, 12 June 1970,
lot 11, rep. in catalogue. This last version is treated less schematically and was
probably painted directly from nature.

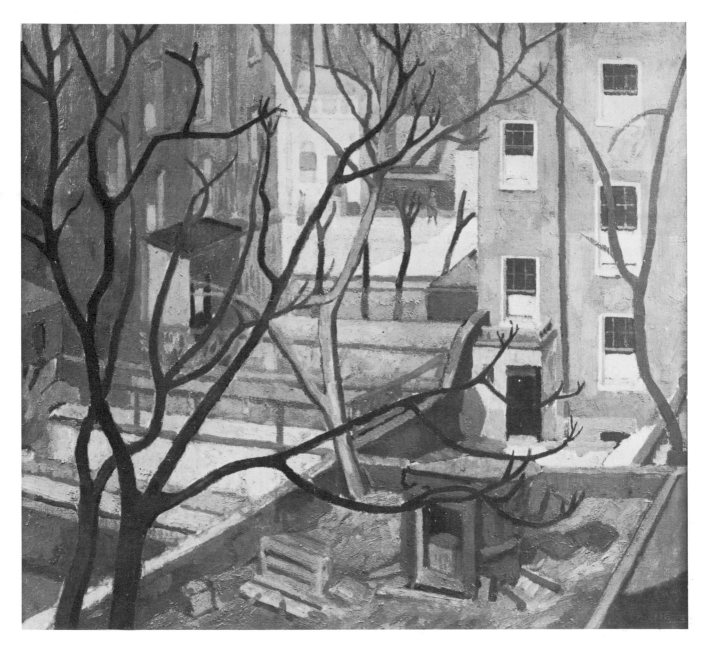

60

Sickert

61 **The Garden of Rowlandson House – Sunset** *c.* 1910–11
Oil on canvas, 24 × 20 (61 × 50.8)
Signed 'Sickert' bottom left
Provenance: Lord Henry Cavendish-Bentinck
Literature: Baron, pp. 117, 352, C. 290, rep. Fig. 200
Exhibited: Whitechapel 1914, 'Twentieth Century Art' (434); Fine Art Society 1976, 'Camden Town Recalled' (143)
Collection: The Tate Gallery, London (1940)

Rowlandson House was one of a terrace of only three houses built between the railway tracks and Hampstead Road. In this painting Sickert was looking over the wall of his garden, past the backs of the next two, much narrower, houses to glimpse the rather grand united façade of the terrace built from No. 247 Hampstead Road (Wellington House Academy where he had a studio) to the opening of Mornington Crescent. He painted this same distant terrace over his garden wall, omitting the house backs represented here, in a painting now in the Art Gallery of Aberdeen; yet another version of this subject was sold at Christie's, 1 March 1974, lot 116. Both of these pictures appear, stylistically, to be later works than the version illustrated. Neither has the dramatic sunset effect which Gore also used in some of his London landscapes.

Gilman

62 **Mornington Crescent** *c.* 1912
Oil on canvas, 20¼ × 24¼ (51.4 × 61.6)
Provenance: Miss M. S. Davies
Exhibited: Tooth 1934 (5)
Collection: National Museum of Wales, Cardiff (1963)

It is difficult to be certain of the locality of this painting. If the traditional title is correct, Gilman probably painted from the garden of 247 Hampstead Road looking over towards the back of Mornington Crescent.

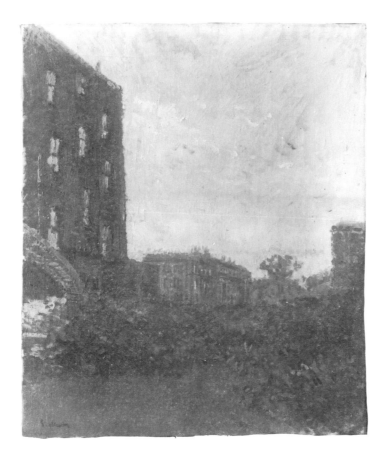

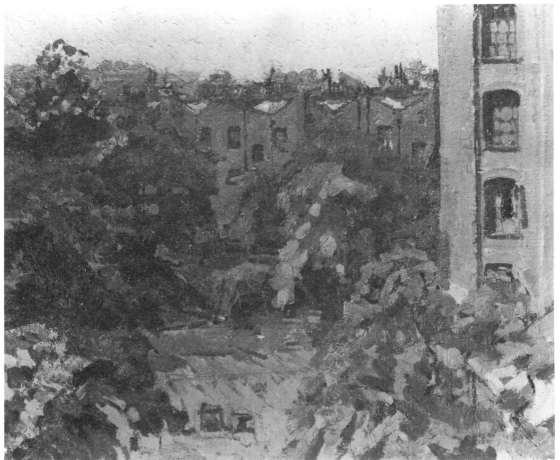

Drummond

63 **Interior. A Sculptor's Studio** *c.* 1910
Oil on canvas, 21¾ × 22¾ (55.2 × 57.8)
Signed 'Drummond' bottom right
Exhibited: A.A.A. 1910 (34); Norwich 1976, 'A Terrific Thing' (ex. cat.)
Collection: Private

This painting, discovered in 1976 by the present owner in a junk shop, can only be the work so highly praised by Rutter when it was exhibited at the A.A.A. in 1910. In spite of its battered state, it is still possible to see why Rutter found the work powerful. Using dark colours and thickly impasted paint (both presumably learned from Sickert, his master at the Westminster School of Art since 1908), Drummond grouped the tones into simplified masses thus encouraging an unSickertian clarity of definition. The composition is still somewhat cluttered and the spatial representation awkward, but Drummond's decorative constructive ability is already apparent.

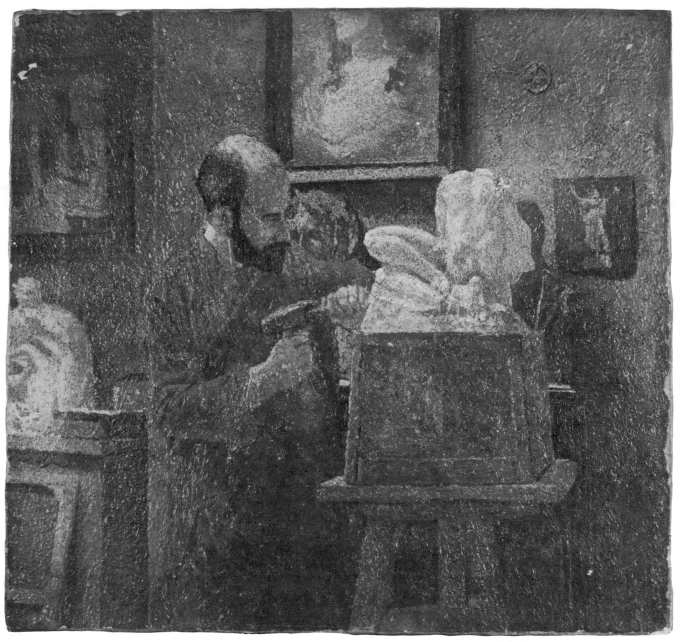

63

Gilman

64 **Portrait of Elène Zompolides. The Blue Blouse** *c.* 1910
Oil on canvas, 24 × 18 (61 × 45.7)
Signed 'H. Gilman' bottom left
Exhibited: N.E.A.C. summer 1910 (257); Tooth 1934 (6); probably Redfern
Gallery 1939, 'The Camden Town Group' (58) as *Portrait of Elène*; Lefevre Gallery
1943 (9); Arts Council 1954 (13); Colchester 1969 (13); Bedford 1969, 'The
Camden Town Group' (12); Fine Art Society 1976, 'Camden Town Recalled' (27)
Collection: City of Leeds Art Gallery and Temple Newsam House (1943)

One of the first pictures to show Gilman using the small, closely juxtaposed and
interlocking touches of thick paint in full colour which has been characterized as his
'mosaic' style. The undefined background of this portrait is built up as densely as
the figure and thus, in colour and texture, plays an active rôle. The importance of
every part of his picture is central to Gilman's art throughout his career but in most
of his later portraits, when the patterning of his composition became an integral part
of his total style, the sitter is placed within an elaborated interior. Elène Zompolides
is believed to have been a friend of Gilman.

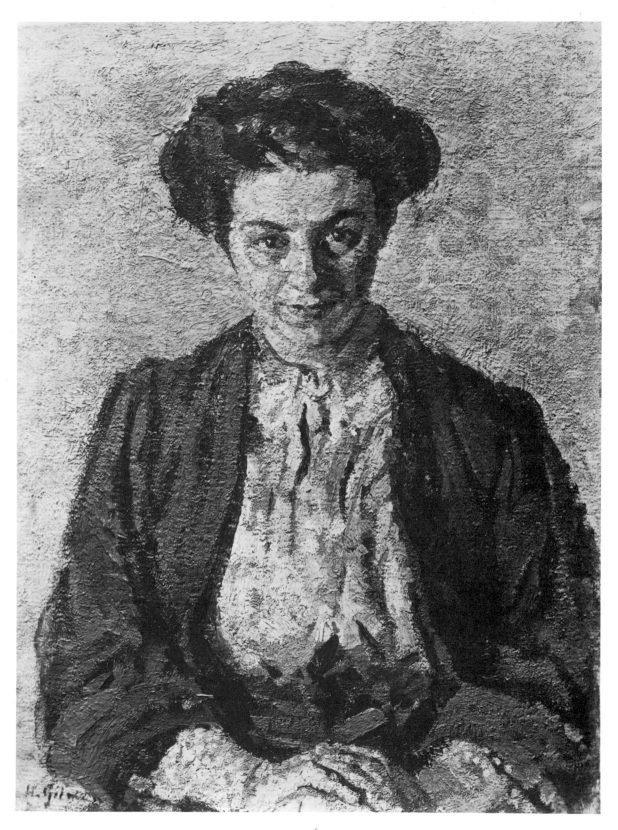

64

Lightfoot

65 **View of Conway** *c.* 1910
Oil on canvas, $22\frac{5}{8} \times 30$ (57.4 × 76.2)
Provenance: the artist's family
Exhibited: possibly N.E.A.C. winter 1910 (368) as *Conway*; Colchester 1961, 'Camden Town Group' (48); Walker Art Gallery, Liverpool 1972 (41); Fine Art Society 1976, 'Camden Town Recalled' (93)
Collection: Walker Art Gallery, Liverpool (1954)

In 1910 Lightfoot visited North Wales and made many paintings and drawings of the Conway area. The dense paint surface is characteristic of Slade School practice at this period and especially of Professor Fred Brown's work, but the stilted composition has more in common with an earlier generation of less naturalistic landscape artists and perhaps harks back to Lightfoot's training in Chester and Liverpool. Gail Engert, in the Walker Art Gallery catalogue, identified this view as from above Gyffin, looking north towards Deganwy and the Great Orme. She also observed that this picture appears to be a studio interpretation based on more informal and direct drawings and studies. It is probable that Lightfoot would have submitted a very finished version to the N.E.A.C., but positive identification is not possible.

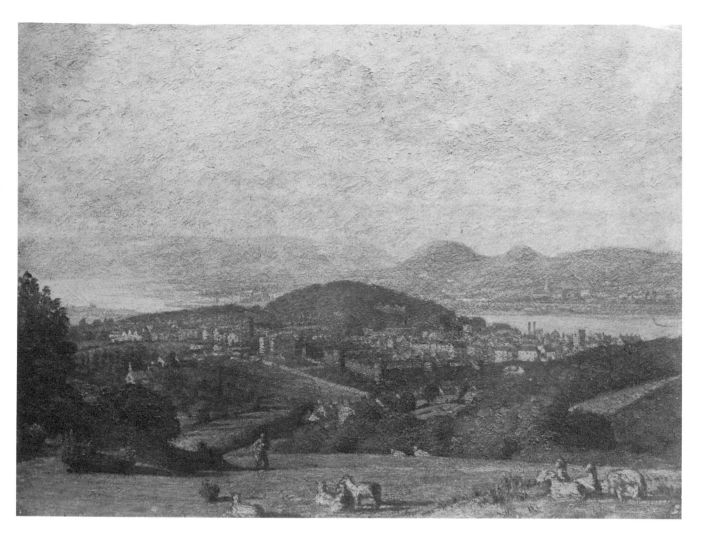

65

Gore

66 Gauguins and Connoisseurs at the Stafford Gallery 1911–12
Oil on canvas, 33 × 28¼ (83.8 × 71.7)
Signed 'S. F. Gore' bottom right
Provenance: Sir Michael Sadler
Exhibited: Leicester Galleries 1930, 'The Camden Town Group' (23); Arts Council 1955 (33); Redfern Gallery 1962 (47); Norwich 1976, 'A Terrific Thing' (29)
Collection: Private.

An explicit gesture of homage to Gauguin both in subject and style. The exhibition represented by Gore took place in November 1911 and incorporated pictures by Cézanne as well as Gauguin. Several of the 'connoisseurs' have been identified: Augustus John is the bearded man in the left foreground; Wilson Steer is the bemused central figure, hatless with a stick under his arm; the gallery owner Nevill is the other hatless man with his hand to his face. The Gauguins are, left to right: *Manao Tupapao, Christ in the Garden*, and *The Vision after the Sermon*.

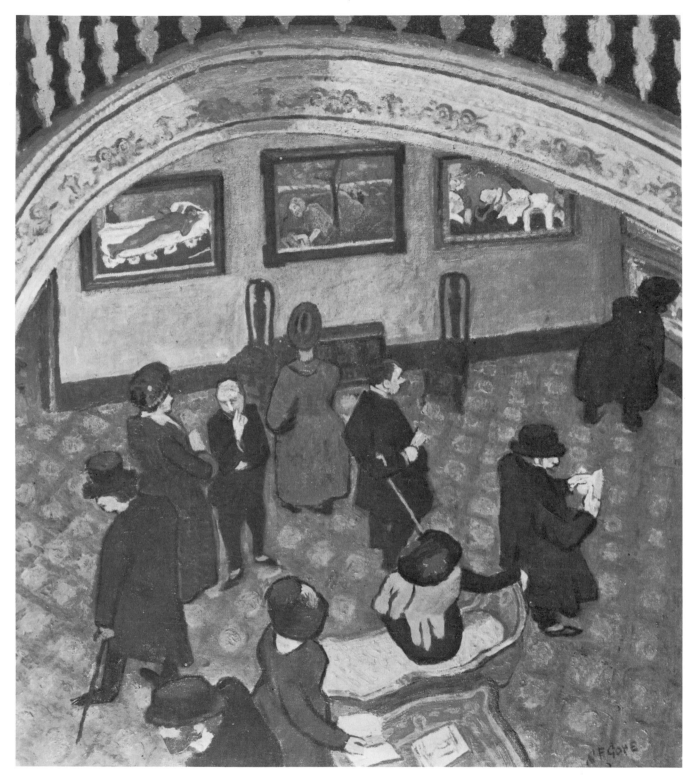

66

Grant
67 **Girl in Bed** *c.* 1908–9
Oil on canvas, 14 × 18 (35.6 × 45.7)
Signed 'D. Grant' bottom right
Collection: Private

The incidental detail of this painting, the chamber pot under the bed and the picture
on the background wall cut off by the edge of the canvas, suggests that in this early
work Grant was influenced by the Fitzroy Street circle and by Sickert in particular.

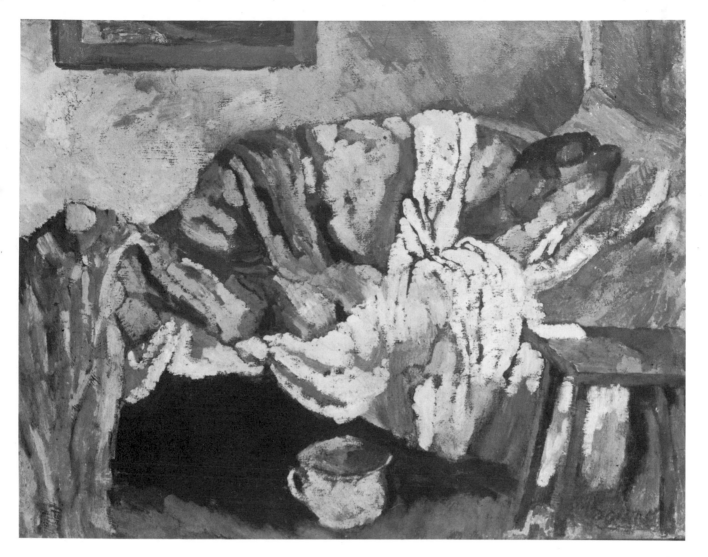

67

John
68 **The Red Feather** *c.* 1911
Oil on board, $15\frac{7}{8} \times 12\frac{3}{4}$ (40.2 × 32.4)
Signed 'John' bottom left
Collection: Ulster Museum, Belfast (1929)

The model is Dorelia, wearing the same hat as in the picture of the same title reproduced by Easton and Holroyd, Pl. 53. The background, more particularized in this standing portrait than in the seated study just mentioned, appears to be North Wales where Dorelia accompanied John in May 1911 (shortly to return without him). Inspired by John, Henry Lamb (Pl. 70) and Innes (Pl. 69) also painted romantic girls in poetic landscapes. The figures, especially in the work of John and Innes who often painted together in Wales, do not so much inhabit the landscape as grow out of it, immobile forms improbably perched in wild and desolate settings.

Innes
69 **By the Lake, Bala** *c.* 1911–12
Oil on panel, 9 × 13 (22.9 × 33)
Provenance: Horace de Vere Cole; the Earl of Sandwich; Mr and Mrs J. Stanley-Clarke
Literature: Fothergill, rep. Pl. 50
Exhibited: Leicester Galleries 1928 (109); Redfern Gallery 1939 (47); Fine Art Society 1976, 'Camden Town Recalled' (79); Southampton 1977–8 (81)
Collection: The Fine Art Society Ltd

John Hoole, in the catalogue he prepared for the Southampton exhibition, has corrected the title of this picture (previously called *By the Lake Arenig* or *The Mountain Lake*). He also revised the dating (given by Fothergill as *c.* 1913, by me in the Fine Art Society catalogue as *c.* 1912–13). In 1911 and 1912 John and Innes often worked alongside each other in North Wales. While painting together around Mount Arenig and Lake Bala in the spring and early summer of 1911, Innes adopted John's method of sketching rapidly in oil on small panels. John's example also helped Innes develop his use of pure vivid colour and his style based on the rhythmical patterning of landscape into simplified essential shapes.

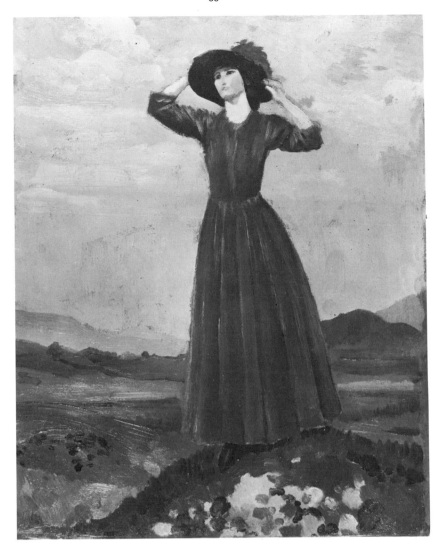

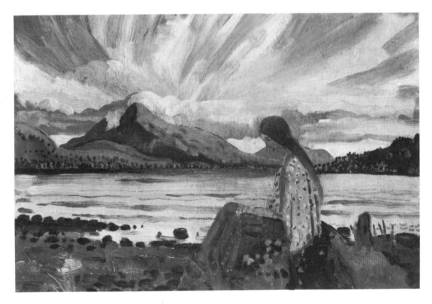

69

Lamb

70 **Portrait of Edie McNeill** 1911
Oil on panel, 12½ × 8¾ (31.7 × 22.2)
Signed with initials and dated 'H. L. 1911' and dedicated 'to J. B. 1913' bottom
right
Provenance: J. L. Behrend
Exhibited: Fine Art Society 1976, 'Camden Town Recalled' (88)
Collection: Private

The model, Edie McNeill, is a sister of John's Dorelia. She stayed with Lamb in
Douélan, Brittany, during the summer of 1911 and proved an admirable model if
not an ideal companion. This picture is a fully worked out study for, or version of,
the large painting (51½ × 32) now in the Southampton Art Gallery. The large
picture, exhibited at the N.E.A.C. in the winter of 1911 (see note to Pl. 94), adds little
detail to this small version besides a row of buttons down the bodice of the dress.
Lamb wrote to Lytton Strachey from Douélan in August 1911: 'My ménage
continuing the same and cannot be broken up till a large portrait of the Woman is
finished. A smaller one is already finished – rather successfully in a modest style.'
Lamb also painted a half-length portrait of Edie McNeill (Pl. 94).

Bayes

71 **The Lemon** *c.* 1910–12
Oil on canvas board, 10⅞ × 14½ (27.6 × 37)
Signed in monogram 'W B' bottom left
Exhibited: Leicester Galleries 1918 (46); Fine Art Society 1976, 'Camden Town
Recalled' (1)
Collection: City Art Galleries, Sheffield (1972)

The Sheffield Art Galleries prefer the date 1912 for this painting, but Mrs Bayes
who modelled for it recollected to me that it was done around 1910. At this period
Bayes was establishing a reputation as a designer of decorations, often carried out on
a very large scale. His small pictures, generally painted on board or sometimes in oil
on paper, were usually done on holidays abroad. Many feature his wife in a
landscape setting. The title comes from the fruit she is eating. The rhythmic design
of the landscape, the way the figure is integrated into the composition, and the sharp
colours may be due to the influence of John on Bayes's work on this scale.

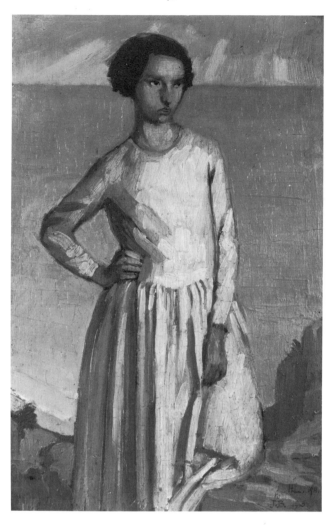

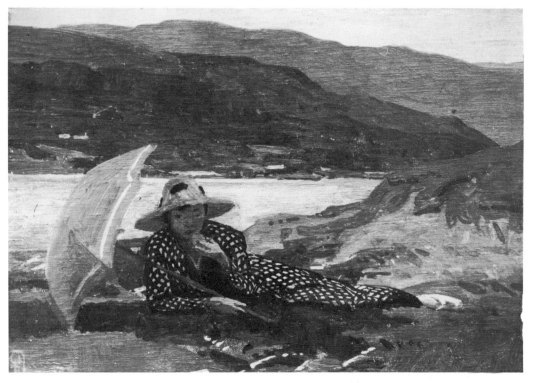

Manson

72 **Self Portrait. The Fitzroy Street Studio** *c.* 1911
Oil on canvas, 26 × 16¼ (66 × 41.2)
Signed 'J. B. Manson' bottom right
Exhibited: possibly Leicester Galleries 1944 (51) and Wildenstein 1946 (4) as *Self Portrait. Camden Town*; Fine Art Society 1976, 'Camden Town Recalled' (102); New Grafton Gallery 1979 (ex. cat.)
Collection: Anthony d'Offay Gallery

The title of this picture is inscribed on a stretcher label. It shows the artist looking somewhat worried and intense during the period when he was secretary of the Fitzroy Street and Camden Town Groups. Another self-portrait by Manson of about 1912 is in the Tate Gallery collection. The Tate *Self Portrait* may be the one exhibited in 1930 at the Leicester Galleries 'Camden Town Group,' (40) show as of 1912. The painting exhibited in 1944 and 1946 was dated 1911 in the catalogue.

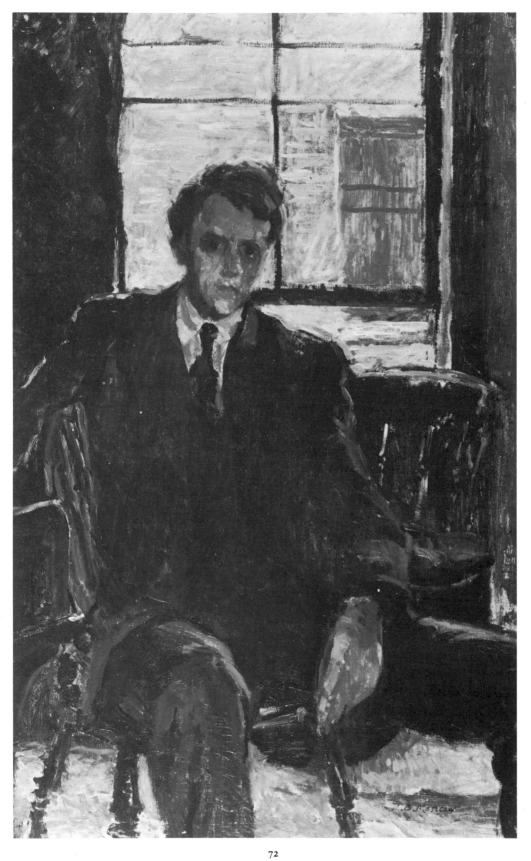

72

Section II:
Camden Town Group Exhibitions 1911

Bayes
Pictures at the First and Second Camden Town Group exhibitions

June 1911
32 Character Sketches for Lord Dunsany's play 'The Gods of the Mountain'
33 Panel for Piano Front
34 Classical Landscape (see Pl. 73)
35 Design for part of a stage scene for the Haymarket Theatre

Note
None of these pictures has been found. The *Character Sketches* were 'good drawings' according to an annotated catalogue. Lord Dunsany's play was performed at the Haymarket Theatre and it is probable that the stage scene design was also for this production. It was 'a *décor* Hispano-Moorish in character' (*Daily Telegraph*, 22 June 1911), a theme to which Bayes often returned later in his career. These two exhibits were much admired by the critics. Bayes's *Panel for Piano Front* was a 'synthetic rendering of the successive stages of a classic dance, in white on an Indian red ground', (*Observer*, 18 June 1911) described as a delightful 'free adaptation of the Pompeian style of decoration' (*Daily Telegraph*).

December 1911
50 The Bridge
51 The Glass Door (?Pl. 74)
53 Padstow Regatta

Note
Bayes's exhibits were again much admired by the critics: 'There is something satisfying in the austere modernity of Mr. Walter Bayes, who in the impersonal coldness reveals a certain probity and dignity. He is able to suggest beneath the aerial envelope, beneath the perpetually changing vesture of the earth, something of architectural structure, of permanence' (*Daily Telegraph*, 14 December 1911). A letter written by Neville Lytton to Edward Marsh (quoted by Christopher Hassall, *Edward Marsh*, London, Longmans, 1959, p. 179) suggests that Marsh bought *The Bridge*: 'I went to see your purchases from the Camden Town group and I quite see the point of the picture of the people leaning over the pier (Walter Bayes, is it not?) though it is not my style of picture.' *The Bridge* was 'a bathing scene, reduced to essentials' (*Evening Standard and St James's Gazette*, 6 December 1911); 'an open air scene enwrapped in a half-veiled sunlight' (*Daily Telegraph*); and it included a 'bather in the water below' (*Truth*, 13 December 1911). Lytton 'liked even better the picture next to it of a crowd on a shore.' This second picture must be *Padstow Regatta*, described by the *Daily Telegraph* as having 'an admirable background, and a foreground of fine rhythm, marred, however, by the multitude of small and rather over-defined figures that people the shore'. The *World* (19 December 1911) recorded that it was executed in watercolour.

Bayes

73 **Coast Scene** 1911
Oil on paper, $11\frac{1}{4} \times 12\frac{1}{8}$ (28.6 × 30.8)
Signed and dated 'W BAYES 1911' bottom right
Provenance: Arthur Crossland
Exhibited: Fine Art Society 1976, 'Camden Town Recalled' (3)
Collection: Bradford Art Galleries and Museums (1947)

As a work of 1911 in which both the compositional structure and the statuesque
foreground figure openly acknowledge a classical inspiration, the style of this *Coast
Scene* probably resembles that of *Classical Landscape* in the first Camden Town
Group exhibition. The critics classed Bayes as a 'Modernist' because of his gift for
synthesis and simplification, and as a 'Classicist' because of his evident concern
with design and rhythm. His isolation within the Camden Town Group was
recognized. Bayes's own account, published in 1930, of the Camden Town Group is
revealing on this point. He disparaged the practice current within the group of
working from nature, 'returning again and again to the same study' as if this in itself
'was in some sort an evidence of seriousness, as the working from cumulative
knowledge was not . . . For perennial repainting from Nature their execution had
the great advantage that you could always poise another lump of stiff paint on a
surface already so rough and corrugated that it would not show as a scar.' Bayes tried
to convey the refined essence of his observation of nature, discarding its superficial
detail. His method of simplification depended upon the exact values and relation-
ships of tone and allowed of no corrections.

Bayes

74 **The Open Door** *c.* 1911
Oil on canvas, $27\frac{1}{8} \times 23\frac{1}{4}$ (69 × 59)
Signed in monogram 'W B' bottom left
Provenance: Sylvia Gosse
Exhibited: probably Carfax Gallery December 1911, 'Camden Town Group' (51)
as *The Glass Door*
Collection: Johannesburg Art Gallery (1913)

This picture was included in the undated supplement to the 1910–11 catalogue of
the Johannesburg Art Gallery but, like Gilman's *The Reapers* (Pl. 122), has been
mistakenly listed as presented to the gallery in 1910. *The Reapers*, however, is dated
1912 and was exhibited in 1912 which makes presentation in 1910 impossible. It too
was given to the gallery by Sylvia Gosse. It is probable that she made her bequest in
one single year, and 1913 is indicated because we know this was the year she
presented Sickert's *The Pork Pie Hat* of 1898 to Johannesburg. I have found no
press descriptions of *The Glass Door* to support the identification of *The Open Door*
with this exhibited painting.

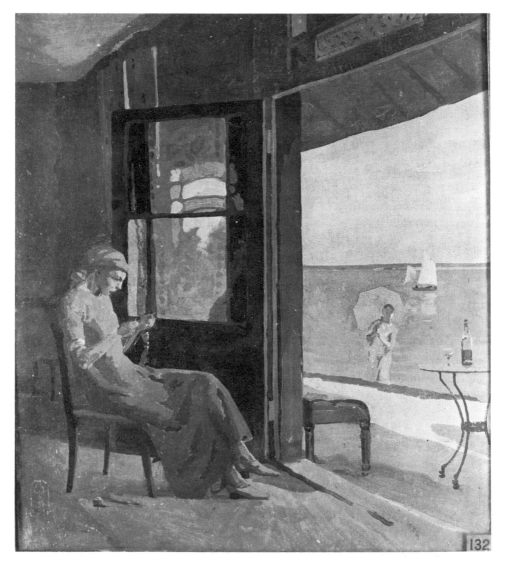

Bevan
Pictures at the First and Second Camden Town Group exhibitions

June 1911
28 Crocks
29 The Cab Horse (Pl. 75)
30 In Sussex (Pl. 76)
31 The Yard Gate

Note
The original version of *Crocks* was destroyed by the artist who did, however, paint another version of the same or similar composition in 1922 (rep. R. A. Bevan, Pl. 78). Although *The Yard Gate* is the title of several paintings of the farm-yard gate in Mydlow, Poland, where Bevan worked in 1907 and 1908, the painting exhibited with this title in 1911 was yet another English cab-yard subject. According to Desmond MacCarthy (*Eye Witness*, 6 July 1911) it showed a horse just disappearing into the stable. This was possibly the picture formerly in Judge Evans's collection, reproduced in the short-lived magazine *Colour* in July 1918. The painting is now of unknown whereabouts.

December 1911
31 The Cabyard, Night (Pl. 77)
32 No. 12612
33 Landscape with Cattle
34 Morning Sunlight

Note
No. 12612 was a cab-scene (*Sunday Times*, 3 December 1911), but the painting has not been traced. *Morning Sunlight* has also not been identified. There is a later picture of this title (*c.* 1917) but it is possible that the painting exhibited in 1911 is now known by a different name. A painting called *Morning Sunlight* was also shown by Bevan at the A.A.A. in 1909. I have found no contemporary descriptions to help identify the picture. The same is true of *Landscape with Cattle* which might be any one of a number of Sussex landscapes similar to *Fields at Cuckfield* (Pl. 76), exhibited as *In Sussex* at the first Camden Town Group exhibition. Some suggestions are given in the plate note to that picture.

Bevan

75 **The Cab Horse** or **Putting To** *c.* 1910
Oil on canvas, 25 × 30 (63.5 × 76.2)
Provenance: Duveen Paintings Fund
Literature: Tate Gallery Catalogue, rep. in colour Pl. IX; R. A. Bevan, rep. Pl. 31
Exhibited: N.E.A.C. winter 1910 (91); Carfax Gallery June 1911, 'The Camden
Town Group' (29); probably Carfax Gallery 1913 (38) as *Putting to*; Goupil Gallery
1926 (129); Fine Art Society 1976, 'Camden Town Recalled' (8)
Collection: The Tate Gallery, London (1949)

Bevan's picture, with its ungainly blue-violet horse and its strong notes of vermilion
and green, attracted little hostile notice from critics at the Carfax Gallery. The
Observer (18 June 1911) thought his 'group of post-impressionist pictures testify to
a distinguished sense of colour' but found them uncomfortably unfinished. The
conservative *Morning Post* (3 July 1911) decided that *The Cab Horse* and *The Yard
Gate* were 'the most arresting (you can hardly avoid Scotland Yard metaphor) in
design and colour . . . They will undoubtedly repel you at first unless you have been
through the Paris Autumn Salon cure. Then after, say ten minutes, examination of
the other pictures you will realise . . . that the painter has something to say, and that
his horses *have* brought news from Ghent – "pleasant or unpleasant" is beside the
question.' Desmond MacCarthy (*Eye Witness*, 6 July 1911) tried to analyse Bevan's
use of 'imaginary and fantastic' colour: 'The horse between the shafts is a violet
horse, the gate-pillars are an apricot red, everywhere there is an unreal iridescence,
the shabby box-cloth coat of the yardmaster has a dove-like sheen on it; yet this
fanciful colouring does not interfere with the realism of the scene; it seems even to
enhance it, as though this convention of unnatural, bright colour succeeded in
conveying a sense of the life of the stable-yard which was still an important part of
our actual impression of such scenes.'

Bevan

76 **Fields at Cuckfield** *c.* 1909–10
Oil on canvas, 18 × 22 (45.7 × 55.9)
Provenance: the artist's family
Literature: R. A. Bevan, rep. Pl. 32
Exhibited: Carfax Gallery June 1911, 'The Camden Town Group' (30) as *In Sussex*;
Goupil Gallery 1926 (105); Southampton 1951, 'The Camden Town Group' (8);
Colchester 1961, 'Camden Town Group' (7); Colnaghi 1965 (21)
Collection: Private

R. A. Bevan identifies *Fields at Cuckfield* as the painting shown with the Camden
Town Group in June 1911. Bevan's family home was Horsgate, in Cuckfield,
Sussex, where Bevan often painted in the summer. It is probable that *Landscape
with Cattle*, shown in the second Camden Town Group exhibition, was a painting of
this area, perhaps *The Front Field*, *Horsgate* of 1911, rep. in colour R. A. Bevan, Pl.
39, or *Gravelye Farm Cuckfield* (both in private collections).

Bevan

77 **The Cabyard, Night** *c.* 1910 (colour p. 25)
Oil on canvas, 25 × 27½ (63.5 × 69.9)
Signed 'Robert Bevan' bottom right
Literature: R. A. Bevan, rep. Pl. 27 in colour
Exhibited: Carfax Gallery December 1911, 'The Camden Town Group' (31);
Carfax Gallery 1913 (12); Brighton 1913–14, 'English Post-Impressionists, Cub-
ists and others' (36); Arts Council 1956 (7); Colnaghi 1965 (24); Fine Art Society
1976, 'Camden Town Recalled' (9)
Collection: Art Gallery, Brighton (1913)

This painting, the only one acquired by a public gallery during the artist's lifetime,
was bought by the Brighton Art Gallery from the 1913–14 exhibition. The press
paid relatively little attention to Bevan's work at both the June and December
Camden Town Group exhibitions. However, Frank Rutter compensated for his
own failure to mention Bevan's pictures when reviewing the first exhibition, by
advising the Contemporary Art Society to get one of Bevan's masterly cab-scenes
for the nation before more appreciative foreign collectors snapped them up (*Sunday
Times*, 3 December 1911). J. B. Manson, as reviewer for the *Outlook* (9 December
1911), contributed the most penetrating analysis of Bevan's gifts. He considered
Bevan's most remarkable quality was his ability to render 'strong form solely by
subtle division of tones of colour', and he found this 'a valuable testimony to the
capabilities of impressionism'. He admired Bevan's 'fine, spirited sense of design',
and went on to pinpoint the distinction between Bevan's use of colour and that of
Gore: 'He does not use, as Mr. Gore does, his analysis of the colour of a particular
scene, but to some extent he uses his empirical knowledge of the effects of
colour-tones in his self-imposed obligation to produce a fairer and more harmoni-
ous arrangement than is often presented by definite aspects of Nature.'

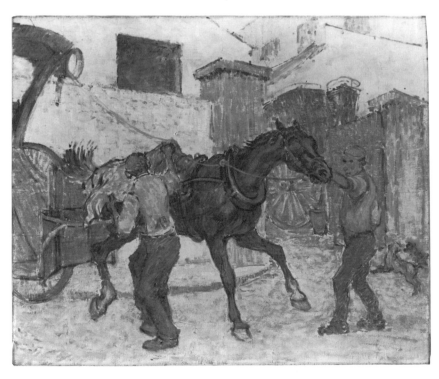

75

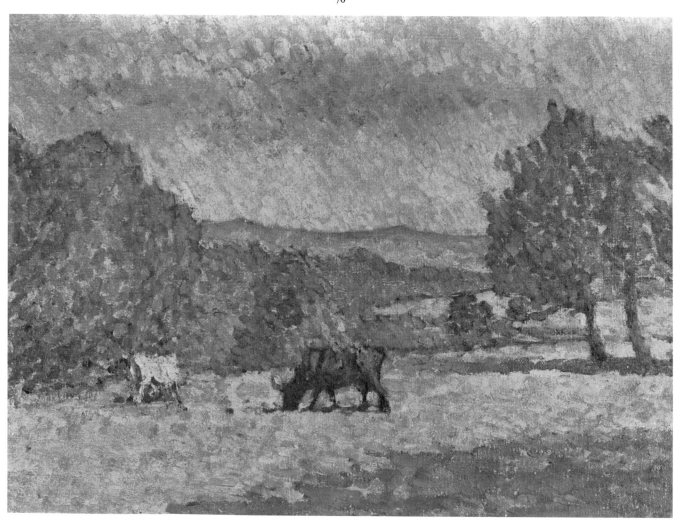

76

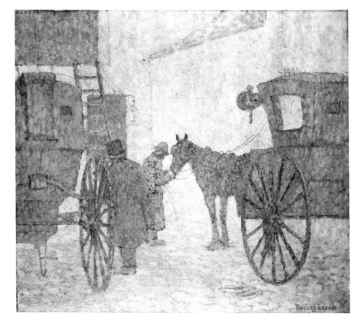

77

220 Section 11: Camden Town Group Exhibitions 1911

Drummond
Pictures at the First and Second Camden Town Group exhibitions

June 1911
44 A Chelsea Garden (?Pl. 78)
45 Woman Knitting
46 Paddington Station
47 Interior

Note
With the possible exception of one painting, Drummond's pictures from this first exhibition are of unknown whereabouts. Few critics paused to describe works by such an unknown artist. I have found no mention of *Woman Knitting* and only one reference to *Interior*. This tells us, unhelpfully, that 'his small room interior presents very skilfully there figures that seem the very spirits of that particular place' (*Manchester Guardian*, 28 June 1911). Drummond's most important exhibit was undoubtedly *Paddington Station*. He showed it again at the Whitechapel exhibition of 'Twentieth Century Art' in 1914, and it was borrowed from a private collector in 1928 for the London Group Retrospective exhibition (inaccurately dated 1913). It was an original subject. The *Manchester Guardian* tells us it showed 'a handsome decorative use of the girders and hanging cloths', a description which suggests it might possibly have influenced Gilman's *Leeds Market* (Tate Gallery) of *c.* 1914–15. A contemporary catalogue annotation remarked that the painting was 'monochromy', while *Art News* (15 July 1911) noted that its chief characteristic was 'Beauty of colour wedded to a strikingly decorative design . . . It is much lower in key than Mr. Ginner's vivid canvases, but it has a subdued richness which is most attractive.'

December 1911
38 Viva
39 At Dusk
40 Portrait of a Lady
41 Portrait of Charles Ginner (Pl. 79)

Note
I have found no contemporary descriptions to help identify three of Drummond's four exhibits.

Drummond

78 **The Garden** *c.* 1909
Oil on canvas, 20 × 16 (50.8 × 40.6)
Exhibited: possibly Carfax Gallery June 1911, 'The Camden Town Group' (44) as
A Chelsea Garden; Fine Art Society 1976, 'Camden Town Recalled' (12)
Collection: Private

Unlike most of his Camden Town colleagues Drummond lived in Chelsea. The
subject of this picture certainly resembles characteristic Chelsea gardens. Indeed,
with its mature tree and its croquet hoops, it could represent the garden of the
Chelsea Arts Club (before the 1930s extensions and the patio were built). If this
identification is correct the female figures must have been added from imagination
(and they do not fit very comfortably into their setting) because women were not
then admitted to the Club. Press reviews seldom mentioned *A Chelsea Garden*. The
Daily News (17 June 1911) called it 'delicately perceived', and a catalogue annota-
tion described it (like *Paddington Station*) as 'monochromy'. As an exercise
confined mainly to a range of greens *The Garden* fits this description. The
impressionistic rendering of the figures suggests the picture antedates Drum-
mond's urban landscapes of 1910 onwards in which the figures are treated as
emphatic accents in an overall design. From 1910 onwards Drummond's exterior
scenes have almost always a pronounced architectural interest which is lacking in
The Garden.

Drummond

79 **Portrait of Charles Ginner** 1911
Oil on canvas, 23¾ × 19 (60.3 × 48.2)
Signed 'DRUMMOND' bottom right
Exhibited: Carfax Gallery December 1911, 'The Camden Town Group' (41);
Colchester 1961, 'Camden Town Group' (10); Arts Council 1963–4 (4); Newcastle
1974, 'The Camden Town Group' (5); Fine Art Society 1976, 'Camden Town
Recalled' (17)
Collection: Southampton Art Gallery (1956)

One of the most striking images of Camden Town portraiture, showing Ginner (not
long arrived in England) still looking wickedly French. Drummond and Ginner
were in sympathy with each other from the beginning of their association. They
both liked strong colours and bold patterns. Drummond is not known to have
painted portraits of his other Camden Town colleagues, except for the enigmatic
back-views of *19 Fitzroy Street* which also features Ginner. The handling of this
portrait suggests that Drummond reacted strongly to the Van Gogh paintings on
view at the Grafton Gallery in the winter of 1910–11.

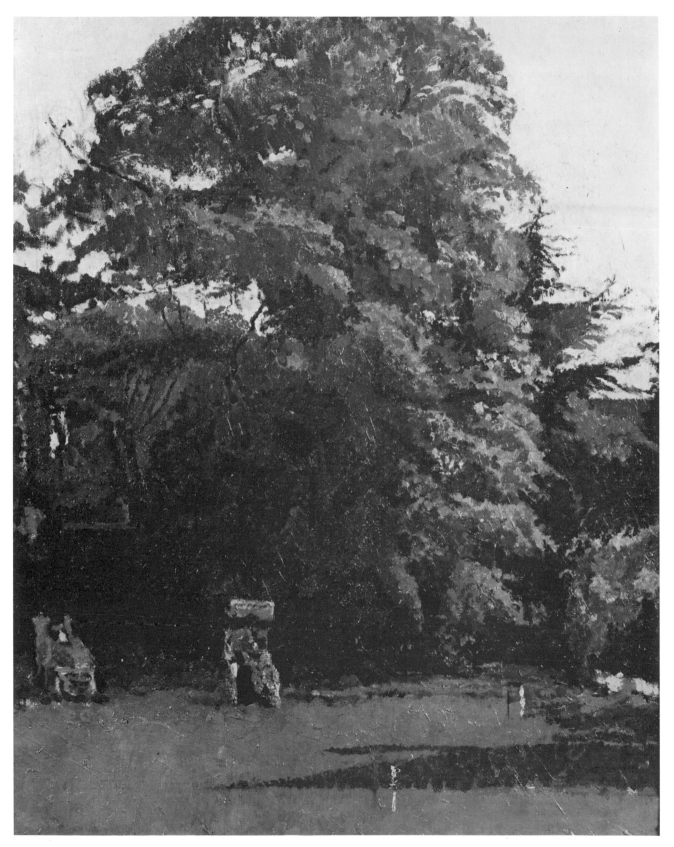

78

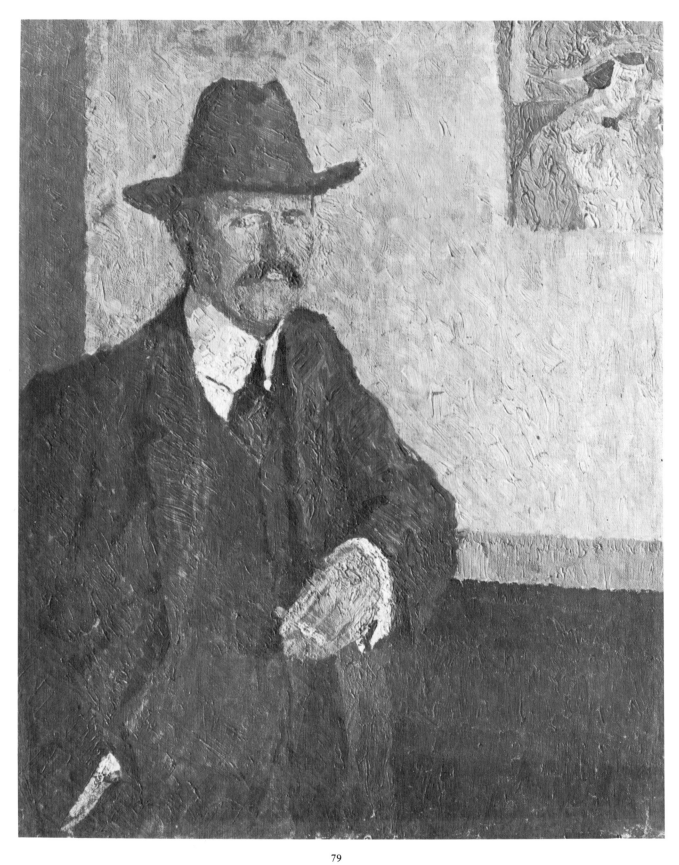

79

224　Section II:　Camden Town Group Exhibitions 1911

Gilman
Pictures at the First and Second Camden Town Group exhibitions

June 1911
52 The Snow Scene (Pl. 80)
53 Portrait
54 The Sofa (?Pl. 81)
55 Head of an Old Woman

Note
Art News (15 June 1911) noted that 'expressiveness and actuality' together with 'fine characterization distinguish the very personal "Portrait", . . . by Mr. Gilman.' *Bazaar* (30 June 1911) wrote that this portrait was of 'Kaleidoscopic glitter that would be disturbing to live with'. Although these unspecific remarks are not sufficient to identify the painting, a possible candidate is *Portrait of Mrs Whelan* (Fine Art Society, rep. catalogue of 'Camden Town Recalled' 1976 exhibition, p. 19). When exhibited at Reid and Lefevre in 1964 this portrait was dated 1916, but stylistically this would seem much too late. The tawny range of colours and the application of the paint in scattered marks of colour which break down the contours of the forms, suggest a date nearer to 1911. This handling might well have occasioned the *Bazaar* critic's comment. *Head of an Old Woman* was called a 'vigorous study' (*Daily Telegraph*, 22 June 1911), while the *Athenaeum* noted its 'robust characterization'. On grounds of style and date, *The Old Lady* (Bristol City Art Gallery) is the most likely candidate for identification with the exhibited study.

December 1911
19 Le Pont Tournant (Pl. 83)
20 Nude. No. 1
21 Dieppe
22 Nude (see Pl. 82)

Note
Dieppe is probably the painting now belonging to the Save and Prosper Group Ltd, an ambitious panoramic view of the town executed in a richly broken technique. For information on Gilman's two paintings of the nude see under Pl. 82.

Gilman

80 **Washing in the Snow** *c.* 1909–10
Oil on canvas, $11\frac{1}{2} \times 15$ (29.2 × 38)
Provenance: Miss Blaker; F. A. Girling
Exhibited: probably Salon des Indépendants, Paris 1910 (2120); Carfax Gallery
June 1911, 'The Camden Town Group' (52) as *The Snow Scene*; Fine Art Society
1976, 'Camden Town Recalled' (28)
Collection: Private

The press tended to neglect Gilman's contributions to the June exhibition but this
little picture attracted admiration. The *Daily Telegraph* (22 June 1911) called it
'Frank yet subtle in its light, delicate harmony, moderate and true in its im-
pressionistic rendering of a curious effect'. *Bazaar's* comments (30 June 1911)
prove that the picture illustrated here is the work exhibited in 1911: 'An oil-
painting that has almost the transparency of water-colour, and is an exercise in
white, is of laundry hung out.' This painting is inscribed on the back, like many of
Gilman's pictures sent to exhibition, with the 19 Fitzroy Street studio address.
Arthur Clifton of the Carfax Gallery acquired it from the artist, probably after the
exhibition, and sold it at Christie's on 5 July 1925, lot 58.

Gilman

81 **Lady on a Sofa** *c.* 1910
Oil on canvas, 12 × 16 (30.5 × 40.6)
Signed 'Gilman' bottom right
Provenance: Judge William Evans; Hugh Blaker
Exhibited: probably N.E.A.C. summer 1910 (256); possibly Carfax Gallery June
1911, 'The Camden Town Group' (54) as *The Sofa*; Arts Council 1954 (16); Fine
Art Society 1976, 'Camden Town Recalled' (26)
Collection: The Tate Gallery, London (1948)

The Sofa at the first Camden Town Group exhibition could either have been this
painting or a slightly smaller half-length of a woman asleep on the same sofa
(formerly collection Edward le Bas, sold Christie's, 3 March 1978 lot 181, rep. in
catalogue). Both these paintings, in their warmer, brighter colours and in the way
the paint has been built up in dabs and smears to a richer and rougher texture,
illustrate Gilman's adoption of the broken handling developed by his Fitzroy Street
colleagues. The subject and its presentation, however, still have an Edwardian
flavour more reminiscent of Steer than of Fitzroy Street. The Tate Gallery
catalogue records that this painting was in Judge Evans's collection by 1911 and he
could have bought it from the Carfax Gallery exhibition or direct from 19 Fitzroy
Street. The painting had entered Hugh Blaker's collection by 1928.

Gilman

82 The Model. Reclining Nude *c.* 1910–11
Oil on canvas, 18 × 24 (45.7 × 61)
Signed 'H. Gilman' bottom right
Exhibited: possibly Carfax Gallery December 1911, 'The Camden Town Group'
(22) and Carfax Gallery 1913 (9) as *Nude No. 2*; Lefevre Gallery 1943 (20); Lefevre
Gallery 1948 (23); Lefevre Gallery 1950, 'Camden Town Group' (9); Fine Art
Society 1976, 'Camden Town Recalled' (30)
Collection: The Arts Council of Great Britain (1958)

Gilman numbered, rather than described, his nudes. It is possible that the numbering denoted a chronological sequence and thus that a specific number remained constantly attached to a particular picture. At Gilman's joint exhibition with Gore in January 1913, *Nude* Nos 1 and 2 were joined by Nos 3 and 4. It is, however, interesting that at his joint exhibition with Ginner at the Goupil Gallery in April 1914 Gilman showed no paintings of the nude. It is probable that this subject-matter was virtually dropped from his vocabulary by that date. Although a few paintings of the nude exist which stylistically belong to a date later than 1914, these are experimental in character and unfinished works. Several represent the model in awkward attitudes of arrested movement, rather than repose, and unflattering close-up back-views were sometimes used. Gilman's earlier nudes, especially those posed on metal bedsteads, were directly inspired by Sickert. *The Model* appears to be one of his first pictures in the genre. The tentative suggestion that *The Model* may be *Nude No. 2* from the second Camden Town Group exhibition is based on a comparative description (*Daily Telegraph*, 14 December 1911) of two nudes in the show: '"Nude No. 2" – the same model with the same imperfections less cynically exhibited – is made attractive by a flicker of fitful sunlight on the undraped body that seems to crave indulgence from the spectator for its ugliness.' *The Times* critic (11 December 1911) contributed a penetrating comparison of Gilman's and Sickert's figure pictures: Gilman's 'two very able nudes . . . look as if they were sitting to be painted, not as if the artist had surprised them at some characteristic moment. You scarcely notice Mr. Sickert's colour, it belongs so entirely to his subjects. But Mr. Gilman's colour seems rather to be imposed upon his subject, though it surprises by its freshness and ingenuity. His pictures are very well made, but they are made, whereas Mr. Sickert's seem to have grown.'

Gilman

83 **Le Pont Tournant (The Swing Bridge) Dieppe** 1911 (colour p. 39)
Oil on canvas, 12 × 16 (30.5 × 40.6)
Provenance: presented as a wedding present to W. R. Sickert and Christine
Drummond Angus by the Camden Town Group
Exhibited: Carfax Gallery December 1911, 'The Camden Town Group' (19); Fine
Art Society 1976, 'Camden Town Recalled' (33)
Collection: Private

The Camden Town Group must have chosen this painting as a present for Sickert
and his new wife (their marriage was in July 1911) before the December exhibition
because, unlike Gilman's other contributions, it was unpriced and thus, by
implication, not for sale. The direct handling, in a scatter of brightly coloured
marks, and the variety and purity of the colours, show Gilman moving away from
the influence of Sickert towards a style based on colour contrasts. Sir Claude
Phillips (*Daily Telegraph*, 14 December 1911) classified Gilman as 'a neo-
impressionist with a personal accent of his own, that suffices to make the obvious
and everyday interesting. "Le Pont Tournant" gives this curious type of modern
bridge with accuracy as regards impression, but also with a sense of novelty and
wonderment. And this is enough to give the study a *raison d'être*.'

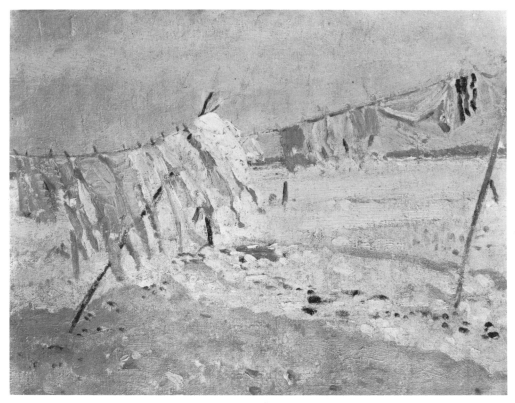

80

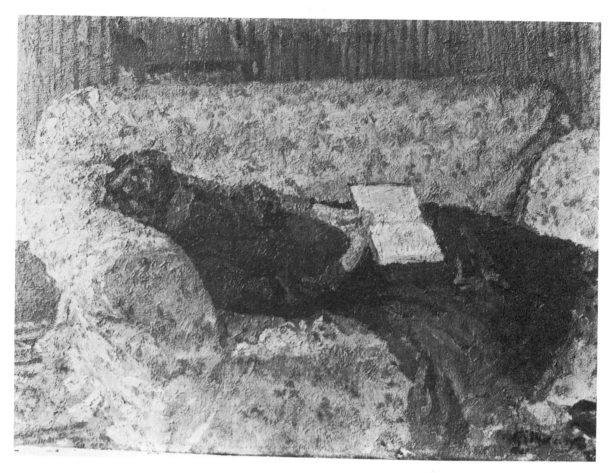

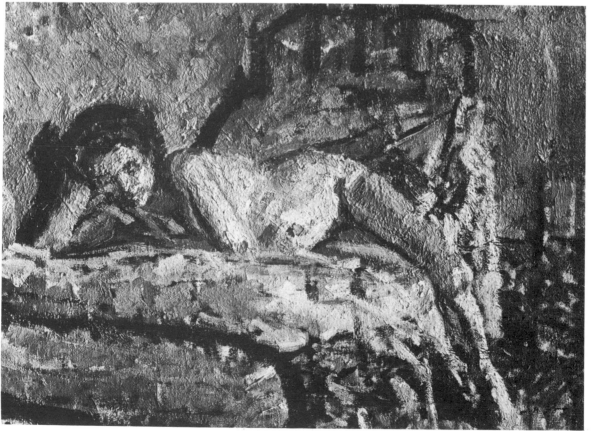

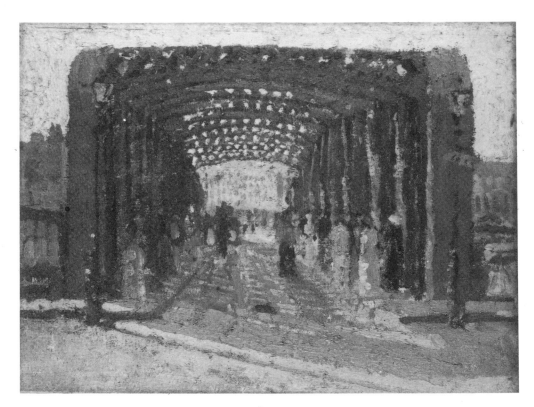

83

Ginner
Pictures at the First and Second Camden Town Group exhibitions

June 1911
36 Sheaves of Corn (Pl. 84)
37 Battersea Park
38 Still Life
39 The Sunlit Wall (Pl. 84a)

Note
The Sunlit Wall dominated critical reaction to Ginner's work at the Camden Town exhibition. A sample is quoted in the text. The *Observer* (18 June 1911) considered Ginner to be the most daring artist of the whole group. Besides mentioning *The Sunlit Wall* ('a triumphant song of pure brilliant colour'), the critic remarked that Ginner's *Still Life* was 'painted with the passionate intensity of a Cézanne, but with a far better grip of form'. Ginner's notebook records that this *Still Life* represented fruit and a tea-pot and measured 14 × 18 inches (Ginner was inconsistent about the convention of stating height before width, so it could have been an upright picture). After re-appearing in several exhibitions between 1911 and 1914 the artist recorded that the picture was lost. Ginner painted two versions of *Battersea Park. No. 1*, painted in 1910, is now in the Art Gallery of South Australia, Adelaide. *Battersea Park No. 2*, painted in 1911, is the picture shown at the Camden Town Group exhibition and other exhibitions including the A.A.A. and the *Salon des Indépendants*, Paris in 1912, and at the Ginner and Gilman joint exhibition at the Goupil Gallery in 1914. It was bought by a dealer from the Southport area and is now of unknown whereabouts. For reference it measured 25 × 19½ inches. According to the *Daily Telegraph* (22 June 1911) *Battersea Park* and *The Sunlit Wall* were, 'Startlingly brilliant, yet not garish in colour, frank and forcible as visual impressions of Nature in its summer vesture'. A pochade sketch of *Battersea Park No. 2* was sold at Christie's, 13 November 1964, lot 97.

December 1911
27 The Sunlit Quay
28 The Wet Street
29 The Café (Pl. 85)
30 Evening (Pl. 86)

Note
The Sunlit Quay, a panoramic view of Dieppe, is in the Walker Art Gallery, Liverpool. *The Wet Street* is also a Dieppe subject. It was bought by the water-colourist Douglas Fox-Pitt in 1911, and re-appeared at Sotheby's, 27 June 1979, lot 46.

Ginner

84 Sheaves of Corn 1910
Oil on canvas, $18\frac{3}{4} \times 20$ (47.6 × 50.8)
Signed 'C. Ginner' bottom right
Provenance: Mrs Ruby Dyer (sister of the artist)
Literature: Ginner, Vol. I, p. xxxii
Exhibited: Carfax Gallery June 1911, 'The Camden Town Group' (36); Piccadilly
Gallery 1969 (2); Fine Art Society 1976, 'Camden Town Recalled' (40)
Collection: Private

Of Ginner's four pictures in the first Camden Town Group exhibition *Sheaves of
Corn* attracted the least notice. It is a much more subdued and disciplined work than
The Sunlit Wall. The chopped strokes and broken colours of Van Gogh have been
assimilated to convey an equally intense, but more ordered, response to nature. The
painting was studied in Sussex, near Rottingdean.

Ginner

84a The Sunlit Wall 1908
Oil on canvas, $18\frac{1}{4} \times 25\frac{3}{4}$ (46.4 × 65.4)
Provenance: Mrs Ruby Dyer (sister of the artist)
Literature: Ginner, Vol. I, p. iii
Exhibited: Salon Costa, Buenos Aires 1909; Carfax Gallery June 1911, 'The
Camden Town Group' (39); Whitechapel 1914, 'Twentieth Century Art' (372);
Piccadilly Gallery 1969 (1)
Collection: Messrs. Thomas Agnew & Sons Ltd.

The first painting entered in Ginner's notebooks where the subject is identified as
Paysage à Charenton. Ginner gave it as a wedding present to his sister and it was she
who lent it to the Whitechapel exhibition. Examples have been quoted above of
critical reaction to the vivid colour and thick paint of *The Sunlit Wall* upon its
exhibition with the Camden Town Group. Oddly enough its clumsy drawing
escaped comment.

Ginner

85 The Café Royal 1911
Oil on canvas, 25×19 (63.5 × 48.3)
Signed 'C. GINNER' bottom right
Provenance: presented by the artist to the 'Allies Week' Fund sale at Brighton in
1914 where it was bought by Douglas Fox-Pitt; Miss Patience Scott; Sir Henry
Holt; Edward le Bas
Literature: Ginner, Vol. I, p. xxvii

Exhibited: A.A.A. 1911 (139); Carfax Gallery December 1911, 'The Camden Town Group' (29) as *The Café*; Salon des Indépendants, Paris 1912 (1334); Goupil Gallery 1914 (22); Redfern Gallery 1939, 'The Camden Town Group' (7); Arts Council 1953 (2)
Collection: The Tate Gallery, London (1939)

The Café Royal was a favourite haunt of artists at this period and Ginner was clearly fascinated by its ornate decoration. The figures have not been identified. The subject-matter is uncharacteristic of Ginner whose relatively few interiors with figures tended to represent scenes of work (a hospital ward, factories and so on) rather than places of entertainment. Gilman, undoubtedly influenced by Ginner as well as by Orpen, made two paintings of the Café Royal in 1912 (Pl. 109)

Ginner
86 Evening, Dieppe 1911 (colour p. 35)
Oil on canvas, 24 × 18¼ (61 × 46.3)
Signed 'C. Ginner' bottom right
Provenance: Mrs L. Fox-Pitt
Literature: Ginner, Vol. 1, p. xli
Exhibited: Carfax Gallery December 1911, 'The Camden Town Group' (30); Fine Art Society 1976, 'Camden Town Recalled' (44)
Collection: Private

Evening, *The Sunlit Quay* and *The Wet Street* were all painted by Ginner in Dieppe in 1911. *Evening* and *The Sunlit Quay* were conceived as a complementary pair. Together they provide a complete panorama of Dieppe seen across the harbour with the higgledy-piggledy network of streets hemmed in behind the arcaded quays. *Evening* is executed in a harmony of gold and blue; *The Sunlit Quay* has the addition of warmer salmon-pink tones. The background mass in *Evening* is the cliff which drops down sheer to the sea below. The silhouette of the château (now the museum) can be seen on the ridge. The constructive use of small, tight touches of thick paint, the decisive definition, and the rhythmic patterning of both these Dieppe views introduce Ginner's mature style. Both pictures, but especially the night scene, have a poetic quality which was often submerged by Ginner's obsessional concern with detail later in his career. It is interesting to note that the Fox-Pitt family owned three of Ginner's four contributions to the second Camden Town Group exhibition. Mrs L. Fox-Pitt bought *The Wet Street* in 1911 from the exhibition. Three years later Douglas Fox-Pitt bought *The Café Royal*.

84

84a

Section II: Camden Town Group Exhibitions 1911 235

85

86

Gore

Pictures at the First and Second Camden Town Group exhibitions

June 1911

24 The Bed Sitting Room
25 Mornington Crescent (?Pl. 87)
26 Scene III
27 Stage Sunrise (Pl. 88)

Note

I have discovered no helpful descriptions of *The Bed Sitting Room*, nor is this title found in other exhibitions of Gore's work. It is possible that the painting was a Mornington Crescent interior, similar to the one in the Leeds Art Gallery (Pl. 22). *Scene III*, a music hall painting, has not been identified.

December 1911

15 The Mad Pierrot Ballet (?Pl. 2)
16 The Garden (see Pl. 59)
17 Portrait
18 The Promenade

Note

Neither *Portrait* nor *The Promenade* is identified. The latter was a theatre interior (*Queen*, 9 December 1911). Notices of Gore's work at the second Camden Town Group show concentrated on *The Mad Pierrot Ballet* and *The Garden*. The music hall may be the picture illustrated as Pl. 2. The identification of *The Garden* is also problematical. Gore painted garden scenes at most of the places where he worked, especially at Garth House, Hertingfordbury, in 1908 and 1909 and at Rowlandson House in 1911. He exhibited a painting called *The Garden* at the N.E.A.C. in 1909, probably a Garth House subject (examples in public collections include pictures in the Walker Art Gallery, Liverpool, and the Harris Museum, Preston). However, press reviews of *The Garden* at the Carfax Gallery in 1911 indicate this was an urban scene. The *Daily Telegraph* (14 December 1911) noted the artistic rendering of 'the row of typically English houses at the back', while *Truth* (13 December 1911) remarked that the painting might show 'the next-door villa trembling in the misty light'. Several pictures fit these descriptions. Possible candidates include the picture in Toledo (Pl. 59); *The Garden, Rowlandson House* (Anthony d'Offay 1974, No.14, rep. in catalogue in colour) which shows the view from the garden staircase railings across the wall to Rutland Street on the opposite side of Hampstead Road; and *The End of the Garden* (also Anthony d'Offay 1974, No.2, not illustrated) painted from a point further to the right, in front of the Hampstead Road façade of Rowlandson House, to show the view over the garden wall straight down Rutland Street as far as Stanhope Street.

Gore

87 **Mornington Crescent** *c.* 1911
Oil on canvas, 20 × 24 (50.8 × 61)
Provenance: Hugh Blaker
Exhibited: possibly Chenil Gallery 1911 (9) as *The Steeple and the Tube* or (15)
Mornington Crescent, Tube Station; possibly N.E.A.C. summer 1911 (211) as *The
Camden Theatre*; probably Carfax Gallery June 1911, 'The Camden Town Group'
(25); possibly Leicester Galleries 1928 (74) as *Camden Theatre from Mornington
Crescent*; Arts Council 1955 (31); Colchester 1970 (34); Fine Art Society 1976,
'Camden Town Recalled' (67)
Collection: British Council (1948)

It is worth recalling a passage in 'A Perfect Modern', Sickert's moving tribute to
Gore published after the artist's death (*New Age*, 9 April 1914): 'There was a few
years ago a month of June which Gore verily seems to have used as if he had known
that it was to be for him the last of its particularly fresh and sumptuous kind. He
used it to look down on the garden of Mornington Crescent. The trained trees rise
and droop in fringes, like fountains, over the little well of greenness and shade
where parties of young people are playing at tennis. The backcloth is formed by the
tops of the brown houses of the Hampstead Road, and the liver-coloured tiles of the
Tube Station.' The 'well of greenness' is now replaced by the Carreras building; the
houses in the Hampstead Road are demolished. But Mornington Crescent remains
as a particularly decrepit terrace and the liver-coloured tiles of the tube station
happily also survive. The steeple in the background of this picture belonged to the
church of Old St Pancras and St Matthew in Oakley Square. The church, ruined
and without its steeple, was finally demolished in 1977. Gore painted so many views
of Mornington Crescent, many from his window at No.31, that it is impossible to
know which picture was exhibited where. Only this painting and a smaller,
sketchier view in the Johannesburg Art Gallery incorporate both the steeple and the
tube station described in the title of No.9 at the Chenil Gallery. The description in
the *Bazaar* (30 June 1911) of *Mornington Crescent* in the Camden Town Group
exhibition, 'with the Camden Theatre and the very vivid red Tube Station walls
heightened by the crescent's acrid green vegetation', narrows the selection down to
the same two paintings. The Camden Theatre (the domed building next to the tube
station) is obscured by vegetation in many of Gore's exterior views of Mornington
Crescent (for example the version formerly belonging to Edward le Bas). However,
although both the tube station and the theatre are visible in the Johannesburg
version, the colour notes as well as the greater finish of the British Council picture
strongly support the suggestion that it is the painting exhibited at the Carfax
Gallery.

Gore

88 **Stage Sunrise. The Alhambra** *c.* 1910
Oil on canvas, 16 × 20 (40.6 × 50.8)
Provenance: Miss Sybil Waller
Exhibited: Carfax Gallery June 1911, 'The Camden Town Group' (27); Anthony d'Offay 1974 (7); Fine Art Society 1976, 'Camden Town Recalled' (59)
Collection: Private

The Alhambra in Leicester Square was Gore's favourite music hall. Unlike Sickert's shabbier haunts, it mounted spectaculars, specializing in ballets and acrobatic turns rather than bawdy songs. Gore revelled in the riot of colour presented by the luscious backdrops and the ornate costumes. Sickert's early music halls featuring the stage behind the auditorium provided Gore with his compositional point of departure, but whereas Sickert had generally represented a single artiste on stage, Gore often depicted scenes of absurd multiple animation. Gore used the stage décor at the Alhambra to indulge his taste for more exotic effects of colour than were possible in the painting of landscape and interiors. Relatively few of Gore's music hall paintings are in public collections, but examples are to be found in the Tate Gallery, London (*Inez and Taki*), in the Department of the Environment collection (*The Alhambra*), and in the Johannesburg Art Gallery (*The Windmill Ballet*). When Gore abandoned the dazzling, colourful stippled touch of Impressionism, the music hall was perhaps no longer the ideal vehicle for his style. Apart from *Rinaldo* (Pl. 5) of 1911, *The Balcony at the Alhambra* (Pl. 6) of 1911–12, and a curiously distorted representation of *A Singer at the Bedford* (Tate Gallery) of 1912, Gore abandoned the music hall as a subject for painting after 1910.

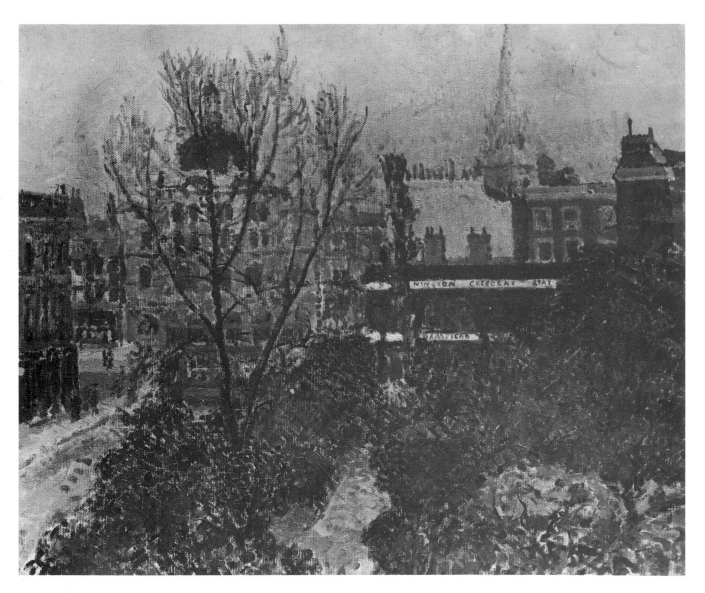

87

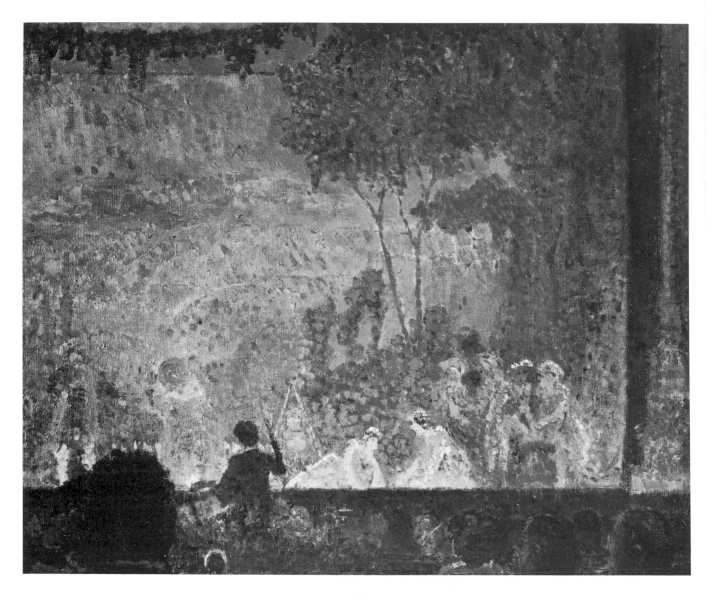

88

Grant

89 **Tulips** 1911
Oil on panel, $20\frac{1}{2} \times 19\frac{1}{2}$ (52 × 49)
Signed and dated 'D. GRANT 1911' bottom left
Provenance: Sir Edward Marsh
Literature: Sir Edward Marsh, *A Number of People, a Book of Reminiscences*,
London, Heinemann, 1939, p. 355; Christopher Hassall, *Edward Marsh*, London,
Longmans, 1959, p. 179
Exhibited: Carfax Gallery December 1911, 'The Camden Town Group' (53);
Whitechapel 1914, 'Twentieth Century Art' (365); Southampton 1951, 'The
Camden Town Group' (75); Plymouth 1974, 'The Camden Town Group' (18);
Fine Art Society 1976, 'Camden Town Recalled' (71)
Collection: Southampton Art Gallery (1954)

This painting is the only one Grant ever exhibited with the Camden Town Group of
which he was little more than a nominal member. Edward Marsh bought the picture
from the exhibition, an event of considerable historical importance. Marsh,
henceforth one of the most enlightened patrons of contemporary British artists,
acknowledged that the change of heart which converted him from Ancient to
Modern collecting occurred with its purchase. Its strong and heavy colours perhaps
helped educate Marsh's taste towards his later appreciation of Mark Gertler's work.
As we have seen from Neville Lytton's letter (quoted above in the note to Bayes's
work at the second Camden Town Group) *Tulips* was not Marsh's only acquisition
from the exhibition. He probably also bought Bayes's *The Bridge*. It is thus not quite
true to state (as often happens) that Grant's picture was the first modern work
bought by Marsh. Indeed, Marsh already owned paintings by traditional living
artists, including examples by Lytton who had guided his early activity as a
collector. Nevertheless, Grant's painting was certainly more progressive in style
than anything Marsh had previously owned. Lytton was outraged: 'I really must
protest against the Tulips. It is a disgraceful picture. It has neither colour, drawing,
nor composition. Its technique is atrocious and it is incompetent beyond measure.
. . . I repeat the Tulips are a *disgrace*. I quite understand that you should give the
classic a rest and buy samples of romantic artists, but this is not art at all.' The press
was less discouraging. Sir Claude Phillips (*Daily Telegraph*, 14 December 1911)
thought the flower-piece was 'beautifully done, somewhat after the fashion of
Manet, the only jarring note being the purple figured cloth on which the vase of
flowers rests'. Marsh himself was sufficiently proud of his purchase to lend it to the
Whitechapel exhibition in 1914, and Lytton ceased to be his artistic mentor.

89

244 Section II: Camden Town Group Exhibitions 1911

Innes
Pictures exhibited with the Camden Town Group

December 1911
7 Arenig (see Pl. 90)
8 Welsh Landscape
9 Flowers (Pl. 91)
10 The Mountain Stream

Note

Welsh Landscape cannot be identified. It has been suggested (Tate Gallery catalogue) that *Waterfall* in the Tate collection, a watercolour of 1911, could be *The Mountain Stream*. John Hoole (catalogue to Innes exhibition, Southampton 1977–8) suggested as two further possibilities another watercolour in the Tate Gallery (*The Waterfall* of 1910) and a privately owned version of the same subject. However, the critic of *Queen* (9 December 1911), noting that Innes's work imitated Augustus John, wrote: '"Mountain Stream", with its impossibly elongated figure, measuring about fourteen heads to the body, makes an attractive caricature of one of the exhibits at the Goupil Salon.' No figure appears in any of the waterfall subjects. The only known picture by Innes to include both the running water indicated in the title and a figure (indeed impossibly elongated) is *The Green Dress, Arenig* (private collection, rep. Fothergill Pl. 40, incorrectly identified as *Tan-Y-Griseau*; exhibited Southampton 1977–8, No. 92, rep. in catalogue). This picture was, therefore, probably the painting exhibited at the Carfax Gallery.

Innes

90 **Arenig** 1911
Oil on canvas, 14⅛ × 20 (35.9 × 50.8)
Signed and dated 'J. D. Innes 1911' bottom left
Provenance: Horace de Vere Cole; Lady Kroyer-Kielberg; Vincent Massey
Literature: Fothergill, rep. Pl. 17
Collection: The National Gallery of Canada, Ottawa (Gift of the Massey Foundation, 1946)

Mount Arenig was, for Innes, the consummation of his passionate vision of nature. In 1911 he and John shared a cottage, overlooked by the mountain, by a brook called Nant-Ddu. Innes painted the mountain in all its moods, in every light. Arenig became the personification of Euphemia Lamb, his greatest love, and he is said to have buried her letters in a silver casket on its summit. It is impossible to say which was the picture of Arenig exhibited by Innes with the Camden Town Group. The Ottawa painting is illustrated here because it is a work of 1911 rather than one of the many later pictures of the same subject. It is probably not the exhibited *Arenig* because Sir Claude Phillips (*Daily Telegraph*, 14 December 1911) would surely have noted its low cloud effect when he described Innes's painting as 'a beautiful study of hill and valley, wrapped in the shadow of deepening evening, yet still rich in colour'. This description suggests that the *Arenig* at the Carfax Gallery was closer in its mood to *Sunset in the Mountains* (private collection, No. 78 in the 1977–8 Southampton exhibition, rep. in colour in the catalogue).

Innes

91 **Ranunculus** *c.* 1911
Oil on panel, 9½ × 13⅛ (24.1 × 33.3)
Provenance: Sir Edward Marsh; Contemporary Art Society
Literature: rep. Fothergill, Pl. 43; *Studio*, CXLVI, August 1953, p. 39 in colour
Exhibited: Carfax Gallery December 1911, 'The Camden Town Group' (9) as *Flowers*; National Gallery 1921 (46) as *The Marsh Marigold*; Redfern Gallery 1939 (54); Leicester Galleries 1952 (73); Sheffield 1961 (30)
Collection: Walker Art Gallery, Liverpool (1954)

The description in the *Daily Telegraph* (14 December 1911) of *Flowers* as 'a study of sturdy, juicy, yellow blooms, rising solitary in the foreground of a meadow landscape' proves it can only be *Ranunculus*. Neville Lytton did not mention this picture among Edward Marsh's purchases from the Camden Town Group exhibition; nevertheless, Marsh could have bought it on this occasion. He certainly owned it by 1921 when he lent it to the National Gallery Innes exhibition.

90

91

John
Pictures exhibited with the Camden Town Group

June 1911
1 Llyn Cynlog (see Pl. 92)
2 Nant-ddu

Note

These are the only pictures John showed with the Camden Town Group. Both were landscape studies in oil of Welsh subjects almost certainly painted during the month before the exhibition. John's reputation was such that nearly every critic noted his work, in spite of its informality, and most wondered what the artist had to do with Camden Town. However, the press descriptions do not serve to identify the pictures with any conviction. They tell us the general character of his offerings which, according to *Queen* (24 June 1911), 'one likes as decorative patches of colour rather than as studies of actual form in landscape'. *Llyn Cynlog* attracted more attention than *Nant-ddu*. The title of the latter is that of the brook by the side of Mount Arenig where Innes and John rented a cottage in May 1911 (and used as their base in North Wales in 1911 and 1912). In 1976 (catalogue of the Fine Art Society, 'Camden Town Recalled' exhibition, No. 82) I made a very tentative attempt to identify *Nant-ddu* with the *Arenig* side of a double-sided panel by John in the Leeds Art Gallery. It shows a derelict cottage by a brook under the side of Mount Arenig. In handling it is more simple and direct than the reverse side showing a *Landscape of Chirk* which, stylistically, appears to date from 1912 when we know John was working at Chirk in North Wales. However, the suggestion that this sketch of *Arenig* could be *Nant-ddu* is far from convincing.

John

92 **Llyn Cymeog** *c.* 1911
Oil on panel, 12½ × 15 (31.8 × 38.1)
Signed 'John' bottom left
Provenance: Sir Michael Sadler; S. Samuels
Exhibited: possibly Carfax Gallery June 1911, 'The Camden Town Group' (1) as
Llyn Cynlog; Leicester Galleries 1930, 'The Camden Town Group' (17); Redfern
Gallery 1939 (2); Arts Council 1948 (8); Fine Art Society 1976, 'Camden Town
Recalled' (81)
Collection: W. P. George, Esq.

Neither Llyn Cymeog nor Llyn Cynlog is to be found on a map of the Arenig region
of North Wales. The peaks in this landscape almost certainly represent Arenig
studied from a point high up on the mountain. Perhaps the lake ('llyn' in Welsh) was
too small to figure on a map. If John submitted a handwritten title to the Carfax
Gallery, as *Llyn Cymeog* (rather than *Cwmeog*), his 'me' could easily have been read
as 'nl', particularly if his 'l' was looped. Carfax Gallery titles were, indeed,
frequently misprinted. The Welsh word 'eog' means 'salmon'; 'cwm' means a
mountain valley, but is sometimes misspelt 'cym'. On the other hand, the final 'log'
often appears in Welsh place names and a Llyn Conglog is to be found not far from
Arenig. The complex problems posed by the attempt to locate the subject of John's
1911 exhibit are virtually insoluble. Moreover, the picture illustrated here is not
specifically a lake scene as it should be whatever the precise name of the llyn in
question. However, it does appear to present a very small pool of water trapped
between the peaks and its insignificant size may indeed explain why this particular
lake cannot be found on a map. Press descriptions of John's exhibit are not much
help. *Art News* (15 July 1911) wrote that both John's landscapes were 'characterized
by great beauty of colour. In spite of a slight sense of restlessness "Llyn Cynlog" has
the further attraction of simplified form.' The handling of *Llyn Cymeog* is aptly
described as restless. On the other hand, the *Daily News* (17 June 1911) gave a
detailed colour guide to John's work: '"Llyn Cynlog" in particular is a vision of rich
and beautiful colour, boldly, joyously, and with powerful innocence used in the
utterance of a nature theme. This comradeship of profound and airy blues, of greys
and amethysts and silvers, is a thing to live with, to rejoice in.' While *Llyn Cymeog*
possesses all the colours mentioned, greens are not listed although these are an
important constituent of its colour harmony. However, Desmond MacCarthy (*Eye
Witness*, 6 July 1911) did remark on the 'beautiful, lush blues and greens' of John's
two landscape sketches. The evidence is contradictory and confusing, and the
problem not yet solved.

92

Lamb
Pictures at the First and Second Camden Town Group exhibitions

June 1911
21 Brittany Peasant Boy (Pl. 93)
22 Boy's Head
23 Man Fishing

Note
Lamb's three pictures were of Breton subjects, although only the first was thus designated in the title. Desmond MacCarthy (*Eye Witness*, 6 July 1911) wrote: 'Mr Lamb shows two Breton boys and an admirable picture of a Breton fisherman with a long pole, at the base of a cliff. There is something dour in his art; the clayey green of which he is so fond is not in itself a pleasing colour, yet his pictures have a charm which lasts.' *Boy's Head* may be the painting (private collection) illustrated in G. L. Kennedy's book on Lamb as Pl. 3, or *Head of a Boy* in the Manchester City Art Gallery. *Man Fishing* is now of unknown whereabouts, but may be the *Breton Fisherman* in the 1961 Leicester Galleries Lamb memorial exhibition (66).

December 1911
5 Portrait (?Pl. 94)
6 Drawing (see note to Pl. 94)

Lamb
93 **Brittany Peasant Boy** 1910
Oil on panel, 14 × 10 (35.5 × 25.4)
Signed and dated 'Lamb/1910' bottom left
Provenance: R. F. Shaw-Kennedy
Exhibited: Carfax Gallery June 1911, 'The Camden Town Group' (21); Fine Art Society 1976, 'Camden Town Recalled' (86)
Collection: Private

One of a pair of little paintings on the same rural Breton theme. Lamb exhibited the other picture, *Breton Cowherd*, at the N.E.A.C. in the winter of 1910. A contemporary catalogue annotation describing *Brittany Peasant Boy* as leaning against a tree proves that the picture illustrated here was the one exhibited in 1911. John's example encouraged the early development of Lamb's feeling for pure line and flat colour; it perhaps also inspired him to seek ideal beauty and simplicity in the people and landscape of rural France. Lamb was the more conscious artist in his manipulation of the structure of his compositions to express the mood of his subjects, whether it be the lyricism of this picture or the overpowering tragedy of peasant bereavement illustrated in *Mort d'une Paysanne* (National Art Gallery of

New Zealand, Wellington) exhibited at the N.E.A.C. in the summer of 1911. A version of this N.E.A.C. painting is in the Tate Gallery. The critics were, indeed, tempted to compare the very different moods of Lamb's contributions to these two summer exhibitions. The *Observer* (18 June 1911) was pleased that the pictures at the Carfax Gallery were not 'marred by eccentric exaggeration of expression'. The *Daily Telegraph* (22 June 1911), on the other hand, was disappointed to find 'an element of something like grandeur' missing from the Carfax paintings. The inspiration behind both John's and Lamb's figures in a landscape was Puvis de Chavannes, a source which the *Daily Telegraph* critic Sir Claude Phillips evidently recognized when he regretted that Lamb's *Man Fishing* lacked 'that pathos which so ennobles the *Pauvre Pêcheur* of Puvis de Chavannes'. Lamb's response to the art of Puvis was, on the whole, less romantic and more analytical than John's. His art had a harder classical edge to it. In fact Frank Rutter (*Sunday Times*, 18 June 1911), noting the smooth paint and firm drawing of Lamb's three Breton pictures at the Carfax Gallery, defined the artist as a modern classicist 'just as Gauguin – whom he so discriminately admires – was also essentially classic.'

Lamb

94 . **Portrait of Edie McNeill. Purple and Gold** *c*. 1910 (colour p. 29)
Oil on canvas, 24 × 20 (61 × 50.8)
Provenance: probably Judge William Evans; Wilfrid A. Evill; Lord Ilford
Exhibited: probably N.E.A.C. winter 1910 (77) and Carfax Gallery December 1911, 'The Camden Town Group' (5) as *Portrait*; probably Goupil Gallery 1918, 'The Collection of the late Judge William Evans' (91) as *Lady, with red background*; Leicester Galleries 1961 (41) as *Mrs McNamara*; Fine Art Society 1976, 'Camden Town Recalled' (87)
Collection: A. R. B. Burrows Esq.

When Edie McNeill married she became Mrs. McNamara – hence the later title. During the summer of 1911 she modelled for two standing portraits, the small picture shown as Pl. 70 and the large version in Southampton Art Gallery. However, the half-length illustrated here may have been painted at an earlier date. It is not related stylistically to the standing portraits and the artist knew Edie McNeill before 1911. The *Portrait* shown at the N.E.A.C. in 1910 was described by the *Manchester Guardian* (22 November 1910) as showing a 'girl in a mole-coloured dress, which does not need its strong crimson background' – words apt to the picture now known as *Purple and Gold*. Evidently Lamb sent two portraits of Edie McNeill to exhibitions in the winter of 1911, one to the Carfax Gallery in December and the other to the N.E.A.C. (also under the title *Portrait*). The *Daily Telegraph* (14 December 1911) tells us that Lamb's *Portrait* at the Carfax Gallery was 'an admirably firm and well-characterized study of the same *farouche*, resentful young model who appears in Mr. Lamb's picture at the New English Art Club.' The problem of sorting out which picture was exhibited where, is eased by the report of

the Camden Town Group show in the *Evening Standard and St. James's Gazette* (6 December 1911): 'The honours of the exhibition go to Mr. Henry Lamb for his "Portrait" (5). Painted apparently from the same model as his picture at the New English Art Club, this head and shoulders of a girl in red has the strange dignity and beauty that come of painting what is felt rather than seen.' Although the critic described the model's dress as red, whereas its soft brown mixed with pinky-purple tones better fitted the adjective 'mole-coloured', the rich ruby red of the background dominates the visual after-impression. Press reviews also prove that the large Southampton Art Gallery painting of *Edie McNeill* is the *Portrait* shown at the N.E.A.C. The *Star* (23 November 1911), for example, wrote of this *Portrait*: 'The colour is an exquisite and subtle harmony of greys, the only touch of positive colour in the picture being the narrow strip of red that borders the girl's neck.' The *Glasgow Herald* (22 November 1911) described 'the dusky, dark-haired girl meditatively standing on the rather timidly painted cliff, with beyond an expanse of still sea'. *Bazaar* (15 December 1911) remarked: 'how supple the plainly-clad figure, and how well its lines and shape fill the unbroken background'. The remote possibility that the small version (Pl. 70) of this Southampton picture was exhibited is ruled out by the *Glasgow Herald* (4 December 1911) noting that the *Portrait* at the Carfax Gallery was smaller than Lamb's N.E.A.C. picture. Lamb's drawing at the Carfax Gallery may have been a study for the Southampton *Edie McNeill*, because the *Daily Telegraph* described it as 'the figure of another (or, perhaps the same) model, standing in vacant space on an eminence'. The *Telegraph* critic was here reviewing the Camden Town Group exhibition, where the half-length was on view, so that his uncertainty as to whether the drawing represented the same model is less surprising. The Southampton Art Gallery own a drawing for their painting which could be the work exhibited at the Carfax Gallery.

93

94

256 Section II: Camden Town Group Exhibitions 1911

Lewis
Pictures at the First and Second Camden Town Group exhibitions

June 1911
7 The Architect (No. 1) (?Pl. 95)
8 The Architect (No. 2) (?Pl. 95)

December 1911
35 Port de Mer
36 Au Marché
37 Virgin and Child

Note

All three works from the December exhibition are lost. According to Lewis (*Rude Assignment*, p. 121) *Port de Mer* was a 'largish' painting representing 'two sprawling figures of Normandy fishermen, in mustard yellows and browns'. On the other hand, Frank Rutter (*Sunday Times*, 3 December 1911) described the picture as 'a blaze of yellow for sunlight, three extraordinarily simplified but cunningly placed figures to symbolise the picturesque loafing of fishermen at rest'. The *Glasgow Herald* (4 December 1911) also read three figures, two of 'slouching gait', in Lewis's picture. The painting entered Augustus John's collection, but inexplicably disappeared. *Au Marché* and *Virgin and Child* were evidently also paintings. Their price (20 guineas) was the same as *Port de Mer* and the critics did not distinguish between their medium when discussing Lewis's contributions. *The Times* (11 December 1911) called all three 'geometrical experiments'. According to the *Glasgow Herald* the Child in *Virgin and Child* 'consists chiefly in the disproportionately large eye and the bruised look of the face', but he found the Virgin benign. Other critics were outraged and insulted. An inside view, from the extreme right wing of the Camden Town Group, is given by Manson in the *Outlook* (9 December 1911). He tried, rather clumsily, to pretend that Lewis's style was 'old hat': 'such work has been produced in the gay metropolis [Paris] for the last twenty years.' Manson went on to propose that painting should either be abstract in content as well as design, or if 'they are meant to represent life in some way, they must be built up on a fundamental basis of Nature.' Lewis's drawing was 'untrue and distorted, and therefore bad'. As designs, Manson suggested, they were better fitted for 'a fin-de-siècle carpet'. Having disposed of Lewis, Manson could then go on to write: 'It is from Mr. Lucien Pissarro's work that I derive most satisfaction', and thus proclaim his allegiance to objective perceptual art. Pissarro himself was sufficiently outraged by Lewis's paintings to draft the letter to Gore quoted in the Introduction (p. 40).

Lewis

95 **Architect with Green Tie** 1909
Pen and ink and gouache, $9\frac{1}{2} \times 5\frac{1}{4}$ (24.1 × 13.3)
Signed and dated 'Wyndham Lewis 1909' bottom left
Provenance: John Quinn; Richard Wyndham (bought from Quinn sale, New York, 1927)
Literature: Michel, p. 348, rep. Pl. 2; Cork 1976, pp. 14–15, 70, rep. p. 14
Exhibited: probably Carfax Gallery June 1911, 'The Camden Town Group' (7 or 8); Tate Gallery 1956 (4); Arts Council 1974 (3); Fine Art Society 1976, 'Camden Town Recalled' (91)
Collection: Private

The 1974 Arts Council catalogue summarizes the reasons for supposing that this drawing was exhibited as *The Architect* (either No. 1 or No. 2) at the Carfax Gallery: the identification of the drawing, previously called *The Green Tie*, with the drawing catalogued in the Quinn sale as *Architect with Green Tie*, and Bomberg's (unpublished) description of Lewis's contributions to the Carfax Gallery exhibition. Contemporary press reviews support this identification. The *Sunday Times* (18 June 1911), discussing the irreproachable sobriety of the exhibition, added: 'A few visitors may be shocked at the elongated noses in the squarely-drawn heads by Mr. Wyndham Lewis . . . but with the exception of these two pen drawings I can not recall any exhibit which could justly be described as "queer".' The *Observer* (18 June 1911) judged the exhibition in similar terms but took more exception to Lewis's 'pen-drawings . . . executed in an amateurish, laboured method of cross-hatching, which is painfully at variance with the artist's grotesque affectation of archaism.' The reaction of the *Morning Post* is quoted in the text. It is probable that the gouache (colour was not mentioned by the critics) was superimposed on the pen hatching at a later date. Lewis frequently altered his work years afterwards, and sometimes also altered the dates inscribed. If *Architect with Green Tie* is one of the drawings shown at the Camden Town Group exhibition, it is possible that the other was *Anthony* (Victoria and Albert Museum), a drawing of the same date and probably the same sitter. *Anthony* is reproduced by Michel, Pl. 2, beside *Architect with Green Tie*.
(Reproduced by courtesy of The Museum of Modern Art, New York)

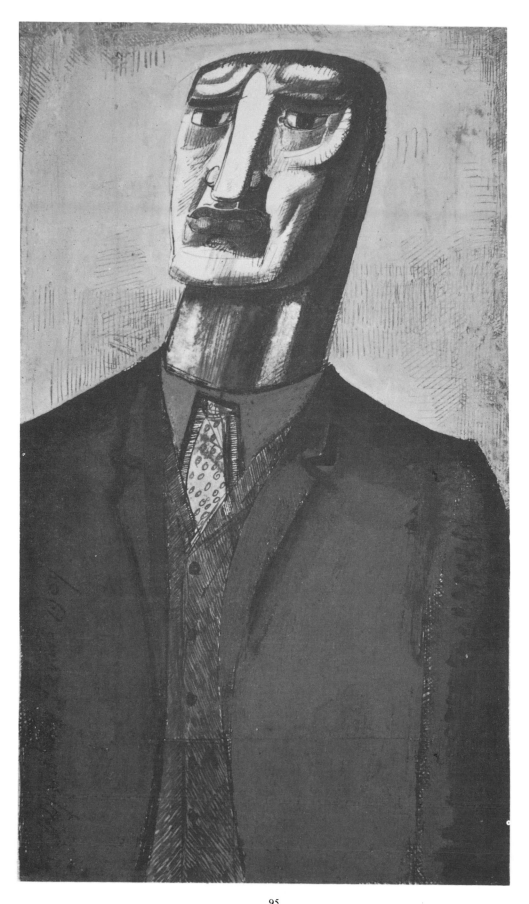

95

Lightfoot
Pictures exhibited with the Camden Town Group

June 1911
17 Mother and Child (Pl. 96)
18 Frank (Pl. 97)
19 On Luddery Hill (Drawing)
20 A Child Playing with a Ball (Drawing)

Note
Child Playing with a Ball (private collection) is reproduced in the Walker Art Gallery 1972 catalogue of their comprehensive Lightfoot exhibition, Pl. 19. Like the two paintings it formerly belonged to Arthur Clifton, owner of the Carfax Gallery. It is probable that another drawing from Clifton's collection, *Cows and Calves in a Field* (private collection), is the fourth work exhibited by Lightfoot as *On Luddery Hill*.

As the comments quoted below in the notes to Pls 96 and 97 reveal, the critics wondered at Lightfoot's membership of the Camden Town Group. The artist himself regretted his inclusion and alleged in an interesting letter to his Slade contemporary, Rudolph Ihlee, that he had never consented to becoming a member. The full text of this letter is published p. 12 of the Rudolph Ihlee exhibition catalogue, Graves Art Gallery Sheffield and Belgrave Gallery London, 1978. Its chief content was a harsh condemnation of the Camden Town Group exhibition. Lightfoot thought Lamb's work 'paltry'. He despised John's 'wild' sketches and judged that Adrian Allinson would soon match John's achievement ('For he is equal to him now in lack of humbleness – he has only got to practice drawing wild lines.'). He found Gore's theatre pieces 'as pretty as any young lady would wish to see – drawing, none – colour pretty – but not by any means good. He approaches as many schemes of colour in one picture as Whistler did in the whole of his lifework.' Lightfoot evidently resigned from the Camden Town Group forthwith. He wrote to Ihlee: 'I swear on my oath I will never show with the crowd again. It is 19 Fitzroy Street to the core. My stuff looks as much out of place and absurd as I do when I go to the Saturday afternoon lying competition at Sickert's.' He did, however, welcome the good relationship he had established with Clifton and hoped to exhibit at the Carfax Gallery, alone, in the future. Three months later Lightfoot killed himself.

Lightfoot

96 Mother and Child *c.* 1911
Oil on canvas, tondo diameter 23⅛ (58.8)
Provenance: Arthur Clifton
Exhibited: Carfax Gallery June 1911, 'The Camden Town Group' (17);
Whitechapel 1914, 'Twentieth Century Art' (352); Leicester Galleries 1930, 'The
Camden Town Group' (44); Walker Art Gallery 1972 (56); Fine Art Society 1976,
'Camden Town Recalled' (97)
Collection: Private

Lightfoot's paintings stood out as totally different in mood, style and ideal from his
fellow-exhibitors at the Carfax Gallery. The *Daily Telegraph* (22 June 1911) hoped
that 'this youthful painter will not allow himself to be drawn from the fair path upon
which he has now entered, either by excess of praise or by the influence of brothers
in art of more "advanced" views.' The *Morning Post* (3 July 1911) also pondered
Lightfoot's future: his 'powerful drawings suggest that, unlike his fellow "won-
ders", he is going to compromise with the past. His two oil pictures are carried
further in the old-fashioned sense than anything in the gallery. He is obviously not
going to remain satisfied with the light, rather precarious, painting of the Camden
Town Group. He is a William Orpen in the making.' Lightfoot was twenty-four
when he painted *Frank* and *Mother and Child*. Only one painting executed at a
slightly later date than these two is known, another *Mother and Child* (private
collection). When this later painting was exhibited in Belgium in 1921 it was
acclaimed as a masterpiece and bought by the president of the Beaux-Arts de Liège.
Lightfoot's powerful sense of design, the exquisite precision of his drawing, his
ability to render the most subtle nuances of tone, were precocious gifts. He seems to
have been out of step with his contemporaries, although many admired his work
deeply. Both *Frank* and *Mother and Child* were included in two Contemporary Art
Society exhibitions (although not acquired by the c.a.s.), one in Manchester in
1911 and the other at the Goupil Gallery, London, in 1913. Roger Fry picked out
the tondo in his catalogue preface to the Manchester show: 'Mother and Child is
more than a tentative effort of a young artist; it is already a definitive achievement
and serves to show how great a loss to art his early death has inflicted.' The mother
and child theme obsessed Lightfoot in 1911. While there may be symbolist
elements in his work, his art was a passionate response to nature, perceived through
the emotions as well as through the eye.

Lightfoot

97 Boy with a Hoop. Frank *c.* 1911
Oil on canvas, 30⅛ × 20 (76.5 × 50.8)
Provenance: Arthur Clifton
Exhibited: Carfax Gallery June 1911, 'The Camden Town Group' (18) as *Frank*;
Whitechapel 1914, 'Twentieth Century Art' (344) as *Boy with a Hoop*; Leicester

Galleries 1930, 'The Camden Town Group' (41); Walker Art Gallery 1972 (51); Fine Art Society 1976, 'Camden Town Recalled' (95)
Collection: Private

The picture is inscribed on the stretcher with the artist's name and address (13 Fitzroy Road, Primrose Hill). The model for this pensive study of childhood was Frank Jones, son of Lightfoot's landlord. His daughter still lives in the house where Lightfoot lodged and remembers that after the artist's suicide, when a creak was heard from upstairs, her family would say, 'That's Mr Lightfoot'. As with *Mother and Child*, the critics responded to *Frank* with great admiration. According to the *Sunday Times* (18 June 1911) the painting was 'academic in the best sense of the word. If there is a suggestion of Whistler in the colour, the drawing at least recalls nothing more modern and revolutionary than Holbein.'

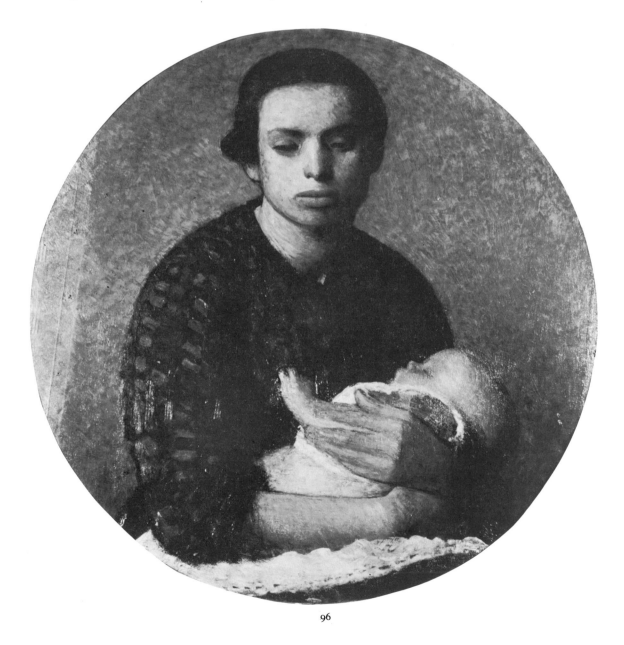

96

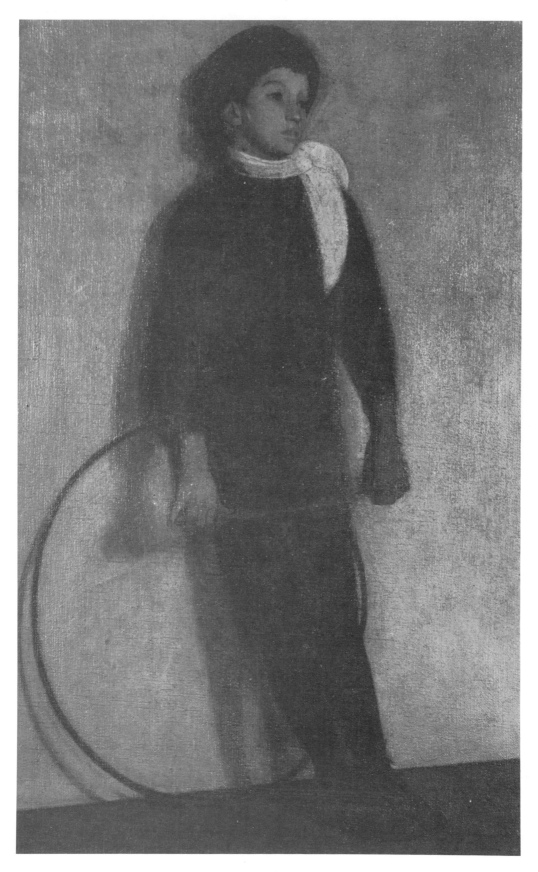

97

Manson
Pictures at the First and Second Camden Town Group exhibitions

June 1911
 3 A Corner of the Garden (?Pl. 98)
 4 The Avenue, St. Valéry-s-Somme
 5 Child's Head
 6 In the Garden Suburb

Note
Manson's work was little noticed in press reviews of the Camden Town Group exhibition. *In the Garden Suburb* was probably an outdoor scene in Hampstead Garden Suburb where Manson lived (in Hampstead Way). *Child's Head* was probably one of his many studies of either Mary or Jean, the artist's daughters. *Art News* (15 July 1911) tells us that this 'attractive' picture was 'characterized by purity of colour'. The same critic described *The Avenue, St. Valéry-s-Somme* as 'a pleasing study of autumn foliage'. This painting had previously been exhibited by Manson at the N.E.A.C. in the winter of 1909; thus it represented Manson's work before he came to know Lucien Pissarro.

December 1911
46 Evening Sunlight
47 The Sussex Downs, Storrington (see Pl. 99)
48 Portrait of a Lady
49 The Sunlit Valley

Note
I have discovered no descriptions of any work exhibited by Manson in December 1911. Nor, with the exception of the Storrington subject, do his titles aid identification.

Manson
98 **Lilian in Miss Odell's Garden** *c.* 1910
Oil on canvas, 16 × 20 (40.6 × 50.8)
Exhibited: probably Carfax Gallery June 1911, 'The Camden Town Group' (3) as *A Corner of the Garden*; probably Whitechapel 1914, 'Twentieth Century Art' (426) as *A Cornish Garden*; Maltzahn Gallery 1973 (8); Fine Art Society 1976, 'Camden Town Recalled' (101)
Collection: Private

Lilian (*née* Laugher) was the artist's wife. They married in 1903. She was a teacher of music and had studied the violin in Germany. In 1908 she was appointed Director

of Music at North London Collegiate School for Girls (succeeding Bernard Shaw's mother). Miss Odell, another teacher at the school, lent the Mansons her cottage in Padstow, Cornwall, where this picture was painted. The subject and the date of this picture suggest it could have been the work exhibited at the Carfax Gallery. Moreover, if Manson gave the title of his exhibits to the Carfax Gallery verbally, they might easily have misheard his instruction *A Cornish Garden* as *A Corner of the Garden*. The colours in this picture are fresher and the touch more spontaneous than in the Douélan landscapes (e.g. Pl. 44).

Manson

99 The Valley Farm, Storrington, Sussex 1911
Oil on canvas, $15\frac{1}{2} \times 19\frac{1}{2}$ (39.3 × 49.5)
Signed and dated 'J. B. MANSON/1911' bottom right
Provenance: Geoffrey Blackwell; F. A. Girling
Collection: Sotheby's, 13 March 1973, lot 65

In style and handling this landscape is close to Pissarro's *Cottage at Storrington* (identified as Waterfall Cottage) in the Worthing Art Gallery. Pissarro's picture is also dated 1911 and it is probable that the two artists were together in the Sussex village. The picture by Manson illustrated here is not the work exhibited with the Camden Town Group which is of unknown whereabouts. Another dated Storrington subject of 1911 is *Babes in the Wood*, a charming study of the artist's daughters flitting through trees rather in the manner of Lucien Pissarro's early paintings of the 1880s to 90s. It is reproduced in the Maltzahn Gallery catalogue of Manson's work, compiled by David Buckman in 1973.

98

99

Pissarro

Pictures at the First and Second Camden Town Group exhibitions

June 1911

13 Buttercups, Colchester

14 View of Colchester

15 Well Farm Bridge, Acton (Pl. 100)

16 A Foot-Path, Colchester (Pl. 101)

Note

Buttercups, Colchester was sold, from the estate of Mrs William Greve, at Christie's 11 June 1976, lot 33 (rep. in catalogue), and resold at Sotheby's, 22 June 1977, lot 33, (rep. in catalogue) to the Caspar Gallery. It is a view across meadows towards the outskirts of the town. *View of Colchester* is the view from Sheepen in the collection of the Colchester Public Library.

December 1911

42 Sunset, Epping

43 The Mill, Finchingfield (sketch)

44 The Turban (Pl. 102)

45 The Brook, Sunny Weather

Note

Pissarro took a cottage at Epping from 1893–7. It is possible that *Sunset, Epping* dates from that period. It was re-exhibited at the Carfax Gallery in 1913 (27). The Brook was Pissarro's family house at Stamford Brook from 1902 onwards. Pissarro painted at Finchingfield in 1905. Thus it appears that, unlike the June exhibition when Pissarro showed three very recent pictures, he chose in December to present a selective retrospective account of himself. I do not know the whereabouts of the three other pictures.

Pissarro

100 **Well Farm Bridge, Acton** 1907

Oil on canvas, 18 × 21½ (45.7 × 54.5)

Signed in monogram and dated 'LP 1907' bottom right

Exhibited: N.E.A.C. winter 1907 (110); Carfax Gallery June 1911, 'The Camden Town Group' (15); Carfax Gallery 1913 (8) lent by the Leeds Arts Collection Fund; Arts Council 1963 (21); Fine Art Society 1976, 'Camden Town Recalled' (107)

Collection: City of Leeds Art Gallery and Temple Newsam House (1925)

Frank Rutter, who in 1912 became curator of the Leeds Art Gallery, perhaps initiated the purchase of this picture by the Arts Collection Fund. As has been

noted, Lucien Pissarro's train landscapes were inspired by his father. The *Observer* (18 June 1911) noticed and commended this influence: 'in sacrificing his wonted deliberate naiveté to a closer approach to the style of his namesake, Camille Pissarro, [Lucien] manages to extract real beauty from as unpromising a subject as a railway cutting.' Pissarro was probably attracted to railway subjects less from a Camden Town bias towards finding beauty in unexpectedly prosaic places, than from the strong constructive elements afforded by their perspectives.

Pissarro

101 **A Foot-Path, Colchester** 1911
Oil on canvas, 21 × 25 (53.3 × 63.5)
Signed in monogram and dated 'LP 1911' bottom right
Exhibited: Carfax Gallery June 1911, 'The Camden Town Group' (16); Carfax Gallery 1913 (26); Colchester 1961, 'Camden Town Group' (55); Arts Council 1963 (26); Fine Art Society 1976, 'Camden Town Recalled' (109)
Collection: the artist's family

Three of Pissarro's four pictures at the Carfax Gallery in 1911 were Colchester views painted a little earlier in the year. The critic of *Art News* (15 July 1911) noticed how he subtly varied his treatment according to the need: 'Mr. Pissarro has no patent prescription.' The *Daily Telegraph* (22 June 1911) summed him up as 'an impressionist pure and simple, and one of the calmer and more objective order'. The *Morning Post* (3 July 1911), ever facetious, called him a 'Marconigraph between Camden Town and the French battlefields of art', perhaps not realizing that the battle for Impressionism of Pissarro's type had been fought and won years before. Desmond MacCarthy's comments (*Outlook*, 6 July 1911) summed up the more intelligent reactions of the press when he wrote of Pissarro's 'four pictures of patient and admirable honesty. Like his father, he has no wish to embellish anything in Nature and scorns to select her exceptional moods or to avoid the commonplace. They are all taken in bright sunlight. You can feel the touch of the east wind in his view of Colchester. The day he paints is one which everybody would describe on meeting an acquaintance as "very fine"; a perfect day for a coronation or a cricket match, but one on which the epicurean is apt to feel that there is not much that is interesting under the sun.'

Pissarro

102 **Orovida wearing a Turban** 1907
Oil on canvas, 17½ × 14½ (44.5 × 36.9)
Signed in monogram and dated 'LP09' bottom right
Provenance: F. B. C. Bravington
Exhibited: N.E.A.C. summer 1909 (222); Carfax Gallery December 1911, 'The
Camden Town Group' (44); Carfax Gallery 1913 (4); Brighton 1913–14, 'English
Post-Impressionists, Cubists and others (63); Fine Art Society 1976, 'Camden
Town Recalled' (105)
Collection: Private

A portrait of the artist's daughter, the painter Orovida Pissarro (1893–1968), aged
about thirteen. It was entitled *The Turban* in early exhibitions. Lucien Pissarro
painted few portraits. His experience as a designer of woodcuts seems to have
influenced the delicate colouring and the attractive close-knit decorative patterning
which especially distinguish this picture. Manson (*Outlook*, 9 December 1911)
declared: 'I would rather possess ... "The Turban", than any other picture I
know.'

100

101

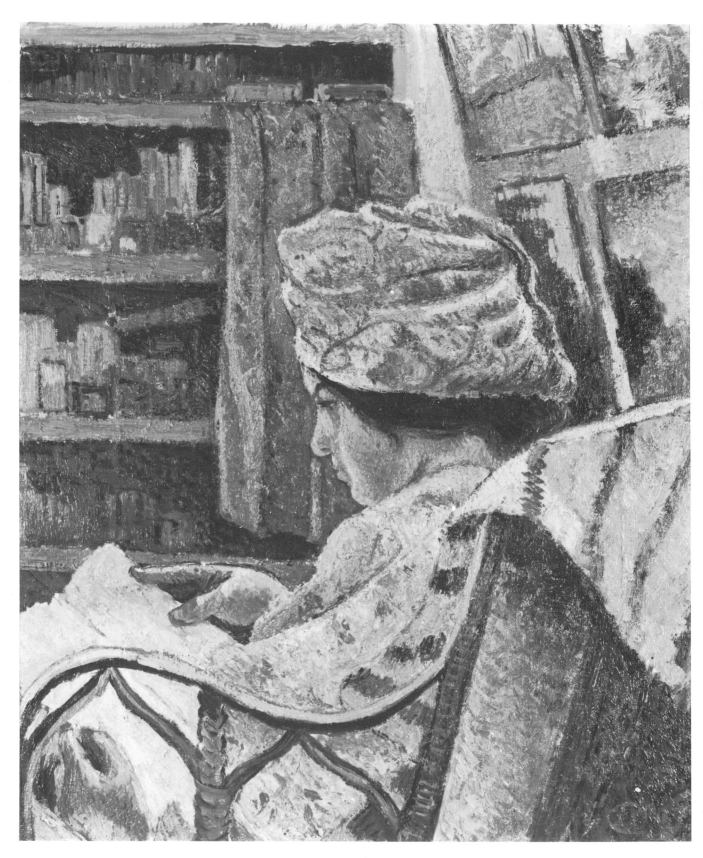

102

272 Section II: Camden Town Group Exhibitions 1911

Ratcliffe
Pictures at the First and Second Camden Town Group exhibitions

June 1911
48 The Window Seat
49 Haystacks
50 The Dressing Table
51 Graven Images

December 1911
23 Cottage Window Seat
24 Sunshine (?Pl. 103)
25 Still Life
26 The Veranda

Note
No picture exhibited by Ratcliffe at the Carfax Gallery shows in 1911 can be identified with certainty. Indeed, his career as an exhibitor began in the summer of 1911, first with the Camden Town Group in June and then with the Allied Artists' Association in July. Next to Doman Turner (who also launched himself on the public for the first time this summer, and whose contributions were all drawings) Ratcliffe's were the most modestly priced works. Those critics who noted his pictures treated the artist with respect, and grouped him together with Drummond and Gilman (*Morning Post*, 3 July 1911) or with Manson (*Truth*, 28 June 1911, *Sunday Times*, 3 December 1911). The only description of an individual picture noted that *The Window Seat* gave a 'view of waste common with a gypsy van' (*Bazaar*, 30 June 1911). An *Interior* of about this date is illustrated (Pl. 104) as a substitute for one of the pictures actually exhibited in 1911.

Ratcliffe
103 **In the Sun** *c.* 1911
Oil on canvas, 18 × 14 (45.7 × 35.6)
Signed 'W. Ratcliffe' bottom left
Provenance: the artist's family
Exhibited: possibly Carfax Gallery December 1911, 'The Camden Town Group' (24), Brighton 1913–14, 'Work of English Post-Impressionists, Cubists and others' (127), and London Group 1914 (102) as *Sunshine*; Roland, Browse & Delbanco 1946 (41) as *Sunshine*; Southampton 1951, 'The Camden Town Group' (109) as *In the Sun*; Letchworth 1954 (3) as *In the Sun, Letchworth*
Collection: Walker Art Gallery, Liverpool (1956)

The fact that this painting was exhibited in 1946 under the same title as the work shown in the three early exhibitions supports the suggestion that it is that work. Roland, Browse & Delbanco presumably selected their exhibition with the artist's co-operation, so the title has authenticity. On the other hand, they dated the picture 1914, information which must also have come from the artist. However, artists are notoriously inaccurate about the retrospective dating of their work (an example is quoted in the note to Drummond's exhibits at the first Camden Town Group show). Moreover, when the picture was lent by the artist to the Southampton exhibition (under the present title) an exhibition reference was given to the Brighton show, although uncertainty was expressed as to whether it was No. 127. It certainly could not have been any other of Ratcliffe's six contributions to the 1913–14 exhibition. The *Sunshine* shown in Brighton was priced at the same 8 guineas as the *Sunshine* shown at the Carfax Gallery in 1911. The price had gone up to 10 guineas at the London Group. It is very unlikely that three or even two different pictures with the same title were shown on each of these occasions. Stylistically the picture in Liverpool accords with what we know of critical reaction to Ratcliffe's work at the Carfax Gallery. The only individual mention of the picture (*Daily Telegraph*, 14 December 1911: 'Of Mr Ratcliffe's contributions the pretty, scintillating "Sunshine" is the best') neither refutes nor confirms the identification.

Ratcliffe

104 **Interior** *c.* 1911
Oil on board, $15\frac{1}{2} \times 19\frac{1}{2}$ (39.3 × 49.5)
Signed 'W. Ratcliffe' bottom left
Provenance: Edward le Bas
Exhibited: Fine Art Society 1976, 'Camden Town Recalled' (111)
Collection: Private

None of the interiors exhibited by Ratcliffe at the two 1911 Camden Town Group shows has been found. The *Daily Telegraph* (22 June 1911), reviewing the first exhibition, called him a 'valiant and well-skilled Impressionist of the French type', while an annotation in a catalogue of this show noted the 'fresh colour' of *The Window Seat*. These remarks rule out the possibility that two rather dark and tentative cottage interiors, which came from the artist's studio after his death to the Letchworth Art Gallery, can be exhibition works of this date. The painting illustrated, although not one of the Camden Town Group pictures, is probably a contemporary work. It reflects knowledge of the interiors by Gilman and Gore, and is particularly close to Gore's *Interior. Fireside Scene* (Pl. 22). Edward le Bas is though to have bought the painting from Roland, Browse & Delbanco at the time of their Ratcliffe exhibition in 1946; however, it is not one of the paintings listed in the catalogue.

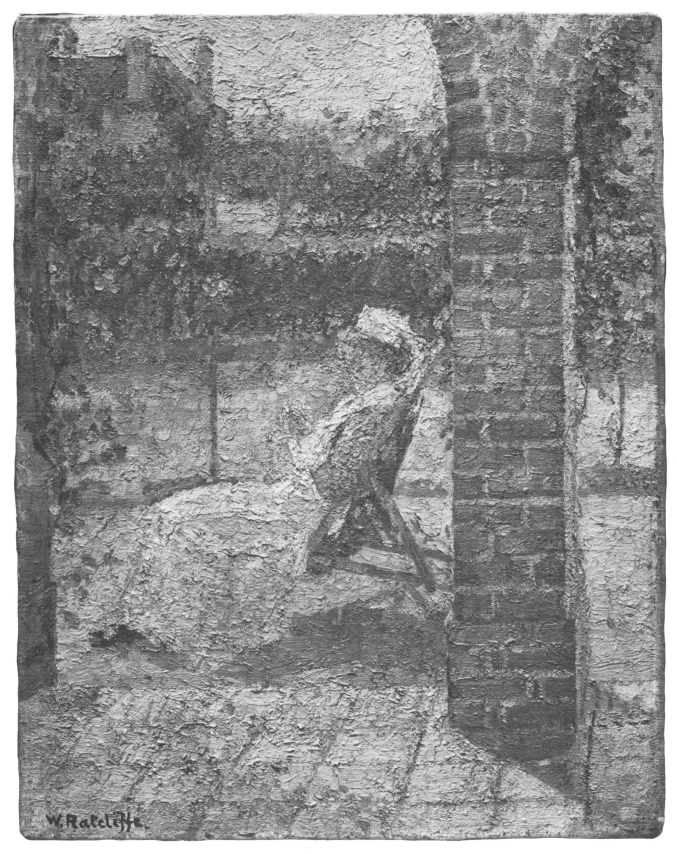

103

Section II: Camden Town Group Exhibitions 1911 275

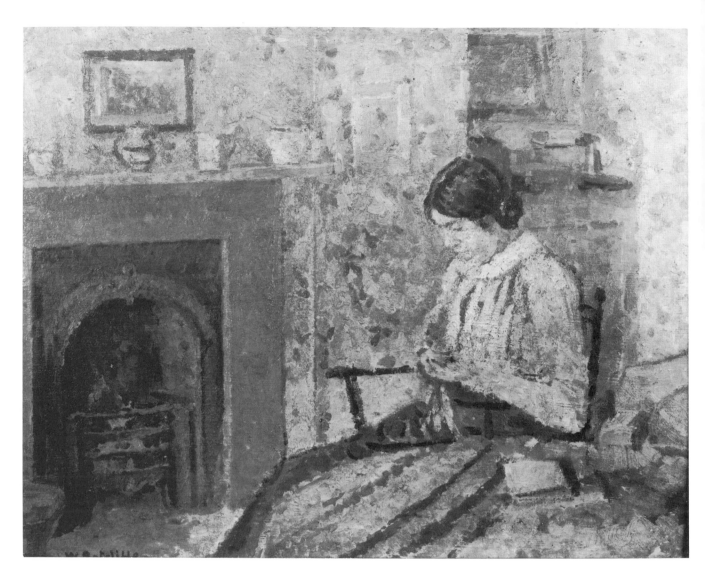

104

276 Section II: Camden Town Group Exhibitions 1911

Sickert
Pictures at the First and Second Camden Town Group exhibitions

June 1911
9 'Chicken' (Lent by Miss Jean McIntyre) (Pl. 105)
10 The Camden Town Murder Series, No. 1 (Pl. 106)
11 Lena
12 The Camden Town Murder Series, No. 2 (see Pl. 106)

Note
The critics concentrated entirely on Sickert's *Camden Town Murder* pictures, leaving *'Chicken'* and *Lena* unreported. I have not been able to identify *Lena*.

December 1911
11 Louie
12 Mother and Daughter (see Pl. 107)
13 The Old Hôtel Royal
14 Carolina dell'Acqua

Note
Louie, described by Sir Claude Phillips (*Daily Telegraph*, 14 December 1911) as 'a powerful, living study of slatternly humanity' is a bust portrait study of a coster girl painted *c.* 1906 (private collection, unpublished and unreproduced). It is not possible to identify either *The Old Hôtel Royal* or *Carolina dell'Acqua*. Sickert painted the Dieppe hotel many times before its demolition in 1900 but the reviews do not serve to pinpoint the precise version exhibited. Carolina dell'Acqua was one of his favourite models in Venice in 1903–4 and appears in a wide variety of interior scenes. It is interesting that, with the exception of *Mother and Daughter*, Sickert showed no recent work at this exhibition.

Sickert
105 **'Chicken'** *c.* 1908
Oil on panel, 15 × 12½ (38.1 × 31.7)
Provenance: Mrs A. E. D. Anderson (*née* McIntyre)
Literature: Baron, pp. 350–1, C. 280
Exhibited: Carfax Gallery June 1911, 'The Camden Town Group' (9); Fine Art Society 1976, 'Camden Town Recalled' (137)
Collection: Private

Jean McIntyre, one of Sickert's most talented pupils at Rowlandson House, lent this painting to the Camden Town Group exhibition. An annotated catalogue of the exhibition confirms the identification by describing *'Chicken'* as 'girl at mantel

glass'. 'Chicken', who often modelled for Sickert, is named by Denys Sutton (pp. 174–5) as Emily Powell. Sickert had a studio in a house where she lived with her parents. This is one of his earliest portraits of her, done when she was about eleven years old. She was training to be a singer which explains why she modelled playing the piano for Sickert in his Red Lion Square studio during the winter of 1914–15. This intimate and vibrant little study was totally neglected by critics at the Camden Town Group exhibition.

Sickert

106 **'What shall we do for the Rent?'** *c.* 1909
Oil on canvas, 19 × 15 (48.3 × 38.1)
Provenance: Dr Alastair Hunter; J. W. Blyth
Literature: Baron, pp. 112, 349–50, C. 275, rep. Fig. 193 as *Summer Afternoon*
Exhibited: possibly Salon d'automne, Paris 1909 (1582 or 1583) as *L'Affaire de Camden Town*; Carfax Gallery June 1911, 'The Camden Town Group' (10 or 12) as *The Camden Town Murder Series No. 1 or No. 2*; Arts Council, Edinburgh 1953 (12) as *The Camden Town Murder*; Fine Art Society 1973 (65) as *Summer Afternoon*; Fine Art Society 1976, 'Camden Town Recalled' (140)
Collection: Kirkcaldy Museums and Art Gallery (1964)

The bewildering range of titles needs explaining. The title used here is the one preferred by the Kirkcaldy Art Gallery. Sickert himself was probably responsible for suggesting the title *Summer Afternoon* to his pupil and biographer Robert Emmons who previously owned the other version of this subject (private collection, rep. Browse 1960, Pl. 61; Lilly, Pl. 16). These two pictures form a complementary pair. The *Summer Afternoon* title was a piece of Sickertian perversity. Although *Summer Afternoon* is less gloomy in tone than the painting illustrated here, the critics in June 1911 understandably, if variously, interpreted the time of day as twilight or early morning, never a sunny afternoon.

All the critics devoted considerable space to Sickert's two pictures, treating them as a pair instead of individually. Their descriptions serve to identify the Kirkcaldy picture and *Summer Afternoon* as the *Camden Town Murder Series* exhibits. For example, the *Sunday Times* (18 June 1911) wrote: 'The unclothed figure on the bed and the clothed figure of the man seated at the side afford a contrast which has interested painters for centuries, though Mr. Sickert has given a novel note to a favourite theme by viewing it in dim twilight through a quivering veil of atmosphere which gives just the sense of mystery and even of impending tragedy to justify the titles.' The *Daily Telegraph* (22 June 1911) noted: 'In both a sinister being sits quietly watching in the dim, struggling light of morning the nude figure of a woman stretched out on a miserable couch.' While most of the critics accepted Sickert's title as descriptive of his subject, dealing with what the *Observer* (18 June 1911) termed 'the utter depravity of a particularly unsavoury phase of life', they also recognized that Sickert's concern was not simply with illustration. The *Daily Telegraph* realized that he 'compasses something that the impressionists very rarely

aim at, and still more rarely attain. He combines the dramatic with the merely visual impression.' *Art News* (15 July 1911) explained that 'as Rembrandt found a fine problem of colour in a butcher shop, so Mr. Sickert finds in the sordid surroundings of a tawdry tragedy a fascinating problem of colour, design and suggestion of form.' Desmond MacCarthy (*Eye-Witness*, 6 July 1911) wrote:

Mr. Sickert's two studies of the Camden murder owe their impressiveness entirely to this emotional suggestiveness of light and shadow; the way the light from the window falls across the woman's body and under the bed, leaving the figure of the man in sinister obscurity, is aesthetically beautiful, but it is also most expressive. Mr. Sickert has been accused by critics of misusing his talents in painting such a subject. The objection is absurd. His treatment shows no vulgar sensationalism or love of horror, but an imaginative interest well worth sharing.

Sickert

107 **Mother and Daughter. Lou! Lou! I Love You** 1911
Pen and black ink on paper, $10\frac{3}{4} \times 6\frac{3}{4}$ (27.3 × 17.1)
Signed and dated 'Sickert 1911' bottom right, inscribed 'Study for etching. Mother & daughter' along lower edge
Provenance: Thomas Lowinsky
Literature: rep. *New Age*, 6 July 1911, as *Lou! Lou! I Love You*; Baron, pp. 121, 353, 358
Collection: Anthony d'Offay Gallery

Sickert also etched and painted this subject. He exhibited the painting (rep. Browse 1960, Pl. 64) with the Camden Town Group in December 1911 as *Mother and Daughter*, although earlier in the year he had published the drawing in the *New Age* under a different title. Painting and drawing are identical in composition and virtually the same size. The drawing is illustrated here to show the variety of touch Sickert employed when using pen and ink, an approach which profoundly influenced Gilman's later development as a draughtsman.

105

106

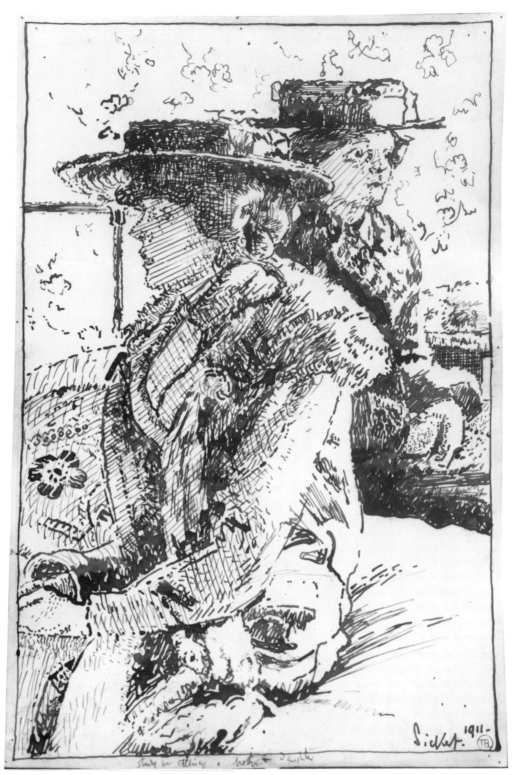

107

Turner

Drawings at the First and Second Camden Town Group exhibitions

June 1911

40 Duncan and Godfrey in 'The Coster's Courtship'. Pastel
41 Elizabeth II at Brighton. Watercolour
42 In the Grand Circle. Drawing
43 Brighton Shelters

Note

Only two drawings by Turner are known, and neither was exhibited at the Carfax Gallery in June. The fullest review of his work was given in the *Sunday Times* (18 June 1911): 'we may possibly find a future recruit to classicism in Mr. J. Doman Turner, whose watercolours show a tendency to ascetic composition though his drawing "In the Grand Circle" ... reveals a touch of Sickertian romanticism.'

December 1911

1 Walberswick
2 H.M.S. '—' Sheerness
3 St. Valéry-s-Somme
4 The Sound of Kerrera and Kerrera Island, Oban

Note

St. Valéry-s-Somme is one of Turner's two extant drawings and was formerly in the possession of Gore. Executed in soft pencil, pen and ink and watercolour with the planes of colour and tone clearly defined, it has something of the quality of a drawing by Walter Taylor. Turner's second extant drawing is reproduced here, rather than *St. Valéry-s-Somme*, because it is both more accomplished and better illustrates the influence of Gore, and via Gore of Sickert, on his pupil's style and method.

Turner

108 **Montvilliers, near Le Havre** *c.* 1910–11
Chalk and watercolour, $10\frac{3}{4} \times 14\frac{3}{4}$ (27.3 × 37.5)
Inscribed with title, bottom left
Provenance: Spencer Frederick Gore and Mrs Gore
Exhibited: Southampton 1951, 'The Camden Town Group' (129); Colchester 1961, 'Camden Town Group' (73); Arts Council 1961, 'Drawings of the Camden Town Group' (106); Hampstead 1965, 'Camden Town Group' (75); Fine Art Society 1976, 'Camden Town Recalled' (152) miscatalogued as *St. Valéry-sur-Somme*
Collection: Private

Both of Turner's drawings were exhibited in 1976 but in cataloguing them I confused the two titles. The inscription on *Montvilliers* had previously been obscured by an old mount. Gore instructed Turner in the art of drawing by letter and this correspondence is being prepared by Frederick Gore for publication in 1979. Above all Gore insisted that Turner should concentrate on expressing the patterns of light and shade and half-tones. In several letters he recommended chalk or charcoal, rather than harder pencil, to avoid Turner's tendency to draw too much in outline.

108

Section III(a):
Introductory (1912)

Gilman

109 **The Café Royal** 1912

Oil on canvas, 29¼ × 24½ (74.3 × 62.2)

Signed and dated 'H. Gilman 1912' bottom right

Exhibited: Carfax Gallery 1913 (5 or 40); Colchester 1969 (19)

Collection: Mr and Mrs Evelyn Joll

The Café Royal, opened in 1865, quickly became a favourite meeting place for writers and artists and has remained so until the present day. It was much patronized by members of the Camden Town Group who would repair to its dining-rooms and bars to continue discussions initiated earlier in the day at 19 Fitzroy Street. The most remarkable painted records of extensive aspects of its exuberant interior were painted between 1911 and 1916. Ginner's picture of 1911 (Pl. 85) perhaps sparked off the fashion, to be followed by William Orpen's brilliant interior (Musée d'Art Moderne, Paris; copy of original Nicols Bar, Café Royal). Orpen's work, showing endless reflected vistas of barley-sugar columns and moulded ceiling decorations, complete with easily recognizable portraits of James Pryde, Augustus John, George Moore and William Nicholson, was painted from 1911–12 and exhibited at the New English Art Club in the summer of 1912. Gilman, like Ginner, peopled his interior with figures rather than portraits. However, the character, conception and planning of his composition, and even his handling, are much closer to Orpen. Orpen's painting was also the progenitor of Adrian Allinson's *chef d'oeuvre* of 1915–16 (coll. the Café Royal). Only William Strang remained free of Orpen's influence when he painted his extraordinarily idiosyncratic and totally individual tableau of Café Royal clients and staff in 1913 (private collection; rep. in colour, Parkin Gallery catalogue 1972, 'The Café Royalists'). Gilman painted two versions of *The Café Royal*, both exhibited in January 1913. The whereabouts of the second picture is unknown. Gilman's work at the Café Royal perhaps triggered his interest in café interiors, expressed during 1913 in three paintings of *An Eating House* (Graves Art Gallery, Sheffield; formerly collection of Edward le Bas; and an unfinished version in the artist's family collection), although the character of this establishment presented a complete contrast to the ornate decadence of the fashionable Regent Street location. In these *Eating House* pictures Gilman compensated for the lack of decoration by painting the bare walls and the range of benches and tables (presented with uncompromising rectilinearity) in vivid vermilion and emerald greens. Gilman's pictures, in their turn, evidently influenced William Ratcliffe's best-known painting, *The Coffee House, East Finchley* of 1914 (Pl. 137).

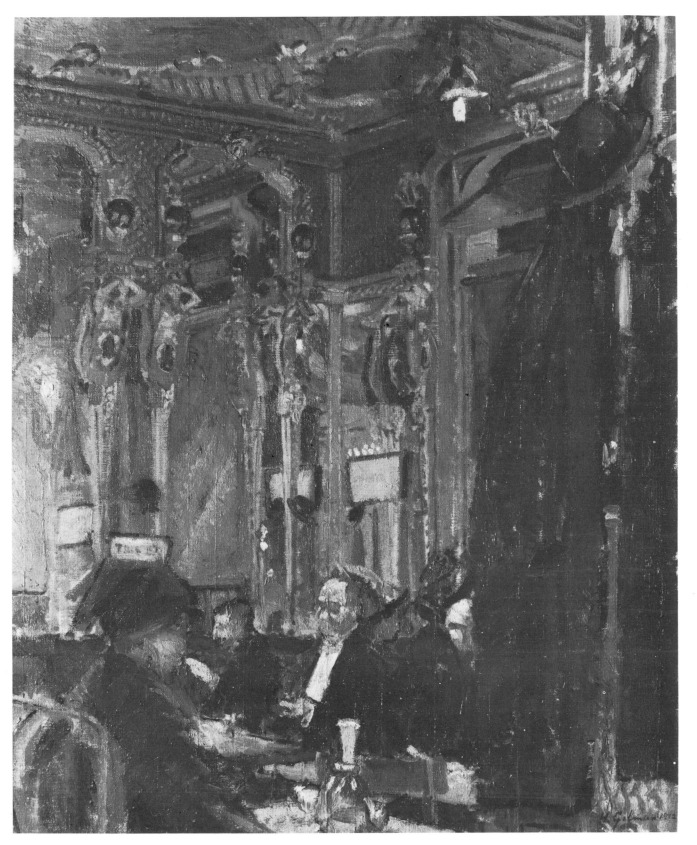

109

Gilman

110 **A Swedish Village** 1912
Oil on canvas, $15\frac{1}{2} \times 19\frac{1}{2}$ (39.4 × 49.5)
Signed 'H. Gilman' bottom left
Provenance: the artist's daughter, Mrs Duce
Exhibited: Arts Council 1954 (21)
Collection: National Gallery of Canada, Ottawa (1963)

Gilman visited Sweden and Norway in 1912 and 1913. It is always assumed that he visited both countries on both occasions. However, the existing evidence suggests that he visited (or at least stayed to paint in) Sweden in 1912, and Norway in 1913. Three of his four pictures at the Camden Town Group exhibition in December 1912 were Swedish subjects, as were seven of his twenty-four pictures at the Carfax Gallery in January 1913. No Norwegian subject was shown at any exhibition before October 1913 when *A Bridge in Norway* (possibly *Canal Bridge, Flekkefjord*, Tate Gallery, more probably *A Mountain Bridge, Norway*, Worthing Art Gallery) was included in the Doré Gallery exhibition of Post-Impressionists and Futurists. Thereafter Norwegian pictures made regular appearances whenever Gilman exhibited, for example at the Goupil Gallery Autumn Salon in 1913 (*Norwegian Interior*), at the London Group in March 1914 (*Waterfall, Norway*, Pl. 132), at the winter 1914 N.E.A.C. (*Norwegian Fjord*), and most significantly at his joint exhibition with Ginner at the Goupil Gallery in April 1914 when five Norwegian, as opposed to four Swedish, subjects were included. The problem is complicated by the tradition that Gilman and Ratcliffe visited these Scandinavian countries together, and Ratcliffe can certainly be placed in Sweden in 1913. Indeed, Ratcliffe's official address, as printed in the A.A.A. exhibition catalogue in 1913, was in Sweden. There is no evidence from documents or from paintings that Ratcliffe was in Scandinavia in 1912, and none that he visited Norway in 1913. The explanation may be that in 1913 Ratcliffe and Gilman crossed the water to Scandinavia together, that then either Ratcliffe accompanied Gilman to Norway and after a brief social stay went on alone to Sweden, or that Gilman saw Ratcliffe settled in Sweden and then left for Norway. This chronological division of Gilman's Swedish and Norwegian pictures is borne out by their style and handling. Although Gilman was clearly still experimenting in Norway, alternating the virtuoso drawing, the flat paint and lurid colours of the *Canal Bridge, Flekkefjord* with, in his landscapes of mountains and water, a vehement Courbet-like application of fat smears of paint in darker blue and green colours, his handling was consistently confident and direct. A more tentative approach seems to underly the vacillations in his style in Sweden. It is interesting that Gilman signed the painting illustrated here in a round, childish script to suit its stylistic character. It is possible that the picture was exhibited in one of the early shows (see note to Gilman's contributions to the third Camden Town Group exhibition).

110

Gore

111 **The Footpath, Letchworth** 1912
Oil on canvas, 16 × 20 (40.6 × 50.8)
Signed 'S. F. Gore' bottom right
Provenance: R. P. Bevan
Exhibited: Carfax Gallery 1913 (34); N.E.A.C. summer 1913 (196); Colchester 1970
(49)
Collection: Private

While Gilman was away in Sweden, Gore borrowed his house in Letchworth. He
worked with incredible energy and inspiration to complete a series of experimental
pictures in which he expressed the essential structure of the landscape and domestic
architecture in flat, interlocking, angled planes of brilliant colour. *The Footpath* is
one of Gore's slightly less radical Letchworth paintings. It belonged to Bevan and
may well have influenced his own angular, constructive handling of landscape
forms.

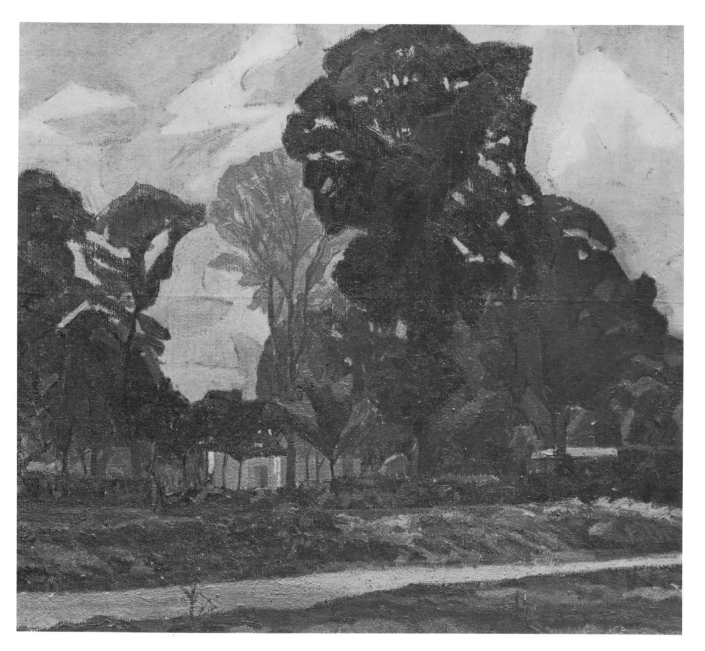

III

Gore

112 The Beanfield, Letchworth 1912
Oil on canvas, 12 × 16 (30.5 × 40.6); G 154A
Signed 'S.F.Gore' bottom right
Provenance: the artist's family
Literature: *Connoisseur*, March 1974, p. 174, rep. in colour
Exhibited: Carfax Gallery 1913 (26); Redfern Gallery 1962 (58); Colchester 1970
(46); Anthony d'Offay 1974 (24)
Collection: The Tate Gallery, London (1974)

John Woodeson (Colchester catalogue) notes that this picture was painted from a
spot near Wilbury Hills Road, about half a mile from its junction with Wilbury
Road (where Gilman's house was No. 100). The chimneys in the distance are those
of a brickyard. A label by Gilman on the back of this picture states: 'The colour
found in natural objects (in the field of beans for instance in the foreground), is
collected into patterns. This was his own explanation.' This explanation helps our
understanding of all Gore's Letchworth pictures. In his attempt to express the
underlying structure of natural objects he not only grouped the colours into
uniform patterns, he also reduced the wayward shapes of nature, trees, clouds, and
so on, down to their basic geometrical forms. The resultant stylization may appear
exaggerated and conceptual, but it sprang from intensely concentrated observation
of the subject and was never conditioned by mental gymnastics.

Gore

113 The Cinder Path 1912
Oil on canvas, 27 × 31 (68.6 × 78.7)
Provenance: Mme. Gerfain; F. W. Burford; John Lumley
Exhibited: either Grafton Gallery 1912–13, 'Second Post-Impressionist Exhibi-
tion' (116) or Carfax Gallery 1913 (31)
Collection: The Tate Gallery, London (1975)

Fortunately there are two versions of *The Cinder Path* to explain how Gore managed
to exhibit two pictures with this title contemporaneously. *The Cinder Path* was not
one of his contributions to the Grafton Gallery exhibition when it opened in October
1912. It was added for December to January when the exhibition was extended.
Several artists were forced to withdraw their pictures and to fill gaps on the walls
during the extra run of the show Fry appealed for more contributions. Gore obliged
with *The Cinder Path*, duly catalogued in the revised edition published to cover such
additions and subtractions. Nevertheless, the other version of the picture (Ash-
molean Museum, Oxford) has often been catalogued as the picture included in both
these contemporary exhibitions. There is no evidence to sort out which picture was
shown where. On the whole it is probable that the Tate painting was at the Grafton
Gallery where, among radical works, its size would have been an advantage, and the

Ashmolean version (measuring only 14 × 16 inches) was placed in the more intimate Carfax Gallery. Several of Gore's Letchworth pictures feature tracks and paths (a notable example is *The Icknield Way*, Pl. 115) and it is probable that Gore was attracted by their geometrical perspectives. John Woodeson (Colchester catalogue note to Ashmolean version) recorded that the cinder path ran from Works Road, Letchworth, across the fields to Baldock.

112

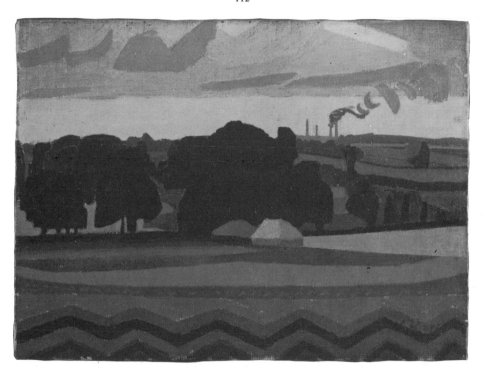

Gore

114 **Letchworth Station** 1912
Oil on canvas, 25 × 30 (63.5 × 76.2)
Provenance: Hugh Blaker; Peter Cochrane
Exhibited: Grafton Gallery 1912–13, 'Second Post-Impressionist Exhibition'
(133); Whitechapel 1914, 'Twentieth Century Art' (418); Colchester 1970 (50)
Collection: Anthony d'Offay Gallery

This picture vanished from Blaker's collection and was discovered in a street
market by Mr Cochrane many years later. It was reproduced in the Grafton Gallery
catalogue.

Gore

115 **The Icknield Way** 1912 (colour p. 51)
Oil on canvas, 25 × 30 (63.5 × 76.2)
Stamped 's. F. GORE' bottom right
Provenance: the artist's family
Exhibited: Southampton 1951, 'The Camden Town Group' (63); Arts Council
1955 (35); Redfern Gallery 1962 (61)
Collection: Art Gallery of New South Wales, Sydney (1962)

I can do no better than quote from Quentin Bell's unpublished article on the
Camden Town Group. Discussing Gore's Letchworth paintings, Professor Bell
wrote: 'The period culminates in an extraordinary painting: *The Icknield Way*,
1912–13, in which, amidst a wide plain of violent orange and purple fields, a jagged
track of acid green plunges towards the sunset jigsaw of rhomboidal clouds. It
marked, I fancy, a turning point in his career. He had painted a picture which may
fairly be termed Cubist or perhaps Futurist, he had not known his own strength . . .'
The Icknield Way is an ancient track situated close to Wilbury Hills Road, near to
the spot from which Gore painted *The Beanfield, Letchworth*. Gore does not appear
to have exhibited *The Icknield Way*, perhaps preferring to keep this, his most radical
experiment, as a private work.

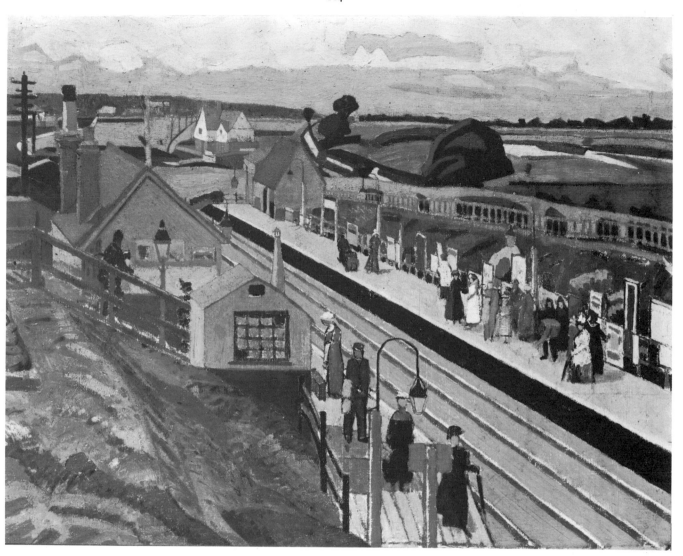

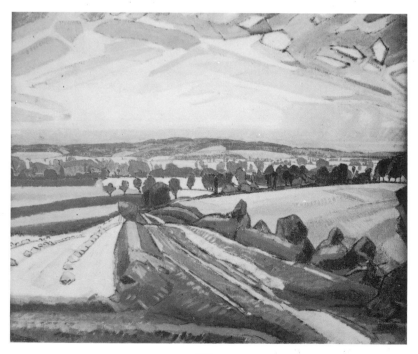

Ginner
116 **West Country Landscape** *c.* 1912
Oil on canvas, 20 × 24 (50.8 × 61)
Signed 'C. GINNER' bottom right
Provenance: possibly Sir Augustus Daniel
Literature: possibly Ginner, Vol. 1, p. lviii
Exhibited: possibly Carfax Gallery 1912, 'The Camden Town Group' (23) and
Goupil Gallery 1914 (27) as *Rain on the Hill*
Collection: David and Duncan Drown

Almost certainly a Somerset landscape painted when Ginner stayed with H. B. Harrison at Applehayes. We know from Ginner's notebooks that *Rain on the Hill* measured 20 × 24 and was one of two pictures by Ginner bought by Augustus Daniel. In the Leicester Galleries exhibition of Daniel's collection in 1951 two Ginner paintings were duly included, a *Still Life* (recorded in the notebooks) and *Meadow Landscape* (78). This *Meadow Landscape* could, therefore, only be *Rain on the Hill*. It was exhibited as *Meadow Landscape* in the Arts Council 1953 show (7), lent by the Leicester Galleries. At a Christie's sale in 1972 a *Meadow Landscape*, provenance Augustus Daniel, size 20 × 24, appeared and was sold. At a Christie's sale over a year later *West Country Landscape*, with no catalogue details except medium and size, was bought by the present owner. It does not bear the stock mark used by Christie's for *Meadow Landscape* but the stretcher had been cleaned and shaved. Attempts to trace the history of *Meadow Landscape* subsequent to its sale at Christie's have been fruitless. Pictures certainly do pass through Christie's from time to time unrecognized from their previous appearances and lacking former stock marks. I believe that there is a strong possibility that this *West Country Landscape*, Augustus Daniel's *Meadow Landscape*, and thus *Rain on the Hill* are all the same picture. The strong diagonal strokes of Ginner's brush and the whole aspect of the landscape illustrated clearly represent the subject described in the original title.

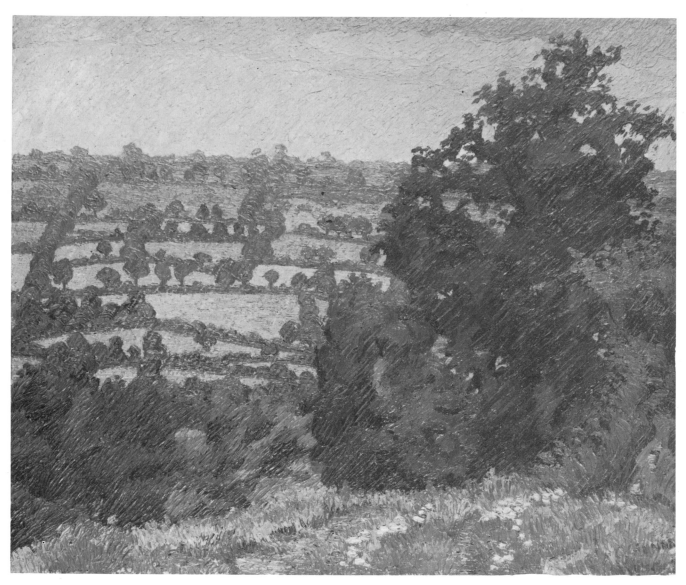

116

Gore

117 **Study for Mural Decoration** 1912
Oil on paper, 11 × 24 (27.9 × 61)
Exhibited: Southampton 1951, 'The Camden Town Group' (62); Colchester 1970
(52); Norwich 1976, 'A Terrific Thing' (31)
Collection: Private

This study, another in the Tate Gallery dominated by striped tigers, and possibly a
watercolour sketch on the theme of a tennis game (coll. the artist's family), are
preparations for Gore's mural/s at Madame Strindberg's 'Cave of the Golden Calf'.
Both this study and that in the Tate Gallery are squared.

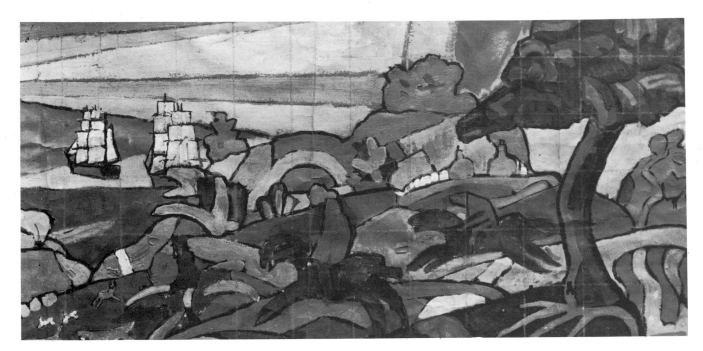

117

Section III(b):
Camden Town Group Exhibition 1912

Bayes
Third Camden Town Group exhibition

December 1912
35 Le Petit Casino
36 Shade
37 Port

Note

I have located none of these pictures. They were all well received by the press. '"Shade" . . . is a beautiful picture, tender and dignified: green bathing coaches and figures under trees contrasted with the brilliance of a summer sea and sky' (*Pall Mall Gazette*, 12 December 1912). The critics noted that Bayes only allowed himself to paint in flat tones, without any darks. They commended his sense of design. '"Shade" . . . and "Le Petit Casino" . . . have both a certain largeness and monumental character of design in spite of their general flatness of tint. The larger "Port" . . . is even more noble and stately in its effect. It reminds one vaguely of some of Poussin's dignified and reticent compositions. It looks, however, more like a set composition than either of the two other pictures. The sprawling figure of the man in the foreground hardly harmonises with the stately tree and ship or with the charming figures of the women on the right' (*Star*, 10 December 1912). *Port* also reminded the critic of *The Times* (19 December 1912) of Poussin: 'but [it] is not a mere scholastic imitation. There is some incongruity between the homeliness of the background and the majestic figures, but none between the colour and the grandeur of form at which the artist aims. In his other works the colour . . . seems to us too bright, or perhaps too pretty for the sharpness of the forms.' Judge Evans bought *Port* and it was included after his death in the Goupil Gallery exhibition of his collection (80).

Bevan
Third Camden Town Group exhibition

December 1912
38 A Devonshire Farm
39 'Quiet with all road nuisances' (Pl. 118)
40 In the Blagden Hills
41 The Horse Mart

Note

Bevan showed *A Devon Farm* at the Carfax Gallery in April 1913 and at the Doré Galleries in October. He showed *The Farm on the Hillside, Devon* at the London

Group in March 1914 and at the N.E.A.C. in the summer. Whether or not these were all the same picture is unknown. *In the Blagden Hills* was probably a typical Carfax Gallery misprint for *In the Blackdown Hills*, the title of a painting in Bevan's exhibition at the Carfax Gallery in April 1913. Both these pictures were presumably painted while Bevan was staying with H. B. Harrison at Applehayes in 1912, but neither is now identified. *The Horse Mart* was probably the picture now in the Tate Gallery as *Horse Sale at the Barbican* (rep. R. A. Bevan, Pl. 43). *The Horse Mart* was re-exhibited at the Carfax Gallery in April 1913 and at Brighton 1913–14. The price Bevan asked for *The Horse Mart* at the Camden Town Group (35 guineas as opposed to 20 for '*Quiet with all road nuisances*') supports the suggestion that it is the Tate Gallery *Horse Sale*, for the Tate picture is large (31 × 48 inches), complex in composition and very carefully prepared. It is probable that Bevan decided to change its title to *A Sale at the Barbican* when he re-exhibited it with the Cumberland Market Group in 1915 (19).

Bevan

118 **'Quiet with all road nuisances'** *c.* 1912
Oil on canvas, 18½ × 23¾ (47 × 60.3)
Literature: R. A. Bevan, rep. Pl. 37
Exhibited: Carfax Gallery December 1912 (39); Carfax Gallery 1913 (27); Arts Council 1953, 'The Camden Town Group' (10) as *Quiet in all Traffic*; Arts Council 1956 (11); Colchester 1961, 'Camden Town Group' (4); Colnaghi 1965 (28); Hampstead 1965, 'Camden Town Group' (2); Bedford 1969, 'The Camden Town Group' (3); Fine Art Society 1976, 'Camden Town Recalled' (10)
Collection: Private

Bevan began to paint horse-sale pictures about a year after his cab-yard subjects. The scene represented here was at Aldridge's, Upper St Martin's Lane. *The Times* critic (19 December 1912) cited Bevan's horse-sale contributions to the Carfax Gallery as examples of the irrationally bright colour used by several of the exhibitors. He quarrelled with the colour, not because it was brighter than it could be in reality, but because he felt colour should express a mood, and the mood of Bevan's pictures was hardly exultant. As Bevan developed, his colours tended to refer less and less to fortuitous effects. Just as his drawing became more angular and schematic, so he simplified his areas of colour to build up the overall design of his pictures. His fine sense of tone enabled him to suggest convincing spatial relationships between objects painted in the most arbitrary colours.

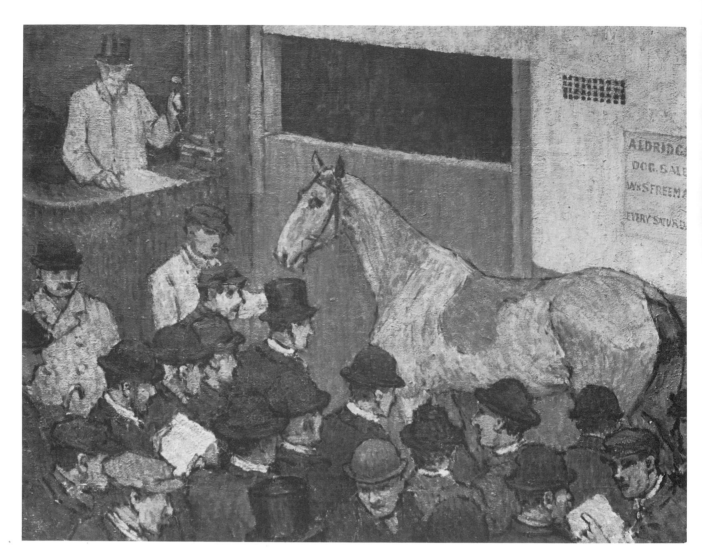

118

302 Section III(b): Camden Town Group Exhibition 1912

Drummond
Third Camden Town Group exhibition

December 1912
26 The Oratory, London (Pl. 119)
27 At the Piano (Pl. 120)
28 Chestnut Leaves
29 St James's Park (Pl. 121)

Note
Chestnut Leaves has not been identified.

Drummond
119 **Brompton Oratory** *c.* 1910
Oil on canvas, 21 × 8 (53.3 × 20.3)
Provenance: the artist's family
Exhibited: probably A.A.A. 1910 (33) as *Interior. Oratory of St Philip*; Carfax Gallery
December 1912, 'The Camden Town Group' (26) as *The Oratory, London*; Arts
Council 1953, 'The Camden Town Group' (13); Arts Council 1963 (3); Fine Art
Society 1976, 'Camden Town Recalled' (14)
Collection: The Arts Council of Great Britain (1954)

Brompton Oratory is dedicated to St Philip, hence the suggestion that this picture
was exhibited at the A.A.A. in 1910. This dating is supported by the fact that
Sickert's striking vertical interior of *The New Bedford* (Pl. 4), exhibited at the A.A.A.
and the N.E.A.C. in 1909, was almost certainly the point of departure for Drum-
mond's novel approach to the painting of the church and congregation. Music hall
and church are seen from an equivalent viewpoint, so that the grouping of the
figures and their relationship to the architectural setting are similar in both.
Drummond's picture is much more tidy. He replaced Sickert's crusty polychrome
with a flatter application of simplified areas of strong colour. He limited his palette
to a few basic colours using, for example, the red of his architecture for the flesh
tones and chair backs. Whereas Sickert's forms are open, Drummond's are
self-contained. If, as I believe, this painting is a work of 1910 it reveals that
Drummond's feeling for emphatic patterns antedated his association with Ginner
who entered the Fitzroy Street circle after the A.A.A. exhibition. It also proves that,
unlike most of Sickert's pupils, Drummond's artistic personality was sufficiently
mature and well-defined to assimilate his master's methods (to work from draw-
ings, to relate figures and setting, to observe tonal values and relationships) without
imitating his mannerisms.

Drummond

120 **The Piano Lesson** *c.* 1912
Oil on canvas, $35\frac{1}{4} \times 23\frac{7}{8}$ (89.5 × 60.6)
Signed 'DRUMMOND' bottom right
Exhibited: probably Carfax Gallery December 1912, 'The Camden Town Group'
(27) as *At the Piano*
Collection: Art Gallery of South Australia, Adelaide (1969)

Although this picture is undated the costume supports the stylistic evidence for
placing it in 1912. Whereas Drummond asked only 15 guineas for *Chestnut Leaves*
and 20 guineas for *The Oratory* at the Carfax Gallery, he asked 30 guineas for *At the
Piano*, the same price as *St James's Park*. This suggests it was a large painting and
rules out the possibility that a small sketch of *The Artist's Mother at the Piano*, lent by
the artist's widow to the Bedford 'Camden Town Group' exhibition in 1969, is the
work shown in 1912. The painting represented on the left, propped up on the
bookshelf, may be *Neuville Lane*, a small work by Ginner presented to Drummond.
The pianist is probably the artist's first wife.

Drummond

121 **St James's Park** 1912 (colour p. 47)
Oil on canvas, $28\frac{1}{2} \times 35\frac{1}{2}$ (72.4 × 90.2)
Signed 'DRUMMOND' bottom right
Provenance: Denys Sutton
Exhibited: Carfax Gallery December 1912, 'The Camden Town Group' (29);
Salon des Indépendants, Paris 1913 (905); Brighton 1913–14, 'English Post-
Impressionists, Cubists and others' (133); Arts Council 1963 (6); Newcastle 1974,
'The Camden Town Group' (6); Norwich 1976, 'A Terrific Thing' (24)
Collection: Southampton Art Gallery (1953)

The *Pall Mall Gazette* (12 December 1912) found no 'refinement of colour or grace
of drawing' in any of Drummond's pictures at the Carfax Gallery and was
particularly irritated by 'the empty glare of their gaudy tints'. *The Times* (19
December 1912) disapproved of the bright colours in Drummond's *St James's
Park*, Bevan's two horse-sale pictures, Ginner's *Piccadilly Circus* and Gilman's *The
Reapers*: 'in all of these pictures the colour would suit only a most exultant mood,
and a design and execution equally exultant. Thus one feels that the colour is
incongruous and imposed upon the picture for its decorative effect. It is in fact
nothing but a new kind of prettiness, which would tire us as soon as it ceased to
surprise.' The sweet rich tints of Drummond's *St James's Park* are indeed pretty yet
they do not cease to surprise. The initial inspiration for this picture must have been
Seurat's *Une Dimanche Après-Midi à L'Ile de la Grande-Jatte*. Drummond might
have seen the picture on exhibition at the *Salon des Indépendants* in 1905, at
Bernheim-Jeune in 1908–9, or perhaps he had seen it illustrated in *Art Décoratif* on

20 June 1912. Drummond has recaptured Seurat's sense of time suspended at a moment of pure poetry, and to do so he used the same means as Seurat: the frozen movement, the simplified silhouettes and the cool receding perspective of the figures; birds (replacing Seurat's dogs and monkey) as wayward accents; even the basic compositional structure, with the picture divided diagonally into a stretch of land and a stretch of water, is the same. But Drummond did not plagiarize. He assimilated the lessons of Seurat to produce an individual masterpiece of English art.

119

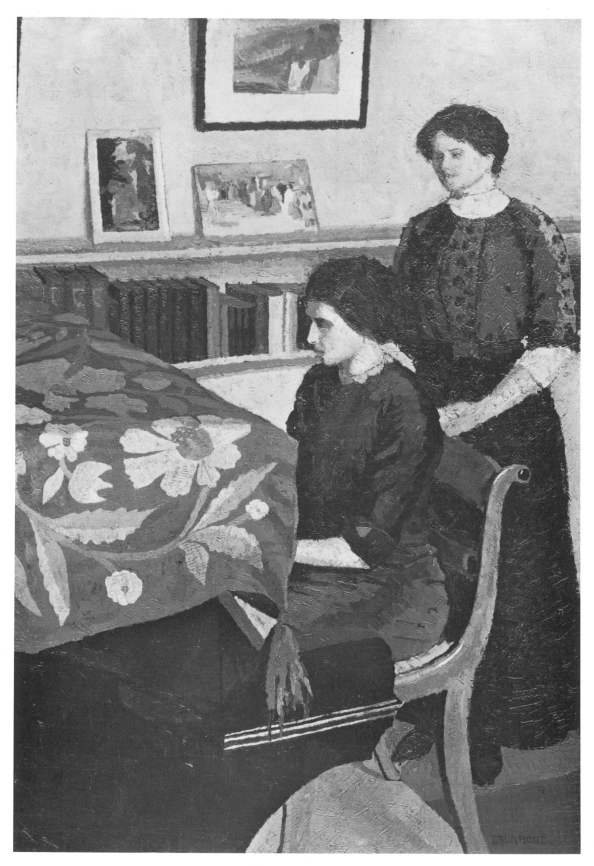

306 Section III(b): Camden Town Group Exhibition 1912

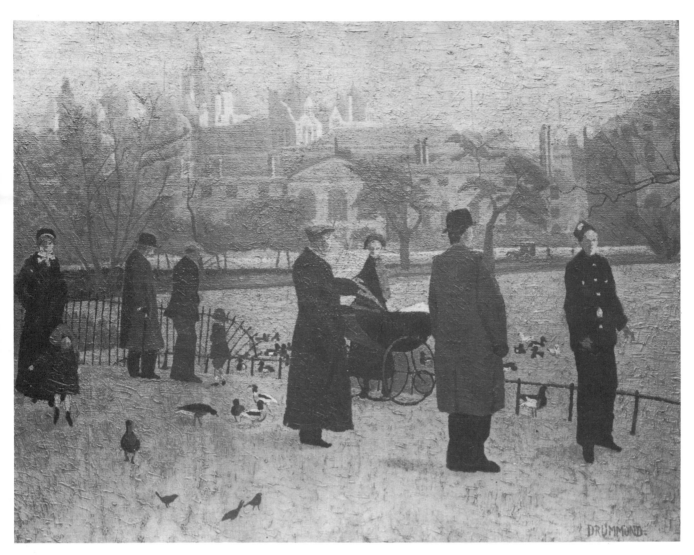

121

Gilman
Third Camden Town Group exhibition

December 1912
17 Kyrksjön, Gladhammer, Sweden
18 Portrait
19 Porch, Sweden
20 Reapers, Sweden (Pl. 122)

Note
Neither *Kyrksjön* nor *Portrait* can be identified. Although *Kyrksjön* might be the village represented in Pl. 110 the price Gilman asked for this picture (26 guineas as against 18 for *Porch*) renders this suggestion unlikely. It is just possible that the *Swedish Village* was exhibited as *Porch*, an architectural feature which is found in the painting illustrated.

Gilman
122 **The Reapers, Sweden** 1912
Oil on canvas, 20 × 24 (50.8 × 61)
Signed 'H. Gilman' bottom right
Provenance: Sylvia Gosse
Exhibited: Carfax Gallery December 1912, 'The Camden Town Group' (20); Carfax Gallery 1913 (11)
Collection: Johannesburg Art Gallery (1913)

See note to Pl. 74 concerning the date at which this picture was presented to the Johannesburg gallery. Miss Gosse presumably bought it from or after the Carfax Gallery exhibition in January. Memories of Van Gogh, Millet, and perhaps Gauguin in the strong outline drawing, all contributed to Gilman's inspiration.

122

Ginner
Third Camden Town Group exhibition

December 1912
21 Still Life
22 North Devon (Pl. 123)
23 Rain on the Hill (?Pl. 116)
24 Piccadilly Circus (Pl. 124)

Note
Ginner's notebooks record that the full title of his *Still Life* at the Carfax Gallery was *The Pots and the Carpet*. He had previously exhibited the same picture at the Barbazanges Gallery in Paris in May, and later showed it at the Doré Galleries in the Post-Impressionist and Futurist exhibition (October 1913) and at his joint exhibition with Gilman at the Goupil Gallery (April 1914) as *Pots*. It measured 18 × 14 inches (or vice versa) and was sold to Mrs Victor Sly. Its present location is unknown to me.

Ginner

123 **North Devon** 1912
Oil on canvas, 20 × 30 (50.8 × 76.2)
Signed 'C. GINNER' bottom right
Provenance: H. B. Harrison; Edward le Bas
Literature: Ginner, Vol. 1, p. lix
Exhibited: Carfax Gallery December 1912, 'The Camden Town Group' (22); Whitechapel 1914, 'Twentieth Century Art' (339)
Collection: Private

Like *Rain on the Hill* (?Pl. 116), *North Devon* was painted while Ginner was staying with H. B. Harrison near the Devon/Somerset border. Harrison bought the picture in 1914, probably from the Whitechapel exhibition.

Ginner

124 **Piccadilly Circus** 1912
Oil on canvas laid down on board, 32 × 26 (81.3 × 66.3)
Signed 'c. GINNER' bottom right
Provenance: H. Holdsworth
Literature: Ginner, Vol. I, p. lxi
Exhibited: Carfax Gallery December 1912, 'The Camden Town Group' (24);
Brighton 1913–14, 'English Post-Impressionists, Cubists and others' (35); Goupil
Gallery 1914 (19)
Collection: Private

In 1912 Ginner began to paint tautly constructed London townscapes, full of
incident and bustle. Although he had painted London subjects before, for example
Battersea Park and the roofscape *Corner in Chelsea*, these were motifs from the more
gentle peripheries of the city. In 1912 he went right into the heart of London to
study *Leicester Square* (Brighton Art Gallery) and *Piccadilly Circus*. He had
executed a poster with this title for Madame Strindberg's 'Cave of the Golden Calf',
but whether or not it was related compositionally to the painting is unknown. The
extraordinary concentration of this picture suggests it might have evolved from
fuller studies, that Ginner ruthlessly pared away inessential extensions until he
arrived at his vortical solution. All sorts of meanings may be read into the picture.
The market woman left over from an older age about to be obliterated by the
motorized machinery of the new could be seen as a social comment. But Ginner was
an observer rather than a philosopher and the power of his picture springs rather
from his acute eye for detail and his genius for design. The *Pall Mall Gazette* (12
December 1912) judged that '"Piccadilly Circus," both in its crude tones and
jumbled composition, happily suggests the noise and confusion of that busy
thoroughfare.' Other critics were less pleased with its effects. It is worth recording
that *Piccadilly Circus* is one of a great number of paintings by Ginner bought by the
Southport dealer T. W. Spurr. Several of his purchases found their way to public
collections in the Midlands and the North of England. Others, like this picture,
were bought by northern private collectors and have since come back on the
market. *Piccadilly Circus*, for example, was sold by its owner from Halifax at
Christie's in 1938, and re-emerged at Christie's on 1 March 1974 (114). Many more
Spurr purchases are still of unknown whereabouts.

123

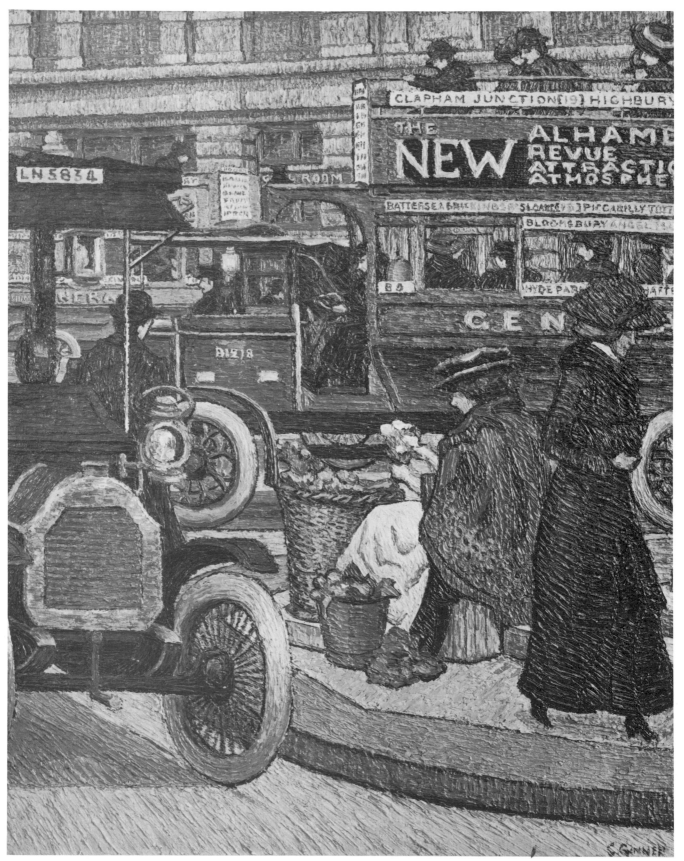

124

Section III(b): Camden Town Group Exhibition 1912 313

Gore
Third Camden Town Group exhibition

December 1912
13 Letchworth Common
14 The Broken Fence
15 Euston from the Nursery (Pl. 125)
16 The Pond

Note
Letchworth Common may be *Letchworth* in the Tate Gallery. *The Broken Fence* may well be a painting of *Panshanger Park* of *c.* 1908–9 (private collection) in which a fence, with a slat missing, features in the foreground. *The Pond* was described by the *Pall Mall Gazette* (12 December 1912) as 'gold and green ... rhythmical in design'. This may be the picture in the Worthing Art Gallery unless, as is possible, the Worthing picture represents a scene in Richmond Park (in which case it could only have been painted 1913–14). On the whole, by the time the critics had commended Bayes, reviled Lewis and discussed Sickert, little space was left for other exhibitors at the Carfax Gallery. Gore's work was mentioned in passing without much enthusiasm (e.g. *The Times*, 17 December 1912, 'well-considered ... of an accomplished mediocrity'), but seldom described in terms helpful to identification.

Gore
125 **The Nursery Window, Rowlandson House** 1911
Oil on canvas, 16 × 20 (40.6 × 50.8); G.136
Stamped 's. f. gore' bottom right
Provenance: the artist's family
Exhibited: Carfax Gallery December 1912, 'The Camden Town Group' (15) as *Euston from the Nursery*; Redfern Gallery 1962 (52); Anthony d'Offay 1974 (13)
Collection: Private

The great terminus of Euston Station is seen across the railway tracks at the back of Rowlandson House. Gore used the iron bars protecting the window of the nursery as an effective grid to pull his whole design together on the surface and to give interest to the rather amorphous foreground and middle distance. This device was not appreciated by the critic of *Queen* (14 December 1912) who accused the artist of being 'more concerned with the bars of the nursery window than with the light and life outside', but this description serves to identify the picture illustrated here as the exhibited painting.

125

Lamb
Third Camden Town Group exhibition

December 1912
30 Study of a Head
31 Study of a Head

Note
Both studies were 'of young girls of the rustic class' (*Daily Telegraph*, 17 December 1912), interpreted as 'heads of children' (*Pall Mall Gazette*, 12 December 1912). According to the latter paper they had 'a Raphaelesque largeness of contour', were 'phlegmatic and heavy-handed in modelling, with an impassive, stolid look . . . and they are both bare in texture.' The *Daily Telegraph* noted that 'the execution has a certain not altogether pleasant "tightness." But there are manifest, as central and vital qualities, a breadth and comprehensiveness of vision, a forceful directness of execution . . . Mr. Lamb has the indefinable quality of style.' It is probable that one of these heads is *Head of an Irish Girl* in the Tate Gallery. The catalogue of a Christie's sale, 14 December 1973, under lot 177, *Breton Peasant Woman* from the Behrend collection, quotes a letter from Lamb to Lytton Strachey written in Ireland and dated 6 December 1912 stating that Behrend had paid him £30 for 'one of the heads I sent to the Carfax Show'. The catalogue note was inserted to support the suggestion that this *Breton Peasant Woman* (rep. G. L. Kennedy, frontispiece) might have been the work exhibited with the Camden Town Group. However, the Breton model is an old woman, not a young girl. On the other hand, the painting of the *Irish Girl* now in the Tate Gallery not only fits the press descriptions, but it belonged to Behrend who presented it to the gallery in 1917. It was painted in Donegal in 1912.

Lewis
Third Camden Town Group exhibition

December 1912
25 Danse

Note
This picture is lost. Critical comment is quoted in the text.

Manson
Third Camden Town Group exhibition

December 1912
 5 The Cuckmere, Alfriston
 6 Still Life (?Pl. 126)
 7 A little French Harbour
 8 Moonlight and Snow

Note
The Cuckmere, Alfriston inspired no special comment in reviews, although on the whole Manson's work was better noticed in this third exhibition. *The Cuckmere* is probably the oil on panel sketch, inscribed on the back 'Alfriston September 1912', exhibited at the Maltzahn Gallery 1973 (14) when in the possession of the artist's daughter, and at the Fine Art Society 1976, 'Camden Town Recalled' (103), on loan from a private collector. It is a freely sketched landscape in blues and greens. The *Pall Mall Gazette* (12 December 1912) noted 'A bright little French harbour in the style of Boudin . . . but I prefer a dextrous, short-hand sketch . . . "Moonlight and Snow."' I do not know the present whereabouts of either picture. *Moonlight and Snow* was, however, included in the Leicester Gallery Manson exhibition in 1944 (71) and in the memorial show at Wildenstein in 1946 (8) where it was dated 1912.

Manson

126 **Still Life. Tulips in a Blue Jug** 1912
Oil on canvas, 16 × 20 (40.6 × 50.8)
Signed and dated 'J. B. Manson/?1912' lower centre right
Provenance: Sir Augustus Daniel
Exhibited: possibly A.A.A. 1912 (96); Goupil Gallery Autumn Salon 1912 (83);
possibly Carfax Gallery December 1912, 'The Camden Town Group' (6); possibly
Doré Galleries 1913, 'Post-Impressionists and Futurists' (44); possibly Brighton
1913–14, 'English Post-Impressionists, Cubists and others' (44); possibly
Whitechapel 1914, 'Twentieth Century Art' (398) as *Flowers*
Collection: Private

A rare example of a still-life with flowers painted before Manson began to specialize
in flower pieces from the 1920s onwards. The extensive list of exhibitions is
suggested because so few still-lifes of appropriate date are known. The *Daily
Telegraph* (17 December 1912) described Manson's *Still Life* as 'a brilliant if
somewhat mechanical piece of neo-impressionism' adding that 'Without the aid of
the catalogue it would have been difficult to guess that to the same brush we owe the
attractive landscape "Moonlight and Snow."' The richness of handling and the
depth of colour are indeed uncharacteristic of Manson's work at this early date.
These qualities, together with the artificiality of the arrangement of fancy objects in
a shallow space, suggest that Manson deliberately undertook an exercise in the
manner of Ginner (e.g. Pl. 51).

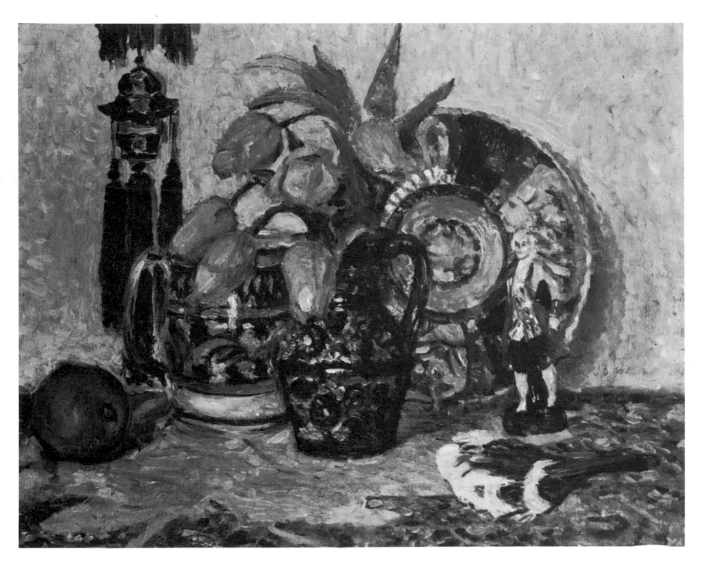

126

Pissarro
Third Camden Town Group exhibition

December 1912
 9 Escalier d'Eragny
10 An Essex Hall
11 Stamford Brook Green (Snow) (?Pl. 127)
12 Tomatoes

Note
Pissarro was not concerned with exhibiting recent pictures and at least two of his exhibits in 1912 were very early works. *Tomatoes* is the picture of 1893 (artist's family collection) last exhibited at the New Grafton Gallery 1977, 'Orovida Pissarro and her Ancestors – Lucien and Camille' (7). *An Essex Hall*, already shown at the N.E.A.C. in winter 1909 (54), is *Coopersale Hall, Essex* also of 1893, last exhibited at the Leicester Galleries 1963 (3) and now in America. *Escalier d'Eragny* could have been painted from 1889 (when Camille Pissarro built a studio there) onwards. Lucien's last visit to Eragny before the 1912 exhibition had been in 1909 when he spent the summer there.

Pissarro
127 **Stamford Brook Green. Sun and Snow** 1909
Oil on canvas, $17\frac{1}{4} \times 21$ (43.8 × 53.3)
Signed in monogram and dated 'LP 09' bottom right
Exhibited: N.E.A.C. summer 1909 (85); probably Carfax Gallery December 1912, 'The Camden Town Group' (30)
Collection: Sotheby's, 13 December 1967, lot 23

Pissarro lived at Stamford Brook and painted the Green under snow more than once. For example, *Stamford Brook Green. Snow and Mist* was also shown at the N.E.A.C. in 1909 and re-exhibited at the Carfax Gallery in May 1913 (17) where its price (120 guineas) was far higher than any other picture. Nevertheless Arthur Clifton of the Carfax Gallery bought the *Snow and Mist* painting and lent it to the Whitechapel 'Twentieth Century Art' exhibition in 1914 (444). Although the atmospheric description appended to the title of the painting exhibited in the Camden Town Group show was simply 'Snow', the *Daily Telegraph* (17 December 1912) described the 'effect of snow' as 'delicately flushed with the rose of sunset', thus supporting the identification of the exhibited painting with that illustrated here. The press all liked this picture better than Pissarro's other contributions. Monet's influence was noted (e.g. the *Star*, 10 December 1912, and the *Daily Telegraph*), and the critics' one quibble was that as a piece of convincing Impressionism the picture suffered from too great an objectivity in front of nature. The *Star*

regretted the absence of 'composition or design'; the *Daily Telegraph* noted: 'the artist lurks, impassive and effaced, behind his subject, disdainful apparently of anything approaching poetic interpretation.'

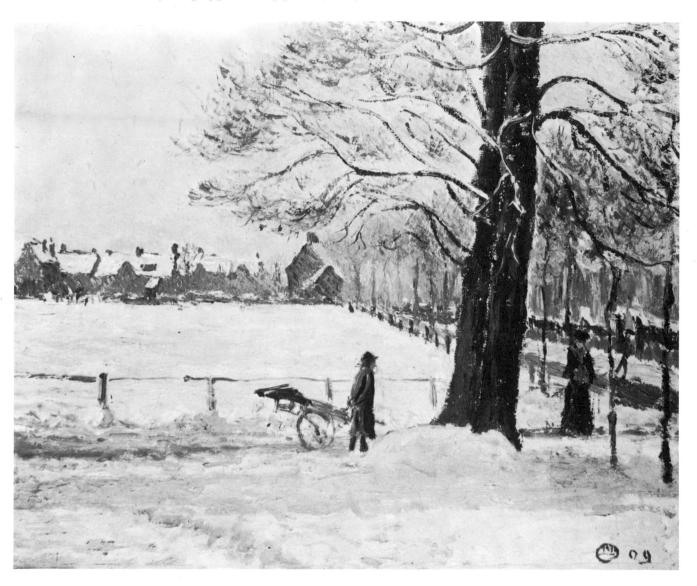

127

Ratcliffe
Third Camden Town Group exhibition

December 1912
42 Clarence Gardens (Pl. 128)
43 Hotel Cecil from Hungerford Bridge
44 Still Life
45 Landscape

Note
Neither *Still Life* nor *Landscape* can be identified. They were not described in the press who concentrated on Ratcliffe's two London views. *Hotel Cecil from Hungerford Bridge* is of unknown whereabouts. Like *Clarence Gardens* it was priced at 15 guineas, whereas the other two works were 10 guineas apiece.

Ratcliffe

128 **Clarence Gardens** *c.* 1912
Oil on canvas, 20 × 30 (50.8 × 76.2)
Signed 'W. Ratcliffe' bottom left
Provenance: Contemporary Art Society, presented to Russell-Cotes Art Gallery and Museum, Bournemouth, in 1945
Exhibited: A.A.A. 1912 (187); Carfax Gallery December 1912, 'The Camden Town Group' (42); Whitechapel 1914, 'Twentieth Century Art' (420)
Collection: Private

The Bournemouth gallery received this picture from the C.A.S. as *London Square* and subsequently sold it at auction on behalf of the corporation. Clarence Gardens, the residential development which very soon replaced the original Clarence Market, was painted by both Gilman and Ratcliffe in about 1912. The site is now occupied by a housing estate. Ratcliffe exhibited two pictures of *Clarence Gardens* at the A.A.A. in 1912, one (187) priced at 12 guineas and the other (188) at 10 guineas. It is probable that this second version is the smaller painting (private collection) exhibited in 'Camden Town Recalled' at the Fine Art Society in 1976 (112) and reproduced in the catalogue p. 10. This smaller painting represents the south-east corner of the square, whereas the painting illustrated here looks west over the gardens situated on either side of Osnaburgh Street. When compiling the 1976 catalogue I did not know of this larger, more formal, painting and therefore assumed that the smaller version was the picture exhibited at the Carfax Gallery in 1912 and Whitechapel in 1914. Commenting on Ratcliffe's London views, the *Daily Telegraph* (17 December 1912) observed: 'Out of two in themselves fairly prosaic scenes . . . Mr. W. Ratcliffe has without offending against the modesty of truth, extracted elements of beauty.'

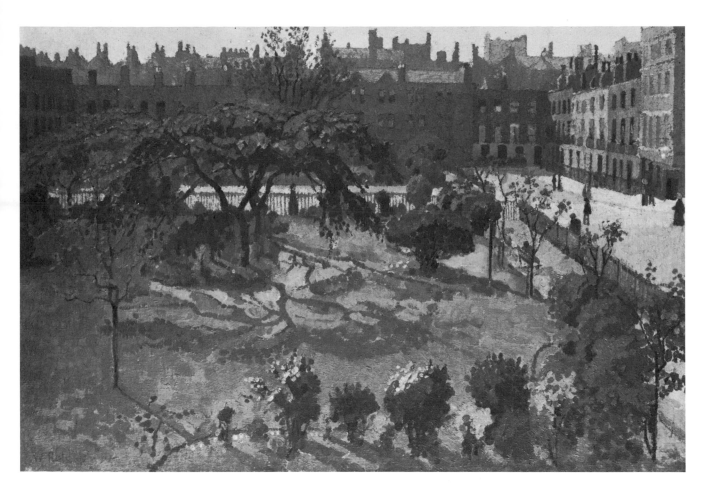

128

Sickert
Third Camden Town Group exhibition

December 1912
32 Past and Present
33 Chicken
34 Summer in Naples (Pl. 129)

Note

Past and Present, described by the *Daily Telegraph* (17 December 1912) as 'a mature wench and another younger – both equally objectionable', is of unknown whereabouts. According to the *Outlook* (14 December 1912), the girl possessed 'a bright impertinent eye' and 'plaited hair'. This suggests that Sickert's model was the girl represented in a drawing, *My Awful Dad* (Ashmolean Museum, Oxford, rep. Baron, Fig. 235). The '*Chicken*' exhibited in December 1912 is not the same '*Chicken*' previously shown at the first Camden Town Group exhibition (Pl. 105). 'Chicken' often modelled for Sickert, most frequently playing the piano in his Red Lion Square studio during the winter of 1914. Besides Pl. 105, two pre-war portraits of 'Chicken' are known to me: one belonged to Edward lè Bas (rep. Lilly, Pl. 11) and the other is of unknown whereabouts (rep. Browse 1960, Pl. 66). Such descriptions of the picture as were published in the press tend to point to the latter as the work exhibited in 1912. For example, it was 'A study of a child . . . in an impulsive and wayward mood, but the instinct for selection has not slept, and so life is captured in a masterly ellipsis' (*Pall Mall Gazette*, 12 December 1912). According to the *Yorkshire Observer* (7 December 1912) it was 'a pretty portrait of a girl'. Moreover, the picture reproduced by Miss Browse appears to be a work of 1912, whereas that from Edward le Bas's collection is more probably a work of early 1914.

Sickert

129 **Dawn, Camden Town** *c.* 1909
Oil on canvas, 19¾ × 16 (50.2 × 40.6)
Signed 'Sickert' bottom right
Provenance: Arthur Clifton
Literature: Baron, pp. 111–12, 116, 184, 349–50, C.273, rep. Fig. 191
Exhibited: Carfax Gallery December 1912, 'The Camden Town Group' (34) as *Summer in Naples*; Chicago 1938 (8); Pittsburgh 1938 (30); Agnew 1960 (70); Fine Art Society 1973 (64)
Collection: Private

Sickert's main contribution to the third Camden Town Group exhibition attracted distaste and admiration (sometimes together) in equal measure. Every critic rose to the bait presented by Sickert's exceptionally perverse choice of title, and many provided full descriptions of the painting to prove their point. Thus the painting, in spite of its new title, can be identified beyond any doubt. The *Star* (10 December 1912), for example, told its readers that the painting 'represents a hideous middle-aged woman in a state of nature seated on a bed in a wretched attic. Seated on the bed beside her is an ordinary street-corner loafer fully dressed. His attitude suggests that he is suffering from some kind of internal discomfort. But there is no evident relation between the two figures. They seem unaware of each other's existence, and they appear to belong to two different realms of thought. The colour of the picture is a discord in dirty mud – the colour Mr. Sickert has made peculiarly his own.' *The Times* (19 December 1912), on the other hand, remarked that if Sickert's colour 'is a little grimy ... so is his mood'. The *Daily Telegraph* (17 December 1912) found the 'unstimulating realism' of the 'masterly, sordid, unemotional study' depressing: 'As to the bravura and withal the subtlety of the execution, as to the consummate ability of the artist, there can hardly be two opinions. . . . Is Mr. Sickert cynical, is he flouting the conventional proprieties, or is he really content with these musty, flabby realities – three ugly motives upon which he plays skilful, but still ugly variations?' The *Pall Mall Gazette* (12 December 1912) judged Sickert 'serenely (and very consciously) contemptuous of popular opinion'. It is probable that Sickert's choice of subject was deliberately calculated to remind the critics, perhaps even to remind his fellow-exhibitors, of themes developed in Fitzroy Street under his guidance. His were the only typically 'Camden Town' figure pictures left in an exhibition dominated by landscapes. Apart from Lewis's *Danse*, *Summer in Naples* was the only provocative painting at the Carfax Gallery.

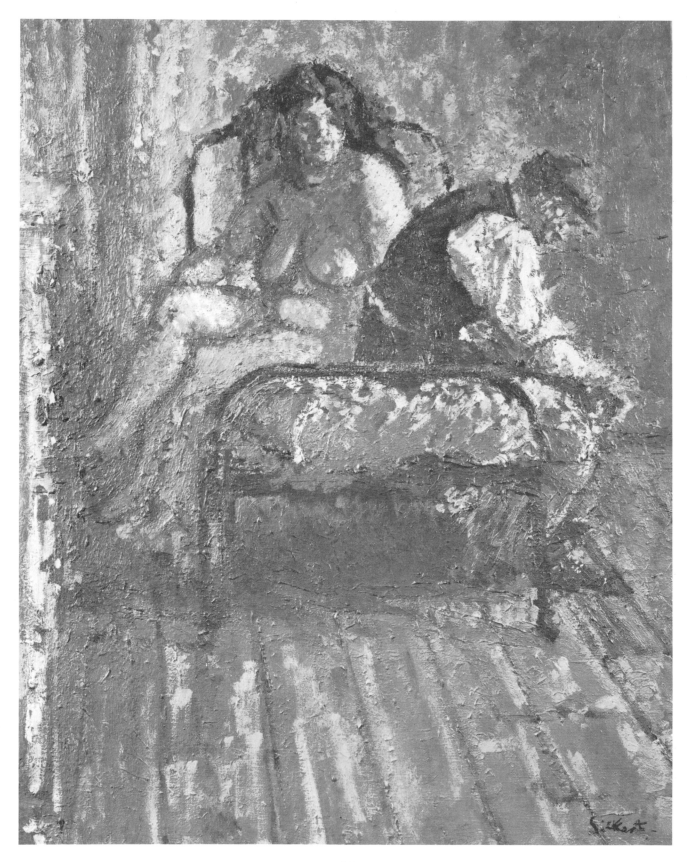

129

326 Section III(b): Camden Town Group Exhibition 1912

Turner
Third Camden Town Group exhibition

December 1912
1 Eastbourne
2 Canal Boats
3 The Fair Green, Mitcham
4 Mitcham Common. Watercolour

Note
None of these works is known today, nor did they inspire much comment from critics. *The Times* (19 December 1912) found the watercolour of Mitcham 'very pleasant'. The three remaining works were 'pleasant tinted drawings' (*Queen*, 14 December 1912).

Section III(c):
Aftermath

Bayes

130 View from the Hôtel des Bains, Locquirec, Brittany *c.* 1913

Oil on board, 9 × 14 (22.9 × 35.5)

Provenance: Judge William Evans; Wyndham T. Vint

Exhibited: Carfax Gallery 1913 (21); Goupil Gallery 1918, 'The Collection of the late Judge William Evans' (63); Fine Art Society 1976, 'Camden Town Recalled' (4)

Collection: The Vint Trust (on loan to Cartwright Hall Art Gallery and Museum, Bradford)

Pale-toned sketches of beach scenes formed a large part of Bayes's production at this period. The example illustrated is one of two Locquirec subjects lent by the Vint Trust to the Bradford Art Gallery. Both were probably painted during the summer of 1913 when the Bayes family were in Brittany and stayed at Locquirec. The Bristol City Art Gallery have an oil on paper sketch called *On the Shore* which is probably earlier in date than these two Locquirec scenes. The Art Gallery of Hamilton Ontario have yet another little beachscape, coolly articulated with a few accents of figures, jetty and wooden palings, entitled *Low Tide, St. Valéry*. It is probably a work of 1911–12.

Pissarro

131 Rye from Çadborough. Grey Morning 1913

Oil on canvas, 21 × 25½ (53.3 × 64.8)

Signed with monogram and dated 'LP 1913' bottom left

Provenance: Harold Esselmont; C. J. Aron; Mr and Mrs R. T. Harris

Exhibited: possibly N.E.A.C. winter 1913 (90) as *Rye from Cadboro' - cloudy weather*

Collection: Christie's, 11 May 1973, lot 60

Pissarro painted in Rye in 1912 and exhibited six Rye subjects at the N.E.A.C. in the winter. From July to September 1913 he returned to Rye, this time in the company of Manson, his daughter Orovida and another disciple, the Sunday painter James Brown. All five of his paintings at the N.E.A.C. in the winter were done during this summer. One, *The Hills from Cadboro*, was bequeathed to the Manchester City Art Gallery by Charles Rutherston. The description 'cloudy weather' suits the picture illustrated better than 'grey morning'. Moreover, there is another picture entitled *Rye from Cadboro Cliff - grey morning*, taken from a point further from the town, in the collection of the Department of the Environment. This too might have been the 'cloudy weather' picture. *Rye from Cadboro's brickfield* exhibited at the N.E.A.C. could be the painting sold at Christie's, 12 June 1970, lot 84, rep. in catalogue. All the pictures listed above are the same size.

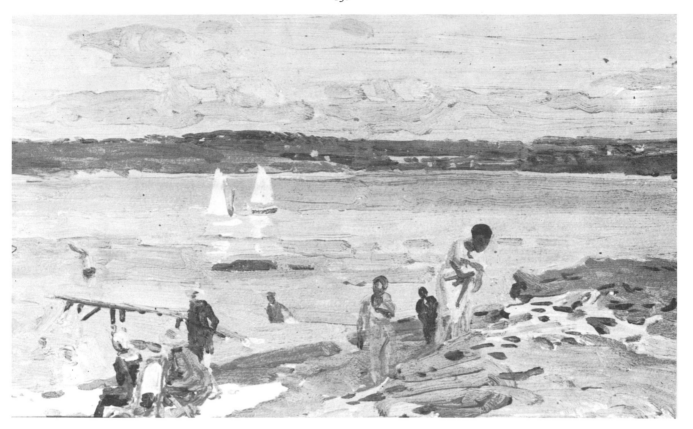

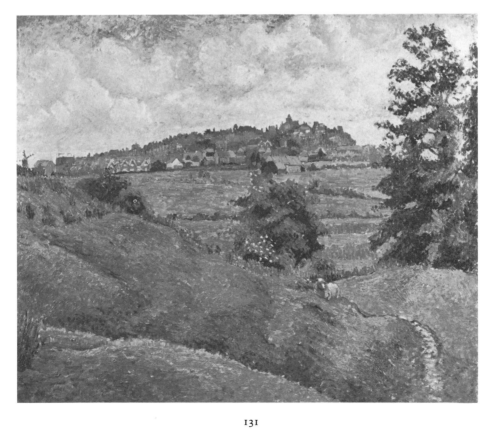

131

Section III(c): Aftermath 331

Gilman

132 **Norwegian Waterfall** 1913
Oil on canvas, 20 × 24 (50.8 × 61)
Signed 'H. Gilman' bottom right
Provenance: J. Alford; A. J. Carrick-Smith
Literature: Lewis and Fergusson, rep. p. 79
Exhibited: London Group 1914 (3); Goupil Gallery 1914 (39); Goupil Gallery
1915, 'Cumberland Market Group' (21); Leicester Galleries 1919 (37)
Collection: Western Australian Art Gallery, Perth (1974)

The artist's son believes that Ratcliffe modelled for the male nude in the fore-
ground, but no other evidence supports the claim that Ratcliffe accompanied
Gilman to Norway in 1913. In fact the nude could be Harald Sund who may have
joined Gilman at this time. The slab-like application of the thick paint suggests that
Gilman recalled Courbet's handling of similar rocky aspects of nature. John Alford
probably bought this picture from the Goupil Gallery exhibition in 1915. He lent it
to the memorial show at the Leicester Galleries in 1919. It was subsequently sold at
Christie's on 2 July 1934 before entering Mr Carrick-Smith's collection. Other
paintings by Gilman of Norwegian subjects in public collections include *The Canal
Bridge, Flekkefjord* in the Tate Gallery, *Mountain Bridge, Norway* in the Worthing
Art Gallery and *Lake in the Hills* (possibly a Norwegian fjord subject) in the
Auckland City Art Gallery.

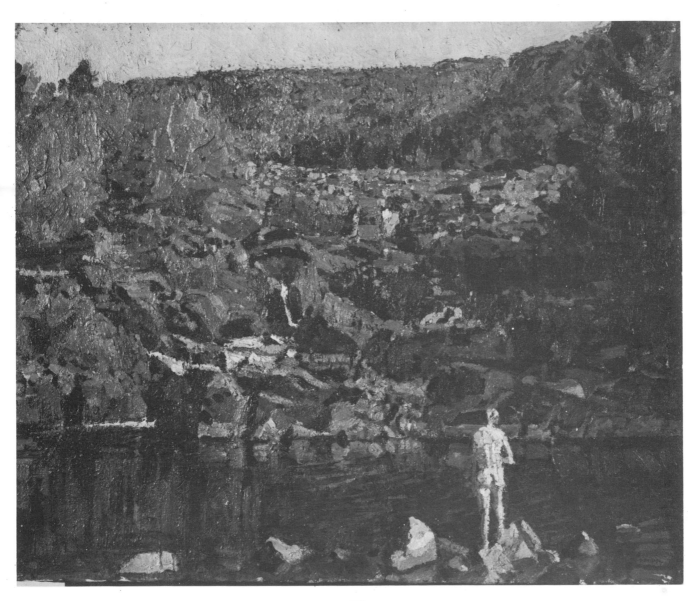

132

Gilman

133 **The Coral Necklace** 1914
Oil on canvas, 24 × 18 (61 × 45.7)
Signed and dated 'H. Gilman 1914' bottom left
Provenance: Edward le Bas
Literature: Fairfax Hall, rep. in colour Pl. 4
Exhibited: Goupil Gallery 1914 (40); N.E.A.C. summer 1914 (269) as *Girl with coral
necklace*; Goupil Gallery 1915, 'Cumberland Market Group' (43); Tooth 1934 (20);
Lefevre Gallery 1943 (13); Norwich 1976, 'A Terrific Thing' (26)
Collection: Brighton Art Gallery (1969)

The sitter is undoubtedly Mary L., wearing the same hairband and set in the Maple
Street interior represented in the profile portrait sold from Edward le Bas's
collection at Christie's, 3 March 1978, lot 115 (rep. in catalogue in colour). In the
profile portrait the rich pink of the background wallpaper set the colour key. In the
painting illustrated here the red necklace provides the dominant note. In both
pictures Gilman has built up the surface of his picture to a very thickly churned
impasto by applying the paint in generous blobs and smears. Sickert waged his
vendetta against Gilman's and Ginner's excessive use of impasto at precisely the
period when these portraits were painted.

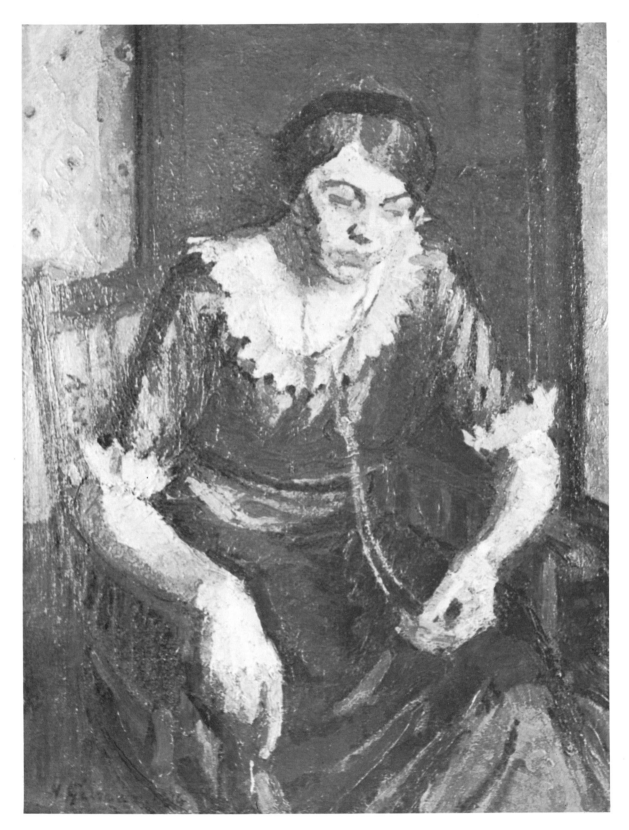

133

Ratcliffe

134 **Summer Landscape** 1913
Oil on canvas, $19\frac{5}{8} \times 29\frac{3}{4}$ (49.9 × 75.6)
Signed and dated 'W. Ratcliffe 1913' bottom left
Exhibited: possibly London Group 1914 (25) as *In the Garden Suburb*
Collection: Department of the Environment (1960)

Almost certainly a landscape of Hampstead Garden Suburb where Ratcliffe lived (in Willifield Green) at this period. It seems to be a view over Hampstead Heath extension from Meadway (before the numerous residential cul-de-sacs were built between Meadway and the Heath). Ratcliffe exhibited two Hampstead Garden Suburb subjects at the London Group in March 1914. The other, entitled *From the Club Tower, Garden Suburb*, is the more strongly coloured painting now in the possession of the Hampstead Garden Suburb Institute. The Club Tower faced Ratcliffe's house on Willifield Green; it is now demolished and the site occupied by Fellowship House. The painting from the Club Tower shows a view down Willifield Way towards Central Square where St Jude's and the Free Church are silhouetted in the distance. When acquired from the Leicester Galleries the landscape illustrated here had no geographically distinctive title.
(Crown Copyright – reproduced with permission of the Controller of Her Majesty's Stationery Office)

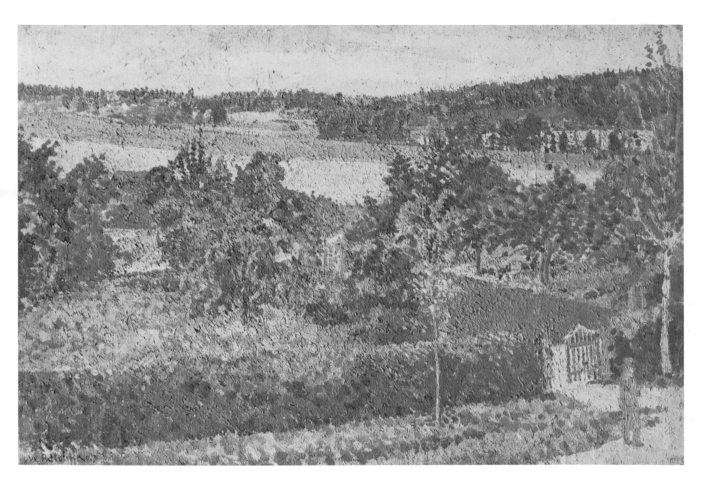

134

Ratcliffe

135 **Spring at Sundsholm, Sweden** 1913
Oil on canvas, 24 × 30 (61 × 76.2)
Signed 'W. Ratcliffe' bottom right
Exhibited: possibly A.A.A. 1913 (89) as *A Swedish Homestead*; possibly Brighton
1913–14, 'English Post-Impressionists, Cubists and others' (124) as *A Swedish
Homestead* or (125) as *Spring, Sweden*; possibly London Group 1914 (7) as
Sundsholm, Smaland, Sweden and/or London Group spring 1917 (79) as *Sundsholm,
Sweden*; possibly Roland, Browse & Delbanco 1946 (35) and Letchworth 1954 (40)
as *Swedish Homestead*; Fine Art Society 1976, 'Camden Town Recalled' (114)
Collection: Anthony d'Offay Gallery

Ratcliffe painted many landscapes while in Sweden in 1913 (there is no evidence to
support the tradition that he was in Sweden in 1912) when his address, as given in
the A.A.A. catalogue, was Sundsholm, Färholt. Among titles known from exhibi-
tion catalogues are *Spring* or *Springtime in Sundsholm* and *A Swedish Homestead*. I
believe that the wrong title may, in recent times, have become attached to the
painting illustrated here. The present title was used by Agnew in their 1972
exhibition of 'Twentieth Century British Art' and I followed it when compiling the
1976 Fine Art Society catalogue. However the 1946 Roland, Browse & Delbanco
catalogue lists both *A Swedish Homestead* and *Springtime in Sundsholm*, the
measurements of the former being those of the painting illustrated but those of the
Springtime picture being 20 × 30 inches. A third Sundsholm picture, called *The
House in the Sun*, measuring 24 × 30 was also included in the 1946 exhibition and
could be the painting illustrated here. Public collections owning other Swedish
pictures by Ratcliffe include the Art Gallery of Hamilton, Ontario (*Landscape with
Gate, Sweden*, dated 1913), Manchester City Art Gallery (*Swedish Farm* and *Winter
Scene, Sweden*), the Department of the Environment (Pl. 136), and Leeds City Art
Gallery (*Landscape with Cow*, probably a Swedish subject). I know of two other
Swedish landscapes in private collections. In most of these landscapes Ratcliffe
emphasized the perspective construction and the patterning of his picture surface.
His colour key tended to become more vivid and high-toned, dominated in this
painting by purples and turquoise greens. His handling was often very tight, the
paint applied in small, stippled touches of thick but dry-textured paint.

135

Ratcliffe

136 Beehives in the Snow 1913
Oil on canvas, 16 × 20 (40.6 × 50.8)
Signed and dated 'W. Ratcliffe 1913' bottom right
Exhibited: A.A.A. 1913 (90) as *Bee-hives*; Brighton 1913–14, 'English Post-Impressionists, Cubists and others' (126); Whitechapel 1914, 'Twentieth Century Art' (430) as *Swedish Beehives*
Collection: Department of the Environment (1962)

The smaller scale of this picture perhaps encouraged Ratcliffe to adopt a more spontaneous and naturalistic approach to its execution than is usual in his work of this period.
(Crown Copyright – reproduced with permission of the Controller of Her Majesty's Stationery Office)

Ratcliffe

137 The Coffee House, East Finchley 1914
Oil on canvas, 20 × 24 (50.8 × 61)
Signed 'W. Ratcliffe' bottom right
Exhibited: London Group spring 1919 (35); Roland, Browse & Delbanco 1946 (43); Colchester 1961, 'Camden Town Group' (59); Plymouth 1974, 'The Camden Town Group' (23); Newcastle 1974 'The Camden Town Group' (53)
Collection: Southampton Art Gallery (1953)

This picture was bought from the artist who wrote in 1953: 'I well remember the time it was painted, just before the first war started. I was then living in the Hampstead Garden Suburb and discovered this Coffee House at East Finchley and went in to lunch one day and afterwards started a drawing sitting on the back seat with the sunlit red blind behind me and reflected in the mirror opposite. I was interested enough to carry on for several days and used to walk over the fields to E. Finchley almost dayly [*sic*] until I had enough information for the picture, which was progressing at home at the same time . . . ' It is probable that the recent memory of Gilman's two versions of *An Eating House* (see note to Pl. 109) exhibited at the Goupil Gallery in April 1914 helped awaken Ratcliffe's eye to the pictorial possibilities of the scene before him. The insistent rectilinear quality of Ratcliffe's drawing, and his colour scheme based on vivid reds, emerald greens and purple, owe their inspiration to Gilman's example. The tonal simplification of Ratcliffe's forms and the frozen focus, on the other hand, owe more to the example of Drummond than of Gilman. The result of Ratcliffe's fusion of these sources is an unforgettable image of a seedy suburban café whose patrons, waitress and unappetising dainties wait like statues for some Prince Charming to awaken them over seventy years later.

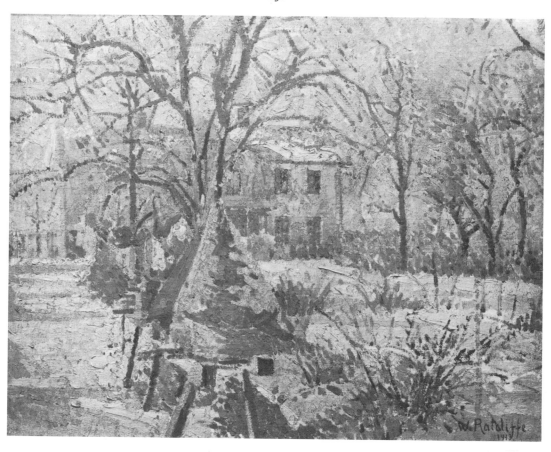

Ginner

138 Victoria Station. The Sunlit Square 1913
Oil on canvas, 30 × 34¾ (76.2 × 88.3)
Signed 'C. GINNER' bottom right
Literature: Ginner, Vol. 1, p. lxvi
Exhibited: A.A.A. 1913 (544); Doré Galleries 1913, 'Post-Impressionists and Futurists' (49); Goupil Gallery 1914; Southampton 1951, 'The Camden Town Group' (44)
Collection: Bootle Art Gallery (1924)

Presented to the Bootle Art Gallery by the Contemporary Art Society who bought the picture from Ginner in 1916. Ginner recorded in his notebook that this painting was exhibited in his two-man show at the Goupil Gallery in 1914 but it is not listed in the catalogue. Ginner's own title for the painting was *The Sunlit Square* and as such it was exhibited in 1913, but the picture is now known by its geographically more descriptive name.

Drummond

139 Queen Anne's Mansions *c.* 1912
Oil on canvas, 26½ × 19½ (67.3 × 49.5)
Signed 'Drummond' bottom right
Provenance: the artist's family
Exhibited: A.A.A. 1913 (324) and Whitechapel 1914, 'Twentieth Century Art' (428) as *London Flats*; Redfern Gallery 1939, 'The Camden Town Group' (67); Southampton 1951, 'The Camden Town Group' (17); Arts Council 1953, 'The Camden Town Group' (15); Colchester 1961, 'Camden Town Group' (11); Arts Council 1963 (7); Plymouth 1974, 'The Camden Town Group' (4)
Collection: Plymouth City Art Gallery (1954)

Drummond and Ginner both found the streets and architecture of London fascinating as a subject for painting. It is probable that there was reciprocity in the influence of one painter on the other. Drummond's cityscapes tend to be more poetic, Ginner's more vital, but there are often striking similarities in the way they related their figures to the architecture, in their loving concern with vehicles and with street furnishings (such as lamp-posts and railings), and sometimes in the quaint notation of their figures. Drummond used softer colours than Ginner, although in *The Angel Islington* (private collection) of 1914 Ginner adopted a palette closer to Drummond's to evoke the foggy light of a darkening winter afternoon.

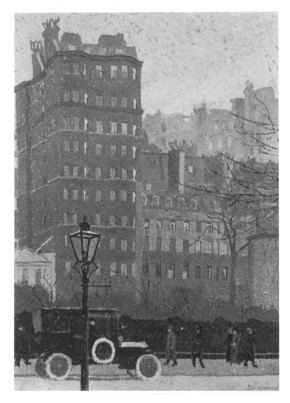

343

Drummond

140　**In the Cinema** *c.* 1912–13
Oil on canvas, 27⅜ × 27⅜ (69.5 × 69.5)
Signed 'DRUMMOND' bottom left
Provenance: the artist's family
Exhibited: probably A.A.A. 1913 (325) as *The Kinema*; Brighton 1913–14, 'English Post-Impressionists, Cubists and others' (130) as *Cinema*; Whitechapel 1914, 'Twentieth Century Art' (127) as *A Cinema Theatre*
Collection: Ferens Art Gallery, Kingston upon Hull (1969)

Cinema interiors were a new subject for painting, posing something of the same challenge to the artist as music hall interiors. Indeed, early cinema performances took place in music halls. In the winter of 1912 Sickert exhibited *Cinematograph* at the N.E.A.C., according to the *Daily Telegraph* (23 November 1912) 'a puzzling picture . . . with a line of very dark figures glancing towards the light'. The *Daily Chronicle* (26 November 1912) critic found the picture so dark he likened it to a coal mine. The only extant painting to suit these descriptions and the 1912 title is *The Gallery of the Old Mogul* of 1906 (private collection, rep. Browse 1960, Pl. 13), although if the sale catalogue annotation that Jacques-Emile Blanche bought this picture from the Hôtel Drouot in 1909 is correct it can not be the painting exhibited in 1912. However, to explain Drummond's picture it is perhaps enough to know that Sickert exhibited a very dark cinema interior in 1912. Drummond's painting is also extremely dark in colour and tone and it is barely possible to distinguish the separate stains of wine-reds, blues and purples from each other. Within the next few years Bayes also executed an ambitious cinema interior entitled *Oratio Obliqua* (Manchester City Art Gallery).

Drummond

141　**Girl with Palmettes** *c.* 1914
Oil on canvas, 19⅝ × 15⅞ (49.8 × 40.3)
Collection: The Tate Gallery, London (1967)

This strikingly modern-looking picture, with its compelling design and its green shadows in the face, has been tentatively dated *c.* 1920 by the Tate Gallery. However, these qualities and the handling of the crusty-textured paint suggest a pre- rather than a post-war date. Drummond painted very little during the war and when he returned to the easel he favoured a flatter and duller paint surface. His colours became more muted and muddy. Drummond's *Portrait of Ginner* (Pl. 79) proves that, like his Camden Town colleagues, he could assimilate the concentrated pure colours of French Post-Impressionism and use Fauve conventions when modelling faces. *Girl with Palmettes* can best be understood as a bold sequel to the 1911 portrait. The costume supports the dating. The hat is the kind worn by unfashionable women who moved in 'arty' circles before the war. The spiky white

collar was evidently a common trimming at this period because it also appears in Gilman's *The Coral Necklace* (Pl. **133**). Unfortunately, the early exhibition history of this picture is unknown. Drummond seldom favoured helpfully descriptive titles and exhibited most of his portraits simply as *Portrait*.

140

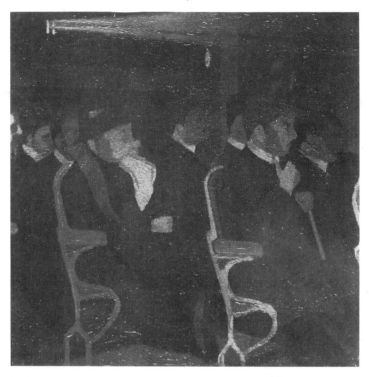

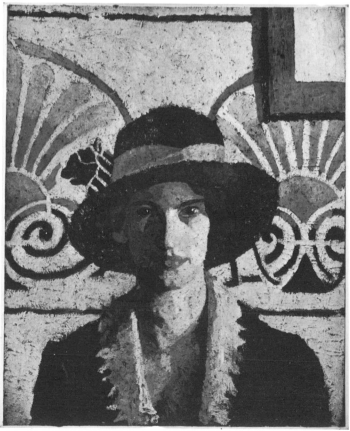

141

Gore

142 Cambrian Road, Richmond 1913
Oil on canvas, 16 × 20 (40.6 × 50.8); G.201A
Stamped 's. f. gore' bottom left
Exhibited: Carfax Gallery 1916 (17); probably Paterson & Carfax 1920 (2);
probably Leicester Galleries 1928 (17); Arts Council 1955 (41); Southampton
1951, 'The Camden Town Group' (68); Colchester 1970 (65)
Collection: Private

An annotation in a copy of the 1920 catalogue noted the exhibited picture as
showing 'houses & roadway'. The Gores moved to 6 Cambrian Road in the summer
of 1913; this view is taken from outside their house. In his landscapes of the streets,
houses and the park of Richmond painted during the last year of his life, Gore seems
to have retreated from the violent stylization with which he had experimented in his
Letchworth subjects of 1912. Quentin Bell's description of *The Icknield Way* (Pl.
115) has been quoted. Having stated that this Letchworth painting might 'fairly be
termed Cubist or perhaps Futurist', Professor Bell continued:

. . . he had not known his own strength and now perceived that he might end by breaking
something valuable. At all events, during 1913 and 1914, the epoch of Neo-Realism, he
paused: he ceased to pursue geometrical shapes, his work is more graceful though no less
strong. In the Richmond landscapes there is a return of tenderness and of atmosphere and a
deeper understanding of Cézanne, he seems to be discovering his true self, an artist neither
oversweet nor over violent, but astonishingly poetical. Then he died.

Bevan

143 The Town Field, Horsgate 1914
Oil on canvas, 20 × 24 (50.8 × 61)
Provenance: Charles Ginner; Anton Lock
Collection: Reading Art Gallery (1975)

Painted during the late summer of 1914, the last period when Bevan worked from
his father's house in Sussex. A different view of this field, painted at the same date,
is in a private collection (rep. R. A. Bevan, Pl. 44). The evolution in Bevan's style
between 1910 and 1914 can be seen by comparing this picture with Pl. 76, both
Sussex landscapes.

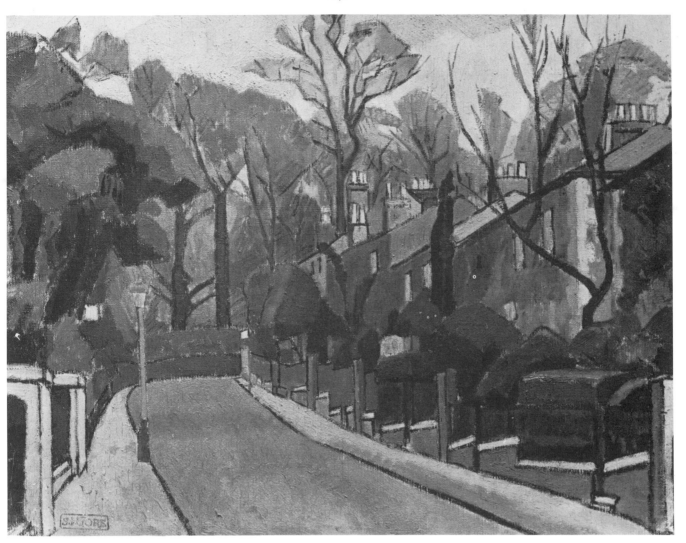

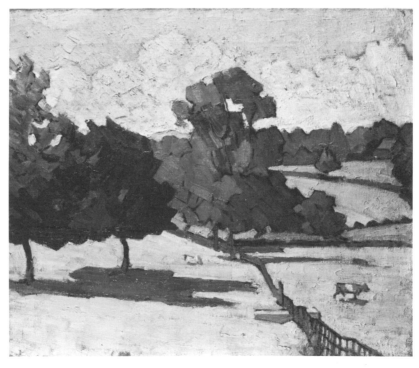

347

Bevan

144 **Self Portrait** *c.* 1913–14
Oil on canvas, 18 × 14 (45.7 × 35.5)
Literature: R. A. Bevan, p. 20, rep. Frontispiece in colour
Exhibited: Goupil Gallery 1926 (156); Southampton 1951, 'The Camden Town Group' (9); Arts Council 1953, 'The Camden Town Group' (9); Arts Council 1956 (16); Colnaghi 1961 (2); Colnaghi 1965 (36); Fine Art Society 1976, 'Camden Town Recalled' (11)
Collection: Private

A terminal date of 1914 is provided for this picture by R. A. Bevan recalling that the patches on the studio wall, where sketches had been pinned, disappeared during re-decoration that year. Bevan rarely painted portraits. This was, essentially, a private work and was not exhibited until after the artist's death. In style and conception Bevan's and Gore's (Pl. 145) self-portraits are strikingly similar.

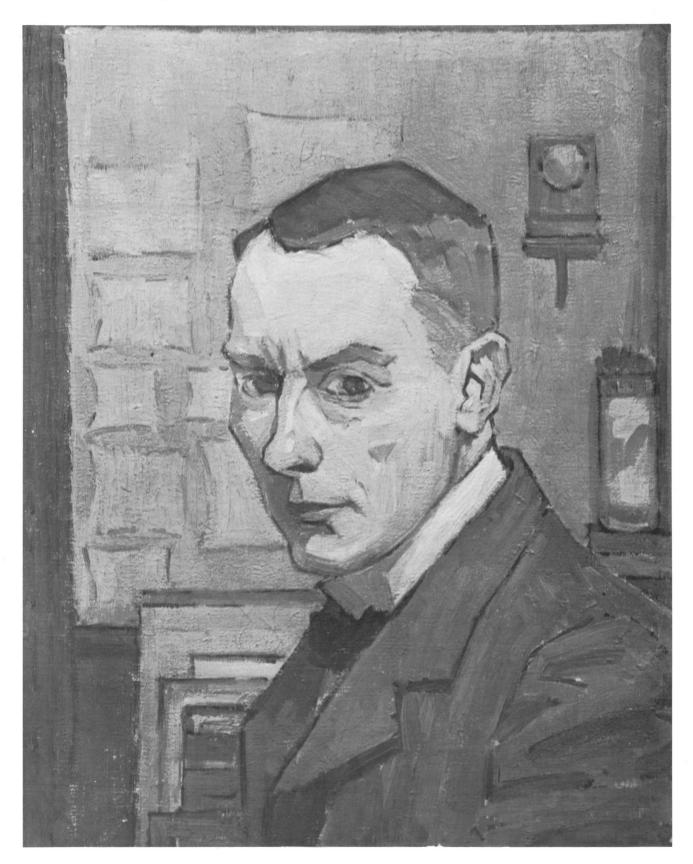

144

Gore

145　**Self Portrait** *c.* 1914
Oil on canvas, 16 × 12 (40.6 × 30.5); G.198
Stamped 's. f. gore' bottom right
Provenance: the artist's family
Exhibited: Colchester 1970 (67); Anthony d'Offay 1974 (30) rep. in colour in catalogue
Collection: National Portrait Gallery, London (1974)

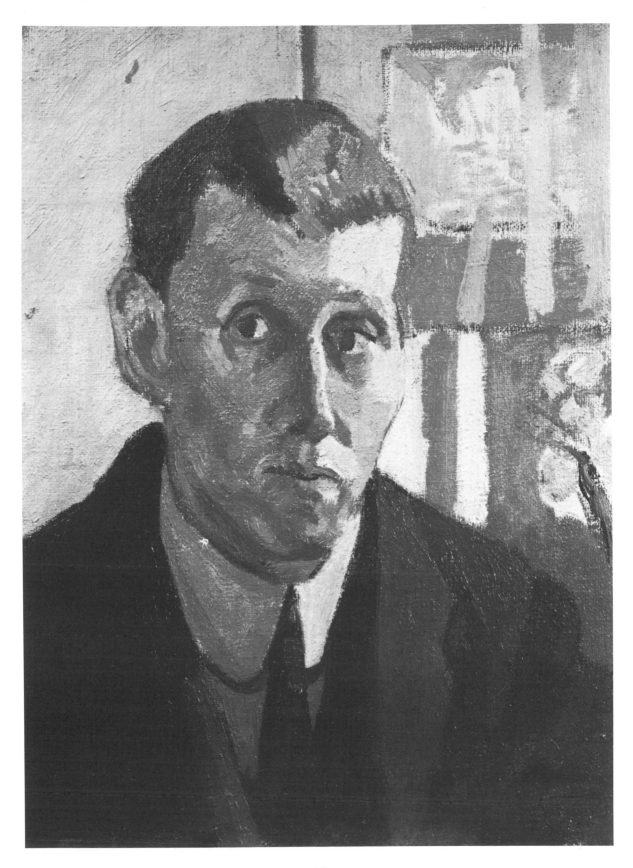

145

Bevan

146 **Cumberland Market, North Side** *c.* 1914
Oil on canvas, 20¼ × 24½ (51.4 × 62.2)
Provenance: possibly John Brophy
Literature: R. A. Bevan, rep. Pl. 47
Exhibited: possibly Goupil Gallery 1926 (121); Southampton 1951, 'The Camden Town Group' (12); Arts Council 1956 (20); Norwich 1976, 'A Terrific Thing' (22)
Collection: Southampton Art Gallery (1947)

The view from Bevan's Cumberland Market studio, headquarters of the group he, Ginner and Gilman established in 1914. This painting may be the *Cumberland Market* exhibited in the group's exhibition at the Goupil Gallery in 1915 (8). Bevan painted several views of this market and both the Southampton painting and a horizontal composition looking across the square (private collection, rep. R. A. Bevan, Pl. 50) have been suggested as the painting exhibited in the 1926 memorial show. R. A. Bevan also reproduced (Pl. 49) *Haycarts, Cumberland Market* from Edward le Bas's collection (sold Christie's, 3 March 1978, lot 179, rep. in colour). Yet another Cumberland Market subject, *The Weigh House*, was sold from a private collection at Christie's, 8 June 1979, lot 38 (rep. in catalogue in colour). This last version is very close in composition to the Southhampton painting.

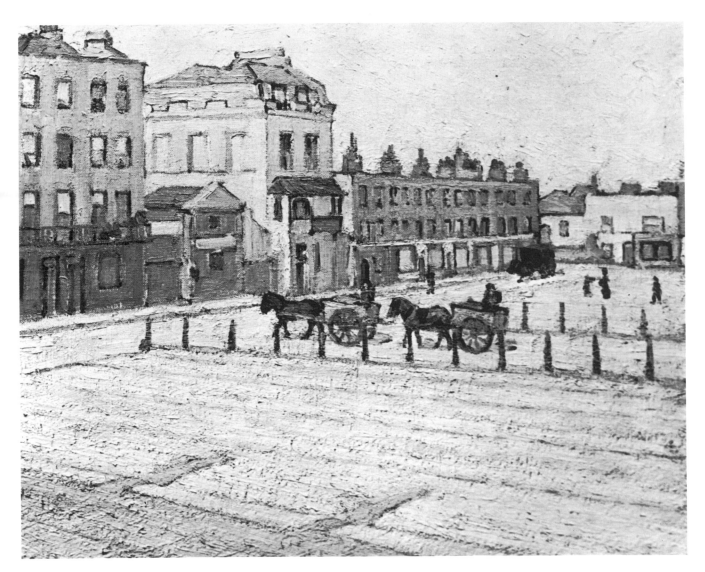

146

Sickert

147 **Nude seated on a Couch** 1914
Oil on canvas, 20 × 16 (50.8 × 40.6)
Signed 'Sickert' bottom right
Provenance: Charles Rutherston
Literature: Baron, pp. 128–30, 133, 137, 155, 357, C. 310, rep. Fig. 220
Exhibited: Sheffield 1957 (32); Hull 1968 (15); Fine Art Society 1973 (72)
Collection: Manchester City Art Gallery (1925)

In a letter to Nan Hudson of February 1914 Sickert sketched six examples from a series of 'direct little pictures 20 × 16 on the way', among them this painting. He also inscribed the model's name, Miss Ison, on this sketch and on another sketch of a half-length portrait related to the *Portrait of a Woman* (rep. Lilly, Pl. 38) which has in the past been tentatively identified as Virginia Woolf. (The format of this finished portrait is, however, narrower than the sketch which includes part of a mantelpiece in the background.) Having rejected the tight stippled application of thick paint developed when he was working in close association with Gore from 1907–9, Sickert had been searching for a way to give his pictures weight, movement and 'quality'. He found thickly worked paint 'beastly', but the alternative summary treatment thin and poor. The solution he considered ideal for small-scale informal figure subjects in 1913–14 was to apply successive free, loose coats of different-sized touches of flat paint, allowing each individual coat to dry thoroughly before the next superimposition. His current belief in this method conditioned the extreme distaste he felt in front of the churned impasto used by Gilman and Ginner.

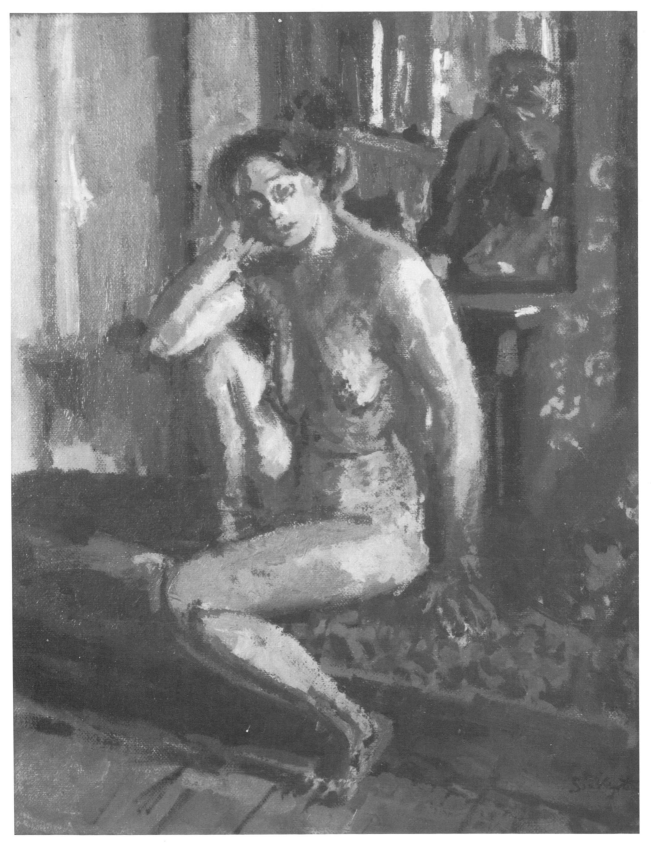

147

Appendix

Check-list of oils
in public collections painted 1906–14
by members of the Camden Town Group

The following check-list is not a full-scale catalogue. It is intended as a guide to the location of oil paintings, in public ownership throughout the world, executed by members of the Camden Town Group. Two members, Augustus John and Duncan Grant, have been omitted. Not only was their membership of the Camden Town Group nominal, but they have also been the subjects of recent literature and exhibitions which provide information about the ownership of their work. However, for reference, a selection of the major collections including their paintings of this early period is given in the notes below. It was obviously necessary to impose a date-bracket on this check-list and the years 1906–14 were chosen because they cover the period discussed in this book. However, the chronological limitations affect the coverage of individual members' work in different ways, and therefore some supplementary notes are given below, artist by artist.

The general method used to catalogue the paintings (variations as applied to individual artists are cited in the notes below) is as follows:

All paintings are in oil.

Sizes: inches first, centimetres bracketed.

Locations of signatures, dates and other inscriptions are not noted.

Provenance (abbreviated as Prov.): interim ownership by dealers and sale-room histories are not cited. However, if known to me, the dealer from whom a painting was acquired is cited in brackets after the acquisition date.

Exhibitions (abbreviated as Exh.): only early exhibitions up to 1919, whether mixed or one-man, arc listed. In a few cases exhibition references are listed without catalogue numbers because I have been unable to obtain a copy of the relevant catalogue.

Literature (abbreviated as Lit.): with a few exceptions (see notes below) references are not cited.

Reproduction (abbreviated as Rep.): with a few exceptions (see notes below) references are not given if the painting is illustrated in this book (in which case the plate number is given and the work is more fully catalogued in the accompanying note). However, colour reproduction references are given again if the work is illustrated here in black and white. If the painting is not illustrated in this book a reproduction reference, from any source, is given whenever possible.

Abbreviations as for plate notes with the following additions:

Acqu. acquired (by purchase, gift or bequest)

C.A.S. Contemporary Art Society

Walter Bayes

Although his career was long, Bayes did not enjoy much public recognition. Therefore, the chronological limitations of the check-list have not caused the exclusion of many major paintings. *Oratio Obliqua* of 1917 is noted under the Manchester City Art Gallery collection. Another very important painting by Bayes in public ownership is *Top o' the Tide* (exhibited at the Royal Academy in 1899) in the Walker Art Gallery, Liverpool. The Tate Gallery owns *The Ford*, a Barmouth estuary picture of *c*. 1917–20, and the Leicestershire Museums and Art Galleries have *The Flanks of Cader*, exhibited at the Leicester Galleries in 1918. Bayes's very large *The Underworld* (rep. Richard Shone, *The Century of Change*, 1977, Pl. 54), executed during the course of the First World War, was recently destroyed by fire in the store of the Imperial War Museum. One problematical unsigned painting might be mentioned here; it is *Victoria Station. Troops Leaving for the Front* in the Royal Albert Memorial Museum, Exeter (rep. Agnew catalogue of 1975 exhibition, 'British Paintings 1900–1975', No. 46). It is clearly a work of the First World War and may well have been inspired by F. J. Mortimer's photograph of 1917, entitled *The Gate of Goodbye*, which shows a nearly identical scene although the figure groups are differently composed in the painting. If, as has been suggested, the painting is by Bayes, remembering his penchant for tricky titles, it might be *Embarquement pour Cythère* exhibited at the Leicester Galleries in 1918 (41).

BRADFORD
Cartwright Hall Art Gallery and Museum

Coast Scene 1911 (Pl. 73)
Paper, $11\frac{1}{4} \times 12\frac{1}{8}$ (28.6 × 30.8); signed and dated
Prov. Arthur Crossland; Acqu. 1947

N.B. Bradford also have two views of Locquirec, Brittany, painted *c*. 1913 on loan from the Vint Trust. One rep. Pl. 130.

BRISTOL
City Museum and Art Gallery

On the Shore ?1906–14
Paper, $6\frac{1}{4} \times 9$ (15.9 × 22.9); signed in monogram
Prov. C.A.S.; Acqu. 1952

BURY
Art Gallery

The Blue Pool ?1912–15
Canvas, $12\frac{5}{8} \times 20$ (32.1 × 50.8); signed in monogram
Prov. George and Nellie Clough; Acqu. 1941

Café Scene ?*c*. 1912–15
Oil and tempera on board, $11 \times 13\frac{1}{4}$ (27.9 × 33.7)
Prov. Franklin and Margaret Howarth; Acqu. 1939
Exh. possibly Leicester Galleries 1918 (18) as *The Terrace*

LONDON
Arts Council of Great Britain

Wine and Fruit c. 1914–15
Canvas, 31×23 (78.7 × 58.4); signed with initials
Acqu. 1952
Exh. Carfax Gallery 1915 (1); Leicester Galleries 1919 (34)

MANCHESTER
City Art Gallery

Cornlands ?*c*. 1914
Canvas, $10\frac{1}{2} \times 14$ (26.7 × 35.6)
Prov. Charles Rutherston (bought from Carfax Gallery 1915); Acqu. 1925
Exh. Carfax Gallery 1915 (33)

N.B. *Cornfield* was included in Bayes's exhibition at the Chenil Gallery in May 1911.

Manchester also possesses one of Bayes's most important works, the cinema interior *Oratio Obliqua* of 1917, bought by Howard Bliss and presented to the gallery in 1926. The Boston Museum of Fine Arts has an oil on canvas study for the Manchester picture (probably exhibited at the Goupil Gallery in 1928, No. 18, and acquired by the Museum in 1934). The South London Art Gallery has a very large-scale version which is now in bad condition and requires immediate restoration.

OLDHAM
Art Gallery and Museum

A Boire (Thirst) ?date
Canvas, $53\frac{5}{8} \times 71\frac{1}{2}$ (136.2 × 181.6)
Prov. Alderman C. Hardman; Acqu. 1920

SHEFFIELD
Graves Art Gallery

The Lemon c. 1910–12 (Pl. 71)
Canvas board, 10⅞ × 14½ (27.6 × 37); signed in
monogram
Acqu. 1972 (from Anthony d'Offay Gallery)
Exh. Leicester Galleries 1918 (46)

Girl on Beach c. 1914–15
Board, 15 × 10⅞ (38.1 × 27.6); signed in monogram
Prov. E. W. Jenkinson; Acqu. 1965
Exh. possibly Carfax Gallery 1915 as *On the Sands
No. 1* (2), *On the Sands No. 2* (22) or *Among the Dunes*
(6)

On the Beach c. 1914–15
Board, 10⅝ × 15 (27.1 × 38.1)
Acqu. 1965 (from Piccadilly Gallery)
Exh. as for *Girl on Beach* with which it is clearly
contemporary

CANADA

HAMILTON (Ontario)
Art Gallery of Hamilton

Lowtide. St. Valéry c. 1911–12
Canvas on board, 6½ × 13¼ (16.5 × 33.7); signed
with initials
Prov. C.A.S.; Acqu. 1959
Exh. possibly Carfax Gallery 1913 (26) as *The falling
tide*; possibly Leicester Galleries 1918 (24) as
Lowtide at noon

N.B. Several St Valéry subjects were exhibited in
October 1913.

NEW ZEALAND

AUCKLAND
City Art Gallery

Lady with Sunshade c. 1912
Canvas, 14 × 12⅜ (35.5 × 31.4); signed in
monogram
Acqu. 1956 (from R. E. Abbott, Barnes)
Exh. possibly Carfax Gallery 1913 (4) as *Girl with
Parasol, Plage de la Palud*
Rep. Auckland Art Gallery *Quarterly*, No. 34, 1966

N.B. Several la Palud scenes were exhibited in
October 1913.

SOUTH AFRICA

JOHANNESBURG
Art Gallery

The Open Door c. 1911 (Pl. 74)
Canvas, 27⅛ × 23¼ (69 × 59); signed in monogram
Prov. Sylvia Gosse; Acqu. 1913
Exh. probably Carfax Gallery December 1911,
'Camden Town Group' (51) as *The Glass Door*

Robert Bevan

R. A. Bevan's *Memoir* of his father includes a list of
works by Bevan in public collections, and repro-
duces a good selection of the artist's earlier and later
pictures.

ABERDEEN
Art Gallery

Ploughing on the Downs c. 1907
Canvas, 21¾ × 31¾ (55.2 × 80.7)
Acqu. 1939 (probably from Redfern Gallery where
exh. in Camden Town Group show No. 42)
Exh. Baillie Gallery 1908 as *Ploughing the Hillside*
Rep. R. A. Bevan, Pl. 21

Grooming Horse c. 1909
Canvas, 14¾ × 16¾ (37.5 × 42.6)
Prov. Frank Rutter; Acqu. 1938
Exh. Goupil Gallery 1926 (119) as *The Toilet*

BELFAST
Ulster Museum

The Yard Gate, Mydlow (Poland) *c.* 1907
Canvas, 22 × 19 (55.9 × 48.2)
Acqu. 1970 (from Hamet Gallery)
Rep. Fine Art Society 1969, 'Channel Packet', Pl. 18

BRADFORD
Cartwright Hall Art Gallery and Museum has *Haze
over the Valley, c.* 1913, on loan from the Vint Trust.

BRIGHTON
Art Gallery

The Cabyard, Night c. 1910 (Pl. 77 and in colour)
Canvas, 25 × 27½ (63.5 × 69.9); signed
Acqu. 1913 (from Brighton exhibition)
Exh. Carfax Gallery December 1911, 'Camden
Town Group' (31); Carfax Gallery 1913 (12);
Brighton 1913–14, 'English Post-Impressionists,
Cubists and others' (36)

CARDIFF
The National Museum of Wales

Maples at Cuckfield 1914
Canvas, 20 × 24 (50.8 × 61); signed and dated
Prov. Sir Louis F. Fergusson; Miss M. S. Davies;
Acqu. 1963

EXETER
Royal Albert Memorial Museum

A Devonshire Valley No. I c. 1913
Canvas, 20 × 24 (50.8 × 61); title inscribed on
stretcher
Acqu. 1968 (from Thos Agnew & Sons)
Exh. probably Goupil Gallery Autumn Salon 1913
(147)

GLASGOW
Art Gallery and Museum

Three Poplars and a Well (Poland) *c.* 1907–8
Canvas on board, 10½ × 12¾ (26.7 × 32.4)
Acqu. 1968 (from R. A. Bevan)

HUDDERSFIELD
Art Gallery (Kirklees Metropolitan Council)

Showing the Paces, Aldridge's c. 1913–14
Canvas, 20 × 24 (50.8 × 61)
Prov. C. E. Mansell; Acqu. 1967
Rep. R. A. Bevan, Pl. 38

IPSWICH
The Museum

A Small Southdown Farm (Sussex) 1906
Canvas, 14⅞ × 17¾ (37.8 × 45.1); signed
Prov. R. A. Bevan; Acqu. 1974
Exh. probably Baillie Gallery 1908 (24)
Rep. d'Offay Couper 1969, 'Robert Bevan. Early
Paintings 1895–1908' (29)

LEAMINGTON SPA
Public Art Gallery and Museum (Warwick District
Council)

Back of the Farm, Sussex 1906
Canvas, 15 × 18 (38.1 × 45.7)
Acqu. 1969 (from d'Offay Couper Gallery)
Rep. d'Offay Couper 1969, 'Robert Bevan. Early
Paintings 1895–1908' (30)

LIVERPOOL
Walker Art Gallery

Under the Hammer c. 1913–14
Canvas, 25⅛ × 36⅛ (63.7 × 91.7); signed
Prov. Mrs Bevan; Acqu. 1933
Exh. London Group 1914 (89); probably
Whitechapel 1914, 'Twentieth Century Art' (404);
probably Goupil Gallery 1915, 'Cumberland Market
Group' (47)
Rep. R. A. Bevan, Pl. 45

N.B. There are two smaller versions, hence the
uncertainty about exhibitions.

LONDON
Tate Gallery

The Cab Horse or *Putting to c.* 1910 (Pl. 75)
Canvas, 25 × 30 (63.5 × 76.2)
Acqu. 1949 (from Duveen Paintings Fund)
Exh. N.E.A.C. winter 1910 (91); Carfax Gallery June
1911, 'Camden Town Group' (29); probably Carfax
Gallery 1913 (38) as *Putting to*

Horse Sale at the Barbican c. 1912
Canvas, 31 × 48 (78.5 × 122); signed
Prov. Mrs Bevan; Acqu. 1934 (Chantrey Bequest
Purchase)
Exh. probably Carfax Gallery December 1912,
'Camden Town Group' (41), Carfax Gallery 1913
(48), Brighton 1913–14, 'English
Post-Impressionists, Cubists and others' (32) as *The
Horse Mart*; probably Goupil Gallery 1915,
'Cumberland Market Group' (19) as *A Sale at the
Barbican*
Rep. R. A. Bevan, Pl. 43

Haze over the Valley c. 1913
Canvas, 17 × 21 (43 × 53.5)
Prov. R. A. Bevan; Acqu. 1959 (from P. & D.
Colnaghi)

OXFORD
Ashmolean Museum

In the Downs near Lewes 1906
Canvas, 15 × 18 (38.1 × 45.7); signed
Prov. R. A. Bevan; Acqu. 1961

READING
Museum and Art Gallery

The Town Field, Horsgate 1914 (Pl. 143)
Canvas, 20 × 24 (50.8 × 61)
Prov. Charles Ginner; Anton Lock; Acqu. 1975

SOUTHAMPTON
Art Gallery

Mydlow Village, Poland c. 1907–8
Canvas, 24½ × 32 (62.2 × 81.3); signed
Prov. Dennis Peel; Acqu. 1952
Exh. possibly A.A.A. 1909 (1041) as *A Polish Village*

A Sale at Tattersall's c. 1911–12
Canvas, 20⅛ × 24⅛ (51.1 × 61.3)
Prov. Miss Horsfall (bought from Carfax Gallery in 1913); Lt.-Col. J. K. McConnel; Acqu. 1974
Exh. Carfax Gallery 1913 (24) as *Tattersall's*
Rep. R. A. Bevan, Pl. 29 in colour

Cumberland Market, North Side c. 1914 (Pl. 146)
Canvas, 20¼ × 24½ (51.4 × 62.2)
Prov. possibly John Brophy; Acqu. 1947
Exh. possibly Goupil Gallery 1915, 'Cumberland Market Group' (8)

AUSTRALIA

PERTH
Western Australian Art Gallery

The Farm Gate in Sunlight (Mydlow) *c.* 1907–8
Canvas, 19⅜ × 16 (49.1 × 40.8)
Acqu. 1974 (from Leva Gallery)

NEW ZEALAND

AUCKLAND
City Art Gallery

The Well at Mydlow, Poland, No. 1 c. 1908–9
Canvas, 23¾ × 31½ (60.3 × 80)
Prov. R. A. Bevan; Acqu. 1961
Rep. R. A. Bevan, Pl. 24

N.B. The Scottish National Gallery of Modern Art, Edinburgh, has a late reworking of this subject, rep. R. A. Bevan, Pl. 25.

U.S.A.

BOSTON
Museum of Fine Arts

The Parade at Aldridge's 1914
Canvas, 23¼ × 30 (61.9 × 76.2)
Prov. R. A. Bevan; Acqu. 1931
Rep. Colnaghi 1965, Pl. VI

Malcolm Drummond

There are few paintings by Drummond of any date in public collections. The most notable works excluded by my date-bracket are: *The Park Bench* of *c.* 1918–19 in the Royal Albert Memorial Museum, Exeter; *Hammersmith Palais de Danse* of 1920 in the City Museum and Art Gallery, Plymouth; *The Coconut Shy* of about the same date in the City Art Gallery, Leeds; and *Chelsea Public Library* (exhibited at the A.A.A. in 1920 as *Silence*) in the University of Leeds Art Collection.

CARLISLE
Museum and Art Gallery

Foreshortened Male Nude c. 1909
Canvas, 11½ × 17½ (29.2 × 44.5)
Prov. Mrs Margaret Drummond; Acqu. 1964

KINGSTON UPON HULL
Ferens Art Gallery

In the Cinema c. 1912–13 (Pl. 140)
Canvas, 27⅜ × 27⅜ (69.5 × 69.5); signed
Acqu. 1969 (from Thos Agnew & Sons)
Exh. probably A.A.A. 1913 (325), Brighton 1913–14, 'English Post-Impressionists, Cubists and others' (130) and Whitechapel 1914, 'Twentieth Century Art' (127)

LONDON
Arts Council of Great Britain

Brompton Oratory c. 1910 (Pl. 119)
Canvas, 21 × 8 (53.3 × 20.3)
Acqu. 1954
Exh. probably A.A.A. 1910 (33); Carfax Gallery December 1912, 'Camden Town Group' (26)

LONDON
Tate Gallery

Boyne Hill Vicarage c. 1910
Canvas, 20 × 16 (50.8 × 40.6)
Prov. Mrs Margaret Drummond; Acqu. 1963

Girl with Palmettes c. 1914 (Pl. 141)
Canvas, 19⅝ × 15⅞ (49.8 × 40.3)
Acqu. 1967

NEWCASTLE UPON TYNE
Laing Art Gallery

19 Fitzroy Street c. 1913–14 (Pl. 18 and on cover)
Canvas, 28 × 20 (71 × 50.8)
Acqu. 1976

OXFORD
Ashmolean Museum

A Chelsea Street c. 1912
Canvas, 23¾ × 17¾ (60.3 × 45)
Prov. R. A. Bevan; Acqu. 1957

PLYMOUTH
City Museum and Art Gallery

Queen Anne's Mansions (London Flats) c. 1912
(Pl. 139)
Canvas, 26½ × 19½ (67.3 × 49.5); signed
Prov. Mrs Margaret Drummond; Acqu. 1954
Exh. A.A.A. 1913 (324); Whitechapel 1914,
'Twentieth Century Art' (428)

SHEFFIELD
Graves Art Gallery

The Artist's Desk c. 1914–15
Canvas, 20 × 16 (50.8 × 40.6); signed
Prov. K. T. Powell; Acqu. 1975

SOUTHAMPTON
Art Gallery

Girl Dressing ?c. 1911
Canvas, 18 × 14 (45.6 × 35.5)
Acqu. 1975

N.B. I am doubtful about the date of c. 1911 and
believe that this could be a post-war painting by
Drummond.

Portrait of Charles Ginner 1911 (Pl. 79)
Canvas, 23¾ × 19 (60.3 × 48.2); signed
Acqu. 1956
Exh. Carfax Gallery December 1911, 'Camden
Town Group' (41)

St James's Park 1912 (Pl. 121 and in colour)
Canvas, 28½ × 35½ (72.4 × 90.2); signed
Prov. Denys Sutton; Acqu. 1953
Exh. Carfax Gallery December 1912, 'Camden
Town Group' (29); Salon des Indépendants, Paris
1913 (905); Brighton 1913–14, 'English
Post-Impressionists, Cubists and others' (133)

Backs of Houses, Chelsea c. 1914
Canvas, 26 × 22½ (66 × 57.2)
Prov. Victor Pasmore; Acqu. 1952

AUSTRALIA

ADELAIDE
Art Gallery of South Australia

The Piano Lesson c. 1912 (Pl. 120)
Canvas, 35¼ × 23⅞ (89.5 × 60.6); signed
Acqu. 1969
Exh. probably Carfax Gallery December 1912,
'Camden Town Group' (27).

Harold Gilman

The terminal date of 1914 has unfortunately
excluded the works of Gilman's maturity, from 1915
until his death in February 1919. Among the most
important paintings executed during these years are
his famous portraits of *Mrs Mounter at the Breakfast
Table* (Walker Art Gallery, Liverpool, and Tate
Gallery, London). The City Art Gallery, Leeds, has
a study for this portrait and the Ashmolean Museum,
Oxford, owns *Interior with Mrs Mounter*. The British
Council owns the *Interior* reproduced as the frontis-
piece to Lewis and Fergusson's *Appreciation*, and the
Auckland City Art Gallery possesses the stylistically
similar *Mother and Child* (rep. p. 75 in this *Apprecia-
tion*). The Manchester City Art Gallery has the late
Portrait of the Artist's Mother (rep. *Appreciation*, p.
89) as well as a study for the portrait of *Miss Fletcher*
of c. 1916. The City Art Gallery, Wakefield, owns
the portrait of *Mrs Victor Sly* first exhibited in 1915
and almost certainly painted early that year (rep.
Appreciation, p. 95). Gilman's large painting of
Halifax Harbour, commissioned by the Canadian
Government as a War Memorial in 1918, is in
Ottawa.

Catalogue note: reproduction references to Lewis
and Fergusson's book are given, because of its early
publication date, even if the painting is illustrated in
the plates section.

ABERDEEN
Art Gallery

Portrait of a Lady c. 1906
Canvas, 21⅜ × 21⅜ (54.3 × 54.3); signed
Prov. Mrs Barbara Duce; Acqu. 1957

N.B. Said to represent Grace (*née* Canedy), the first
Mrs Gilman

The Artist's Mother at Lecon Hall c. 1911
Panel, 9¾ × 13¾ (24.8 × 34.9); signed or stamped
Acqu. 1955

BIRMINGHAM
City Museum and Art Gallery

The Nurse c. 1908
Canvas, 24⅛ × 20⅛ (61.3 × 51.1); signed
Acqu. 1947 (from Reid & Lefevre)
Rep. *Illustrations of 100 Oil Paintings in the Permanent Collection*, Birmingham Art Gallery, 1952, p. 16

Portrait Study of a Woman c. 1910–11
Canvas, 16⅛ × 12 (50 × 30.5)
Prov. Arthur Crossland; Acqu. 1959 (from Thos Agnew & Sons)
Rep. *Catalogue of Paintings*, Birmingham Art Gallery, 1960, Pl. 44b

BRADFORD
Cartwright Hall Art Gallery and Museum

Portrait of a Man (said to be *Bernhard Sickert*) c. 1912–14
Canvas, 22¾ × 17½ (57.8 × 44.5); signed
Prov. Sir John Rothenstein; Acqu. 1964 (from Reid Gallery)

BRIGHTON
Art Gallery

The Coral Necklace 1914 (Pl. 133)
Canvas, 24 × 18 (61 × 45.7); signed and dated
Prov. Edward le Bas; Acqu. 1969
Exh. Goupil Gallery 1914 (40); N.E.A.C. summer 1914 (269); Goupil Gallery 1915, 'Cumberland Market Group' (43)
Rep. Lewis and Fergusson, p. 69

BRISTOL
City Museum and Art Gallery

The Old Lady c. 1911
Canvas, 13½ × 11¾ (34.3 × 29.9)
Prov. Hugh Blaker; Acqu. 1948 (from Leicester Galleries)
Exh. possibly Carfax Gallery June 1911, 'The Camden Town Group' (55)

N.B. Inscribed on stretcher: 'Portrait of a Lady Harold Gilman 19 Fitzroy St. Bought of the Artist'.

CAMBRIDGE
Fitzwilliam Museum

Still Life. The Mantelpiece c. 1909–10 (Pl. 25)
Canvas, 12⅜ × 16⅜ (31.4 × 41.6); signed
Prov. the artist's mother; Capt. S. W. Sykes; Acqu. 1948
Exh. probably Carfax Gallery 1913 (50)

Nude on a Bed c. 1911–12 (Pl. 21)
Canvas, 24 × 18 (61 × 45.7)
Prov. Edward le Bas; B. Fairfax Hall; Acqu. 1967

CARDIFF
The National Museum of Wales

The Kitchen c. 1908 (Pl. 46)
Canvas, 24 × 18 (61 × 45.7)
Acqu. 1957
Exh. probably Goupil Gallery 1914 (3); probably Leicester Galleries 1919 (35)

Mornington Crescent c. 1912 (Pl. 62)
Canvas, 20¼ × 24¼ (51.4 × 61.6)
Prov. Miss M. S. Davies; Acqu. 1963

EXETER
Royal Albert Memorial Museum

Girl Combing her Hair c. 1911–13
Canvas, 24 × 18 (61 × 45.7); signed
Acqu. 1968 (from Thos Agnew & Sons)
Exh. Brighton 1913–14, 'English Post-Impressionists, Cubists and others' (39); Goupil Gallery 1914 (2); Leicester Galleries 1919 (33)
Rep. Colchester 1969 catalogue

GLASGOW
Art Gallery and Museum

Contemplation c. 1914 (Pl. 43)
Canvas, 14 × 12 (35.5 × 30.5); signed
Prov. F. A. Girling; Acqu. 1974 (from Thos Agnew & Sons)

HUDDERSFIELD
Art Gallery (Kirklees Metropolitan Council)

Tea in a Bed-sitter c. 1913–14
Canvas, 27¾ × 35¾ (70.5 × 90.9); signed
Prov. Lady Alice Shaw-Stewart; Lady Howick of Glendale; Acqu. 1965 (from Leicester Galleries)
Rep. Lewis and Fergusson, p. 61 as *Interior*

N.B. There is uncertainty about the date of this picture which has been placed as early as *c*. 1912 (Richard Shone, *The Century of Change*, 1977, Pl. 33) and as late as 1916–17 (Colchester 1969 catalogue, No. 42).

IPSWICH
The Museum

Seated Girl in Blue *c*. 1912–13
Canvas 16 × 22⅛ (40.6 × 58.1)
Prov. R. P. and R. A. Bevan; Acqu. 1974

N.B. Given by the artist to the Bevans.

KINGSTON UPON HULL
Ferens Art Gallery

Clarence Gardens *c*. 1912
Canvas, 20 × 24 (50.8 × 61); signed
Prov. Major R. A. Hornby; Acqu. 1965 (from Leicester Galleries) ·
Exh. Carfax Gallery 1913 (1 or 18); Goupil Gallery 1914 (13 or 18); possibly Leicester Galleries 1919 (11)

N.B. There are two versions of *Clarence Gardens* (the other in Odin's Restaurant, London, who also have Gilman's life-size portrait of a *Negro Gardener*). It is not possible to know which version was exhibited where. *Clarence Gardens* in Hull was wrongly entitled *Mornington Crescent* when exhibited at the Lefevre Gallery 1943 (7).

KIRKCALDY
Museum and Art Gallery

The Thames at Battersea *c*. 1907–8 (Pl. 47)
Canvas, 23 × 35 (58.4 × 88.9); signed
Acqu. 1951

Romney Marsh *c*. 1909–10
Canvas, 10 × 14 (25.4 × 35.6); signed
Prov. J. W. Blyth; Acqu. 1964

The White Jumper *c*. 1911
Board, 14 × 10 (35.6 × 25.4)
Prov. J. W. Blyth; Acqu. 1964

LEEDS
City Art Gallery and Temple Newsam House

Portrait of Spencer Gore *c*. 1906–7
Canvas, 14½ × 12½ (36.9 × 31.7)
Acqu. 1936
Exh. Leicester Galleries 1919 (1)

In Sickert's House at Neuville *c*. 1907
Canvas, 23¾ × 17¾ (60.3 × 45); signed or stamped
Acqu. 1944

N.B. There is some doubt about whether this painting does represent Sickert's house near Dieppe where the Gilmans stayed in 1907. Hubert Wellington believed that it represented Gilman's house at Letchworth.

Portrait of Elène Zompolides. The Blue Blouse c. 1910 (Pl. 64)
Canvas, 24 × 18 (61 × 45.7); signed
Acqu. 1943 (from Reid & Lefevre)
Exh. N.E.A.C. summer 1910 (257)

LIVERPOOL
Walker Art Gallery

Interior with Flowers *c*. 1911 (Pl. 52)
Canvas, 24⅛ × 28¼ (61.3 × 71.8); signed or stamped
Acqu. 1945 (from Reid & Lefevre)

LONDON
The Arts Council of Great Britain

The Model. Reclining Nude *c*. 1910–11 (Pl. 82)
Canvas, 18 × 24 (45.7 × 61); signed
Acqu. 1958
Exh. possibly Carfax Gallery December 1911, 'Camden Town Group' (22) and Carfax Gallery 1913 (9)

LONDON
British Council

Shopping List *c*. 1912
Canvas, 23¼ × 19¼ (59.1 × 48.9); signed
Acqu. 1948 (from Reid & Lefevre)

LONDON
Department of the Environment

Landscape ?c. 1911–12
Canvas, 20¼ × 23¾ (51.4 × 59.1); signed
Acqu. 1960 (from Leicester Galleries)

N.B. This could be a Norwegian landscape of 1913, or an earlier English landscape. I have not seen the painting which is at present located in the British Embassy, Monrovia – hence the uncertainty about its subject and date.

LONDON
Tate Gallery

Edwardian Interior c. 1907 (Pl. 12)
Canvas, 21 × 21¼ (53.3 × 54); signed
Prov. Hubert Wellington; Acqu. 1956

French Interior c. 1907
Canvas, 24¼ × 20¼ (61.6 × 51.4); signed
Prov. Mrs E. M. Macdonald; Acqu. 1947 (from
Lefevre Gallery)
Exh. Leicester Galleries 1919 (3)

Lady on a Sofa c. 1910 (Pl. 81)
Canvas, 12 × 16 (30.5 × 40.6); signed
Prov. Judge William Evans; Hugh Blaker; Acqu.
1948 (from Leicester Galleries)
Exh. probably N.E.A.C. summer 1910 (256);
possibly Carfax Gallery June 1911, 'Camden Town
Group' (54)

Canal Bridge, Flekkefjord c. 1913–14
Canvas, 18 × 24 (45.7 × 61); signed
Prov. Walter Taylor; Acqu. 1922
Exh. London Group, spring 1915 (26) as *Flekkefjord*
Rep. Tate Gallery Catalogue, *Modern British
Paintings, Drawings and Sculpture*, 1964, Pl. IV in
colour

N.B. Possibly painted from drawings after Gilman's
return from Norway. It is close, stylistically, to *Leeds
Market*. This could be the *Bridge in Norway* shown at
the Doré Galleries in 1913 and with the 'Cumberland
Market Group' in 1915 listed under the Worthing
Museum and Art Gallery *Mountain Bridge, Norway*

Leeds Market c. 1913–15
Canvas, 20 × 24 (50.8 × 61); signed
Prov. Walter Taylor; the Very Reverend E.
Milner-White; Acqu. 1927
Exh. London Group winter 1915 (61)
Rep. Lewis and Fergusson, p. 71

The Artist's Mother c. 1913
Canvas, 24 × 20 (61 × 50.8); signed
Acqu. 1943
Exh. Brighton 1913–14, 'English
Post-Impressionists, Cubists and others' (43);
Goupil Gallery 1914 (47) rep; Goupil Gallery 1915,
'Cumberland Market Group' (20)

OXFORD
Ashmolean Museum

Cave Dwellers, Dieppe 1907 (Pl. 45)
Canvas, 10 × 14 (25.4 × 35.5); signed and
indistinctly dated
Prov. Sir Lewis F. Fergusson; Rex Nan Kivell;
R. A. Bevan; Acqu. 1957
Exh. A.A.A. 1908 (1386); Carfax Gallery 1913 (38)
Rep. Lewis and Fergusson, p. 81

Dieppe c. 1911
Canvas, 17½ × 23½ (44.5 × 59.7)
Prov. the artist's family; Acqu. 1961

SHEFFIELD
Graves Art Gallery

An Eating House c. 1913
Canvas, 22½ × 29½ (57.2 × 74.9)
Prov. Walter Taylor; Alec G. Walker; Acqu. 1965
Exh. Goupil Gallery 1914 (5) rep. as *An Eating House
(No. 2)*; London Group 1914 (29 or 43); possibly
Goupil Gallery 1915, 'Cumberland Market Group'
(49)
Rep. Lewis and Fergusson, p. 73; Richard Shone,
The Century of Change, 1977, Pl. 34 in colour

N.B. Two versions of *An Eating House* were exhibited
in Gilman's Goupil Gallery show in 1914 but the
Sheffield version was reproduced as *No. 2*. The fact
that this was a second version may explain the
curious square grid marks over the whole surface of
the picture. Gilman could have used some squared
device to help him transpose the design of the first
version (formerly collection Edward le Bas) to this
later picture and it seems he laid it down while the
paint was still wet.

SOUTHAMPTON
Art Gallery

An Interior c. 1907–8
Canvas, 14½ × 12 (36.8 × 30.5)
Acqu. 1937

The Breakfast Table c. 1910–11
Canvas, 27 × 20¾ (68.6 × 52.7); signed
Prov. Philip James; Acqu. 1948

Portrait of Sylvia Gosse 1913
Canvas, 27 × 20 (68.6 × 50.8); signed
Acqu. 1950
Exh. possibly Goupil Gallery Autumn Salon 1913
(103); Goupil Gallery 1914 (4 or 24); possibly
London Group 1914 (92); possibly Leicester
Galleries 1919 (14)

N.B. Another portrait of Sylvia Gosse exists, formerly in the collection of Eustace Calland, sold Sotheby's, 21 November 1962, lot 104. Which version was exhibited where is unknown, but the Southampton painting is the bigger.

WAKEFIELD
City Art Gallery

Self Portrait c. 1909–10
Canvas, 10 × 12 (25.4 × 30.5); signed
Acqu. 1938

N.B. This may not be a self-portrait.

WORTHING
Museum and Art Gallery

Mountain Bridge, Norway 1913
Canvas, 24 × 31 (61 × 78.7); signed
Prov. Hugh Blaker; Miss Jenny Blaker; Acqu. 1945
Exh. probably Doré Galleries 1913, 'Post-Impressionists and Futurists' (52) as *A Bridge in Norway*; Goupil Gallery 1914 (49); probably Goupil Gallery 1915, 'Cumberland Market Group' (6) as *A Bridge, Norway*

N.B. The picture at the Doré Galleries in 1913, shown again with the 'Cumberland Market Group' in 1915, could be the *Flekkefjord* picture in the Tate Gallery.

YORK
City Art Gallery

The Artist's Children c. 1906–7
Canvas, 24 × 18 (61 × 45.7); signed
Prov. the Very Reverend E. Milner-White; Acqu. 1950

Interior with Nude c. 1914
Canvas, 24 × 20 (61 × 50.8); signed
Prov. the Very Reverend E. Milner-White; Acqu. 1950

AUSTRALIA

ADELAIDE
Art Gallery of South Australia

The Washstand c. 1914
Canvas, 24 × 18⅛ (61 × 46); signed
Acqu. 1963 (from Leicester Galleries)
Exh. Goupil Gallery 1915, 'Cumberland Market Group' (14)

BRISBANE
Queensland Museum

Clarissa c. 1911
Canvas, 24 × 18 (61 × 45.7); signed
Acqu. 1956 (from Lefevre Gallery)

N.B. A seated girl, nude to the waist.

HOBART
Tasmanian Museum and Art Gallery

The Black Hat c. 1911–12
Canvas on panel, 18 × 15 (45.7 × 38.2)
Acqu. 1961 (from Robert Haines, Sydney)

MELBOURNE
National Gallery of Victoria

Study c. 1910–11
Canvas, 14⅛ × 12 (35.9 × 30.5); signed
Acqu. 1946

N.B. Possibly a study of Madeline Knox.

PERTH
Western Australian Art Gallery

Norwegian Waterfall 1913 (Pl. 132)
Canvas, 20 × 24 (50.8 × 61); signed
Prov. J. Alford; A. J. Carrick-Smith; Acqu. 1974 (from Leva Gallery)
Exh. London Group 1914 (3); Goupil Gallery 1914 (39); Goupil Gallery 1915, 'Cumberland Market Group' (21); Leicester Galleries 1919 (37) lent by J. Alford
Rep. Lewis and Fergusson, p. 79

SYDNEY
Art Gallery of New South Wales

Self Portrait c. 1910–11
Canvas, 14⅛ × 10 (35.9 × 25.4)
Acqu. 1946

CANADA

FREDERICTON (New Brunswick)
Beaverbrook Art Gallery

The Verandah, Sweden 1912
Canvas, 20 × 16 (50.8 × 40.6); signed
Acqu. 1954 (from Redfern Gallery)
Exh. possibly Doré Galleries 1913, 'Post-Impressionists and Futurists' (50); Goupil Gallery 1914 (20 or 29); possibly Goupil Gallery 1915, 'Cumberland Market Group' (28)

N.B. Two pictures with this title were exhibited in 1914; thus it is uncertain which version was shown in the other exhibitions. This painting appears on an easel in the background of Drummond's *19 Fitzroy Street* (Pl. 18).

HAMILTON (Ontario)
Art Gallery

Romney Marsh c. 1912
Canvas, 18 × 24 (45.7 × 61); signed
Acqu. 1967

OTTAWA
National Gallery of Canada

A Swedish Village 1912 (Pl. 110)
Canvas, 15½ × 19½ (39.4 × 49.5); signed
Prov. Mrs Barbara Duce; Acqu. 1963 (from Leger Gallery)

NEW ZEALAND

AUCKLAND
City Art Gallery

Lake in the Hills c. 1913
Canvas, 21¾ × 26¼ (55.2 × 66.6); signed
Prov. C.A.S.; Acqu. 1968

N.B. Possibly a Norwegian fjord subject, in which case it could be *Norwegian Fjord*, exhibited at the N.E.A.C. winter 1914 (112) and at the Leicester Galleries in 1919 (24).

WELLINGTON
National Art Gallery

Girl Dressing c. 1912–13
Canvas, 23½ × 18 (59.7 × 45.7)
Acqu. 1957
Exh. Leicester Galleries 1919 (40) as *Girl putting on her Jacket*
Rep. Lewis and Fergusson, p. 67, as *Girl putting on her Coat*

SOUTH AFRICA

JOHANNESBURG
Art Gallery

The Reapers, Sweden 1912 (Pl. 122)
Canvas, 20 × 24 (50.8 × 61); signed
Prov. Sylvia Gosse; Acqu. 1913
Exh. Carfax Gallery 1912, 'Camden Town Group' (20); Carfax Gallery 1913 (11)

Charles Ginner

Galleries throughout Great Britain are well endowed with paintings by Ginner who enjoyed a long and productive career. Although the artist's *Notebooks* allow nearly every painting and drawing to be accurately dated, few galleries have had access to reliable information on the chronology and history of their works by Ginner. Observance of the date-bracket in the check-list at least serves to distinguish Ginner's early from his later works. The cut-off point has excluded some notable and relatively early paintings, in particular *Leeds Roofs* of 1915 (King George VI Art Gallery, Port Elizabeth, South Africa), *The Barges, Leeds* of 1916 and *Early Morning, Surrey (Oxted)* of 1917 (Southampton Art Gallery) and *Penally Hill* of 1916 (Glyn Vivian Art Gallery, Swansea).

Catalogue note: Ginner *Notebook* references are given for each painting as part of its essential data.

BOOTLE
Museum and Art Gallery

Victoria Station. The Sunlit Square 1913 (Pl. 138)
Canvas, 30 × 24 (76.2 × 61); signed
Ginner, Vol. 1, p. lxvi
Prov. C.A.S.; Acqu. 1924
Exh. A.A.A. 1913 (544); Doré Galleries 1913, 'Post-Impressionists and Futurists' (49); Goupil Gallery 1914

BRIGHTON
Art Gallery

Leicester Square 1912
Canvas, 25½ × 22 (64.7 × 55.9); signed
Ginner, Vol. 1, p. liii
Prov. C. K. Butler (bought in 1912); Edward le Bas; Acqu. 1969
Exh. A.A.A. 1912 (74)

LEEDS
City Art Gallery and Temple Newsam House

The Circus 1913
Canvas, 30 × 24 (76.2 × 61); signed
Ginner, Vol. 1, p. lxiii
Prov. E.M.O'R. Dickey; Acqu. 1976 (from Anthony d'Offay Gallery)
Exh. A.A.A. 1913 (545) as *The Circus, Islington*; Goupil Gallery 1914 (26)
Rep. Richard Shone, *The Century of Change*, 1977, Pl. 28

N.B. This picture appears on an easel in the background of Drummond's *19 Fitzroy Street* (Pl. 18)

Leeds Canal 1914
Canvas, 29 × 23 (73.7 × 58.4); signed
Ginner, Vol. 1, p. lxvii
Prov. E. Forbes; Mrs R. Caldicott; Acqu. 1962
Exh. Goupil Gallery Autumn Salon 1914; Goupil
Gallery 1915, 'Cumberland Market Group' (17);
A.A.A. 1916

LIVERPOOL
Walker Art Gallery

The Sunlit Quay, Dieppe 1911
Canvas, 25½ × 18⅜ (64.8 × 46.7)
Ginner, Vol. 1, p. xl
Prov. C.A.S.; Acqu. 1950
Exh. Carfax Gallery December 1911, 'Camden
Town Group' (27); Salon des Indépendants, Paris
1912 (1333); Brighton 1913–14, 'English
Post-Impressionists, Cubists and others' (27);
Goupil Gallery 1914 (50)

LONDON
Museum of London

London Bridge 1913
Canvas, 30 × 19 (76.2 × 48.3); signed
Ginner, Vol. 1, p. lxv
Prov. R. V. Williams; Acqu. 1968 (from Thos.
Agnew & Sons)
Exh. A.A.A. 1913 (546); Brighton 1913–14, 'English
Post-Impressionists, Cubists and others' (31);
Goupil Gallery 1914 (30); Goupil Gallery 1915,
'Cumberland Market Group' (41)

N.B. Bought by R. V. Williams when exhibited at the
Birmingham Repertory Theatre in 1920.

LONDON
Tate Gallery

The Café Royal 1911 (Pl. 85)
Canvas, 25 × 19 (63.5 × 48.3); signed
Ginner, Vol. 1, p. xxvii
Prov. Douglas Fox-Pitt (bought 1914); Miss
Patience Scott; Sir Henry Holt; Edward le Bas;
Acqu. 1939
Exh. A.A.A. 1911 (139); Carfax Gallery December
1911, 'Camden Town Group' (29); Salon des
Indépendants, Paris 1912 (1334); Goupil Gallery
1914 (22)

MANCHESTER
City Art Gallery

Landscape with Farmhouses c. 1912–13
Canvas, 20 × 27 (50.8 × 68.6); signed
?Ginner, Vol. 1, p. lx
Prov. E. C. Gregory; Acqu. 1929

N.B. Stylistically this painting belongs to the
1912–13 period, and could well be a Somerset
subject of 1912 or 1913. The present title is clearly
not the one originally given by Ginner to the
painting, nor was Mr Gregory its first owner as he
does not appear in Ginner's list of clients. Thus it is
not possible to state definitively that the Manchester
picture is a particular work in Ginner's notebooks. It
could, nevertheless, be *Applehayes* of 1912
(measuring 20 × 27) which once belonged to Miss
Bernadette Murphy. In subject and treatment it is
particularly close to *Clayhidon* of 1913 (rep. Goupil
Gallery 1914 catalogue).

SHEFFIELD
Graves Art Gallery

Le Quai Duquesne 1913
Board, 9¾ × 7 (24.7 × 17.8)
Ginner, Vol. 1, p. xi
Prov. Mary Godwin (presented by the artist); Acqu.
1977

N.B. A pochade sketch for a painting of the same title,
executed in 1913 and first exhibited at the London
Group in 1914 and then at the Goupil Gallery in
Ginner's joint exhibition with Gilman, sold at
Christie's after 1921 and now of unknown
whereabouts.

WORTHING
Museum and Art Gallery

Rottingdean 1914
Canvas, 25¾ × 32¼ (65.4 × 83.2); signed
Ginner, Vol. 1, p. lxxiii
Prov. Frank Rutter; Acqu. 1935
Exh. London Group 1914 (91); Goupil Gallery 1914
(33)

AUSTRALIA

ADELAIDE
Art Gallery of South Australia

Battersea Park No. 1 1910
Canvas, 27 × 20 (68.6 × 50.8); signed
Ginner, Vol. 1, p. xviii
Prov. Mrs C. W. Harrison; Acqu. 1958 (from
Messrs Tooth)

Spencer Frederick Gore

In view of the artist's death in 1914 and because there are no publicly owned works executed in oil before 1906, all paintings by Gore known to me in public collections are detailed in the check-list.

Catalogue note: whenever they are known to me Gilman label numbers are given as part of the essential data of a picture. Exhibitions up to 1920 are included.

ABERDEEN
Art Gallery

The Blue Petticoat c. 1910
Canvas, 13 × 11¾ (33 × 29.9)
Acqu. 1940

Hertingfordbury c. 1908
Canvas, 20 × 30 (50.8 × 76.2)
Acqu. 1967

BELFAST
Ulster Museum

Applehayes c. 1909–10
Canvas, 20⅛ × 24 (51.1 × 61); signed
Prov. Sir R. Lloyd Patterson; Acqu. 1929 (from Leicester Galleries)

BIRMINGHAM
City Museum and Art Gallery

Self Portrait c. 1906
Canvas, 21 × 17 (53.3 × 43.2); stamped; ?G.30
Prov. the artist's family; Acqu. 1962 (from Redfern Gallery)

Wood in Richmond Park 1913–14
Canvas, 20 × 24 (50.8 × 61); stamped
Acqu. 1928 (from Leicester Galleries)
Rep. *Connoisseur Year Book*, 1960, p. 106, Fig. 12

BRADFORD
Cartwright Hall Art Gallery and Museum

Panshanger Park c. 1908
Canvas, 20 × 24 (50.8 × 61)
Acqu. 1962

Suburban Street (Cambrian Road) 1913–14
Canvas, 20 × 15⅞ (50.8 × 40.3); stamped
Prov. Sir Edward Marsh; C.A.S.; Acqu. 1956

BRISTOL
City Museum and Art Gallery

Nude on a Bed c. 1910 (Pl. 20)
Canvas, 12 × 16 (30.5 × 40.6); signed and stamped ?G.104
Acqu. 1950 (from Reid & Lefevre)

CAMBRIDGE
Fitzwilliam Museum

Morning. The Green Dress c. 1908–9 (Pl. 39 and in colour)
Canvas, 18 × 14 (45.7 × 35.5)
Prov. Frank Rutter; J. W. Freshfield; Acqu. 1955

CARDIFF
The National Museum of Wales

Mornington Crescent c. 1911
Canvas, 20 × 24 (50.8 × 61); stamped
Prov. J. L. Behrend; Miss M. S. Davies; Acqu. 1963

DARLINGTON
Art Gallery

Yorkshire Landscape 1907
Canvas, 17½ × 23½ (44.5 × 58.8); stamped; ?G.66
Prov. S. E. Thornton (bought from Carfax Gallery in 1918); C.A.S.; Acqu. 1943
Exh. possibly Carfax Gallery 1916 (20); Carfax Gallery 1918 (12)
Rep. John Russell, *From Sickert to 1948*, 1948, Fig. 12

EXETER
Royal Albert Memorial Museum

Panshanger Park c. 1908–9
Canvas, 20 × 24 (50.8 × 61); stamped; G.84A
Acqu. 1968 (from Thos Agnew & Sons)
Exh. possibly Carfax Gallery 1916 (6)

HUDDERSFIELD
Art Gallery (Kirklees Metropolitan Council)

The Terrace Gardens c. 1912–13
Canvas, 20 × 24 (50.8 × 61)
Acqu. 1956 (from Roland, Browse & Delbanco)
Exh. Goupil Gallery Autumn Salon 1913 (156)

IPSWICH
The Museum

Interior. Mornington Crescent c. 1910
Canvas, 16 × 20 (40.6 × 50.8); stamped; G.99A
Acqu. 1968 (from Fine Art Society)

N.B. Related to the painting in the City Art Gallery Leeds, *Interior. Fireside Scene* (Pl. 22).

KINGSTON UPON HULL
Ferens Art Gallery

Still Life with Apples c. 1912 (Pl. 53)
Canvas, 15 × 20 (38.1 × 50.8); signed
Prov. E. C. Gregory; John Gibbs; John Russell;
Acqu. 1961
Exh. Carfax Gallery 1913 (15)

KINGSTON UPON HULL
University of Hull Art Collection

Somerset Landscape c. 1908–9
Canvas, 20 × 24 (50.8 × 61)
Prov. Frederick Gore and Fred Mayor; Acqu. 1965

A Terrace in the Hampstead Road c. 1911
Canvas, 15 × 18 (38.1 × 45.7)
Prov. J. B. Manson; Miss Mary Manson and Mrs Jean Goullet; Acqu. 1963

N.B. This picture is of the garden of Rowlandson House and is very similar to Sickert's painting of this subject in the Tate Gallery (Pl. 61).

LEEDS
City Art Gallery and Temple Newsam House

Interior with Nude Washing c. 1907–8 (Pl. 19)
Canvas, 24 × 18 (61 × 45.7); stamped; G.46
Acqu. 1932
Exh. possibly Chenil Gallery 1911 (22)

Interior. Fireside Scene c. 1910 (Pl. 22)
Canvas, 20 × 24 (50.8 × 61); stamped; G.98A
Acqu. 1950
Exh. possibly A.A.A. 1911 (121); probably Carfax Gallery 1918 (18)

The Balustrade, Mornington Crescent c. 1911
Canvas, 24 × 16 (61 × 40.6); signed
Acqu. 1949 (from Redfern Gallery)
Exh. Carfax Gallery 1913 (37)

Mornington Crescent c. 1911
Canvas, 16 × 20 (40.6 × 50.8); stamped
Acqu. 1934

Letchworth 1912
Canvas, 10 × 12 (25.4 × 30.5); stamped
Acqu. 1936

In Berkshire c. 1912
Canvas, 15 × 21 (38.1 × 53.3); stamped
Acqu. 1936

N.B. Probably a Letchworth subject (Herts).

LEICESTER
Leicestershire Museum and Art Gallery

Harold Gilman's House, Letchworth 1912
Canvas, 25 × 30 (63.5 × 76.2); stamped; G.142
Prov. Frederick Gore and E. Cowie; Acqu. 1974 (from Anthony d'Offay Gallery)
Rep. Richard Shone, *The Century of Change*, 1977, Pl. 31 in colour

N.B. A view of 100 Wilbury Road where Gilman moved (but seldom lived) after 1909. Ratcliffe later lived next door, at 102 Wilbury Road.

LETCHWORTH
Garden City Corporation

The Garden City, Letchworth 1912
Canvas, 24 × 26 (61 × 66); signed and stamped; G.160
Acqu. 1974 (from Anthony d'Offay Gallery)
Exh. possibly Carfax Gallery 1913 (32); possibly Whitechapel 1914, 'Twentieth Century Art' (416); Paterson & Carfax 1920 (16)
Rep. *Connoisseur*, March 1974, p. 178

N.B. Gore painted two pictures with this title and both were exhibited in 1920. However, an annotated catalogue described No. 16 in this show as 'showing city & palings in foreground', as does this painting. The other picture (No. 26 in the 1920 show) was annotated 'with cottage & garden & distance'.

LIVERPOOL
Walker Art Gallery

The Garden, Garth House 1908
Canvas, 20¼ × 24 (51.4 × 61); signed and stamped; G.83A
Acqu. 1949 (from Reid & Lefevre)
Exh. possibly N.E.A.C. winter 1909 (112) as *The Garden*
Rep. Art Council 1955 catalogue (12)

LONDON
The Arts Council of Great Britain

Somerset Landscape c. 1909
Canvas, 16 × 20 (40.6 × 50.8); stamped
Acqu. 1962

Chisholm Road, Richmond 1913–14
Canvas, 16 × 20 (40.6 × 50.8); stamped
Acqu. 1955
Exh. probably Carfax Gallery 1916 (21)

LONDON
British Council

Mornington Crescent c. 1911 (Pl. 87)
Canvas, 20 × 24 (50.8 × 61)
Prov. Hugh Blaker; Acqu. 1948
Exh. possibly Chenil Gallery 1911 (9 or 15); possibly
N.E.A.C. summer 1911 (211); probably Carfax
Gallery June 1911, 'Camden Town Group' (25)

LONDON
Department of the Environment

Hertfordshire Landscape ?c. 1907–8
Canvas, 16½ × 19½ (41.9 × 49.5); stamped
Acqu. 1968 (from Mayor Gallery)

Somerset Landscape c. 1909–10
Canvas, 16¼ × 19¼ (41.3 × 48.9); stamped
Acqu. 1960 (from Leicester Galleries)

The Alhambra c. 1910
Canvas, 16 × 19½ (40.6 × 49.5)
Acqu. 1961 (from Mayor Gallery)

Harold Gilman's House at Letchworth 1912
Canvas, 15¾ × 18¼ (40 × 46.4); stamped
Acqu. 1962 (from Leicester Galleries)

LONDON
National Portrait Gallery

Self Portrait c. 1914 (Pl. 145)
Canvas, 16 × 12 (40.6 × 30.5); stamped; G.198
Acqu. 1974 (from Anthony d'Offay Gallery)
Rep. Anthony d'Offay 1974 catalogue, in colour

LONDON
Tate Gallery

Inez and Taki 1910
Canvas, 16 × 20 (40.6 × 50.8); signed
Prov. Sir Louis Fergusson (bought from the artist in
1910); Acqu. 1948 (from Leicester Galleries)
Exh. A.A.A. 1910 (714)
Rep. *Studio*, XCIX, 1930, p. 111

North London Girl c. 1911 (Pl. 42)
Canvas, 30 × 24 (76.2 × 61); stamped
Prov. J. W. Freshfield; Acqu. 1955

Mornington Crescent c. 1911
Canvas, 25 × 30 (63.5 × 76.2)
Prov. Judge William Evans; Lord Henry
Cavendish-Bentinck; Acqu. 1940
Exh. Carfax Gallery 1916 (3) as *Mornington Crescent
Gardens*; Goupil Gallery 1918, 'The Collection of the
late Judge William Evans' (70) as *The Tree*
Rep. Arts Council 1955 catalogue (29)

*Sketch for a Mural Decoration for the 'Cave of the
Golden Calf '* 1912
Paper mounted on card, 12 × 23¾ (30.5 × 60.3)
Prov. Mrs Malcolm Drummond; Acqu. 1961
Rep. *Apollo*, LXXVI, 1962, p. 234

A Singer at the Bedford Music Hall 1912
Canvas, 21 × 17 (53.3 × 43.2); stamped; G.147A
Prov. Mr & Mrs Robert Lewin; Acqu. 1978

Letchworth 1912
Canvas, 20 × 24 (50.8 × 61); stamped
Prov. J. W. Freshfield; Acqu. 1933 (from Messrs
Tooth)
Exh. possibly Carfax Gallery December 1912,
'Camden Town Group' (13) as *Letchworth Common*;
Paterson & Carfax 1920 (22) as *Near Letchworth*

The Cinder Path 1912 (Pl. 113)
Canvas, 27 × 31 (68.6 × 78.7)
Prov. Mme. Gerfain; Frank Williams Burford;
John Lumley; Acqu. 1975
Exh. either Grafton Gallery 1912–13, 'Second
Post-Impressionist Exhibition' (116) or Carfax
Gallery 1913 (31)

The Beanfield, Letchworth 1912 (Pl. 112)
Canvas, 12 × 16 (30.5 × 40.6); signed and stamped;
G.154A
Acqu. 1974 (from Anthony d'Offay Gallery)
Exh. Carfax Gallery 1913 (26)
Rep. *Connoisseur*, March 1974, p. 174 in colour

The Fig Tree c. 1912
Canvas, 25 × 30 (63.5 × 76.2); signed
Prov. J. W. Freshfield; Acqu. 1955
Exh. Carfax Gallery 1913 (46); N.E.A.C. summer
1913 (151); Brighton 1913–14, 'English
Post-Impressionists, Cubists and others' (50)
Rep. Mervyn Levy, *Drawing and Painting for Young
People*, 1960, facing p. 113 in colour

Houghton Place c. 1912
Canvas, 20 × 24 (50.8 × 61); stamped
Prov. C.A.S.; Acqu. 1927
Rep. John Russell, *From Sickert to 1948*, 1948, Fig.
10

The Gas Cooker 1913
Canvas, $28\frac{3}{4} \times 14\frac{1}{2}$ (73×36.8); stamped; G.173
Acqu. 1962 (from Redfern Gallery)
Exh. Brighton 1913–14, 'English
Post-Impressionists, Cubists and others' (53);
Carfax Gallery 1916 (36)
Rep. John Rothenstein, *The Tate Gallery*, 1962, p.
253

From a Window in Cambrian Road 1913
Canvas, 22×27 (55.9×68.9); stamped
Acqu. 1920
Exh. Paterson & Carfax 1920 (20)
Rep. Tate Gallery Catalogue, *Modern British
Paintings, Drawings and Sculpture*, 1964, Pl. XI in
colour

Richmond Park 1913–14
Canvas, 20×30 (50.8×76.2); stamped
Prov. Lord Henry Cavendish-Bentinck; Acqu.
1940
Exh. Paterson & Carfax 1920 (1)

N.B. This could be *Richmond Park trees* shown at the
N.E.A.C. summer 1914 (181).

MANCHESTER
City Art Gallery

Richmond Winter 1913–14
Canvas, $19\frac{1}{2} \times 23\frac{1}{2}$ (49.5×59.7); stamped
Acqu. 1928 (from Leicester Galleries)

OXFORD
Ashmolean Museum

The Cinder Path 1912
Canvas, $13\frac{3}{4} \times 15\frac{3}{4}$ (34.9×40); stamped
Prov. Mrs R. P. Bevan; Acqu. 1957
Exh. either Grafton Gallery 1912–13, 'Second
Post-Impressionist Exhibition' (116) or Carfax
Gallery 1913 (31)

N.B. See note to Pl. 113.

Richmond Park 1913–14
Canvas, $21\frac{5}{8} \times 29\frac{1}{2}$ (55×74.9)
Prov. R. A. Bevan; Acqu. 1957

PLYMOUTH
City Museum and Art Gallery

Woman in a Flowered Hat c. 1907 (Pl. 33)
Canvas, 20×16 (50.8×40.6); stamped; G.65
Acqu. 1958
Exh. N.E.A.C. spring 1908 (62) as *Some-one waits*

PRESTON
Harris Museum

Garden at Hertingfordbury c. 1908–9
Canvas, 16×20 (40.6×50.8); stamped
Prov. C.A.S.; Acqu. 1942

READING
Museum and Art Gallery

The Mimram, Panshanger Park 1908
Canvas, 20×24 (50.8×61)
Acqu. 1976 (from Thos Agnew & Sons)
Rep. Agnew 1975, 'British Paintings 1900–1975'
catalogue cover in colour

SHEFFIELD
Graves Art Gallery

Reclining Nude Figure c. 1907
Canvas, $17\frac{1}{2} \times 23\frac{1}{2}$ (44.5×59.7); stamped
Prov. Wilfred Janson; Acqu. 1935

SOUTHAMPTON
Art Gallery

The Pool, Panshanger Park 1908
Canvas, 20×24 (50.8×61); stamped; G.80A
Acqu. 1933

N.B. Very close to the painting of the same size and
title in the Art Gallery of New South Wales, Sydney.

View from a Window c. 1908–9
Canvas, 20×16 (50.8×40.6)
Prov. Hugh Blaker; Acqu. 1938

Brighton Pier 1913
Canvas, 25×30 (63.5×76.2)
Acqu. 1956
Exh. possibly Doré Galleries 1913,
'Post-Impressionists and Futurists' (197) and
Brighton 1913–14, 'English Post-Impressionists,
Cubists and others' (54)
Rep. *Blast* no. 1, 1914

N.B. There is another version of this subject (private
collection) which could be the one shown at the Doré
Galleries in 1913 or vice versa. The same picture was
probably not sent to the two exhibitions, and they
were distinguished by slightly different titles (*West
Pier, Brighton* at the Doré Galleries). However, they
both show the same pier.

WAKEFIELD
City Art Gallery

The Cricket Match c. 1908–9 (Pl. 57)
Canvas, 20 × 24 (50.8 × 61); stamped; ?G. 82
Prov. probably Mrs Smith Masters; Acqu. 1945
Exh. A.A.A. 1911 (120)

WORTHING
Museum and Art Gallery

The Pond c. 1912
Canvas, 19½ × 23¾ (49.5 × 60.3); signed
Acqu. 1948
Exh. possibly Carfax Gallery December 1912,
'Camden Town Group' (16); possibly Brighton
1913–14, 'English Post-Impressionists, Cubists and
others' (51)

N.B. This could be a Richmond subject of 1913–14,
in which case it cannot be the work exhibited with
the Camden Town Group in 1912. However,
stylistically it fits better into the context of Gore's
work in 1912.

YORK
City Art Gallery

From a Canal Bridge, Chalk Farm Road 1913
Canvas, 19 × 27 (48.3 × 68.6); stamped; G.165
Prov. Ernest Gye; the Very Reverend E.
Milner-White; Acqu. 1963
Exh. probably London Group 1914 (35) as *The
Canal*; Paterson & Carfax 1920 (31) as *The Regent's
Canal, Chalk Farm*

AUSTRALIA

ADELAIDE
The Art Gallery of South Australia

Autumn Sussex c. 1908–9
Canvas, 18 × 24 (45.7 × 61); stamped
Prov. the Hon. Edward Sackville-West; Acqu. 1967
(from Piccadilly Gallery)

N.B. Almost certainly mistitled.

BRISBANE
Queensland Museum

English Landscape c. 1907–9
Canvas, 16 × 20 (40.6 × 50.8); stamped
Acqu. 1956 (from Lefevre Gallery)

MELBOURNE
National Gallery of Victoria

The Garden of Rowlandson House 1911
Canvas, 24 × 20 (61 × 50.8); signed
Acqu. 1946
Exh. Carfax Gallery 1913 (44) and Brighton
1913–14, 'English Post-Impressionists, Cubists and
others' (55) as *The White Seats*; Carfax Gallery 1918
(1) as *The White Seats, Rowlandson House*

PERTH
Western Australian Art Gallery

View from the Balcony, 2 Houghton Place 1913
Canvas, 20 × 18 (50.8 × 45.7); stamped; G.169A
Acqu. 1976 (from Anthony d'Offay Gallery)

N.B. Three pictures called *From a Window in
Houghton Place* (Nos 1, 2, 3) were included in the
exhibition at Paterson & Carfax in 1920. Catalogue
annotations prove that the Perth painting was
neither *No. 2* nor *No. 3*, but it could have been *No. 1*
(annotated 'balcony & houses & trees').

SYDNEY
Art Gallery of New South Wales

The Pool, Panshanger Park 1908
Canvas, 20 × 24 (50.8 × 61); stamped; G.79A
Prov. S. Ure Smith; Acqu. 1933

The Icknield Way 1912 (Pl. 115 and in colour)
Canvas, 25 × 30 (63.5 × 76.2); stamped
Acqu. 1962 (from Redfern Gallery)

CANADA

FREDERICTON (New Brunswick)
Beaverbrook Art Gallery

Woman standing by a Window 1908
Canvas, 20 × 14 (50.8 × 35.6)
Acqu. 1955 (from Leicester Galleries)

HAMILTON (Ontario)
Art Gallery

The Bedroom c. 1908
Canvas, 20 × 16 (50.8 × 40.6); stamped; G.76
Acqu. 1960

N.B. A woman wearing a shift, standing by the same
brass bedstead as appears in the Bristol *Nude on a Bed*
(Pl. 20).

OTTAWA
National Gallery of Canada

Landscape with Lake c. 1913
Canvas, 20 × 24 (50.8 × 61); stamped
Prov. Vincent Massey; Acqu. 1946

N.B. The present title is a misnomer. The stretch of
water on which a small boy sails a boat is a pond,
rather than a lake. A torn label on the back identifies
the setting as Richmond Park, under which title the
picture was exhibited at the Leicester Galleries in
1928.

NEW ZEALAND

AUCKLAND
City Art Gallery

Tennis, Mornington Crescent Gardens 1910
Canvas, 20 × 24 (50.8 × 61); stamped; G.101A
Acqu. 1955 (from Redfern Gallery)

N.B. See note to Pl. 58 for versions of this subject.

WELLINGTON
National Art Gallery

Cumberland Market (mistitled) 1910
Canvas, 18½ × 16½ (47 × 41.9); stamped; ?G.113
Acqu. 1953 (from Leicester Galleries)
Exh. probably Carfax Gallery 1916 (14) as *From
Wellington House Academy*

N.B. The Gilman label states that the picture was
painted from the balcony of 247 Hampstead Road
(Wellington House Academy in Charles Dickens's
day, a name revived by Sickert when he had a studio
there). Gore has painted the view looking down
Granby Terrace, away from Hampstead Road.

The Window c. 1910–11
Canvas, 23½ × 19½ (59.7 × 49.5); stamped
Acqu. 1961 (from Roland, Browse & Delbanco)

N.B. A figure sits in a window; the view beyond
crosses gardens to a terrace of houses in the
background. However, the layout and architecture
suggests that this is not a view from 31 Mornington
Crescent. It possibly represents Harrington Square
(where Sickert lived after his marriage in 1911). It is
certainly a Camden Town subject.

The Artist's Wife. Mornington Crescent 1911
Canvas, 19 × 15½ (48.3 × 39.4); ?G.130
Acqu. 1961 (from Redfern Gallery)
Exh. almost certainly A.A.A. 1911 (121) in place of
Ballet

N.B. See note to Pl. 22 for explanation of 1911
exhibition identification.

SOUTH AFRICA

JOHANNESBURG
Art Gallery

Applehayes c. 1909
Canvas, 20 × 24 (50.8 × 61)
Prov. Sir Otto Beit; Acqu. 1910
Exh. N.E.A.C. summer 1910 (161)

N.B. The *Sunday Times*, 19 June 1910, reported that
Gore's *Applehayes* at the N.E.A.C. had been bought
for the Johannesburg Gallery.

The Windmill Ballet c. 1910
Canvas, 30 × 24¾ (76.2 × 63); signed
Prov. Sylvia Gosse; Acqu. 1913

From a Window in Mornington Crescent 1911
Canvas, 16 × 20 (40.6 × 50.8); signed (with initials)
Acqu. 1930 (from Leicester Galleries)
Exh. possibly Chenil Gallery 1911 (9 or 15)

N.B. See note to Pl. 87 for details of Chenil Gallery
exhibition. This picture was bought from the
Leicester Galleries 'Camden Town Group'
exhibition where it was No. 43.

PIETERMARITZBURG
Tatham Art Gallery

The Mirror. Woman by a Dressing Table c. 1908–9
Canvas, 17½ × 13½ (44.6 × 34.7)
Prov. Judge William Evans; R. H. Whitwell; Acqu.
1924
Exh. Goupil Gallery 1918, 'The collection of the late
Judge William Evans' (74)

The Sundial c. 1908
Canvas, 15¾ × 20 (40 × 50.8)
Prov. ?Judge William Evans; R. H. Whitwell;
Acqu. 1924

N.B. No picture with this title was exhibited among those from Judge Evans's collection at the Goupil Gallery in 1918; nor is there a 1918 exhibition label on the back. There is, however, a Goupil Gallery label and R. H. Whitwell bought the picture from the gallery on the same day (11 September 1923) as he bought *The Mirror*. He and the Tatham Art Gallery assumed that both pictures were from Judge Evans's collection. The sundial represented was in the garden of Garth House.

U.S.A.

BOSTON
Museum of Fine Arts

Mornington Crescent 1911
Canvas, 16 × 20 (40.6 × 50.8); stamped; G.134A
Acqu. 1931

N.B. An exterior view straight into the gardens, in full summer foliage, with buildings glimpsed in the background.

Back Gardens from Houghton Place 1913
Canvas, 24 × 26 (61 × 66); stamped; G.162A
Acqu. 1931

N.B. See note to Pl. 60 for versions and exhibition details.

TOLEDO
Museum of Art

From the Garden of Rowlandson House 1911 (Pl. 59)
Canvas, 25 × 30 (63.5 × 76.2)
Prov. Lady Ottoline Morrell; Wilfrid A. Evill; Samuel Carr; Acqu. 1952
Exh. possibly Carfax Gallery December 1911, 'Camden Town Group' (16)

Duncan Grant

Richard Shone, *Bloomsbury Portraits*, 1976, illustrates and gives details of many of Grant's publicly and privately owned paintings of this early period. I cite his plate numbers below. The chief public repository of Grant's early work is the Tate Gallery, London, where there are ten paintings done between 1906 and 1914, as well as *The Kitchen* (Shone, Pl. 16) of 1902. The Tate Gallery catalogue of *Modern British Paintings, Drawings and Sculpture* gives full details of seven of these paintings: the double-sided *Lytton Strachey* (Shone, Pl. 15) and *Le Crime et le*

Châtiment (Shone, Pl. 23) of 1909; *James Strachey* (Shone, Pl. 22) of 1910; *The Dancers* (Shone, Pl. 32) of 1910–11; *Lemon Gatherers* (Shone, Pl. 26) of 1910; *Bathing* and *Football* (Shone, Pls 34, 36) of 1911; and *The Queen of Sheba* (Shone, Pl. 46) of 1912. The three works acquired since publication of the Tate Gallery catalogue in 1964 are *The Tub* (Shone, Pl. 52) of 1912; *The Mantelpiece* (Shone, Pl. 81) of 1914; and the *Abstract Kinetic Collage* (Shone, Pl. 88) of 1914. Three paintings of this period from Roger Fry's collection are in the Courtauld Institute of Art Galleries, London: *Portrait of Ka Cox*, or *Seated Woman*, of 1912 (Shone, Pl. 44); *The Dinner Table* of c. 1912; and *Peaches* (Shone, Pl. 30) of c. 1910. The National Portrait Gallery, London, owns a *Self Portrait* of c. 1908 (Shone, Pl. 24), and the Department of the Environment collection has *Cader Idris* of 1912 and *Still Life* dated 1911 but probably painted in 1912. There are paintings by Duncan Grant in most British galleries outside London, but nearly all are later works. Notable exceptions include: *The Ass* (with *The Red Sea*, Shone, Pl. 37, exhibited at the Friday Club in 1912 on the back of the canvas) in the Ferens Art Gallery, Kingston upon Hull; *Portrait of Lady Ottoline Morrell* of 1913–14 in the Leicestershire Museum and Art Gallery; *Tulips* (Pl. 89 in this book) in the Southampton Art Gallery; another *Portrait of Ka Cox* of 1913 in the National Museum of Wales, Cardiff; *Vanessa Bell Painting* of 1913 and a portrait of *John Peter Grant* (Shone, Pl. 20) in the National Galleries of Scotland, Edinburgh; King's College, Cambridge, owns a portrait of *John Maynard Keynes* of 1908. There are also paintings by Grant in galleries in Australia, the U.S.A., Canada and South Africa. Among those painted during this period are *Four Cairn Terriers and a Dog Basket* of c. 1912 in the Tatham Art Gallery, Pietermaritzburg, South Africa, and *Sussex Landscape* of 1909 in the Art Gallery of South Australia, Adelaide.

James Dickson Innes

Innes began painting in oil c. 1906 and died in August 1914, therefore all his oil paintings known to me in public collections are included in the check-list.

Catalogue note: references are provided to the catalogue prepared by John Hoole for the Innes exhibition first held at Southampton Art Gallery in 1977 (and then on tour into 1978) because Mr Hoole's notes collate all the available information on the works exhibited. In addition the plate numbers from Fothergill's book on Innes are quoted even if other reproduction references have been given.

ABERDEEN
Art Gallery

The Little Mother 1909
Canvas, $16\frac{1}{4} \times 13$ (41.3 × 33)
Prov. Horace de Vere Cole; Acqu. 1938
Exh. N.E.A.C. winter 1912 (182)
Rep. Fothergill, Pl. 12
Lit. Southampton 1977–8 (34) rep.

The Spurs of Arenig c. 1911–12
Panel, $9\frac{1}{2} \times 13$ (24.2 × 33)
Acqu. 1958

Portrait of a Gypsy c. 1912
Canvas, 18 × 14 (45.7 × 35.6)
Acqu. 1960
Lit. Southampton 1977–8 (88) rep.

BELFAST
Ulster Museum

Olives at Collioure 1911
Canvas, $12\frac{1}{8} \times 16\frac{1}{8}$ (30.8 × 40.9); signed and dated
Prov. Sir R. Lloyd Paterson; Acqu. 1929

BIRMINGHAM
City Art Gallery

Provençal Coast, Sunset c. 1912–13
Canvas, $19\frac{1}{2} \times 29\frac{1}{2}$ (49.5 × 74.9)
Prov. Earl of Sandwich; Acqu. 1948
Lit. Southampton 1977–8 (113) rep.

Collioure – Morning 1913
Panel, $12 \times 15\frac{1}{2}$ (30.5 × 39.4); signed and dated
Prov. Julian Lousada; Harcourt Johnstone; Mrs J.
B. Priestley; Acqu. 1955
Exh. Whitechapel 1914, 'Twentieth Century Art'
(384) as *Banjules – Morning*
Rep. Fothergill, Pl. 49
Lit. Southampton 1977–8 (114) rep.

BRADFORD
Cartwright Hall Art Gallery and Museum

The Town of Collioure 1908
Canvas, $25\frac{1}{4} \times 31\frac{1}{2}$ (64.1 × 80); signed and dated
Prov. Asa Lingard; Acqu. 1935
Lit. Southampton 1977–8 (27) rep.

N.B. Bradford also has two paintings by Innes on loan
from the Vint Trust.

BRIGHTON
Art Gallery

The Seine at Caudebec c. 1908–9
Canvas, $24\frac{3}{4} \times 32$ (62.9 × 81.3)
Prov. Arthur Crossland; Acqu. 1957 (from
Piccadilly Gallery)
Lit. Southampton 1977–8 (30) rep.

CAMBRIDGE
Fitzwilliam Museum

Arenig Fawr c. 1911–12
Panel, $12 \times 16\frac{1}{8}$ (30.5 × 40.9)
Prov. Lord Ivor Spencer-Churchill; E. M. B.
Ingram; Acqu. 1941
Rep. Fothergill, Pl. 16 as *Tan-Y-Griseau*
Lit. Southampton 1977–8 (72) rep.

CARDIFF
National Museum of Wales

The Bead Chain 1910
Canvas, $54 \times 38\frac{1}{2}$ (137.2 × 97.8); signed and dated
Prov. Horace de Vere Cole; Capt. Geoffrey
Crawshay; Acqu. 1953
Rep. Fothergill, Pl. 13
Lit. Southampton 1977–8 (44) rep.

Pembroke Coast c. 1911
Panel, $12\frac{1}{2} \times 15$ (31.8 × 38.1); signed
Acqu. 1970 (from Leicester Galleries)
Rep. Jenkins, p.12 in colour

Canigou in Snow 1911
Panel, $9 \times 12\frac{3}{4}$ (22.9 × 32.4); signed and dated
Prov. Horace de Vere Cole; Acqu. 1935 (from
Leicester Galleries)
Rep. Fothergill, Pl. 24; Jenkins, p. 15 in colour
Lit. Southampton 1977–8 (60) rep.

The Cathedral at Elne 1911
Panel, 9 × 13 (22.9 × 33); signed and dated
Prov. Horace de Vere Cole; Miss M. S. Davies;
Acqu. 1963
Rep. Jenkins, p. 14 in colour
Lit. Southampton 1977–8 (61) rep.

Arenig c. 1911–12
Panel, 9 × 13 (22.9 × 33)
Prov. Sir Edward Marsh; C.A.S.; Acqu. 1954
Rep. Jenkins, p. 10
Lit. Southampton 1977–8 (76)

The Girl in the Cottage c. 1911–12
Panel, 13 × 8¾ (33 × 22.2)
Prov. Augustus John; Sir Caspar John; Acqu. 1972
Rep. Jenkins, p. 17 in colour
Lit. Southampton 1977–8 (79) rep.

Girl Standing by a Lake c. 1911–12
Panel, 15 × 11½ (38.1 × 29.2)
Prov. Augustus John; Sir Caspar John; Acqu. 1972
Lit. Southampton 1977–8 (97) rep.

Vernet (Provençal Landscape) c. 1912
Canvas, 11 × 15 (27.9 × 38.1)
Prov. Sir Henry and Lady Rushbury; Acqu. 1972
Lit. Southampton 1977–8 (97) rep.

French Landscape c. 1912
Panel, 9½ × 13 (24.1 × 33)
Prov. Sir Henry and Lady Rushbury; Acqu. 1972
Rep. Jenkins, p. 21

The Pyrenees c. 1912–13
Canvas, 20 × 27 (50.8 × 68.9)
Prov. Sir Michael Sadler; Acqu. 1944 (from
Leicester Galleries)
Rep. Fothergill, Pl. 8 as *Mountains*
Lit. Southampton 1977–8 (116) rep.

KINGSTON UPON HULL
University of Hull Art Collection

Sunset in the Pyrenees c. 1912–13
Canvas, 22 × 27¼ (55.9 × 69.2)
Prov. Frank Roberts; Hugo Pitman; Mrs Reine
Pitman; Acqu. 1972

LEEDS
City Art Gallery and Temple Newsam House

In the Pyrenees c. 1911
Panel, 9¼ × 13 (23.5 × 33)
Prov. A. E. Anderson; Acqu. 1929
Rep. Fothergill, Pl. 36

View from 'The White Hart', Guestling, Sussex
c. 1911–12
Panel, 12 × 16 (30.5 × 40.6)
Prov. Asa Lingard; Lady George Cholmondeley;
Acqu. 1966
Rep. Fothergill, Pl. 27
Lit. Southampton 1977–8 (84) rep.

LIVERPOOL
Walker Art Gallery

Ranunculus c. 1911 (Pl. 91)
Panel, 9½ × 13⅛ (24.2 × 33.2)
Prov. Sir Edward Marsh; C.A.S.; Acqu. 1954

Exh. Carfax Gallery December 1911, 'Camden
Town Group' (9) as *Flowers*
Rep. Fothergill, Pl. 43; *Studio*, CXLVI, August 1953,
p. 39 in colour

LLANELLI
Parc Howard Museum and Art Gallery

The Furnace Quarry, Llanelli c. 1906
Canvas, 18 × 23½ (45.7 × 59.7); signed
Acqu. 1923 (from Chenil Gallery)
Rep. Fothergill, Pl. 1
Lit. Southampton 1977–8 (4)

LONDON
Department of the Environment

Welsh Landscape c. 1906–7
Canvas, 19¾ × 27 (50.2 × 68.6)
Acqu. 1960 (from Leicester Galleries)

LONDON
Slade School of Fine Art, University College

Composition. A Scene at the Theatre c. 1908
Canvas laid on board, 54 × 42 (137.2 × 106.7)
Acqu. 1908
Lit. Southampton 1977–8 (33)

LONDON
Tate Gallery

South of France, Bozouls, Near Rodez 1908
Canvas, 19¾ × 25½ (50.2 × 64.8); signed
Acqu. 1919
Rep. Fothergill, Pl.3

Arenig, Sunny Evening c. 1911–12
Panel, 9 × 12¾ (22.9 × 32.4)
Prov. Sir Cyril Butler; Acqu. 1942 (from Redfern
Gallery)

Arenig. North Wales 1913
Panel, 33¾ × 44¾ (85.7 × 113.7); signed and dated
Prov. John Quinn; W. M. Crane; R. Burdon-
Miller; Acqu. 1928
Exh. Chenil Gallery 1913 (12)
Rep. Fothergill, Pl. 48
Lit. Southampton 1977–8 (120) rep.

MANCHESTER
City Art Gallery

Bala Lake c. 1911
Panel, 12¾ × 16¼ (32.4 × 41.3)
Prov. the Hon Jaspar Ridley; Acqu. 1934
Rep. Fothergill, Pl. 44
Lit. Southampton 1977–8 (59) rep.

The Prize Fight c. 1912
Canvas, 13¼ × 17 (33.7 × 43.2); signed
Prov. Mrs Evelyn Russell; R. H. Jackson; Acqu.
1934
Rep. Fothergill, Pl. 31
Lit. Southampton 1977–8 (86)

SHEFFIELD
Graves Art Gallery

Landscape, Pyrenees 1911
Panel, 12 × 16 (30.5 × 40.6); signed and dated
Prov. Augustus John; Acqu. 1964
Lit. Southampton 1977–8 (67) rep.

Landscape with Figure, Arenig c. 1911–12
Panel, 9 × 13 (22.9 × 33)
Prov. Augustus John; Acqu. 1964
Lit. Southampton 1977–8 (80)

SOUTHAMPTON
Art Gallery

The Coast near Collioure c. 1912–13
Canvas, 15 × 18 (38.1 × 45.7)
Prov. Lord Howard de Walden; Acqu. 1951
Lit. Southampton 1977–8 (112) rep. in colour

SWANSEA
Glynn Vivian Art Gallery and Museum

Mount Canigou 1911
Panel, 10 × 13¼ (25.4 × 33.7); signed and dated
Prov. Lady Howard Stepney; Acqu. 1951 (from
Roland, Browse & Delbanco)
Lit. Southampton 1977–8 (69) rep.

N.B. Previously mistitled *View in Wales*.

Arenig Mountain c. 1911–12
Canvas, 10 × 14 (25.4 × 38.4)
Prov. Sir Stafford and Lady Howard Stepney;
Acqu. 1953
Lit. Southampton 1977–8 (75) rep.

AUSTRALIA

ADELAIDE
Art Gallery of South Australia

Spanish Landscape c. 1912
Panel, 12⅞ × 16 (32.7 × 40.6)
Prov. Lord Howard de Walden; Oppenheimer;
Acqu. 1956 (from Roland, Browse & Delbanco)

N.B. Previously called *North African Landscape*.

MELBOURNE
National Gallery of Victoria

Collioure 1911
Canvas, 12⅛ × 16⅛ (30.7 × 41); signed and dated
Prov. Horace de Vere Cole; Asa Lingard; Acqu.
1949 (from Thos Agnew & Sons)

CANADA

OTTAWA
National Gallery of Canada

Arenig 1911 (Pl. 90)
Canvas, 14⅛ × 20 (35.9 × 50.8); signed and dated
Prov. Horace de Vere Cole; Lady Kroyer-Kielberg;
Vincent Massey; Acqu. 1946
Rep. Fothergill, Pl. 17

South Wales, Evening c. 1911–12
Panel, 12⅛ × 16 (30.8 × 40.6)
Prov. Horace de Vere Cole; Lord Ivor
Spencer-Churchill; Maurice Ingram; Vincent
Massey; Acqu. 1946

TORONTO
Art Gallery of Ontario

Afternoon, Ronda, Spain 1913
Canvas, 22⅛ × 30⅜ (56.2 × 77.2); signed and dated
Prov. Sir Michael Sadler; Acqu. 1941

VANCOUVER
Art Gallery

Pyrénées Orientales c. 1912–13
Panel, 9¼ × 13 (23.5 × 33)
Prov. possibly Horace de Vere Cole; Acqu. 1933

Augustus John

John's career was long, productive and publicly
recognized from his student days onwards. Thus
most of the major galleries in Britain and abroad
possess his paintings. The two most extensive public
collections of his work between 1906 and 1914 are
found in the National Museum of Wales, Cardiff,
and in the Fitzwilliam Museum, Cambridge. The
already distinguished representation of Johns in the
Fitzwilliam was increased in 1976 by the addition of
Peter Harris's collection. When this collection was
exhibited at the Fitzwilliam from October to
December 1976 the museum produced a typescript

catalogue giving full details of these newly acquired works. The Cardiff collection has also been catalogued by the National Museum. The Tate Gallery, London, have eight paintings of this period, all included in their 1964 catalogue with the exception of the more recently acquired *Lyric Fantasy* (rep. in colour, Pl. 16, Easton and Holroyd). Important paintings by John in public collections in the British Isles besides the Cardiff, Cambridge and London galleries include: *Gypsy in a Sandpit* and *The Blue Pool* (Aberdeen Art Gallery); *The Red Feather* (rep. Pl. 68 in this book, Ulster Museum, Belfast); *Portrait of Miss Jane Harrison* (Newnham College, Cambridge); several paintings (portraits and more informal studies) in both the Hugh Lane Municipal Gallery and the National Gallery of Ireland, Dublin; a series of formal portraits in the University of Liverpool; the famous portrait of *W. B. Yeats* of 1907 (for which the Tate Gallery owns a study) and *Dorelia in a Landscape* in the City Art Gallery, Manchester; *Port de Bouc* (Southampton Art Gallery); and (amongst other Johns) *The Tutor* and a painting of *Arenig Mountain* in the Glyn Vivian Art Gallery, Swansea. Paintings executed by John during this period in galleries abroad include *La Belle Jardinière* and *Portrait of the Hon. K. Chaloner Dowdall* in the National Gallery of Victoria, Melbourne; *An Equihen Fisher Girl* and *A Summer Noon* in the National Gallery of Canada, Ottawa; *Reading aloud on the Downs* in the Public Art Gallery, Dunedin, New Zealand; *Miss Pettigrew* and *The Woman in Green* (Dolly Henry, mistress of John Currie who shot her and then himself in a fit of jealousy in 1914) in the South African National Gallery, Cape Town; *Rustic Idyll* from Lady Ottoline Morrell's collection in the Tatham Art Gallery, Pietermaritzburg, South Africa; *The Childhood of Pyramus* in the Johannesburg Art Gallery; *The Mumpers*, the huge tempera on canvas picture exhibited by John at the N.E.A.C. in the winter of 1912, in the Detroit Institute of Fine Arts; and finally two informal pictures of 1910, a Provençal study of *Woman Reading* and *Boy on a Cliff* in the Yale University Art Gallery, U.S.A. Reproductions of a reasonable number of these pictures can be found in the various picture-books on John. Especially useful are Sir John Rothenstein's Phaidon volume of 1944 and Malcolm Easton and Michael Holroyd's *The Art of Augustus John*, 1974.

Henry Lamb

The date-bracket isolates his early, formative work and excludes the portraits and family groups in which Lamb later specialized. A notable example of the latter genre is *The Family of Boris Anrep* in the Museum of Fine Arts, Boston.

CAMBRIDGE
Fitzwilliam Museum

Lytton Strachey 1913–14
Canvas, 20 × 16 (50.8 × 40.6)
Prov. C. K. Ogden; Mrs E. O. Vulliamy; Justin Vulliamy; Acqu. 1945

GLASGOW
Art Gallery and Museum

Breton Peasant c. 1910–11
Canvas, 17 × 14 (43.2 × 35.6)
Prov. C.A.S.; Acqu. 1928

LONDON
Tate Gallery

Death of a Peasant 1911
Canvas, 14½ × 12½ (36.8 × 31.8)
Prov. Sir Michael Sadler; Acqu. 1944 (from Leicester Galleries)
Rep. Kennedy, Pl. 1

N.B. Bought by Sir Michael Sadler from Fitzroy Street, probably in 1911. This is the first version of the painting in the National Gallery of New Zealand exhibited at the N.E.A.C. in 1911.

Lamentation 1911
Canvas, 36 × 21 (91.5 × 53.3); signed and dated
Prov. Hugh Blaker; C.A.S.; Acqu. 1956
Exh. N.E.A.C. summer 1911 (209)

Phantasy 1912
Canvas, 34 × 24 (86.5 × 61); signed and dated
Prov. C.A.S.; Acqu. 1924
Exh. N.E.A.C. summer 1912 (152); Whitechapel 1914, 'Twentieth Century Art' (326)
Rep. *Tate Gallery Illustrated Guide*, 1936, p. 117

Irish Girls 1912
Canvas, 29½ × 27¼ (74.9 × 69.2)
Prov. Julian Lousada; Acqu. 1939
Exh. Whitechapel 1914, 'Twentieth Century Art' (340) as *Irish Women*

Head of an Irish Girl 1912
Canvas, 20 × 16 (50.8 × 40.6)
Prov. Mr and Mrs J. L. Behrend; Acqu. 1917
Exh. probably Carfax Gallery December 1912,
'Camden Town Group' (30 or 31) as *Study of a Head*

N.B. See note on Lamb's contributions to the third
Camden Town Group exhibition.

Lytton Strachey 1914
Canvas, 96¼ × 70¼ (244.5 × 178.4)
Prov. J. L. Behrend; Acqu. 1957
Rep. Kennedy, Pl. 9

MANCHESTER
City Art Gallery

Head of a Boy c. 1910
Canvas, 20 × 16 (50.8 × 40.6)
Prov. F. Hindley Smith; Acqu. 1940
Exh. possibly Carfax Gallery June 1911, 'Camden
Town Group' (22) as *Boy's Head*

N.B. It is probable that either this picture or the
similar Breton boy (rep. Kennedy, Pl. 3), was the
work exhibited with the Camden Town Group.

The Lady with Lizards 1911
Canvas, 19 × 15 (48.3 × 38.1)
Prov. Sir Edward Marsh; C.A.S.; Acqu. 1954

SOUTHAMPTON
Art Gallery

Portrait of Edie McNeill 1911
Canvas, 51½ × 32 (130.1 × 81.3); signed and dated
Prov. Sir Michael Sadler; Acqu. 1938
Exh. N.E.A.C. winter 1911 (15) as *Portrait*
Rep. Kennedy, Pl. 2

N.B. See note to Pl. 94. A small version is illustrated
as Pl. 70.

NEW ZEALAND

WELLINGTON
National Art Gallery

Death of a Peasant 1911
Canvas, 18 × 16 (45.7 × 40.6)
Prov. Sir Augustus Daniel; Acqu. 1959
Exh. N.E.A.C. summer 1911 (198) as *Mort d'une
Paysanne*

SOUTH AFRICA

PORT ELIZABETH
King George VI Art Gallery

Meadow in Sunlight ?date
Panel, 8¼ × 13 (21 × 33)
Acqu. 1962 (from Adler Fielding Gallery)

N.B. I have seen neither the picture nor its
photograph and therefore do not know the date.

Wyndham Lewis

All Lewis's earliest paintings are lost. The only
works executed in oil within the period covered by
this book are in the Tate Gallery, London.

The Crowd 1914–15
Canvas, 79 × 60½ (200.7 × 153.7)
Prov. Capt. Lionel Guy Baker; Dr Barnet Stross;
Acqu. 1964
Exh. London Group spring 1915 (83)
Rep. Michel, Pl. VI in colour

Workshop 1914–15
Canvas, 30⅛ × 24 (76.5 × 61)
Prov. John Quinn; Mr and Mrs Edward H. Dwight;
Acqu. 1974
Exh. London Group spring 1915 (85); Vorticist
Exhibition 1915 (6d in Pictures section); New York
Vorticist Exhibition 1917 (36)
Rep. Michel, Pl. 30

Maxwell Gordon Lightfoot

The date-bracket covers all Lightfoot's oil paintings
in public collections except for a *Self Portrait* of c.
1904–5 in the Walker Art Gallery, Liverpool
(Walker 1972 catalogue, rep. Pl. 1).
 Catalogue note: references are given to the 1972
Walker Art Gallery catalogue entries where fuller
information on all Lightfoot's paintings is provided.

LIVERPOOL
Walker Art Gallery

Flowers in a Blue and White Vase 1907
Canvas, 15½ × 12½ (39.4 × 31.8); signed in
monogram and dated
Prov. Herbert Lightfoot; Acqu. 1954
Lit. Walker 1972 (8) rep. Pl. 4

Knapweed, Thistles and other Flowers in a Vase 1907
Canvas, $12\frac{1}{2} \times 15\frac{1}{2}$ (31.8 × 39.4); signed in
monogram and dated
Prov. E. Carter Preston; Sandon Studios Society;
Acqu. 1970
Lit. Walker 1972 (9)

Landscape, Abergavenny c. 1910
Canvas, $20 \times 24\frac{1}{4}$ (50.8 × 61.6)
Prov. Herbert Lightfoot; Acqu. 1954
Lit. Walker 1972 (39)

View of Conway c. 1910–11 (Pl. 65)
Canvas, $22\frac{1}{2} \times 30$ (57.4 × 76.2)
Prov. Herbert Lightfoot; Acqu. 1954
Lit. Walker 1972 (41) rep. Pl. 17

Study of Two Sheep 1911
Canvas, $20 \times 25\frac{1}{8}$ (50.8 × 63.8); signed and dated
Prov. Herbert Lightfoot; Acqu. 1954
Lit. Walker 1972 (42) rep. Pl. 24

LONDON
Slade School of Fine Art, University College

The following works remained in the possession of
the Slade after Lightfoot's training there:

Portrait of a Bearded Man 1908–9
Canvas, 24 × 20 (61 × 50.8)
Lit. Walker 1972 (13)

N.B. Awarded a first prize for figure painting at the
Slade for the year 1908–9.

Backview of Seated Male Nude 1908–9
Canvas, 30 × 20 (76.2 × 50.8)
Lit. Walker 1972 Appendix (27)

Frontview of Standing Male Nude 1908–9
Canvas, 36 × 24 (91.4 × 61)
Lit. Walker 1972 Appendix (28)

N.B. These two studies of the male nude were
together awarded a first prize for figure painting at
the Slade for the year 1908–9.

Interior of Barn with Figures 1909–10
Canvas, $40\frac{1}{2} \times 50$ (102.9 × 127)
Lit. Walker 1972 (17) rep. Pl. 6

N.B. Awarded the Melville Nettleship prize for
Figure Composition at the Slade for the year
1909–10.

James Bolivar Manson

The date-bracket has excluded most of Manson's
paintings in public collections, in particular exam-
ples of his later flower-pieces. The Maltzahn Gallery
publication, compiled by David Buckman to
accompany their exhibition in 1973, incorporates a
useful list of pictures by Manson in public galleries.
For reference the following omissions from this list
are known to me: *Landscape* (probably a South of
France subject of the 1920s) in the City Museum and
Art Gallery, Dundee; a very early portrait of *Edith
Mathews* and *Portrait of S. E. Markham*, M.P. of the
1930s in the Towner Art Gallery, Eastbourne;
Dartmouth of 1921 in the Royal Albert Memorial
Museum, Exeter; *Flowers* in the City Art Gallery,
Wakefield; *A Summer Bunch*, in the Queensland
Museum, Brisbane; and *Ranunculus* in the South
African National Gallery, Cape Town.

BELFAST
Ulster Museum

Air Freshening Breeze, St Briac
Panel, $13\frac{1}{8} \times 18$ (35.3 × 45.7)
Acqu. 1933 (from French Gallery)

N.B. Possibly a work of 1929, because another St
Briac subject was dated to that year in the catalogue
of the Manson memorial exhibition at Wildenstein's
in 1946.

BRIGHTON
Art Gallery

A Breezy Day, Sussex
Canvas, 20 × 24 (50.8 × 61)
Prov. Mrs J. Goldsmith; Acqu. 1970

N.B. This picture is probably a late work of c. 1934–5,
rather than of 1906–14. It may be *Spring in Sussex*,
dated 1934 when included in the Manson exhibition
at the Leicester Galleries in 1944 and dated 1935
when lent by Mrs Goldsmith to the Wildenstein
Manson memorial exhibition in 1946. The Brighton
Art Gallery also acquired *Evening Martigues* from
Mrs Goldsmith's executors in 1970. This second
picture was dated 1929 when exhibited at the
Leicester Galleries in 1944.

KINGSTON UPON HULL
University of Hull Art Collection

Portrait of the Artist's Wife 1911
Canvas, 30 × 25 (76.2 × 63.5)
Prov. Mrs Elizabeth Manson; Miss Mary Manson
and Mrs Jean Goullet; Acqu. 1966

Self Portrait c. 1912
Canvas, 20 × 16 (50.8 × 40.6)
Prov. D. C. Fincham; Acqu. 1938
Rep. *Studio*, CVII, 1934, p. 161

N.B. See note to Pl. 72 for another self-portrait of this period. The Tate portrait is signed and dated 'about 1912' on the stretcher.

BELGIUM

BRUSSELS
Musées Royaux de Beaux-Arts de Belgique

Mary c. 1912
Canvas, 30 × 25¼ (76.2 × 64.1)
Acqu. 1928 (presented by the artist)

N.B. A portrait of the artist's daughter.

Lucien Pissarro

Paintings by Lucien Pissarro, from all periods of his long and prolific career, are in public galleries throughout Great Britain. Fortunately most of these paintings are dated; thus there is little problem in separating his production of any one period from another. The Ashmolean Museum, Oxford, and the City Art Gallery, Manchester, have particularly fine and extensive collections of his paintings, although only two in each gallery fall within my date-bracket.

COLCHESTER
County Library, Essex County Council

View of Colchester from Sheepen 1911
Canvas, 21⅛ × 25⅝ (53.7 × 65); signed in monogram and dated
Prov. Ruth Bensusan-Butt; Acqu. 1949
Exh. Carfax Gallery June 1911, 'Camden Town Group' (14)

EDINBURGH
City Art Gallery

Blackpool Valley 1913
Canvas, 21½ × 25¾ (54.6 × 65.4); signed in monogram and dated
Prov. C.A.S.; Scottish Modern Arts Association; Acqu. 1964
Exh. Carfax Gallery 1913 (9)

KINGSTON UPON HULL
University of Hull Art Collection

Landscape near Chipperfield 1914
Canvas, 21 × 25¾ (53.3 × 65.4); signed in monogram and dated
Acqu. 1960 (from Messrs G. M. Lotinga)

N.B. Pissarro kept a catalogue of his paintings from 1914 until his death in 1944. He painted eight pictures in Chipperfield from April to May 1914, and exhibited two of them at the N.E.A.C. in the summer of 1914, No. 182, *Grey Morning, Chipperfield* and No. 184, *Blossom, Sun and Mist, Chipperfield.*

LEEDS
City Art Gallery and Temple Newsam House

Well Farm Bridge, Acton 1907 (Pl. 100)
Canvas, 18 × 21½ (45.7 × 54.5); signed in monogram and dated
Prov. Leeds Arts Collection Fund; Acqu. 1925
Exh. N.E.A.C. winter 1907 (110); Carfax Gallery June 1911, 'Camden Town Group' (15); Carfax Gallery 1913 (8)

LONDON
Department of the Environment

Great Western Railway, Acton 1907
Canvas, 18 × 21½ (45.7 × 54.5); signed in monogram and dated
Acqu. 1963 (from Leicester Galleries)
Exh. N.E.A.C. spring 1908 (83) as *Acton Station G.W.R.*
Rep. Southampton 1951 and Arts Council 1953 catalogues of Camden Town Group exhibitions

Rye from Cadboro Cliff–grey morning 1913
Canvas, 21 × 25 (53.3 × 63.5); signed in monogram and dated
Acqu. 1963 (from Leicester Galleries)
Rep. Leicester Galleries 1963 Pissaro exhibition catalogue

N.B. See note to Pl. 131 for versions and exhibition details of this subject.

MANCHESTER
City Art Gallery

The Hills from Cadborough 1913
Canvas, 21¼ × 25½ (54 × 64.8); signed in monogram and dated
Prov. Charles Rutherston; Acqu. 1925
Exh. N.E.A.C. winter 1913 (11)

Wild Boar Fell, Brough 1914
Canvas, 23½ × 29½ (59.7 × 74.9); signed in
monogram and dated
Prov. Charles Rutherston; Acqu. 1925
Exh. N.E.A.C. winter 1914 (132); Goupil Gallery
1917 (39)

OXFORD
Ashmolean Museum

Gelée Blanche, Chiswick 1906
Canvas, 15⅜ × 18 (39 × 45.7); signed in monogram
and dated
Acqu. 1952
Exh. N.E.A.C. summer 1912 (198)

Poulfenc à Riec 141910
Canvas, 21¼ × 25⅝ (54 × 65); signed in monogram
and dated
Acqu. 1952
Exh. N.E.A.C. summer 1910 (230)

PRESTON
Harris Museum and Art Gallery

Eden Valley 1914
Canvas, 21 × 25½ (53.3 × 64.8); signed in
monogram and dated
Prov. Sir Michael Sadler; C.A.S.; Acqu. 1924

WORTHING
Museum and Art Gallery

Cottage at Storrington 1911
Canvas, 16 × 20 (40.6 × 50.8); signed in monogram
and dated
Acqu. 1975 (from Thos Agnew & Sons)

SOUTH AFRICA

JOHANNESBURG
Art Gallery

Soleil du Matin 1910
Canvas, 17¼ × 21 (43.8 × 53.5); signed in
monogram and dated
Acqu. 1930 (from Goupil Gallery)
Exh. possibly N.E.A.C. winter 1910 (83) as *Matinée
soleil à Riec*; possibly Carfax Gallery 1913 (1) as
Matin, Soleil, Riec.

William Ratcliffe

The date-bracket covers Ratcliffe's most productive
period and thus includes most of his paintings in
public collections. The Tate Gallery, London, owns

an interior of *The Artist's Room in Letchworth* of 1932,
and the Letchworth Art Gallery inherited the con-
tents of his studio after his death (minus some of the
more important works distributed by the artist's
brother to various galleries, as detailed in the check-
list). The Letchworth collection is uncatalogued. It
includes watercolours, woodcuts and several oils,
some of them unfinished.

ABERDEEN
Art Gallery

Dieppe c. 1913–14
Canvas, 20 × 24 (50.8 × 61)
Acqu. 1963

LEEDS
City Art Gallery and Temple Newsam House

Landscape with Cow c. 1913
Canvas, 20 × 24 (50.8 × 61); signed
Acqu. 1964

N.B. Probably a Swedish subject.

LETCHWORTH
Museum and Art Gallery

Cottage Interior ?1909
Canvas, 19½ × 23½ (49.5 × 59.7)
Acqu. 1955 (from the artist's executors)

Old Cottage at Worth, Sussex ?c. 1909
Canvas, 19 × 22 (52.1 × 55.9)
Acqu. 1955 (from the artist's executors)

Temple Church ?c. 1914
Canvas, 20 × 16 (50.8 × 40.6)
Acqu. 1955 (from the artist's executors)

LIVERPOOL
Walker Art Gallery

In the Sun ?c. 1911 (Pl. 103)
Canvas, 18 × 14 (45.7 × 35.6); signed
Prov. S. K. Ratcliffe; Acqu. 1956
Exh. possibly Carfax Gallery December 1911,
'Camden Town Group' (24), Brighton 1913–14,
'English Post-Impressionists, Cubists and others'
(127), and London Group 1914 (102) as *Sunshine*

LLANELLI
Parc Howard Museum and Art Gallery

Hertford Landscape ?date
Board, 19½ × 24 (49.5 × 61)
Prov. Theodore Nicholl; Acqu. 1975

LONDON
Department of the Environment

Beehives in the Snow 1913 (Pl. 136)
Canvas, 16 × 20 (40.6 × 50.8); signed and dated
Acqu. 1962 (from Leicester Galleries)
Exh. A.A.A. 1913 (90); Brighton 1913–14, 'English
Post-Impressionists, Cubists and others' (126);
Whitechapel 1914, 'Twentieth Century Art' (430)

Summer Landscape 1913 (Pl. 134)
Canvas, 19⅝ × 29¾ (49.9 × 75.6); signed and dated
Acqu. 1960 (from Leicester Galleries)
Exh. possibly London Group 1914 (25) as *In the
Garden Suburb*

LONDON
Fellowship House, Willifield Way, Hampstead
Garden Suburb

Still Life ?date
Canvas, 23½ × 19¼ (59.7 × 48.9); signed
Prov. S. K. Ratcliffe; Acqu. 1956

N.B. Ratcliffe exhibited still-life paintings at the first
and second Camden Town Group exhibitions, at
Brighton in 1913–14 and at the London Group in
1914. However, there is no way of discovering more
about their subject. This picture is of flowers.

LONDON
Hampstead Garden Suburb Institute

From the Club Tower, Hampstead Garden Suburb
c. 1913
Canvas, 19½ × 29½ (49.5 × 74.9); signed
Prov. S. K. Ratcliffe; Acqu. 1956
Exh. London Group 1914 (103)

N.B. See note to Pl. 134. This picture has in the past
been confused with *In the Garden Suburb*, No. 25 at
the London Group in 1914.

MANCHESTER
City Art Gallery

Swedish Farm 1913
Canvas, 24 × 30 (61 × 76.2); signed
Prov. S. K. Ratcliffe; Acqu. 1955
Exh. possibly A.A.A. 1913 (89) as *A Swedish
Homestead*; possibly Brighton 1913–14, 'English
Post-Impressionists, Cubists and others' (124) as *A
Swedish Homestead* or (125) as *Spring, Sweden*

N.B. The problem of sorting out which of Ratcliffe's
extant Swedish subjects were exhibited where, and
under what titles, is touched upon in the note to Pl.
135. The exhibitions listed above were also
suggested for Pl. 135 which has the same
measurements as the Manchester painting.

Winter Scene, Sweden 1913
Canvas, 23½ × 30 (59.7 × 76.2); signed
Prov. E. C. Gregory; Acqu. 1946
Exh. probably Doré Galleries 1913,
'Post-Impressionists and Futurists' (55) and
Whitechapel 1914, 'Twentieth Century Art' (413) as
Snow Scene, Sweden

SOUTHAMPTON
Art Gallery

The Coffee House, East Finchley 1914 (Pl. 137)
Canvas, 20 × 24 (50.8 × 61); signed
Acqu. 1953
Exh. London Group spring 1919 (35)

CANADA

HAMILTON (Ontario)
Art Gallery

Landscape with Gate, Sweden 1913
Canvas, 17 × 25 (43.2 × 63.5); signed and dated
Prov. William Townsend; Acqu. 1965

Walter Richard Sickert

The date-bracket separates Sickert's work of the
Camden Town period from his vast production be-
tween 1882 and 1942. Lillian Browse, in her book on
Sickert published in 1960, included a comprehen-
sive list of Sickert's work, drawings and paintings, in
public collections throughout the world. There
have, of course, been acquisitions since that date but
her list still provides a remarkably accurate guide.
Most galleries in Great Britain, and many in the
English-speaking world, own examples of Sickert's
work of all periods.
Catalogue note: reproduction references to both
Browse, 1960, and Baron, 1973, are given whenever
possible. The catalogue numbers in Baron are also
indicated. These references are, however, not re-
peated in the check-list if the work is illustrated in
this book and therefore more fully catalogued in the
plate notes. Literary references to Baron have not
been given, but with a few exceptions every work
listed is discussed in Baron, whether illustrated in

that volume or not, and can be found in the index of works. The exceptions are: *La Rue Cousin, Dieppe* on loan to the National Gallery of Ireland; *The Blue Hat, Emily* in the City Art Gallery, Manchester; *Bonne Fille* in the Beaverbrook Art Gallery, Fredericton; *Landscape* in the Montreal Museum of Fine Arts; *Farmhouse* in the Gallery of Fine Arts, Columbus, Ohio; and *Two Coster Girls* in the Department of the Environment Collection.

ABERDEEN
Art Gallery

La Gaieté Rochechouart 1906
Canvas, 24 × 20 (61 × 50.8); signed
Prov. Lord Cottesloe; Acqu. 1950
Exh. possibly Bernheim-Jeune, Paris 1907 (50) and 1909 (64)
Rep. Baron, Fig. 156 (C.234)

BATH
Victoria Art Gallery

Lady Noble c. 1905–6
Canvas, 20 × 16 (50.8 × 40.6); signed
Prov. Lady Noble; Acqu. 1948
Rep. Baron, Fig. 138 (C.204)

BIRMINGHAM
Barber Institute

The Eldorado c. 1906
Canvas, 19 × 23¼ (48.3 × 59)
Prov. Madame de Gandarillas; Charles E. Eastman; Acqu. 1968
Rep. Baron, Fig. 163 (C.235)

N.B. It was this version, not as stated in Baron another perhaps unfinished painting of the same subject, that was reproduced in *Studio*, November 1930, p.324.

BIRMINGHAM
City Art Gallery

Noctes Ambrosianae c. 1906
Canvas, 25 × 30 (63.5 × 76.2); signed
Prov. Hilda Trevelyan; Acqu. 1949

N.B. See Baron, C.230, for discussion of the relationship of this version of *Noctes Ambrosianae* to the picture in Nottingham (Pl. 1).

BRISTOL
City Museum and Art Gallery

Army and Navy 1914
Canvas, 20 × 16 (50.8 × 40.6); signed
Prov. C.A.S.; Acqu. 1935
Exh. Carfax Gallery 1914 (21)
Rep. Baron, Fig. 219 (C. 311)

CAMBRIDGE
Fitzwilliam Museum

Mrs Swinton c. 1906
Canvas, 30 × 25 (76.2 × 63.5)
Prov. the Hon. Mrs Maurice Glyn;
J. W. Freshfield; Acqu. 1955
Exh. possibly Bernheim-Jeune, Paris 1907 (36)
Rep. Baron, Fig. 157 (C. 223)

Little Rachel at a Mirror 1907
Canvas, 20 × 16 (50.8 × 40.6); signed
Prov. L. G. Hoare; Keith Baynes; Acqu. 1974
Rep. Columbus Gallery of Fine Art, catalogue of exhibition 'British Art 1890–1928' (101)

Woman with Ringlets c. 1911
Canvas, 14 × 12 (35.6 × 30.5); signed
Prov. F. Hindley-Smith; Acqu. 1939

Oeuillade c. 1911
Canvas, 15 × 12 (38.1 × 30.5); signed
Prov. Howard Bliss; Acqu. 1945
Exh. probably Carfax Gallery 1912 (18) and/or Brighton 1913–14, 'English Post-Impressionists, Cubists and others' (58)

CAMBRIDGE
King's College, Keynes Collection

Théâtre de Montmartre 1906
Canvas, 19¼ × 24 (48.9 × 61); signed
Prov. Lord Keynes
Exh. probably Bernheim-Jeune, Paris 1907 (35) and 1909 (63)
Rep. Browse 1960, Pl. 1 in colour; Baron, Fig. 162 (C. 233)

DUBLIN
National Gallery of Ireland has *La Rue Cousin, Dieppe, c.* 1907, on loan from a private collector

DUNDEE
City Museum and Art Gallery

La Scierie de Torqueville or *Le Vieux Colombier* 1913
Canvas, 26 × 41½ (66 × 105.4); signed
Prov. W. Rees Jeffreys; Acqu. 1955 (from Messrs Tooth)
Exh. Carfax Gallery 1914 (22)
Rep. Baron, Fig. 236 (C. 342)

EASTBOURNE
Towner Art Gallery

The Poet and his Muse or *Collaboration* c. 1906–7
Canvas, 18 × 9 (45.7 × 22.9); signed
Prov. Sylvia Gosse; Acqu. 1955
Exh. probably Bernheim-Jeune, Paris 1907 (72)
Rep Baron, Fig. 173 (C. 256)

EDINBURGH
Scottish National Gallery of Modern Art

La Rue Pecquet c. 1906–8
Canvas, 12¾ × 9⅝ (32.4 × 24.5)
Prov. Sir Hugh Walpole and Dorothea Walpole;
Acqu. 1963

EXETER
Royal Albert Memorial Museum

Le Lit de Cuivre c. 1906
Canvas, 15½ × 19½ (39.4 × 49.5); signed
Prov. Private Collection, Copenhagen; Acqu. 1968
(from Thos Agnew & Sons)
Exh. possibly Bernheim-Jeune, Paris 1907 (55) and 1909 (40)
Rep. Catalogue, Sotheby's, 12 April 1967, lot 62;
Fine Art Society 1976, 'Camden Town Recalled',
p. 8

N.B. A version of the painting illustrated as Pl. 29.

KIRKCALDY
Museum and Art Gallery

'What shall we do for the Rent?' c. 1909 (Pl. 106)
Canvas, 19 × 15 (48.3 × 38.1)
Prov. Dr Alastair Hunter; J. W. Blyth; Acqu. 1964
Exh. possibly Salon d'automne, Paris 1909 (1582 or 1583) as *L'Affaire de Camden Town*; Carfax Gallery June 1911, 'Camden Town Group' (10 or 12) as *The Camden Town Murder Series No. 1* or *No. 2*

Wellington House Academy 1914
Canvas, 16 × 20 (40.6 × 50.8); signed and dedicated to W. H. Davies
Prov. J. W. Blyth; Acqu. 1964

N.B. One of the 'direct little pictures 20 × 16 on the way' which Sickert sketched in his letter to Nan Hudson in February 1914 (see note to Pl. 147).

LEEDS
City Art Gallery and Temple Newsam House

Off to the Pub c. 1912
Canvas, 19¼ × 11½ (48.9 × 29.2); signed
Prov. Capt. A. K. Charlesworth; Lady George Cholmondeley; Acqu. 1966
Rep. Browse 1960, Pl. 63; Baron, Fig. 212 (C. 303)

Café des Arcades or *Café Suisse* c. 1914
Canvas, 21½ × 15 (54.6 × 38.1)
Prov. Mrs M. Clifton; Acqu. 1942

LINCOLN
Usher Gallery

Reclining Nude c. 1906
Canvas, 15 × 20 (38.1 × 50.8); signed
Prov. C.A.S.; Acqu. 1936

LIVERPOOL
Walker Art Gallery

Fancy Dress, Miss Beerbohm 1906
Canvas, 20 × 16 (50.8 × 40.6); signed
Prov. Walter Taylor; Mark Oliver; Mrs D. M. Fulford; Acqu. 1945
Rep. Baron, Fig. 149 (C. 215)

N.B. The British Council owns a later version (c. 1916) of this composition.

LONDON
The Arts Council of Great Britain

The Belgian Cocotte (Head of a Woman) 1906
Canvas, 19½ × 15¾ (49.5 × 40); signed
Prov. Private Collection, Paris; Acqu. 1953
Rep. Baron, Fig. 154 (C. 220)

Woman seated on a Bed 1907
Canvas, 26 × 32 (66 × 81.3); signed and dated
Acqu. 1955
Exh. possibly N.E.A.C. summer 1911 (195) as *The Ebony Bed*
Rep. Baron, Fig. 176 (C. 255)

LONDON
Courtauld Institute of Art

Mrs Barrett 1906
Canvas, 19¾ × 15¾ (50.2 × 40); signed twice
Prov. Roger Fry; Acqu. 1934
Rep. Baron, Fig. 153 (C. 219)

N.B. The Courtauld Institute also possesses another
Sickert from Fry's collection, *Queen's Road,
Bayswater Station* of *c*. 1916.

LONDON
Department of the Environment

Two Coster Girls c. 1908 (Pl. 23)
Panel, 14 × 10¼ (35.5 × 26)
Prov. Vanessa Bell; Mrs A. V. Garnett;
Acqu. 1979 (from Fine Art Society)

LONDON
Tate Gallery

Woman Washing her Hair 1906
Canvas, 18 × 15 (45.7 × 38.1); signed
Prov. Lord Henry Cavendish-Bentinck; Acqu.
1940
Exh. possibly Bernheim-Jeune 1907 (21) as *La
Toilette*
Rep. Baron, Fig. 170 (C. 248)

L'Américaine 1908
Canvas, 20 × 16 (50.8 × 40.6); signed and dated
Prov. Lord Henry Cavendish-Bentinck; Acqu.
1940
Exh. N.E.A.C. summer 1909 (188) and
Bernheim-Jeune, Paris 1909 (4) as *The American
Sailor Hat*
Rep. Browse 1960, Pl. 54; Baron, Fig. 185 (C. 266)

Jacques-Emile Blanche c. 1910
Canvas, 24 × 20 (61 × 50.8)
Prov. Hilda Trevelyan; Acqu. 1938
Exh. N.E.A.C. summer 1912 (163)
Rep. Baron, Fig. 204 (C. 294)

The Garden of Rowlandson House – Sunset
c. 1910–11 (Pl. 61)
Canvas, 24 × 20 (61 × 50.8); signed
Prov. Lord Henry Cavendish-Bentinck; Acqu.
1940
Exh. Whitechapel 1914, 'Twentieth Century Art'
(434)

Off to the Pub c. 1911
Canvas, 20 × 16 (50.8 × 40.6); signed
Prov. Howard Bliss; Acqu. 1943
Exh. probably Dunmow Artists' Picture Show,
November 1911
Rep. Baron, Fig. 205 (C. 296)

Portrait of Harold Gilman c. 1912 (Frontispiece in
colour)
Canvas, 24 × 18 (61 × 45.7)
Prov. Mrs Gilman; Acqu. 1957

Ennui c. 1914
Canvas, 60 × 44¼ (152.4 × 112.4); signed
Prov. C.A.S.; Acqu. 1924
Exh. N.E.A.C. summer 1914 (164)
Rep. Rothenstein 1961, Pl. 11 in colour; Baron, Fig.
223 (C. 313)

Tipperary 1914
Canvas, 20 × 16 (50.8 × 40.6)
Prov. Lord Henry Cavendish-Bentinck; Acqu.
1940
Rep. Browse 1960, Pl. 68

MANCHESTER
City Art Gallery

The Blue Hat, Emily c. 1911–12
Canvas, 20 × 16 (50.8 × 40.6)
Prov. Charles Rutherston; Acqu. 1925
Rep. Browse 1943, Pl. 41

Hubby and Marie 1914
Canvas, 20 × 16 (50.8 × 40.6); signed
Prov. Charles Rutherston; Acqu. 1925

Nude seated on a Couch 1914 (Pl. 147)
Canvas, 20 × 16 (50.8 × 40.6); signed
Prov. Charles Rutherston; Acqu. 1925

MANCHESTER
Whitworth Art Gallery has *The Obelisk*, 1914
(Baron, Fig. 240. C. 346), on loan from a private
collector

NOTTINGHAM
Castle Museum and Art Gallery

Noctes Ambrosianae 1906 (Pl. 1)
Canvas, 25 × 30 (63.5 × 76.2); signed
Prov. Walter Taylor; J. B. Priestley; Acqu. 1952
Exh. N.E.A.C. summer 1906 (123); Salon
d'automne, Paris 1906 (1545)

PLYMOUTH
City Museum and Art Gallery

Little Rachel 1907
Canvas, 16⅜ × 13¾ (42.2 × 35); signed twice
Acqu. 1961
Rep. Baron, Fig. 184 (C. 264)

PORTSMOUTH
City Museum and Art Gallery

Belgian Cocottes. The Map of London 1906
Canvas, 20 × 16 (50.8 × 40.6); signed
Prov. Sir Augustus Daniel; J. W. Blyth; Acqu. 1973
Exh. probably Bernheim-Jeune 1907 (67)
Rep. Browse 1960, Pl. 51

PRESTON
Harris Museum and Art Gallery

Two Women c. 1911
Canvas, 20 × 16 (50.8 × 40.6); signed
Prov. C.A.S.; Acqu. 1938
Rep. Baron, Fig. 203 (C. 295)

SALFORD
Museum and Art Gallery

Reflected Ornaments ?c. 1909
Canvas, 11 × 15½ (28 × 39.4); signed
Acqu. 1964 (from Tib Lane Gallery, Manchester)

N.B. The Salford Gallery believe their picture dates
from June 1919 because the stretcher bears an
inscription, perhaps in Sickert's hand, reading
'Walter Sickert/June 1919 ab'. I cannot explain this
inscription except to remark that it does not
necessarily refer to the date of execution.
Stylistically this thickly impasted still-life fits better
into the context of Sickert's handling in 1909.

SHEFFIELD
Graves Art Gallery

The Soldiers of King Albert the Ready 1914
Canvas, 77¼ × 60 (196.2 × 152.4); signed and dated
Prov. L. G. Wylde; G. P. Dudley Wallis; Acqu.
1969
Exh. N.E.A.C. winter 1914 (151)
Rep. Baron, Fig. 245 (C. 351)

SOUTHAMPTON
Art Gallery

The Juvenile Lead. Self Portrait 1907 (Pl. 35)
Canvas, 20 × 18 (50.8 × 45.7); signed
Prov. Mrs L. G. Wylde; David Niven; Acqu. 1951
Exh. Salon d'automne, Paris 1907 (1535)

The Mantelpiece c. 1906–7
Canvas, 30 × 20 (76.2 × 50.8)
Acqu. 1932
Exh. possibly Bernheim-Jeune, Paris 1907 (48) and
1909 (3)
Rep. Baron, Fig. 210 (C. 298)

N.B. I am inclined to revise the dating I have
previously suggested of *c.* 1911–12 for this picture in
favour of the traditional dating, suggested by Lillian
Browse, of *c.* 1906–7.

AUSTRALIA

ADELAIDE
The Art Gallery of South Australia

Mornington Crescent Nude, Contre-Jour 1907 (Pl. 38)
Canvas, 20 × 24 (50.8 × 61); signed
Prov. Hugh Hammersley; Acqu. 1963

BRISBANE
Queensland Museum

Little Rachel 1907
Canvas, 24 × 20 (61 × 50.8); signed
Prov. Mrs Rayner; Robert Emmons; Acqu. 1956
Exh. Eldar Gallery 1919 (1)
Rep. Browse 1943, Pl. 34

CANADA

FREDERICTON (New Brunswick)
Beaverbrook Art Gallery

Bonne Fille c. 1905–6
Canvas, 18⅛ × 15 (46 × 38.1); signed
Prov. Bernard Falk; Acqu. 1955

The Old Middlesex c. 1906–7
Canvas, 25 × 30 (63.5 × 76.2); signed
Prov. L. G. Wylde; Sir Geoffrey Hutchinson (Lord
Ilford); Lord Beaverbrook; Acqu. 1960
Exh. possibly Bernheim-Jeune, Paris 1907 (38)
Rep. Baron, Fig. 160 (C. 231)

Sunday Afternoon c. 1912–13
Canvas, 20 × 12 (50.8 × 25.4); signed
Prov. Bernard Falk; Acqu. 1955
Rep. Baron, Fig. 214 (C. 305)

HAMILTON (Ontario)
Art Gallery

The Painter in his Studio 1907 (Pl. 36)
Canvas, 20 × 24 (50.8 × 61); signed
Prov. Hugh Hammersley; Robert Emmons; Mrs
George Swinton; Acqu. 1970
Exh. N.E.A.C. spring 1907 (73) as *The Parlour
Mantelpiece*

Hubby and Marie 1914
Canvas, 18½ × 15 (47 × 38.1); signed
Prov. J. Stanley-Clarke; Acqu. 1960
Rep. Baron, Fig. 218 (C. 309)

N.B. Closely based on a composition sketched by
Sickert in his letter to Nan Hudson of February
1914. The picture of the same title in Manchester is
related to this Hamilton picture.

MONTREAL
Museum of Fine Arts

Landscape ?date
Panel, 5⅜ × 9⅜ (13.7 × 23.8); signed
Prov. Mrs Maud Morgan; Acqu. 1961

N.B. I have seen neither the painting nor its
photograph. The Montreal Museum suggest a date
of *c.* 1910.

NEW ZEALAND

WELLINGTON
National Art Gallery

The Blue Hat 1914
Canvas, 18¼ × 15 (46.4 × 38.1); signed
Acqu. 1951

N.B. Another of the 'direct little pictures' sketched in
Sickert's letter to Nan Hudson of February 1914.
Sickert altered his proposed dimensions a little, as he
did for the Hamilton Art Gallery painting of *Hubby
and Marie*.

SOUTH AFRICA

JOHANNESBURG
Art Gallery

La Rue Ste Catherine and the Vieux Arcades 1910
Canvas, 22¼ × 19½ (56.5 × 49.5); signed
Prov. commissioned by Sir Hugh Lane in 1910; Sir
Otto Beit; Acqu. 1910

U.S.A.

BOSTON
Museum of Fine Arts

Les Petites Belges 1906
Canvas, 20 × 16 (50.8 × 40.6); signed
Prov. Mrs Montgomery Sears; Acqu. 1938
Exh. probably Bernheim-Jeune, Paris 1907 (43)
Rep. Baron, Fig. 150 (C. 216)

COLUMBUS (Ohio)
Gallery of Fine Arts

Farmhouse, Dieppe ?date
Canvas, 8¼ × 10 (21 × 25.4); signed
Prov. Miss Marjorie Lilly; Acqu. 1956 (from Thos
Agnew & Sons)

NEW YORK
Metropolitan Museum of Art

Jeanne Daurment, La Cigarette 1906
Canvas, 20 × 16 (50.8 × 40.6); signed
Prov. Vincent Astor; Mrs M. C. Fosburgh;
Acqu. 1979
Exh. probably Bernheim-Jeune, Paris 1907 (81) and
1909 (62)
Rep. Baron, Fig. 155 (C. 221)

NEW YORK
Museum of Modern Art

La Gaieté Montparnasse c. 1907
Canvas, 24 × 20 (61 × 50.8); signed
Prov. G. P. Dudley Wallis; Lord Cottesloe; Mr and
Mrs Emil Ford; Acqu. 1959
Exh. possibly N.E.A.C. summer 1909 (169)
Rep. Baron, Fig. 164 (C. 236)

WASHINGTON
Phillips Art Gallery

Miss Hudson at Rowlandson House c. 1910
Canvas, 36 × 20 (76.2 × 50.8); signed
Prov. Anne Hope Hudson; Ethel Sands;
Acqu. 1966
Rep. Browse 1943, Pl. 37

Indexes

General Index

The General Index covers the text and plate notes only.
It does not cover:
 Biographies Section
 Catalogue data on pictures (e.g. exhibition history, provenance)
 Press reviews, whether the writers are named in the text or not
 Appendix check-list
However, exceptions to the above exclusions are made if the information amplifies an indexed theme or person.

Abbreviations:

A.A.A.	Allied Artists' Association
B.	Biographies Section
CL.	Check-list of works in public collections
C.T.G.	Camden Town Group
F.S.G.	Fitzroy Street Group
L.G.	London Group
N.E.A.C.	New English Art Club
R.A.	Royal Academy

Plate numbers are bracketed and printed in bold type.